Elizabeth Robins Pennell

For a complete list of titles published visit the Edinburgh Critical Studies in Victorian Culture web page at www.edinburghuniversitypress.com/series/ECVC

Also Available:
Victoriographies – A Journal of Nineteenth-Century Writing, 1790–1914, edited by Diane Piccitto and Patricia Pulham
ISSN: 2044-2416
www.eupjournals.com/vic

Elizabeth Robins Pennell

Critical Essays

Edited by Dave Buchanan and
Kimberly Morse Jones

EDINBURGH
University Press

Edinburgh University Press is one of the leading university presses in the UK. We publish academic books and journals in our selected subject areas across the humanities and social sciences, combining cutting-edge scholarship with high editorial and production values to produce academic works of lasting importance. For more information visit our website: edinburghuniversitypress.com

Edinburgh University Press Ltd
The Tun – Holyrood Road, 12(2f) Jackson's Entry, Edinburgh EH8 8PJ

First published in hardback by Edinburgh University Press 2021

Typeset in 11/13 Adobe Sabon by
IDSUK (DataConnection) Ltd, and
printed and bound by CPI Group (UK) Ltd
Croydon, CR0 4YY

A CIP record for this book is available from the British Library

ISBN 978 1 4744 7536 5 (hardback)
ISBN 978 1 4744 7537 2 (paperback)
ISBN 978 1 4744 7538 9 (webready PDF)
ISBN 978 1 4744 7539 6 (epub)

Contents

List of Illustrations

Acknowledgements

Thank you to all the contributors who made this book possible. The community of academics with an interest in Elizabeth Robins Pennell's work has turned out to be larger and more enthusiastic than we ever imagined.

The staff at Edinburgh University Press, especially Michelle Houston and Ersev Ersoy, have been a pleasure to work with. We're grateful, as well, to the Series Editor for offering such thoughtful feedback on the manuscript and to Fiona Sewell for her keen editorial eye.

Dave Buchanan would like to thank the colleagues, friends and family who have encouraged this project, especially David Grant, Asma Sayed, Paul Lumsden, Jack Skeffington, Duncan Jamieson, Carol Bell and, most of all, Theresa Agnew.

Kimberly Morse Jones would like to thank Anna Gruetzner Robins for introducing her to Pennell, and her colleagues and the library staff at Sweet Briar College, as well as her family, for their support.

Notes on Contributors

Christine Bachman-Sanders earned her doctorate in American Studies at the University of Minnesota. Her dissertation examines the relationship between the New Woman, American imperialism and bicycle-tourism in the 1890s. Her research interests are focused on queer and feminist studies, critical race theory, and studies of travel and empire.

Una Brogan teaches in the English department at Université Lyon 3-Jean Moulin, having recently completed her PhD on bicycles in British and French literature (1880–1914) at Université Paris 7-Diderot. Originally from Northern Ireland, she took degrees in French, history, literary translation and comparative literature at Oxford, Warwick and Paris IV-Sorbonne universities, in between stints as a bicycle courier, bike tourer, translator and environmental and migrants' rights activist. She recently contributed a chapter on bicycles in Proust for an edited collection, *Culture on Two Wheels: The Bicycles in Literature and Film* (University of Nebraska Press, 2016).

Dave Buchanan is Associate Professor of English at MacEwan University in Edmonton, Alberta, where he teaches literary non-fiction and travel literature. He edited a new edition of Elizabeth Robin's Pennell's first two cycle-travel books, *A Canterbury Pilgrimage / An Italian Pilgrimage* (University of Alberta Press, 2015). His current research looks at the origins of literary cycling in the late nineteenth century.

Meaghan Clarke is Senior Lecturer in Art History at the University of Sussex. She has published widely on gender, art writing, taste, portraiture, travel, fashionability and Canadian art. She is the author of *Critical Voices: Women and Art Criticism in Britain, 1880–1905* (Ashgate, 2005) and *Fashionability, Exhibition Culture and Gender Politics: Fair Women* (Routledge, 2020).

James Diedrick is Professor of English at Agnes Scott College in Atlanta, Georgia, where he teaches courses on Victorian Literature and Culture, Global Modernism, and Film. He is the author of *Mathilde Blind: Late-Victorian Culture and the Woman of Letters* (University of Virginia Press, 2016) and *Understanding Martin Amis* (University of South Carolina, 1995; revised and expanded edition, 2004), and co-editor of *Depth of Field: Stanley Kubrick, Film, and the Uses of History* (University of Wisconsin Press, 2006).

Jane S. Gabin, originally from New York, received her PhD from the University of North Carolina-Chapel Hill. She has published three books and numerous articles and encyclopedia entries. With extensive teaching experience, ranging from high school to college to life-long learning, she also worked for over twenty years on 'both sides of the desk' in college admissions. She has presented papers at numerous conferences in the US, Canada, France and the UK, specialising in less-heralded Victorian women.

Holly A. Laird, Frances W. O'Hornett Professor of Literature at the University of Tulsa, is author of *Women Coauthors* (University of Illinois Press, 2000) and numerous articles on turn-of-the-twentieth-century women writers; co-lead transcription editor for *The Michael Field Diaries Digital Archive*; co-editor (U.S.) of *Contemporary Women's Writing*; and editor of *The History of British Women's Writing, vol. 7, 1880–1920* (Palgrave, 2016).

Alice L. McLean, PhD in English, specialises in food writing and feminist food studies. She has written extensively on the construction of gender in culinary and gastronomic literature. She is the author of *Aesthetic Pleasure in Twentieth-Century Women's Food Writing: The Innovative Appetites of M.F.K. Fisher, Alice B. Toklas, and Elizabeth David* (Routledge, 2012).

Kimberly Morse Jones is Associate Professor of Art History at Sweet Briar College in Virginia. Her research focuses on Victorian art criticism. She is the author of *Elizabeth Robins Pennell: Nineteenth-Century Pioneer of Art Criticism* (Ashgate, 2015). She is currently working on a four-volume anthology of art criticism from the long nineteenth century to be published by Routledge.

Bonnie Shishko is Assistant Professor of English at Queens University of Charlotte, North Carolina. Her research and teaching focus

on conceptions of the domestic in Victorian literature and culture. Her current book project, 'Epistemologies of the Kitchen: Art, Science, and Nineteenth-Century British Culinary Writing', explores the ways in which emergent scientific and aesthetic theories transformed the Victorian cookbook.

Alex Wong is a fellow of St. John's College at the University of Cambridge, where he teaches English literature. He has academic interests in both early modern literature and the writing of the long nineteenth century. He has edited selections of Swinburne's poems and Pater's essays and is (at the time of writing) working on an anthology of Alice Meynell's verse and prose.

Introduction

Dave Buchanan and Kimberly Morse Jones

In her day, Elizabeth Robins Pennell, accomplished late-Victorian author of over twenty books and over a thousand magazine articles on a stunning variety of subjects – from cycling to travel to art criticism, biography and food – was all too often seen as, at best, a creative co-collaborator with, or, at worst, a writerly sidekick to, her more famous husband, the illustrator Joseph Pennell.[1] Elizabeth Robins was twenty-six years old when she met Joseph Pennell, who was two years younger, in Philadelphia in 1881. They collaborated on an article for the *Century Magazine*. He was commissioned to do the illustrations; she was to provide the text. They hit it off, and, after a three-year courtship, they married and moved to London in 1884. Using that city as their home base, they worked and travelled together extensively in Great Britain and Europe for over three decades, publishing both individually and collaboratively. Joseph's prolific work in illustration, especially etching, was so widely respected that the art historian Joseph Jackson called Joseph 'the greatest American etcher of his time, and one of the leading etchers of all time'.[2] Joseph was invited to illustrate works by some of the leading writers of the era, such as Washington Irving, Henry James and William Dean Howells, and his work appeared in leading magazines on both sides of the Atlantic. Meanwhile, Elizabeth's literary oeuvre, as impressive as it seems now for both its quality and quantity, gained her only moderate success in her day. (The most common adjective used by reviewers of her work was the faint praise 'charming'.)

Like many female writers and artists at this time who were married to male ones, Elizabeth's career was overshadowed by her husband's.[3] This was despite their progressive arrangement, whereby they vowed

to each pursue separate careers – his drawing and her writing – above all,[4] and despite the fact that in the Pennells' many collaborative book- and magazine-writing projects, Elizabeth not only did the bulk of the writing but was intimately involved in the day-to-day tasks of oversee- ing the publication of their work. Although she gained some renown for her early cycling writing in particular (the publisher George Allen once asked if she was the 'Mrs. Pennell of cycling fame'),[5] to many who recognised her name, she was but one half of the collaborative duo Team Pennell. To some others, however, she was merely the 'wife or sister or *something*'[6] of a famous illustrator – defined primarily (and sometimes inaccurately, as the above quotation suggests) by her relationship to a man.

Yet looking back from our vantage point in the early twenty-first century, Elizabeth's accomplishments seem at least as impressive as her husband's – perhaps more so – not only in terms of her ability to write intellectually and engagingly on a broad spectrum of subjects, but also in how the content and style of her writings were ahead of their time. For example, although she didn't receive the credit she deserved in her day, we know now that she practically invented leisure cycle-travel writing in the 1880s. These writings prepared the way not just for the explosion of cycle-travel books in the 1890s but also for twentieth- century classics by writers such as Dervla Murphy and Anne Mustoe. Elizabeth's cycling books are still enjoyed by cycling enthusiasts, and tours retracing some of the couple's original European routes are avail- able today.[7] Elizabeth was also a pioneer in the field of New Art Criti- cism in the 1890s. Her contributions to the development of formalist art criticism anticipated the writings of the American art critic and champion of Abstract Expressionism Clement Greenberg in the twen- tieth century. Moreover, Elizabeth's writings on her friend and fellow American James McNeill Whistler are still well regarded and often quoted. Her unconventional food writing from the same period is now hailed as decades ahead of its time as well. The English writer Jeanette Winterson has traced *The Alice B. Toklas Cookbook* (1954) back to Pennell's food writing[8] and has also linked the English chef and televi- sion presenter Nigella Lawson's casual and pleasurable approach to food to that of Pennell. (Lawson purportedly owns a copy of Pennell's *A Guide for the Greedy by a Greedy Woman*.) It is clear, therefore, that Elizabeth Robins Pennell's body of work warrants further admi- ration and exploration.

The reasons for the underappreciation of Elizabeth's work are complex. In large part, she suffered from the sexism and double stan- dard of a time that tended to downplay women's accomplishments

and overplay men's. (In fact, strange as it seems now, some of the contemporary reviews of their collaborative books praised Joseph's illustrations and said little or nothing at all about Elizabeth's writing, as if it were mere filler between the pictures.)[9] But Elizabeth didn't always help her cause in this regard, sometimes avoiding the spotlight, displaying a reluctance to take credit for some of her work, and preferring to publish a great deal of her periodical writing, especially, anonymously or pseudonymously, as if she were deflecting attention away from herself. Like so many women writers of her age, she seemed to have accepted, to some extent, the view that it wasn't appropriate for a woman to seek attention or fame – at least when writing about certain subjects or in certain venues. Interestingly, although she wrote four book-length biographies, she never wrote a conventional autobiography, despite having lived a life full of adventure, travel, and connection to famous people besides Whistler, such as Edmund Gosse, Thomas Hardy, Walter Pater, Henry James, George Bernard Shaw, J. M. Barrie, Bram Stoker, William Morris and Aubrey Beardsley. Her many travel pieces and books about other people offer occasional glimpses of time spent around famous figures, but rarely does she talk about herself in these works. There are subjective flashes, but these are almost always guarded; she prefers to keep her focus outward. It's as if she deemed her own story hardly worth telling.[10]

It is important to bear in mind when discussing Pennell's shrouded identity that much of her writing, as mentioned above, was published in the periodical press. In addition to her adoption of anonymity or pseudonymity, which were common journalistic practices, the fact that Pennell published non-fiction in the periodical press – much of it in daily newspapers, as opposed to writing fiction, poetry or articles for monthly periodicals, which were perceived as more prestigious and permanent than the fleeting dailies and weeklies[11] – must have made it more difficult for her name to become known. Yet without the periodical press, which opened up new avenues for women writers in the nineteenth century,[12] it is doubtful she would have found her voice as a writer, since this is where she established a foothold in the literary world. Unlike writers whose periodical contributions were later compiled into a full-length novel, collection of poems or volume of criticism, Pennell, with the exception of her cookery articles published in the *Pall Mall Gazette*, did not benefit from this kind of elevated exposure.

In fact, Pennell mostly avoided self-promotion, choosing to focus on advancing aesthetic, rather than personal, concerns. She has been

described by Talia Schaffer as more of a 'forgotten female aesthete' than a New Woman; this despite the fact that Pennell wrote a book about radical Mary Wollstonecraft, enjoyed considerable independence in her unconventional marriage, and cycled extensively in an age when cycling was strongly associated with the New Woman image. It is true that Pennell's interest in beauty in various forms – in visual art, literature, landscapes, architecture, food, music – always trumps any interest she may have had in politics and the Woman Question. While cycling across England and Europe, she sought picturesque landscapes and architecture and traced the footsteps of famous figures of arts and letters; on her quest for 'gypsies',[13] it was their beautiful music and romantic mythos that she was attracted to; in all four of her biography projects, she writes of the lives of artists of one kind or another; her food writing is remarkable for how it treats cuisine as art that sustains the soul as much as the stomach; even her writing produced during the 1910s turns to art as an antidote to the madness of war. Pennell championed the aesthetic impulse, above all, in everything she wrote, often placing her reverence for beauty above building her own reputation. If she avoided talking about herself, it was because she preferred talking about art.

In the decades after Elizabeth's death, the impression of her side-kick status was perpetuated by the few who commented on the Pennells. In a 1939 essay, her brother Edward Robins wrote, 'My sister in her writing worked as hard as her husband, contributing art criticisms to newspapers and reviews, magazine articles, finishing a book now and then.'[14] That last part sounds rather dismissive, given that in her lifetime Elizabeth authored more books than Joseph, by a considerable margin. Edward implies that his sister's major writing projects, including four biographies, ten travel books, a novel, a collection of food essays and two partial memoirs, were mere side hobbies. In 1951, Edward Larocque Tinker, in his tribute to his dear friends, *The Pennells*, describes Elizabeth as the well-mannered, charming (that word again) and tactful foil to her brilliant but cantankerous, outspoken husband.[15] In Tinker's telling, Elizabeth played the supporting wifely role to Joseph's leading man. Her accomplishments, as cycling writer, art critic, journalist, food writer and biographer, were impressive, Tinker admits, but, he implies, they were secondary to her husband's more profound legacy as illustrator and author of books about art. (Never mind that she had a major hand in writing many of those very books, even the ones with just his name on the cover, such was their unusual collaborative creative process.) A couple of decades later, the first academic treatment of Pennell's writing,

John Lawrence Waltman's doctoral dissertation in 1976, furthered this perception. Waltman wrote about Pennell's early unpublished journals but only in so far as they revealed details about the lives of more famous artists and writers the Pennells associated with in London. Pennell herself, and her ideas about art and literature, are almost incidental to Waltman's analysis.

Today, however, Joseph Pennell's star has faded, for all but historians of Victorian illustration. Meanwhile, Elizabeth's is firmly on the rise. No longer is her work overshadowed by her husband's. In recent decades, her books and periodical contributions have begun to be rediscovered and appreciated again, mainly by feminist scholars of art history and literary food writing as well as aficionados of early cycling history. A new edition of her collection of sparkling food essays, *The Delights of Delicate Eating*, appeared in 2000, generating renewed interest in her culinary prose, and that same year Talia Schaffer profiled Pennell in her book *The Forgotten Female Aesthetes* (2000). A few years later, Meaghan Clarke continued the rediscovery process with her discussion of Pennell in *Critical Voices: Women and Art Criticism in Britain, 1880–1905* (2005), and Jane S. Gabin profiled Pennell in her *American Women in Gilded Age London: America Expatriates Rediscovered* (2006). More criticism and appreciations followed, on Pennell's food writing, her art criticism and her cycling exploits, both in scholarly venues and online.[16] This critical attention also began to reveal the existence of a considerable body of anonymous and pseudonymous periodical writing by Pennell that had not been previously attributed to her.

In 2015, the publication of two books marked a new phase in the Pennell recovery: a scholarly edition of her first two cycle-travel books, *A Canterbury Pilgrimage* and *An Italian Pilgrimage*, edited by Dave Buchanan, along with the first book-length study of her work, *Elizabeth Robins Pennell: Nineteenth-Century Pioneer of Modern Art Criticism*, by Kimberly Morse Jones. Now our collection of essays aims to continue this recovery project, by adding to the critical discussion of Elizabeth Robins Pennell's fascinating body of work. We believe that the subjects Pennell wrote about in her lifetime – biography, cycling, travel, food and art – as well as her prose style are as relevant and engaging to readers today as at the *fin de siècle*. More than ever, Pennell's writing deserves to be read, discussed and written about. This collection aims to shift the spotlight away from Joseph or even the Pennells as a collaborative duo and onto Elizabeth alone. The essays here focus on her work

and her story, specifically, as opposed to her role as one part of Team Pennell. In this book, her work finally takes centre stage.

Overview of the Collection

This is the first ever collection of essays on Pennell's work, and we think that the anthology approach is the ideal way to explore the rich variety of her multi-disciplinary writing. We have assembled a diverse range of scholarly backgrounds and critical voices to attempt to do justice to the wide variety of subject matter Pennell explored in her prolific career.

Our aim in this collection is to make further Pennell scholarship possible in a new way, by demonstrating some of the fascinating cross-currents and complexities in her work, and opening up new critical directions and approaches that will continue to be explored by a new generation of scholars. Some readers familiar with Pennell may be surprised that the book contains no essays on Pennell's work on Whistler and only two essays on her art criticism, the field where her work is perhaps best known. This choice was deliberate on our part; criticism on those two areas of Pennell's legacy has been healthy for some time. Instead, we have focused on other, lesser-known, areas of Pennell's oeuvre, in an effort to spark new critical conversations about the writing of this remarkable woman.

As Pennell was interdisciplinary long before the word existed, the essays assembled in this volume represent a range of perspectives, from English studies to art history to food writing and American studies. The chapters are organised around Pennell's particular interests, with either individual essays or clusters of essays treating each of her passions, from biography to cycling to travel, gypsies, art, food and life in London.

In the opening chapter, Dave Buchanan examines the issue of authority over the course of Pennell's long writing life, tracing her conflicting tendencies to crave and deflect attention and recognition for her work, often framing her approach to writing in the context of role playing.

Next, James Diedrick examines the controversy around the republication of the first of four biographies Pennell wrote over the course of her writing career, *The Life of Mary Wollstonecraft*, in a version drastically altered (without her permission) for English readers. He shows how Pennell, at the beginning of her writing career, overcame tremendous obstacles as she faced, first-hand, the vagaries of gender

politics in Victorian publishing. Diedrick also explores how Pennell's complicated relationship with Wollstonecraft's legacy reflects Pennell's shifting, and somewhat surprising, views on the Woman Question.

Two of the essays explore Pennell's further engagement with literary predecessors in the specific context of the cycle-travel writing she pioneered in the 1880s and 1890s. Una Brogan looks at Pennell's tricycle-travelogue/literary pilgrimage *Our Sentimental Journey through France and Italy* as a dialogue, of sorts, with eighteenth-century author Laurence Sterne. Brogan considers Pennell's modern, aesthetic approach to travel and the ways it parallels and contrasts with Sterne's own more sentimental one. Meanwhile Dave Buchanan examines Pennell's final cycle-travel book, *Over the Alps on a Bicycle*, arguing that, in a bold rhetorical experiment, Pennell borrows heavily from the literary contrarian tradition – especially Shelley, Byron and Twain – to defy the conventional pro-Swiss literary camp represented by Rousseau and Ruskin.

Two more chapters treat Pennell's semi-memoir and travelogue *To Gipsyland* (1893). Holly Laird examines *To Gipsyland* in the context of the nineteenth-century quest for gypsy origins, most famously explored by George Borrow and Matthew Arnold. Laird argues that Pennell's own quest as female scholar-gipsy is undone by the problem of modernity. Christine Bachman-Sanders, meanwhile, argues that Pennell's depiction of the Roma people she is so fascinated by is deeply problematic. Pennell's quest for authenticity, driven by her amateur enthusiasm and desire for intimacy, unintentionally reinforces Orientalist and white supremacist views, according to Bachman-Sanders.

Pennell's highly entertaining food writing from the 1890s is the focus of three essays. Alex Wong analyses the ironic and playful prose style of Pennell's culinary essays, tracing how she infuses the gastronomic literary tradition with bursts of influence from prominent Victorian stylists such as Pater, Wilde and Meredith. Bonnie Shishko argues that Pennell's food writing resists the science-ification of Victorian cookery writing, emphasising the art of food, rather than the science. Pennell brings the ideas of New Art Criticism to the kitchen, making a case for 'culinary ekphrasis': seeing food the way one sees visual art, in terms of the formal elements of a painting. Finally, Alice McLean takes Shishko's thesis one step further, arguing that Pennell's food writing engages not only with visual art but also with the performing arts. McLean also situates Pennell's food writing within the context of the history of gastronomic literature, arguing that the author managed to carve out a place for women to express the sensual pleasure of food.

Pennell's art criticism takes centre stage in two chapters. Kimberly Morse Jones shifts the focus away from Pennell's well-known formalist art criticism as applied to modern painting to her lesser-known championing of the 'lower' art forms, such as comics and music hall. Morse Jones argues that Pennell was an early advocate of popular art and explores the tension between 'high' and 'low' art in her writings. And Meaghan Clarke sheds light on women and late-nineteenth-century exhibition culture, examining Pennell's movement and engagement in public spaces, including the British Museum, the National Gallery and the Royal Academy, amongst others, in the vibrant, ever-changing city of London, as well as Paris, in the late 1880s and 1890s.

In the last chapter, Jane Gabin looks at how two underappreciated prose works from the latter part of Pennell's writing career – the memoir *Nights: Venice, Rome in the Aesthetic Eighties; London, Paris in the Fighting Nineties* (1916) and her only novel, *The Lovers* (1917) – demonstrate her complicated response to the events of World War I and to growing older. These works share an elegiac tone that makes for a stark contrast with the satirical and playful mood found in so much of Pennell's early work.

Finally, in the Afterword, Kimberly Morse Jones examines the role of work in Pennell's professional life.

Notes

1. In order to avoid confusion, we use first names, Elizabeth and Joseph, when both Pennells are in the discussion, but when the focus is solely on Elizabeth and her work, we use her last name, Pennell, only. We call her Elizabeth when referring to her before she married.
2. Jackson quoted in Egbert, *Checklist*, title page.
3. Frederick Keppel compares the 'intellectual partnership' of the Pennells to that of Robert and Elizabeth Barrett Browning (*Joseph Pennell*, 17). But the comparison is also apt in terms of recognition.
4. Pennell, *Life and Letters*, 1:123.
5. Pennell, 'Diaries', 3 July 1889.
6. Quoted in Pennell, *Life and Letters*, 1:181.
7. For instance, https://www.experienceplus.com/blog/destinations/italy/bicycling_italy_with_joseph_and_elizabeth_robins_pennell. Accessed 7 August 2016.
8. Coughlin, 'Art of the Recipe', n.p. Winterson's article, 'Greedy Women', appeared in *Stylist Magazine* in 2012. Accessed 30 March 2020. https://www.stylist.co.uk/life/greedy-women/49228

9. A review of *A Canterbury Pilgrimage* noted the 'quaint' prose but proclaimed that the 'book is well worth its price, fifty cents, for the drawings' ('Current Literature'). One reviewer of *An Italian Pilgrimage* wrote that 'Mrs. Pennell . . . is a pleasant, chatty writer' but 'the true charm of the book, however, is in Mr. Pennell's black-and-white sketches' (Review of *An Italian Pilgrimage*, 5). A reviewer of the American version of the same book claimed that the 'most charming feature of the volume is the illustrations' (Review of *Two Pilgrims' Progress*, n.p.).

10. The closest she came to telling her own story was in her partial memoirs, *Our Philadelphia*, which covers only her childhood and youth up to the early 1880s; *To Gipsyland*, of which the first section is autobiographical; and *Nights: Rome, Venice, in the Aesthetic Eighties; London, Paris, in the Fighting Nineties*, a selective memoir about the Pennells' life in aesthetic circles, with the focus squarely on others, not herself. On the challenges of Victorian women writing about their own lives, see also MacKay, 'Life-Writing', 159.

11. Beetham, 'Periodical Writing', 221.

12. See Peterson, *Becoming a Woman of Letters*.

13. Pennell used the word 'gypsy' and its variation 'gipsy', as was customary at the time, to refer to Roma or Romany people. Although gypsy/gipsy is no longer considered appropriate, when discussing Pennell's writing, we use the same terms she used.

14. Robins, 'Philadelphiana', 19.

15. Tinker, *The Pennells*, 5–6.

16. See, for instance, Malpezzi Price, 'Elizabeth Robins Pennell'; Hanlon, 'Imperial Bicyclists'; and Bertelson, 'A Greedy Woman'.

Bibliography

Beetham, Margaret. 'Periodical Writing'. In *The Cambridge Companion to Victorian Women's Writing*, ed. Linda H. Peterson, 221–35. Cambridge: Cambridge University Press, 2015.

Bertelson, Cynthia, 'A Greedy Woman: The Long, Delicious Shelf Life of Elizabeth Robins Pennell'. Accessed 4 August 2014. https://www.finebooksmagazine.com/ issue/200908/pennell-1.phtml

Clarke, Meaghan. *Critical Voices: Women and Art Criticism in Britain, 1880–1905*. Aldershot: Ashgate, 2005.

Coughlin, J. Michelle. 'The Art of the Recipe: American Food Writing Avant la Lettre'. In *Food and Literature*, ed. Gitanjali G. Shahani, n.p. Cambridge: Cambridge University Press, 2018.

'Current Literature'. Review of *A Canterbury Pilgrimage*, by Joseph and Elizabeth Robins Pennell. *Daily Evening Bulletin*, 3 October 1885.

Egbert, Victor. *Checklist of Books and Contributions to Books by Joseph and Elizabeth Robins Pennell*. Philadelphia: Free Library of Philadelphia, 1945.

Gabin, Jane. *American Women in Gilded Age London: Expatriates Rediscovered*. Gainsville: University of Florida Press, 2006.

Hanlon, Sheila. 'Imperial Bicyclists: Women Travel Writers on Wheels in the Late Nineteenth and Early Twentieth Century'. Accessed 4 August 2014. http://www.sheilahanlon.com/?p=1343

Keppel, Frederick. *Joseph Pennell: Etcher, Illustrator, Author*. New York: Keppel, 1907.

MacKay, Carol Hanbery. 'Life-Writing'. In *The Cambridge Companion to Victorian Women's Writing*, ed. Linda H. Peterson, 159–74. Cambridge: Cambridge University Press, 2015.

Malpezzi Price, Paola. 'Elizabeth Robins Pennell (1855–1936): Pioneer Bicycle Tourist in Italy, Travel Writer, and Cycling Advocate for Women'. *Lingua Romana* 11, 2 (Fall 2013): 4–20.

Morse Jones, Kimberly. *Elizabeth Robins Pennell: Nineteenth-Century Pioneer of Modern Art Criticism*. Burlington, VT: Ashgate, 2015.

Pennell, Elizabeth Robins. 'Diaries'. Unpublished. Joseph and Elizabeth R. Pennell Papers. Harry Ransom Center. University of Texas at Austin.

Pennell, Elizabeth Robins. *The Delights of Delicate Eating*. Urbana and Chicago: University of Illinois Press, 2000.

Pennell, Elizabeth Robins. *The Life and Letters of Joseph Pennell*. 2 vols. Boston: Little, Brown, 1929.

Pennell, Elizabeth Robins and Pennell, Joseph. *A Canterbury Pilgrimage / An Italian Pilgrimage*, ed. Dave Buchanan. Edmonton: University of Alberta Press, 2015.

Peterson, Linda H. *Becoming a Woman of Letters: Myths of Authorship and Facts of the Victorian Market*. Princeton and Oxford: Princeton University Press, 2009.

Review of *An Italian Pilgrimage*, by Joseph and Elizabeth Robins Pennell. *Pall Mall Gazette*, 9 December 1886.

Review of *Two Pilgrims' Progress*, by Joseph and Elizabeth Robins Pennell. *Daily Evening Bulletin*, 9 April 1887.

Robins, Edward. 'Philadelphiana'. *Colophon. New Graphic Series* 2 (June 1939): 17–22.

Schaffer, Talia. *The Forgotten Female Aesthetes: Literary Culture in Late-Victorian England*. Charlottesville: University of Virginia Press, 2000.

Tinker, Edward Larocque. *The Pennells*. New York: Frances and E. L. Tinker, 1951.

Waltman, John Lawrence. *The Early London Journals of Elizabeth Robins Pennell*. Dissertation, University of Texas at Austin, 1976.

Authority, Deflection and Role Play in Elizabeth Robins Pennell's Writing Life

Dave Buchanan

In a writing career that spanned fifty years, Elizabeth Robins Pennell wrote about an extraordinarily diverse range of subject matter, none of which she received any formal training in. Tackling such a variety of topics would seem to require remarkable confidence in one's abilities. While that's certainly true in Pennell's case, her writing career exhibits a fascinating tension between, on the one hand, an audacious belief in, and even bravado about, her ability to write authoritatively on a broad range of subjects, and, on the other, a tendency towards self-effacement and even doubt in her abilities, as well as deflection of credit for some of her work. For all her confidence and authority as a writer, she could be self-deprecating about her abilities, reluctant to accept credit for her accomplishments, and curiously ambivalent about fame. In particular, working collaboratively with her husband, she often chose to deflect attention towards him, a tendency that negatively affected her recognition in her day as well as her legacy. And she was often inclined to hide her serious writerly ambitions behind a facade of role playing. That is, she frequently spoke of her approach to writing as 'playing' at particular roles – whether it be art critic or cycling expert or food writer, among others – the way an actor moves from part to part, pretending to be so many different things without really being any of them.

Early Career: 'My Task of Writing'

Elizabeth Robins's earliest experiences as a writer can be traced back to her school days at the Convent of the Sacred Heart in Torresdale,

just outside Philadelphia, where she lived from age eight to age seventeen. In her memoir of her youth, *Our Philadelphia*, she recalls fondly her years spent in this 'strictly cloistered' world.[1] The nuns were French and the education more European than American. It was here that Elizabeth was exposed to the classics of French and English literature. Although she confesses to having had a mischievous streak, she says she was an excellent student, a prize-winner. 'I had a quick memory', she explains, 'study was no great trouble to me'.[2] She also describes herself as a good 'listener', a quality that would come in handy in the world of writing. (Tinker praised her 'genius for sympathetic listening'.[3]) Her friend Agnes Repplier described their literary fun together at the convent, penning verses and performing plays. But this early interest in dramatic role playing was not yet connected to her writing; in fact, her interest in writing seems to have only begun to flourish in her mid-teens. Elizabeth tells a story about how just before she left the convent, at age seventeen, she submitted an essay she'd written on François Villon, as well as a short story, to *Harper's* magazine, both manuscripts 'neatly tied with brown ribbon to vouch for a masculine mind above feminine pink and blues'.[4] Both were rejected, however, ribbons and all.

It was several years after she left Sacred Heart before Elizabeth entertained the serious possibility of writing as a profession, the idea coming from her uncle and mentor, Charles Godfrey Leland. Leland had worked first as a journalist and later wrote poetry and authored numerous books on a range of diverse interests, including witchcraft, folklore, gipsy lore, languages, Eastern philosophy, and public art and design education. He believed that he could write about any subject he put his mind to, provided he'd done his research and put in the work. When Leland returned to Philadelphia in 1880, after spending a decade abroad in England and Europe, he encouraged his talented niece to follow in his literary footsteps. She explains how she saw in her uncle a man who was always reading, always writing, and 'brought with him the aroma, as it were, of the literary life of London'.[5] Of course, Leland had had the benefit of a Princeton education. Elizabeth, meanwhile, had only a convent education, but it provided a solid foundation, and she made her own higher education in Philadelphia's libraries as well as the parlours of Philadelphia-area scholars and writers, such as George Boker and Walt Whitman, where Leland was welcomed with his protégé.

Leland exemplified the power of hard work in the writing world. Elizabeth's uncle was, she recalls, always 'scribbling'[6] away on some project,

a man who devoted himself to writing, to whom writing was a business, who sat down at his desk after breakfast and wrote as my Father after breakfast went down to his office and bought and sold stocks, who never stopped except for his daily walk, who, after dinner, read until he went to bed.[7]

Elizabeth admits she was impressionable and both revered her uncle's opinion and was inspired by his hard-working example. She explains her motivation: 'I must stick at my task of writing or cease to be his companion.'[8] Like Leland, she also treated writing as a full-time job and then some. In *Nights*, her reflection on the artistic circles of the 1880s and 1890s, for instance, she recalls how her days in England and Europe were spent doing legwork, visiting galleries and exhibitions. 'Never was I without my inseparable note-book and pencil in my hand or in my pocket, never without good, long, serious articles to be written in my hotel bedroom . . . So has it been throughout my working life.'[9] Writing for her was always more than a hobby. In her early twenties, bored by assemblies and more interested in books than in boys, she began to realise that a conventional domestic married life was not for her. Writing offered a way 'to become my own bread winner' and, as she put it, 'my substitute for marriage'.[10]

With Leland's encouragement, Elizabeth ventured into the unfamiliar Philadelphia publishing world in the early 1880s, relying primarily on a kind of bookish authority – study and research skills, honed at the convent, encouraged by her uncle – for much of her writing. In fact, some of her earliest published material in the early 1880s, before she began writing about cycling, can be described as semi-scholarly. Her first two major writing projects, one on the history of mischief (originally conceived as a book, it turned into a series of articles in the *Atlantic*) and the other on Mary Wollstonecraft (which did become a book), were the result of 'a stupendous amount of reading in a stupendous variety of books'[11] during days of disciplined study in the cloistered libraries of Philadelphia and, later, London.

Her early attempts at publishing met with little success. Yet Elizabeth was not deterred. She continued to send semi-scholarly pieces off to magazine editors – and be rejected. But she possessed sufficient faith in her skills and knew enough about the publishing world to realise that rejection of her work didn't mean it wasn't good. Thomas Carlyle and many other great men had had their work refused before their genius was acknowledged, she reasoned. 'Therefore', she joked, '– the logic was clear and convincing – the refusal proved me a genius.'[12]

In 1881, Elizabeth's semi-scholarly writing style met a better reception from the new editor of the *Atlantic Monthly*, Thomas Bailey Aldrich. He not only published her first submission, 'Mischief in the Middle Ages', he asked for more. As Shirley Marchalonis explains, the essays in the *Atlantic* at this time tended to 'project a calm, easy, unself-conscious confidence that the writers know what they are saying, know to say it, and never doubt that what they say is valid because it is based on their expertise'.[13] Elizabeth struck this precise note in her early work. Like so many of the magazine's writers, she established a 'voice of effortless, nonstrident, but completely secure authority – the voice of knowledge and wisdom in an age that still liked and expected to be taught as well as entertained'.[14] The *Atlantic* published eight articles by Elizabeth between 1881 and 1883.

Around the same time that Elizabeth began working in the relatively safe, largely bookish realm of semi-scholarly writing, she also ventured out of the library in a riskier way, auditioning for a very different career in the 'wider scope' of newspaper journalism.[15] Her youthful confidence together with Leland's reputation helped her finagle her foot into the door of Philadelphia editors' offices. One of her earliest gigs, as art critic for the *American*, came about when she offered an unsolicited article to the editor, Mr Jenkins, and he accepted 'without asking my qualifications'. A combination of boldness and luck led to what she calls 'the beginning of my long career as art critic'.[16]

While Leland played a key role as writerly mentor, helping his niece establish a sense of her own literary authority, so too did Joseph Pennell. From the moment they met in 1881, he helped foster her confidence as a writer and critic, serving as both coach and agent, of sorts, using his connections to help find her work and encouraging her efforts.[17] When it came to the art world, she later said she was fortunate to have 'had the benefit of J'.s guidance' and 'wise council'.[18] In their early courtship days, he played the role of hometown mentor-wooer, showing and telling Elizabeth 'more about Philadelphia than I had learned in a lifetime, revealing to me in his drawings the beauty of streets and houses I had not the wit to find out for myself'.[19] In large part, it was at Joseph's insistence that Elizabeth left the 'dusty archives' where she had done so much of the research for her writing projects, to explore the vibrant streets of her native city and stretch her writing skills.[20]

In addition to assisting with her aesthetic education, Joseph helped her get established in the journalism world. His good word led to the accreditation needed for her to become a fully fledged art critic for

both the *American* and the *Press*.[21] In those early years, he was her editor and tour guide. She recalls train trips together to New York art shows, where he would 'guide [her] through the gallery' and be at her 'elbow in case of need' as she wrote reviews on the train back to Philadelphia.[22] After they crossed the Atlantic, Joseph helped Elizabeth get hired as the art critic for the *Star* in the late 1880s; when he lost the job because of his controversial views, he recommended his wife take over. As Morse Jones says, 'it is unlikely that the *Star* would have hired Pennell without her husband's nomination, as it was particularly difficult for women to secure a foothold in journalism'.[23]

While her Uncle Leland and her husband Joseph certainly encouraged Elizabeth's writing and contributed to her sense of authority as a writer, the example of successful contemporary women writers also played a significant role. In *Our Philadelphia*, as Elizabeth describes her awkward and half-hearted attempts to enter society after a decade in a convent, she interrupts her generally disastrous tale to recount her revelatory discovery of a small community of women who had 'retired' from the social games of assemblies in favour of quiet study and scholarship. Although she doesn't name any of these women and claims she was then too much of an 'idler' and not of high enough social status to join their ranks, her mention of this group suggests that the option of becoming a 'scholarly woman' clearly made an impression, as she was beginning to consider what might constitute legitimate alternatives to marriage.[24] Later in that same memoir, when describing the literary scene in Philadelphia in the 1870s and 1880s, among her recollections of visits with Walt Whitman and public lectures by Oscar Wilde, Elizabeth mentions a lengthy list of Philadelphia women writers and culture brokers whom she admired: journalists such as Louise Stockton, Helen Campbell and Sarah Hallowell, all of whom wrote for the *Philadelphia Ledger*; and Lucy Hooper, who worked for the *Evening Telegraph*.[25] The art editor Emily Sartain she singles out as a particular focus of her 'envy' for being 'a woman who had attained such an influential and responsible post' with Judge Tourgée's weekly literary magazine *Our Continent*.[26]

But the two women writers Pennell mentions most often as influences and role models are the English authors Vernon Lee (Violet Paget) and A. Mary F. Robinson (Duclaux). Joseph had spent time with both of them in Italy on his tour with W. D. Howells in 1883, and Elizabeth first learned of their exploits through Joseph's letters, which emphasise how impressed he was by their wit and diligent journalistic techniques. Lee and Robinson were 'indefatigable' observers, he reports with admiration, 'their notebooks forever in

their hands'. Elizabeth found these 'exemplary and inspiring tales' and reasoned, 'If I mastered their method, I hoped I might achieve their distinction.'[27] After the Pennells moved to London in 1884, they ended up socialising with both of these women and their families. While Elizabeth found Vernon Lee somewhat intimidating in person, she greatly admired her 'learned and flamboyant essays on art', which may have influenced Elizabeth's early appreciation of aestheticism.[28] Pennell writes with some awe of meeting Robinson ('already a sought-after celebrity' during the Pennells' first summer in London).[29] These confident, successful women writers provided a glimpse of the possible for Elizabeth. If they could put themselves out there, then so could she.

The success of these other women writers helped inspire Pennell's first book, a biography of Mary Wollstonecraft, published in the United States in 1884 as part of a Roberts Brothers series 'Famous Women'. The book, generally well received, was the product of her early research-based approach to writing, and while it shows that Pennell's impressive confidence in her abilities was warranted, a later, altered edition of the book published in England also tested that confidence. When the English version, truncated and 'mutilated' by editor John Ingram without Pennell's permission, received harsh reviews in the British press, Pennell was shaken. Referring to this incident, Waltman asserts that Pennell was insecure about her abilities. He suggests that 'when critics attacked her work, she more often than not blamed herself and turned inward'.[30] This may be an overstatement. It was her first book, and it had been drastically altered without her permission, so it makes sense that she was upset. Still, the contrast with her husband was striking. Joseph was notorious for lashing out at anyone who disagreed with his views. While Elizabeth fretted over the fate of her book, Joseph advised her to forget about the bad reviews – which was easy for him to say.

Accidental Authority

While reading and research provided Elizabeth with much of the authority for her early semi-scholarly magazine writing and the Wollstonecraft project, it was quite the opposite – lived experience – that provided the authority for some of her most successful writing in the 1880s and 1890s: her cycling and travel narratives. With cycling, in particular, Elizabeth became a kind of accidental authority. Prior to the publication of the Pennells' first book together, *A*

Canterbury Pilgrimage, an account of a three-day tricycle trip from London to Canterbury in 1884 in the footsteps of Chaucer's pilgrims, Elizabeth's experience of riding a cycle had been limited. In Philadelphia, Joseph had introduced her to the cycling world, where he had, for several years, been an active club member, racer and advocate for the new sport. In an 1894 essay, Elizabeth mentions first experimenting with a tandem tricycle ten years before 'in the country around Philadelphia',[31] and then after their arrival in London in the summer of the same year we have evidence, in the form of entries in Elizabeth's diary, of further tricycle riding. But their adventure to Canterbury in late August 1884 was almost certainly among her first experiences with cycle-touring.

Yet the book's success at a time of great interest in the possibilities of cycle-touring meant that Elizabeth was suddenly viewed, almost by default, as an expert in the new field, despite her relative newness to the sport. Her London diary tells several stories of how she, specifically, and not just her husband, was both acknowledged and sought out for her cycling expertise. At first she was somewhat reluctant to accept the expert role, but she quickly warmed to it. Visiting cycle-tourists stopped by the Pennells' apartment to pay their respects to the pioneers of cycle-travel, and London literary societies invited the 'Canterbury Pilgrims', as they became known, to give talks about their trip and book.[32] Robert Louis Stevenson, to whom their first book was dedicated, even wrote an appreciative letter praising the volume's merits.[33] In a letter to Joseph on 31 May 1886, Elizabeth is still amazed at the fame their first book brought: 'I wonder when we'll stop hearing about it!'[34]

As a result, Elizabeth was able to parlay this sudden reputation into further writing work, penning more pieces about cycling for magazines such as the *Century* in the United States and the *Pall Mall Gazette* in London, plus four more books about her and her husband's cycling travels in Italy, France, Hungary and Switzerland. This was all despite her lack of knowledge, and even interest, in technical aspects of cycling. As she said in 1897, following a 1,000-kilometre European tour, 'we could not tell you what our machines are geared, what they weigh, or who made the lamps and the bells'.[35] In contrast to some of her earlier work, her authority on cycling came primarily from having done it, rather than having studied it.

Although this authority for cycling writing came chiefly from her experience, Elizabeth shrewdly combined that personal, subjective angle with the earlier source of her semi-scholarly writerly authority: books and research. In fact, her trademark style in this phase of

her career came from a combination of personal experience and her knowledge of literary tradition. Two of the Pennells' cycle-travel books involve literary pilgrimages, tracing the routes of famous authors or literary characters: Chaucer's pilgrims and Laurence Sterne's sentimental traveller; and all of them are chock full of literary references, whether it's Bunyan on the road to Rome, Byron in Switzerland, or Evelyn, Pepys and Dickens in and around London.

That same hybrid model of authority – part experience, part literary knowledge – lies at the heart of her non-cycling travel writing too, such as in the books *Our Journey to the Hebrides* (1889), *The Stream of Pleasure: A Narrative of a Journey on the Thames from Oxford to London* (1891) and *Play in Provence* (1892), and in articles about trips to France, Spain, Switzerland and elsewhere. All of these feature the authorial voice of a well-cultured tour guide, offering sprinklings of famous poetry and prose, as well as relevant historical, musical and visual art trivia. Pennell was careful, however, not to come on too strong with the learning. She liked to stress that she wasn't an academic. For instance, in a 1902 article about a cycling trip in Italy, she confesses, 'I have no Latin' and 'I know Virgil and Horace only in translation. The scholar may say this is equivalent to not knowing them at all.' But she goes on to explain that one doesn't need to be a Latin scholar to feel the charm of travelling through the landscapes made so vivid by those famous poets. In fact, she suggests that too much of a scholarly approach can make one sound like 'a plodding pedant'.[36] Hers was the approach of the enthusiastic, but unpretentious, well-read amateur.

Pennell's amateur approach is particularly evident in her writing about the Roma people, whom she knew as 'gypsies'. Much of her authority on this subject came courtesy of Leland, who had written several books about his fascination with the Roma, became president of the English Gypsy Lore Society in 1888, and was an acknowledged expert on so-called gypsy culture. In the early 1880s in Philadelphia, he took Elizabeth and Joseph with him on his visits to gypsy encampments outside the city, and through these first-hand experiences, Elizabeth developed her own passion for gypsy culture. She and Joseph learned Roma phrases, which appear frequently in their correspondence, and they even dreamed, at one point, of joining a gypsy caravan for their honeymoon. Pennell's writing about gypsies is, as Christine Bachman-Sanders argues in this volume, an example of how Pennell's enthusiastic amateurism could, at times, be detrimental. As Carolyn Dinshaw suggests, the amateur is driven by desire and attachment to the object of attention, rather than by

the academic's discipline and detachment,[37] and we see elements of Pennell's naïve desire in *To Gipsyland*, her account of her experiences with gypsies in Philadelphia, London and Eastern Europe. She describes how smitten she was initially with the romance of gypsy life, even feeling flattered by the impromptu marriage proposal she received from a gypsy man at a festive gathering.[38] Her amateur desire went so far, in fact, as to become problematic, at least for modern readers. The boldness with which she criticises the gypsies' loss of traditional ways in Hungary, and sometimes attempts to appropriate a gypsy identity for herself, makes her sound, at times, oblivious to the complexities of the gypsies' predicament and her own privilege.

Although Pennell lived abroad for over thirty years, the American editions of her travel books, along with articles in magazines such as the *Century* and *Harper's* and the lesser-known *Chautauquan*, contributed to her profile in America especially, where the Pennells together gained a reputation as a kind of authority on, and transatlantic conduit for, European culture, architecture and art that American readers craved. Elizabeth's essays about, and Joseph's illustrations of, European art and architecture, especially the English and French cathedrals that Joseph had been commissioned to draw, were popular enough for the *Century*, in particular, to continue to publish her work well into the 1910s.

'Better from You than from Me'

For all their successes in these joint ventures, Elizabeth tended to prefer Joseph to get much of the credit, even though she seems to have done more than her fair share of the work. The Pennells' collaborative creative process makes it tricky to assign single authorship. In her biography of Joseph, Elizabeth describes 'the manner in which several of his successful books were written': she took dictation from him, she explains, but since he spoke too quickly to transcribe word for word, she ended up 'rounding out' his thoughts, as she put it, implying that she edited his thoughts as she wrote them down. She admits that she found it hard to resist doing this. Later, Joseph switched to using a professional stenographer or wrote himself without Elizabeth's help, and she speculates that his reasons had to do with his desire to escape her over-involvement in his 'writing' process.[39] (Interestingly, Joseph's final book, the memoir *Adventures of an Illustrator*, written with little help from Elizabeth, was a flop.)

At times, Elizabeth could be excessively deferential to her husband, often reinforcing the perception of herself as the junior female assistant to the senior male genius. It was just another role for her; she would gladly 'play the amanuensis', when needed.[40] On many occasions, she writes of her indebtedness to him. In her final book, *Whistler: The Friend*, written after Joseph's death, she suggests that she was lucky to have benefitted from her husband's guidance and implies that her accomplishments owe a great deal to him. She says she 'always felt he [Joseph] took me into partnership simply as a matter of courtesy. Thanks to him, we shared many triumphs.'[41] To some extent, she may be simply trying to puff up the reputation of her deceased husband. But even in some of her diary entries, she displays not just a reverence for his talent but also a need for Joseph's approval of her work. (For instance, in an entry from 10 July 1889, when referring to some of her writings for cycling newspapers, she writes that she 'felt a weight off my mind to find that he [Joseph] liked them'.) For a writer who displayed such confidence in public, she could be less certain of herself in private.

The irony of this is the fact that Elizabeth's writing was often clearly better than her husband's; her deference to his talents wasn't necessarily warranted. Joseph may have been a great illustrator, but he was a mediocre writer, and he knew it. (When the publisher William Heinemann offered Joseph the job of writing Whistler's biography, Joseph insisted that he would only take on the project if Elizabeth could be co-writer, which suggests that he may have had more confidence in her abilities than his own.[42]) In some cases, Elizabeth could be overly modest, especially when trying to explain how some editors liked her work but not Joseph's, like the time when she describes a joint venture with Joseph and another illus-trator, Blake Wirgman, regarding a London production of *Faust* in December 1885. The men's illustrations and Elizabeth's text were submitted to the *Century*, but, in the end, 'no drawings appeared' in the magazine, she explains, 'though my article on the scenery did'.[43] Her use of the passive voice here makes Joseph's failure sound like some cosmic oversight and her success somehow detached from her talent. The editor liked her article better than Joseph's drawings, but she sounds apologetic about it.

Anonymity, Pseudonymity and Freedom

When it came to some of her journalism, Pennell avoided taking credit by publishing anonymously or pseudonymously, a fairly common

practice in late-Victorian journalism. As Clarke and Morse Jones have shown, Pennell used a series of 'signatures', such as N.C.U. (possibly for National Cyclists Union) for her weekly 'Cycle and Camera' column in the *Pall Mall Gazette* and N.N. for the *New York Nation*; P.E.R. (her initials out of order) for *Woman*; and 'Autolycus' for her food writing and for *Art Weekly*. Only when certain periodicals insisted on authors signing their work, as in the case of *Fortnightly Review*, for instance, did she do so.[44] Her use of the signature N.N., probably short for 'No Name', in her pieces for the *Nation* may suggest an attempt to do something more radical than just hide her identity: it implies an unconscious desire to deny its existence altogether.

Pennell may have found that these 'signatures' provided the journalistic authority to speak frankly without fear of personal reprisal. In response to an editor's request to consider signing her real name, she wrote, 'I have always liked best to remain anonymous in doing work of this kind – one has more freedom.'[45] Morse Jones argues that since women's critical writing tended to receive a harsher reception than men's at this time, many women journalists found using a nom de plume an 'essential practice'.[46] To certain insiders familiar with London cycling and art circles, Elizabeth's authorship of weekly columns would have been common knowledge, but beyond that small circle, her role would have been largely obscured.[47]

Although most of the Pennells' travel books are written in Elizabeth's voice, Morse Jones suggests that in some of the Pennells' collaborative periodical writing, Elizabeth actually wrote in *his* voice, ventriloquising, as it were. This certainly happened with their first cycling piece published in the *Century* in 1883; the editors rejected the article Joseph wrote to accompany his illustrations, so she rewrote it for him, but using his voice, the piece appearing unsigned.[48] Waltman claims she also wrote most of Joseph's criticism in the London *Daily Chronicle*.[49] Clarke, meanwhile, suggests that 'by the late 1880s she [Elizabeth] invariably wrote the [art criticism] articles' published under the various pseudonyms Joseph originally used.[50] The same is true of the cycling column 'Cycle and Camera' in *The Penny Illustrated* in the early 1890s under the signature 'N.C.U'.; it was widely assumed that Joseph Pennell was the author, but Elizabeth's diary and letters from this period suggest that she did a lot of the writing for it. Several letters mention her writing the columns on cycling and art while he was away travelling for work. In some instances, she refers to them as 'your' notes, as if they were somehow his even though she wrote them.[51] In fact, when it came to the world of writing and publishing, Joseph came to rely on Elizabeth for far more than her role

as amanuensis and ghostwriter; her diary and their letters reveal that she took a lead role in negotiations with publishers and with handling proofs for their books too. She also says in *Whistler: The Friend* that she managed all the finances for the couple.[52]

In Elizabeth's early art criticism for the *Star*, she also ventriloquised Joseph's voice, but partly out of necessity. The editors of the paper, although delighting in his authoritative tone and propensity for controversy, found his voice at times too acerbic, and therefore sought a replacement who could be provocative yet more restrained. The goal was to make the transition as seamless as possible, as evidenced by the change in pseudonym from ARTIST UNKNOWN to A.U., in order to prevent readers from noticing a change in authorship. Perhaps this accounts for the following statement by Pennell: 'Probably because it is not my usual role, I like occasionally to play the critic.'[53] Such ostensible displays of humility might be understandable early on, but Pennell made this comment in 1893, about three years after she took over from Joseph. By then, she had clearly established her own authority and her own style. In fact, a year earlier she demonstrated tremendous bravado when defending herself in the *Star* against another critic. She imagines her defence:

> I would begin with graceful persiflage, I would gradually and quietly plunge into the philosophical depths whither the average man would never follow, and I would wind up with a few open-air touches just to show that, after all, I am but human.[54]

While Joseph clearly benefitted from Elizabeth's deflection of attention – Morse Jones argues that 'her triumphs became his'[55] – often receiving credit for work he didn't produce, it must be said that he did not always encourage this; he even chided her for it, at times. Perhaps oblivious to the complicated considerations of being a woman writer, he couldn't understand why she didn't just put her name on more of what she wrote. In a letter from New Orleans in February 1882, Joseph writes to Elizabeth about a project of her uncle's, 'Yea, verily, verily, I say unto you, you are to make it your own and publish it under your name. Why not?'[56] Another time, he urges her to sign her name to a piece she wrote: 'I don't want the credit for what I haven't done.'[57] Eventually, however, Joseph stopped protesting and just accepted his wife's offers.

Elizabeth's reasons for publishing anonymously and pseudonymously and generally deflecting attention away from herself are complicated. To some extent, she was simply being practical about the

sexist double standard in late-Victorian publishing. She recognised that there were some advantages to male authorship, especially when writing about certain subject matter, such as cycling or art: some readers would be less likely to challenge its authority.[58] As she says in one letter to Joseph about a cycling article she had written, 'I have signed your name because I think if you are willing to own the paper, it comes better from you than from me.'[59] Also, she consistently worked to boost her husband's career, even if it meant sacrificing a byline. As Morse Jones says, again and again 'Elizabeth put Joseph's career above hers.'[60]

Elizabeth would also have felt the pressure unique to women writers at the time to avoid self-promotion in the public sphere – what Harriet Martineau called 'Literary Lionization'[61] – and to eschew the serious role of artist. Elizabeth typified a trend for women writers in the nineteenth century that Mary Suzanne Schriber describes as a shift from the 'amateur' engaged in an arm of civic, religious and domestic work to 'artist engaged in belles-lettres'.[62] Pennell had a tendency to downplay her role as serious artist, to sell herself and her work short, at times, perhaps as a result of the tendency Schriber describes of Victorian women finding the label 'writer' problematic, since 'high culture was a masculine affair, "artists" were males, and women were offered a place in this world as "idealizing appreciators" . . . only reluctantly seen as creators'.[63] It's hard to imagine Joseph thinking twice about whether or not he was a serious artist, but Elizabeth did.

As Morse Jones points out, while Elizabeth avoided taking credit for her periodical criticism, she wasn't nearly so shy about owning authorship of her magazine articles and books. In fact, in these venues, Morse Jones says that Pennell 'actively promoted herself'.[64] From early on in their partnership, Joseph and Elizabeth dreamed of having their bylines appear together in the pages of the *Century Magazine*.[65] In this sense, Pennell was conflicted about her writing identity. The role of critic, important as it was, was one to be hidden; that of writer of magazine articles and books was one to be proud of. Her diary reveals pride and pleasure at the recognition she received for her travel articles and books of the 1880s and 1890s, and in her travel writing, she occasionally mentions with fondness meeting fellow travellers who had read her books and magazine essays and knew her name because of them.[66]

But overall she was ambivalent about fame. Her convent friend Agnes Repplier wrote in a letter to Elizabeth, speaking of Elizabeth's tireless but unacknowledged efforts on behalf of Whistler: 'Ah, my dear, how unconcerned you are about that such cherished thing, publicity!'[67]

Yet Elizabeth's diary and letters suggest that she was more concerned than she let on. She occasionally expresses private disappointment at being overshadowed by her husband. In a diary entry from 10 February 1886, she mentions a review of their book *Our Sentimental Journey* and how all the praise was given to Joseph 'and myself given a back seat as it were'.[68] Elsewhere she occasionally gets excited about the prospect of some recognition for her achievements. For instance, when she was approached by the *Women's Penny Paper* about being included in an article about 'famous women of the day', she sounds delighted: 'There's fame for you!'[69] Another time, when she hears of an article in the *Century* celebrating women in American literature, she writes to Joseph, 'I am not in it, alas!'[70]

New-Found Authority: Food and Biography

Perhaps the most audacious example of Pennell's claims to literary authority involves her food writing for London's *Pall Mall Gazette* in the 1890s. Although it certainly wasn't the first time she wrote about a subject that she had no formal training in, this enterprise was different from anything she'd attempted previously. Instead of just glossing over her lack of first-hand experience in the kitchen (like many middle-class women at this time, she had a housekeeper who did the cooking and, according to Tinker, Pennell 'couldn't even boil an egg'),[71] Pennell made a virtue of it, boldly and somewhat per-versely proclaiming her lack of apparent authority *as* her authority. She claims that her 'only qualifications [for writing a food column] were the healthy appetite and the honest love of a good dinner'.[72] As Jamie Horrocks observes, Pennell actually 'established her culinary authority by renouncing her knowledge of cookery'.[73] Pennell even liked to joke about it. In *Nights*, for instance, she looks back at how her only concern with staying up late hosting Thursday night social gatherings was 'how, if I did not get to bed until two or three or four o'clock on Friday morning, was I to sit down at my desk at nine and be the brilliant authority on Eating that I thought I was?'[74] Just as the aestheticists pooh-poohed the need for formal training in art criti-cism, Pennell rejects as unnecessary the typical domestic experience claimed as a source of authority by some female food writers.

Pennell may be, for dramatic purposes, overstating her under-qualifications as a food writer, though. She certainly had a bookish connection to food, if not a hands-on one, in the form of an extensive collection of cookbooks, which eventually totalled over 400 items,

some of them dating back to the seventeenth century, and which is now housed in the Library of Congress in Washington, DC. (See her book/bibliography *My Cookery Books*.) As Wong, McLean and Shishko point out in chapters in this collection, Pennell's extensive reading provided valuable knowledge of the literary tradition of food writing, and, in this sense, the literary authority for her food essays, as with her earliest published writing, came more from her reading about (in the pages of Brillat-Savarin and Grimod de la Reynière) than from any actual cooking in, the kitchen.

Pennell's food writing is among her most outrageous and celebrated performances. It was produced during one of the most prolific periods of her writing life: in addition to her weekly food column, she was writing regular cycling ones as well as art criticism for numerous periodicals, all the while working on several book projects, including her memoir/travelogue *To Gipsyland*. Yet the food writing stands out for the singularity of its style and, as Joseph Woll puts it, 'a modern and modernist sensibility, occasionally tinged with appealing self-mockery'.[75] With its playfulness and over-the-top panache, it may be her boldest experiment. Curiously, Pennell kept this uber-confident persona largely separate from her other writing projects, though there are elements of its performative, roguish aspect in *Over the Alps on a Bicycle*. In any event, the food essays in the *Pall Mall Gazette* were so popular that in 1896, a selection of them were collected into a book, *The Feasts of Autolycus: The Diary of a Greedy Woman*. It was a hit and reissued for American readers under a new title, *The Delights of Delicate Eating* in 1901and again in 1923 under the title *A Guide for the Greedy by a Greedy Woman*.

In the new century, moving on from cycling and food writing, Pennell continued her art criticism and returned to writing biography, though her focus shifted to writing about people she knew personally, as opposed to through research only, as had been the case, of course, with Wollstonecraft. In fact, she wrote biographies of the three most important men in her life: her uncle, *Charles Godfrey Leland* (1906), her friend, *The Life of James McNeill Whistler* (1908), and her husband, *The Life and Letters of Joseph Pennell* (1929). The authority for these projects came largely from her personal connection to these men; she knew each of them in a way that few others could claim to. In the case of the Leland biography, Pennell found herself taking over her uncle's unfinished memoir project. It had 'long been understood between us that I was to finish the Memoirs . . . if he did not live to finish them himself.'[76] She was the logical choice to take on this job after Leland's death, but

she never seriously considered ventriloquising for Leland in the way she had for Joseph. Instead, she converted her uncle's autobiography into biography. The book is the result of Pennell's claims to two different kinds of authority: her close personal relationship with Leland and her now formidable skills as a researcher.

Elizabeth's body of writing about James McNeill Whistler exhibits a similar dual authority. She and Joseph knew Whistler personally, after seeking him out when they first arrived in London in 1884. They claimed to have cultivated a deep friendship with the artist, prompting him to eventually ask Joseph to write his biography (which Joseph agreed to do on the condition that Elizabeth assist him). This intimate knowledge of Whistler, in combination with his consent, provided the basis for the Pennells' claim that theirs was the only authorised biography, setting it apart from the myriad others coming out around the same time. Intent that theirs would rise to the top in terms of comprehensiveness as well as authority, Elizabeth set about collecting letters and other valuable materials for writing the biography. However, Whistler's sister-in-law, who happened to be the executor of his will, at one point refused to provide the couple with letters, challenging their claims that he had asked them to write his biography before his death in 1903, leading to a heated battle, which culminated in court in 1907. The Pennells won, and the following year published *The Life of James McNeill Whistler*, which went on to be published in seven further editions. It continues to be regarded as an indispensable source on Whistler.

The role of biographer was a perfect fit for Pennell. It allowed her to combine her talent for research with her formidable inside knowledge of her subjects, but in a way that kept the spotlight away from herself. As biographer, she controlled the narrative while avoiding being the subject of it.

Late Work, More Supporting Roles

In the 1910s, Pennell's writing took a turn for the nostalgic, as she wrote a series of partial memoirs: *Our House and London Out of Our Windows* (1912), *Our Philadelphia* (1914) and *Nights: Rome, Venice, in the Aesthetic Eighties; London, Paris, in the Fighting Nineties* (1916) as well as her only foray into fiction, her war novel, *The Lovers* (1917). With the memoirs, Pennell was once again drawing on personal material as her chief source of authority. Of the three, *Our Philadelphia* is the closest to a proper autobiography, telling the story of her childhood and

adolescence up through the early days of her relationship with Joseph Pennell. For the only time in her writing life, Pennell puts her personal story at the centre of the narrative. However, the book only covers Pennell's life up to her courtship with Joseph in the early 1880s, at which point it abruptly shifts into a series of less personal essays about Philadelphia culture in the 1870s. It's as if she could tolerate writing about her younger self but found the story of her grown-up years somehow inappropriate to relate. The other two memoirs, while recalling Pennell's personal experiences, focus outwardly on the people around her – in her domestic sphere in *Our House* and in an aesthetic sphere in *Nights* – rather than on herself. In the latter, especially, Pennell has a tendency to downplay her own talents, portraying herself as a kind of hack or imposter compared to the 'real' aesthetes around her. As Talia Schaffer says, Pennell 'rather humbly perceived herself as an overworked amateur journalist amongst a crowd of literary artists'.[77] Writing about her own work as a critic in London, in particular, Pennell repeatedly describes herself as 'playing' at the role, as if her successful career, during which she penned hundreds of well-respected reviews for leading London newspapers, was some kind of elaborate performance or ruse.

Her 1917 novel *The Lovers* shows that Pennell, although in her sixties, wasn't done with trying new things. Although she had experimented with fiction back in her convent days, non-fiction was her bread and butter throughout her successful career. Yet the experience of the war was so profoundly disturbing that she may have felt compelled, like many artists at the time, including her husband, to try to process the madness, and assuage the suffering, around her through the creation of art in a new way. In *The Life and Letters of Joseph Pennell*, Elizabeth writes of how the war had a devastating effect on Joseph (she refers to his 'black despair'),[78] but it clearly affected her too. Her war story about two unnamed lovers was a modest success. But the part of novelist didn't suit Pennell, and she went back to more familiar roles as a writer of non-fiction. A year later, the Pennells returned to the United States, where they resided for the remainder of their lives.

Pennell's writing output began to drop off in the 1920s, except for two projects: the final pieces of Whistler material and Elizabeth's biography of her husband, who died in 1926. The latter is particularly interesting and somewhat frustrating for scholars of Elizabeth Robins Pennell as she once again engages in her characteristic deflection of attention. Joseph had written his own autobiography, *Adventures of an Illustrator* (1925) (which, incidentally, hardly mentions Elizabeth, though the book was dedicated to her), which would seem to clear the way for Elizabeth to finally write her own autobiography, or, at the

very least, a memoir about their unique partnership. But, not surprisingly, she passed on the role of autobiographer, instead, choosing to write the two-volume *The Life and Letters of Joseph Pennell* (1929), richly interlaced with hundreds of letters from Joseph and other correspondents over the years. Although the book is written in the first person and she does talk about herself on a few occasions, we get only fleeting flashes of her impressions and reactions. Elizabeth takes pains to minimise her presence in the story of her husband's life. The focus is always squarely on Joseph; Elizabeth's presence in the book is felt most strongly as an obviously biased defender of her husband's legacy. (Like Whistler, Joseph needed one. His brusqueness made him many enemies throughout his life.) Although many of Joseph's letters are addressed to Elizabeth, none of her letters are included. She is, not surprisingly, careful to downplay her presence in the story of his life, preferring to cast herself in a supporting role.

Pennell's view of her profession was curiously ambivalent. At times, especially as a writer of travel books and biography, she clearly relished, even sought out, recognition as a serious literary person. Those particular writerly parts may have seemed to her relatively uncomplicated ones for a woman in her position to own publicly. Other writerly roles, however, as art critic and cycling columnist, for instance, she found problematic or felt conflicted about, and, therefore, was reluctant to claim in a straightforward way, preferring to hide behind pseudonyms or even her husband's name. When she wanted to, she could play the role of bold authorial presence in the spotlight, as she does so brilliantly in her food writing; but just as often she sought out the literary backstage, seeking a kind of authorial invisibility – a prolific No Name, of sorts. Since Pennell was so reluctant – perhaps even unable – to do justice to her own writing and rich legacy, it's now up to others, beginning with the voices in this collection, to do it for her.

Notes

1. Pennell, *Our Philadelphia*, 93.
2. Ibid. 102.
3. Tinker, *The Pennells*, 8.
4. Pennell, *Our Philadelphia*, 238.
5. Ibid. 323.
6. Ibid. 239.
7. Ibid. 323–4.
8. Ibid. 238.

9. Pennell, *Nights*, 21.
10. Pennell, *Our Philadelphia*, 241, 239.
11. Ibid. 242.
12. Ibid. 243.
13. Marchalonis, 'Women Writers', 9.
14. Ibid.
15. Pennell, *Our Philadelphia*, 244.
16. Pennell, *Life and Letters*, 1:179.
17. Pennell, *Our Philadelphia*, 107.
18. Ibid. 394. Pennell, *Life and Letters*, 1:104.
19. Pennell, *Our Philadelphia*, 276.
20. Ibid. 283.
21. Pennell, *Life and Letters*, 1:106.
22. Ibid.
23. Morse Jones, 'Making a Name', 131.
24. Pennell, *Our Philadelphia*, 173–4.
25. Ibid. 338–41.
26. Ibid. 338.
27. Pennell, *Life and Letters*, 1:109.
28. Ibid. 1:192, 1:181.
29. Ibid. 1:117. In Joseph's playful letters to Elizabeth from Florence in 1883, he sounds smitten by Robinson's resemblance to another 'Distinguished authoress we wot of', even playing off the similarities of their names – calling her 'the other Miss Robins-on'. Joseph Pennell quoted in Elizabeth Robins Pennell, *Life and Letters*, 1:83, 1:84.
30. Waltman, *Early London Journals*, 19.
31. Pennell, 'Cycling', 249.
32. Her diary entry from 27 October 1885 mentions an invitation from the Society of Cyclists and another from 13 November 1885 mentions a request from the Shakespeare Society.
33. Pennell, *Life and Letters*, 1:52.
34. Pennell, Pennell-Whistler Collection, box 305.
35. Pennell and Pennell, 'Twenty Years', 188.
36. Pennell quoted in Schriber, *Writing Home*, 166.
37. Dinshaw, *How Soon*, xiv.
38. Pennell, *To Gipsyland*, 35.
39. Pennell, *Life and Letters*, 1:192.
40. Ibid. 1:204.
41. Pennell, *Whistler*, 17–18.
42. Morse Jones, *Elizabeth Robins Pennell*, 102.
43. Pennell, *Life and Letters*, 1:163.
44. Morse Jones, 'Making a Name', 133.
45. Pennell, Pennell-Whistler Collection, box 249.
46. Morse Jones, 'Making a Name', 132.
47. Clarke, *Critical Voices*, 124.

48. Pennell, *Life and Letters*, 1:106.
49. Waltman, *Early London Journals*, 13.
50. Clarke, *Critical Voices*, 124.
51. Letter to Joseph Pennell, 8 April 1891, Pennell, Pennell-Whistler Collection, box 305.
52. Pennell, *Whistler*, 21.
53. Pennell, 'Art and Artists', 1893, 3.
54. Pennell, 'Art and Artists', 1892, 4.
55. Morse Jones, *Elizabeth Robins Pennell*, 25.
56. Pennell, *Life and Letters*, 1:56.
57. Pennell, Pennell-Whistler Collection, box 305.
58. Clarke, *Critical Voices*, 124.
59. Pennell, Pennell-Whistler Collection, box 305.
60. Morse Jones, *Elizabeth Robins Pennell*, 26.
61. Quoted in Morse Jones, 'Making a Name', 133.
62. Schriber, *Writing Home*, 170.
63. Ibid.
64. Morse Jones, 'Making a Name', 134.
65. Pennell, *Life and Letters*, 1:58.
66. For instance, in *Over the Alps on a Bicycle*, she tells of meeting a pair of female American cyclists who 'had read our old story [perhaps *A Canterbury Pilgrimage*], and remembered it' (58).
67. Pennell, Pennell-Whistler Collection, box 378.
68. Pennell, 'Diaries'.
69. Letter to Joseph Pennell, 31 May 1889, Pennell, Pennell-Whistler Collection, box 305.
70. Letter to Joseph Pennell, 2 October 1890, Pennell, Pennell-Whistler Collection, box 305.
71. Tinker, *The Pennells*, 16.
72. Pennell, *My Cookery Books*, 3.
73. Horrocks, 'Camping in the Kitchen'.
74. Pennell, *Nights*, 143.
75. Woll, Review of *The Delights of Delicate Eating*, 106.
76. Pennell, *Charles Godfrey Leland*, 1.
77. Schaffer, 'Importance of Being Greedy', 109.
78. Pennell, *Life and Letters*, 2:181.

Bibliography

Clarke, Meaghan. *Critical Voices: Women and Art Criticism in Britain, 1880–1905*. Aldershot: Ashgate, 2005.

Dinshaw, Carolyn. *How Soon Is Now? Medieval Texts, Amateur Readers, and the Queerness of Time*. Durham, NC, and London: Duke University Press, 2012.

Horrocks, Jamie. 'Camping in the Kitchen: Locating Culinary Authority in Elizabeth Robins Pennell's *Delights of Delicate Eating*'. *Nineteenth-Century Gender Studies* 3, 2 (Summer 2007). Accessed 12 January 2019. http://ncgsjournal.com

Marchalonis, Shirley. 'Women Writers and the Assumption of Authority: The *Atlantic Monthly*, 1857–1898'. In *In Her Own Voice: Nineteenth Century American Women Essayists*, ed. Sherry L. Linkon, 3–26. London: Routledge, 2018.

Morse Jones, Kimberly. *Elizabeth Robins Pennell: Nineteenth-Century Pioneer of Modern Art*. Burlington, VT: Ashgate, 2015.

Morse Jones, Kimberly. '"Making a Name for Whistler": Elizabeth Robins Pennell as a New Art Critic'. In *Women in Journalism at the Fin de Siécle: Making a Name for Herself*, ed. F. Elizabeth Grey, 129–47. London: Palgrave, 2012.

Pennell, Elizabeth Robins. 'Art and Artists'. *Star*, 4 July 1892. [Signed A.U.]

Pennell, Elizabeth Robins. 'Art and Artists'. *Star*, 13 February 1893. [Signed A.U.]

Pennell, Elizabeth Robins. *Charles Godfrey Leland: A Biography*. 2 vols. Boston: Houghton Mifflin, 1906.

Pennell, Elizabeth Robins. 'Cycling'. In *Ladies in the Field: Sketches of Sport*, ed. The Lady Greville. 247–65. New York: Appleton & Co., 1894.

Pennell, Elizabeth Robins. 'Diaries'. Unpublished. Joseph and Elizabeth R. Pennell Papers. Harry Ransom Center. University of Texas at Austin.

Pennell, Elizabeth Robins. *The Life and Letters of Joseph Pennell*. 2 vols. Boston: Little, Brown, 1929.

Pennell, Elizabeth Robins. *My Cookery Books*. Boston and New York: Houghton Mifflin, 1903.

Pennell, Elizabeth Robins. *Nights: Rome, Venice, in the Aesthetic Eighties; London, Paris, in the Fighting Nineties*. Philadelphia: Lippincott, 1916.

Pennell, Elizabeth Robins. *Our Philadelphia*. Philadelphia: Lippincott, 1914.

Pennell, Elizabeth Robins. *Over the Alps on a Bicycle*. London: T. Fisher Unwin, 1898.

Pennell, Elizabeth Robins. Pennell-Whistler Collection. Special Collections, Library of Congress, Washington, DC.

Pennell, Elizabeth Robins. *To Gipsyland*. New York: Century, 1893.

Pennell, Elizabeth Robins. *Whistler: The Friend*. Philadelphia and London: Lippincott, 1930.

Pennell, Joseph and Pennell, Elizabeth Robins. 'Twenty Years of Cycling'. *Fortnightly Review* 68 o.s. (62 n.s.) (August 1897): 188–97.

Robins, Edward. 'Philadelphiana'. *Colophon. New Graphic Series* 2 (June 1939): 17–22.

Schaffer, Talia. *The Forgotten Female Aesthetes: Literary Culture in Late-Victorian England*. Charlottesville: University of Virginia Press, 2000.

Schaffer, Talia. 'The Importance of Being Greedy: Connoisseurship and Domesticity in the Writings of Elizabeth Robins Pennell'. In *The Recipe Reader: Narratives, Contexts, Traditions*, ed. Janet Floyd and Laurel Forster, 105–26. Burlington, VT: Ashgate, 2003.

Schriber, Mary Suzanne. *Writing Home: American Women Abroad, 1830–1920*. Charlottesville, VA: University of Virginia Press, 1997.

Tinker, Edward Larocque. *The Pennells*. New York: Frances and E. L. Tinker, 1951.

Waltman, John Lawrence. *The Early London Journals of Elizabeth Robins Pennell*. Dissertation, University of Texas at Austin, 1976.

Williams, Jacqueline Block. 'Introduction'. In *The Delights of Delicate Eating*, by Elizabeth Robins Pennell, vii–xxv. Urbana and Chicago: University of Illinois Press, 2000.

Woll, Joseph. Review of *The Delights of Delicate Eating*. *Gastronomica: The Journal of Critical Food Studies* 2, 1 (Winter 2002): 105–6.

Rough Crossings: The Transatlantic Fate of Elizabeth Robins Pennell's *Life of Mary Wollstonecraft*

James Diedrick

Introduction

On 18 July 1885, Elizabeth Robins Pennell took to the social media of her time to excoriate John H. Ingram for eviscerating her biography of Mary Wollstonecraft. 'I have just read in the *Athenaeum* for July 11 a notice of the life of Mary Wollstonecraft Godwin, the new volume of the Eminent Women Series, ed. Mr. Ingram', Pennell wrote in a letter to the *Athenaeum* editor. 'Though my name is on the title page, the book is not mine as I wrote it, and as it appeared in the American edition.'[1] The *Life of Mary Wollstonecraft* (1884) was the sixth in the 'Famous Women' series of biographies published by the American firm Roberts Brothers, and Ingram had claimed in an 11 February 1885 letter to Pennell that when he negotiated the rights to republish it in England as part of W. H. Allen's 'Eminent Women' series, the American publisher authorised him to 'cut it down to our limit, viz. about two thirds of original size'.[2] Pennell says about these cuts, 'I was not once consulted. Indeed, I knew nothing of it until I was told it was too late even for me to see the proof-sheets.'[3] Ingram, at the time a well-known and respected biographer and the leading British authority on Edgar Allan Poe, could not let Pennell's public attack go unanswered, and one week later he responded. Employing the passive voice to obscure the fact that he never consulted with Pennell, Ingram claims 'eventually full permission was received "to alter the book as we liked"', and he assumed this permission 'had the sanction of Mrs. Pennell'. If this was not the case, Ingram adds, Pennell should blame Roberts Brothers 'and not . . . her English editor'.[4] The same day this letter appeared Pennell penned a second

letter to the *Athenaeum* in response to Ingram's, which appeared on 1 August. 'I am given to understand there is no one to blame', Pennell wrote in mordant response to Ingram's denial of responsibility, '– a fact which, satisfactory as it may be to American publishers and English editor, unfortunately for me does not lessen my grievance'.[5]

The proximate cause of Pennell's grievance was an unsigned 11 July *Athenaeum* review of the W. H. Allen version of her biography. It was written by the poet, critic and biographer Mathilde Blind, whose 1878 *New Quarterly Magazine* biographical essay 'Mary Wollstonecraft' Pennell drew on in writing her book.[6] Blind begins her review by noting that 'in meeting with neglect, hate, and obloquy Mary Wollstonecraft only shared the fate of every genuine reformer' but adds that in her case 'the ill luck that attended her and the animosity she aroused in her contemporaries seem more or less to have pursued her memory ever since'.[7] These posthumous furies included her latest biographer, it seems, since Blind writes that Pennell's 'painstaking and businesslike' account, 'while carefully enumerating the facts of her heroine's life . . . [fails] to impart any life to her narrative'.[8] More importantly, Blind argues, Pennell fails to treat Wollstonecraft as a distinctly historical figure, one whose intellectual development was profoundly shaped by the French Revolution. As the first woman in England 'to claim for her sex the intellectual training and social and political equality gradually being conceded to women', Blind writes, 'it was almost imperative on the biographer of Mary Wollstonecraft to have drawn some comparison between the Englishwoman's way of dealing with this great question and that of her French contemporaries'.[9] Noting that Nicolas de Condorcet, a leader of the initial stages of the Revolution, published an essay during Wollstonecraft's time in Paris advocating full equality for women, and that women were admitted to the *Cercle Social*, whose members 'consisted of the most advanced philosophical Republicans', Blind laments that Mrs Pennell 'never touches on this subject', and 'confines her remarks to a cursory analysis of the "Vindication of the Rights of Woman"'.[10]

Pennell was clearly stung by Blind's review: the second paragraph of her first *Athenaeum* letter alludes to its specific charges, blaming Ingram for revising and editing her manuscript in such a way as to 'make a book lose whatever life it may originally have possessed, and any analysis it contained seem "cursory"'.[11] Indeed, the reception of her first book in England was Pennell's greatest concern at a time when she and her husband had just settled in London and she was establishing her own literary reputation. Two other negative reviews followed Blind's – one in *The Academy* and one in the

St. James Gazette – and Pennell confided in her journal that she felt 'crushed and melancholy with the accumulated burden of disagreeable criticisms'.[12] In 1890, when the *Fortnightly Review* asked her to write an essay on Wollstonecraft in conjunction with the Roberts Brothers' reissue of her biography, it was Blind's criticisms in particular that still rankled, and she took the *Fortnightly* commission as an opportunity to strike back. She wrote in a letter to husband:

> now, if you remember, the critic in the *Athenaeum* when my Life of Mary came out, took me to task for not knowing what was being done on the Woman Question in France at the same period . . . Three days' work in the British Museum will turn me into a brilliant historical scholar and my article will reduce my former critic to shame and confusion.[13]

Pennell's resilience in the wake of this rough treatment from Ingram and Blind testifies to her determination as a professional writer. The same year Allen issued the truncated version of her biography, Pennell and her husband Joseph published *A Canterbury Pilgrimage*, one of several books they would co-author about cycle-tourism. It was an immediate commercial and critical success.[14] Under her own name she subsequently published hundreds of articles on travel, cooking and cycling in magazines on both sides of the Atlantic, and in the late 1880s and 1890s she emerged as a pioneer of modern art criticism.[15] She returned to biography in the early twentieth century, writing a two-volume life history of her uncle Charles Godfrey Leland, the transatlantic humorist, folklorist and neo-paganist, and co-authoring with her husband a major biography of James McNeill Whistler. But my interest here will remain Pennell's first book – its troubled passage into print in England and its equally troubled reception history – and how these troubles illuminate two larger, interrelated cultural phenomena. The first is the rise of professional women writers in the Victorian era, and their struggles with the male-dominated publishing industry, which Pennell's experiences, especially with C. Kegan Paul and Ingram, exemplify. A related phenomenon – which the subject of Pennell's first book renders inextricable from the first – is the turn to the republican politics and aesthetics of Romanticism among many late-century intellectuals and artists. Mary Wollstonecraft is central to both developments. She served as an inspiration to women of various political orientations seeking to gain agency and autonomy by the pen; she also inspired those who shared her radical ideas of social change. Since Pennell did not share Wollstonecraft's radicalism, her biography met with far more resistance than she anticipated

in its journey from Boston to London.[16] It appeared in England at a time when women were in the process of wresting the narrative of Wollstonecraft's life and work from the firm grip of male writers and editors who sought to make Wollstonecraft safe for the patriarchy, God and country. Three radical women in particular – Mathilde Blind, Olive Schreiner and Millicent Fawcett – wrote counter-narratives that to varying degrees challenged the 'domestication' of Wollstonecraft, as well as Pennell's role in this process. Pennell's biography, its reception in England, and her subsequent essays on Wollstonecraft and the Woman Question offer a remarkable window on the contentious gender politics of late-Victorian England.

'Begin Straight Off with a Book'

For someone who originally conceived of a writing career as her 'substitute for marriage',[17] Pennell was born at the right time. By the mid-century, advanced printing technologies led to the rapid growth of book publishing and publishers, as well as the emergence of a major magazine publishing industry where she got her start (*Atlantic Monthly*, founded two years after Pennell's birth in 1855, published eight of her articles between 1881 and 1883). Virtually orphaned at an early age (her mother died when she was quite young, and when she was seven her father sent her and her sister off to live at convents for ten years, first in France and then in Torresdale, just outside Philadelphia), her early convent education bred independence, bookishness and a literary sensibility steeped in English and French literature. Returning to Philadelphia at age seventeen, she soon began spending much of her time with her uncle, the eminent writer and editor Charles Godfrey Leland, who had travelled widely in Europe and had spent most of the 1870s in London.[18] 'I was anxious to enjoy as much of his company as I could', Pennell wrote, 'for I had found nobody in Philadelphia so entertaining'.[19] She was soon working as his assistant, and she realised that Leland could guide her to a literary career that would allow her to 'earn the money to pay for the independence I wanted above all things'.[20] Elizabeth met her husband through Leland, a meeting which also launched her literary career, since Joseph Pennell was commissioned to illustrate an article on Philadelphia for the *Century Magazine* in 1882, to be written by Leland, which he instead turned over to Elizabeth. Leland then encouraged greater ambition: 'My uncle . . . insisted that I must

begin straight off with a book, something monumental, a *magnum opus*; no writer was known who had not written a book; and to be known was half the battle.'[21]

Both the 'Eminent Women' and 'Famous Women' series of biographies were well under way when Elizabeth took Leland up on this advice and pitched the idea for a biography of Mary Wollstonecraft to the Boston publisher Roberts Brothers in 1883.[22] Her choice may have been partly encouraged by Leland: he was in London in the late 1870s when Paul and Blind were reviving interest in Wollstonecraft, and the 1880 supplement to the *Johnson's New Universal Cyclopaedia* (whose initial four volumes Leland helped edit) contained a laudatory entry on the proto-feminist author, asserting that Paul's memoir of Godwin 'cleared her from unjust stigmas'.[23] Allen began the 'Eminent Women' series with biographies of George Eliot and Emily Brontë (1883), followed by four other biographies that year. Three originated with Allen – Bertha Thomas's *George Sand*, Anne Gilchrist Burrows's *Mary Lamb*- and Helen Zimmern's *Maria Edgeworth* – while Julia Ward Howe's *Margaret Fuller (Marchessa Ossoli)* was brought out by Roberts Brothers. Because most of both the Roberts Brothers and Allen records were destroyed in the early twentieth century,[24] the origin of the two series and the exact nature of the arrangement between the publishers are lost to time.[25] But after the initial two years of publication, when Pennell's *Life of Mary Wollstonecraft* preceded the Allen imprint by one year, most of the titles originated with Allen and were either published the same year or one to three years later by Roberts Brothers. (The Allen series ended in 1895 with a biography of Queen Victoria by Millicent Fawcett, who in 1891 wrote the introduction to a new edition of Wollstonecraft's *A Vindication of the Rights of Woman*.) Both series were inspired by the successful 'English Men of Letters' volumes published by Macmillan starting in 1878 (edited by John Morley), with thirty-nine volumes published up to 1892. (After being relaunched in 1902, the Macmillan series eventually numbered seventy-eight.) The existence and growth of such series exemplify the explosion of publishing and publishers in the nineteenth century; as documented in the *English Catalog of Books*, the 31 largest publishers of series brought out 41 series between 1836 and 1862, 242 between 1881 and 1889, and a remarkable 595 between 1890 and 1897. Clearly, Pennell, and her biography of a woman whose determination to make her living by the pen prefigured her own, entered the market at a propitious time.

'The Literary Pontiff'

If Pennell was fortunate in being mentored by Leland, she was less well served by C. Kegan Paul, the first Wollstonecraft authority she appealed to for assistance. She wrote to Paul in late 1883, having read his biography of Godwin (*William Godwin: His Friends and Contemporaries*, 1876) and his *Mary Wollstonecraft: Letters to Imlay. With Prefatory Memoir by C. Kegan Paul* (1879). Paul was a neighbour of Sir Percy Florence Shelley (the son of Mary Godwin Shelley and Percy Bysshe Shelley) and his wife Jane, both of whom attempted throughout their lives to redeem the reputations of the Shelleys and Wollstonecraft in the face of attacks engendered in part by Godwin's 1798 *Memoirs of the Author of a Vindication of the Rights of Woman*, which was scrupulously honest in recounting Wollstonecraft's radical views, including her belief in free unions, as well as her erotic relationships, children out of wedlock and suicide attempts.[26] Percy and Jane attempted to minimise what they saw as the damage that resulted by destroying manuscripts that contained anything they deemed scandalous, and asking their neighbour to write biographies that would present their famous ancestors in positive terms. Paul, who served as vicar of Sturminster Marshall from 1862 to 1874 before entering the publishing business in London, obliged.

Paul's desire to cleanse Mary Wollstonecraft of any imputations of fleshly impurity or religious heterodoxy produced a portrait of the radical as a domestic angel possessing selfless moral virtue. In the words of Paul's 'Prefatory Memoir', she was a woman who 'loved and suffered much', and who, 'like many more who think always of others rather than self, . . . has been one of the martyrs of society'.[27] Paul insists she 'lived and died a Christian',[28] despite her membership of the Reverend Richard Price's Dissenting community, her attacks on the Judaeo-Christian tradition of misogyny in *A Vindication*, and her expressions of agnosticism in the wake of her relationship to Godwin, an avowed atheist whose late work *The Genius of Christianity Unveiled* analyses the ways in which religious belief is used by the state as an instrument of social oppression.[29] As for Wollstonecraft's erotic relationships, Paul denies her love for the married Fuseli, claiming Godwin's account was based on faulty information, and that her affair with Imlay was a marriage in all but ceremony, the ceremony itself avoided only because of the French political situation at the time.[30] In the face of complicating evidence, Paul simply asserts, 'Mary Wollstonecraft did not, as has been supposed, attack the institution of marriage; she did not assail orthodox religion.'[31] It was this pietistic rewriting of Wollstonecraft's

narrative that led Blind, in her review of Pennell's biography, to call Paul 'the literary pontiff who has at last given Mary Wollstonecraft absolution for her sins against society, and rehabilitated her in the eyes of the public'. Wollstonecraft, Blind wryly observes, 'would have been the first to revolt' against such 'moral whitewashing'.[32]

Paul's letters to Pennell about her proposed biography would have discouraged all but the most dogged of fledgling writers. The two corresponded in early 1884 when Pennell was conducting her research, and Paul presents himself as the final arbiter of Wollstonecraft's life and career. In his 19 January 1884 letter responding to her request for advice he tells Pennell, 'Mary proved . . . the most interesting character, but I think I have told all there is to say about her.'[33] He then invokes the name of Wollstonecraft's descendants, noting that 'a Lady in England who wished to write a Magazine Article on Mary applied to Sir Percy and Mrs. Shelley for further information, but they refused on the grounds that the work had been so thoroughly done that there was no more to be done'.[34] Next he denigrates this 'Lady' by adding that she 'therefore pirated my books, and rewrote my previous material, to which I made no objection'.[35] This 'Lady' was Mathilde Blind, who, as Paul was well aware, had established her bona fides as an authority on Wollstonecraft and Shelley as early as 1870, when she published a detailed analysis of William Michael Rossetti's edition of Percy Bysshe Shelley's collected poetry in the *Westminster Review*.[36] She was the only woman admitted to the inner circle of the 'Shelleyites', which included William Michael Rossetti, Algernon Charles Swinburne, Richard Garnett and Edward Dowden, and she had reviewed several books on Shelley for the *Athenaeum* by the time she came to write her essay on Wollstonecraft.[37] Far from 'pirating' his books, Blind openly acknowledges her debt to Paul's biographical accounts of both Godwin and Shelley in her 1878 *New Quarterly Magazine* essay 'Mary Wollstonecraft', which is signed rather than anonymous, but she goes beyond them to offer her own, more radical reading of Wollstonecraft's works.[38] About those works, Paul asserts that 'no one, of course, except really students of Mary's character, read her writings'[39] – a dubious claim given the existence of Blind's essay as well as George Eliot's 1855 essay 'Margaret Fuller and Mary Wollstonecraft'. Paul's near-erasure of women writers and their authority indicates what Pennell was up against. He does finally allow that there may be 'room for a book in your series, which taking the known facts of her life may give more criticism of and more extracts from her books than I could give'.[40] He ends this first letter on a final note of discouragement by advising

her not to 'bother asking Sir Percy for the mss., which he put at my disposal', since neither he nor his wife would 'allow them to be sent to America'.[41]

'I Am More than Pleased'

Pennell received far greater encouragement from her first publisher and editor, Thomas Niles, who had become a partner in the Roberts Brothers firm in 1873 and was responsible for the high literary quality of the firm's British list (in the 1880s alone he published Oscar Wilde's *Poems*, Christina Rossetti's *A Pageant and Other Poems* and Olive Schreiner's *The Story of an African Farm*). He was also receptive to women writers and women's issues, as he demonstrated by issuing R. B. Harriet Robinson's *Massachusetts in the Woman Suffrage Movement* in 1881. And as Meaghan Clarke has observed, it is appropriate that an American initially commissioned the biography of Wollstonecraft for an American readership. 'The historiography of feminism and societal structures in the US differed considerably from that in Victorian England', she notes, adding that 'there were a variety of ways in which nineteenth-century American women resisted stereotypical Victorian sex roles'.[42] This was certainly true of Pennell herself, as her globetrotting, career-sustaining marriage to Joseph Pennell would soon demonstrate. It is also significant that the first surviving letter from Niles to Pennell about her manuscript in progress, dated 20 May 1884, indicates Niles's openness to Pennell freely discussing in her biography Wollstonecraft's heterodox ideas about the relation between the sexes. Alluding to Pennell's impending marriage, Niles suggests that she take her manuscript with her and finish it in England, noting that her new marital status will make the book 'vastly more interesting . . . Certainly experience of an institution for which Mary had but little reverence will give you authority to write about it.'[43]

Pennell sent Niles the first two chapters of her manuscript from Philadelphia just before her June marriage and move to London. On 4 July he wrote enthusiastically: 'I am more than pleased with the two chapters of "Mary Wollstonecraft" and I do not hesitate to say that if you can finish as you have begun, the book will be satisfactory to us and a credit to yourself.'[44] He ends by expressing confidence in the final manuscript, especially 'if you can get hold of the right material from England', adding that it will be published in the 'Famous Women' series and that she will be paid $200 for her

labour.[45] Just three days after Niles sent this letter Pennell was in the British Museum Reading Room, meeting with Garnett for the first time.[46] Two days later Garnett introduced her to Paul, who invited her to his home on 13 July, where he showed her 'all the books in his possession relating to Mary Wollstonecraft'.[47] She spent many additional days in the Reading Room, writing and consulting with Garnett, who provided her with additional material. On August 4 she recorded in her journal 'Finished "Mary Wollstonecraft!"'[48] She shipped off the manuscript to Niles in Boston, and *The Life of Mary Wollstonecraft* went on sale in the US in the autumn at the price of $1.[49] It was widely reviewed in the American press, and following the publication of the W. H. Allen version became, in Clarke's words, 'a key text' in 'reconsiderations and republications of Wollstonecraft's work during the latter part of the nineteenth century'.[50]

In her *Life and Letters of Joseph Pennell*, Elizabeth records that during one meeting with him, Paul 'objected in no moderate terms' to her Wollstonecraft biography.[51] She doesn't explain the source of Paul's objections, but they are hard to fathom since in large measure both versions of her biography hew to the substance and tone of Paul's accounts. Like Paul in his 'Prefatory Memoir', she strikes a religious note right from the beginning, writing that Wollstonecraft 'devoted herself to the relief of her suffering fellow-beings with the ardor of a Saint Vincent de Paul'.[52] And she fulsomely praises Paul for succeeding in 'vindicating her character and reviving interest in her writings'.[53] As Brenda Ayres has demonstrated, Pennell consistently casts Wollstonecraft's life in terms that would appeal to middle-class Victorian sensibilities, emphasising her selfless devotion to others rather than her 'defiance of social conventions and godly ordinances'.[54] Describing Wollstonecraft's ministrations on behalf of her mentally ill sister Eliza, for instance, who was trapped in a miserable marriage to a husband possessed of an 'insane temper', Pennell writes that 'no one can read the life of Mary Wollstonecraft without loving her, or follow her first bitter struggles without feeling honor, nay reverence, for her true womanliness which bore her bravely through them'. She adds that Wollstonecraft 'never shrank from her duty nor lamented her clouded youth', asserting 'there could be no greater heroism than this'.[55]

Pennell also distances herself from the radical implications of many of Wollstonecraft's statements concerning gender, writing that in *A Vindication* Wollstonecraft does not wish women to 'transform themselves into men by cultivating essentially masculine qualities'.[56] She then offers this comparison of Wollstonecraft to contemporary supporters of women's rights, whom she does not name but would

have included such activists as Susan B. Anthony, Cady Stanton and Millicent Fawcett: 'Enthusiasm never carried her to the absurd and exaggerated extremes which have made later champions of the cause laughing-stocks.'[57] At moments like this, readers might wish Pennell had followed Kegan's advice to take the known facts of Wollstonecraft's life and 'give more criticism of and more extracts from her books than I could give'.[58] After all, in her Introduction Wollstonecraft makes one of the most provocative anti-essentialist statements concerning gender in the entire early history of feminist thought:

> I am aware of an obvious inference: – from every quarter have I heard exclamations against masculine women; but where are they to be found? If by this appellation men mean to inveigh against their ardour in hunting, shooting, and gaming, I shall most cordially join in the cry; but if it be against the imitation of manly virtues, or, more properly speaking, the attainment of those talents and virtues, the exercise of which ennobles the human character, and which raises females in the scale of animal being, when they are comprehensively termed mankind; – all those who view them with a philosophical eye must, I should think, wish with me, that they may every day grow more and more masculine.[59]

By contrast, Pennell seeks to enlist Wollstonecraft in the service of a separation-of-spheres ideology in which education and intellectual development are encouraged so women can contribute to the patriarchy:

> Mary's enthusiasm did not make her blind; she knew that women were wronged by the existing state of affairs; but she did not for this reason believe that they must be removed to a new sphere of action. She defended their rights, not to unfit them for duties assigned them by natural and social necessities, but that they might fulfill them the better . . . Woman was to fight for her liberty that she might in deed and in truth be worthy to have her children and her husband rise up and call her blessed![60]

Granted, Wollstonecraft herself often emphasises that improved educational opportunities for women will make them better wives and mothers – which is one reason *A Vindication* was perceived as uncontroversial when it first appeared. This is why Mathilde Blind complains in her essay that Wollstonecraft could have titled her book *A Vindication of the Duties of Woman*: 'it is in a great measure that they may properly fulfill duties as wives and mothers, sisters and daughters,

that she claims for them certain rights, prominent amongst which she considers that of a thoroughly sound education'.[61] But as the passage above from Wollstonecraft's Introduction indicates, the philosophical core of her treatise is opposed to such essentialising.

Pennell is fitfully attentive to her subject's radicalism and independent spirit. This is most evident in her chapter on Wollstonecraft's move to London in 1788, and her membership of the radical circle that gathered around *Analytical Review* publisher Joseph Johnson, which included William Blake, Henry Fuseli, Thomas Paine and William Godwin. Here Pennell quotes approvingly from Wollstonecraft's letters to Johnson where Wollstonecraft rails against constraints on her freedom: 'Every obligation we receive from our fellow-creatures is a new shackle, takes from our native freedom, and debases the mind, makes us mere earthworms. I am not fond of groveling!'[62] Pennell follows this by reproducing the famous 7 November letter to Wollstonecraft's sister Evelina in which Wollstonecraft declares her determination to support herself through her writing – 'I am then going to be the first of a new genus.'[63] In describing Wollstonecraft's work for Johnson, which included reading manuscripts, translating books from the French and German, and writing articles for the *Analytical Review*, Pennell is drawing on her own early journalistic apprenticeship as she describes the skills this required: 'a keen critical sense, an impartial mind, and not a little moral courage'.[64]

Summarising the importance of this period to Wollstonecraft's intellectual development, Pennell associates her with the heterodox poet Blake in terms that might explain one source of Paul's objection: 'Mary's genius expanded, and ideas but half formed developed into fixed principles. As Swinburne says of Blake, she was born into the church of rebels.'[65] Pennell ends this chapter by discussing Wollstonecraft's first major publication, *A Vindication of the Rights of Man*, her answer to Burke's *Reflections on the Revolution in France*, noting the foundation this provided for her *Vindication of the Rights of Woman*. Pennell writes that it was time for someone to argue the rights of women, and that Wollstonecraft's own experiences up to this time had instilled in her the constructivist insight that 'women were hindered and hampered in a thousand and one ways by obstacles created not by nature, but by man'.[66]

Pennell's own occasional, sardonic observations on the continuing inequalities of the gender and class systems may also have offended Paul. Discussing the outcry against Wollstonecraft for

taking her sister Evelina away from her abusive husband and into hiding, Pennell writes:

> The general belief then was, as indeed it unfortunately continues to be, that women should accept without a murmur whatever it suits their husbands to give them, whether it be kindness or blows. Better a thousand times that the human soul should be stifled and killed than that the Philistines of society should be scandalized by its struggles for air and life.[67]

She also approvingly recounts Wollstonecraft's arguments against Burke's *Reflections on the Revolution in France*, writing that she

> could not endure silently his admonitions to the laboring class to respect the property which they could not possess, and his exhortations to them to find their consolation for ill-regarded labor in the 'final proportions of eternal justice'. 'It is, sir, possible', she tells him with some dignity, 'to render the poor happier in this world, without depriving them of the consolation which you gratuitously grant them in the next.'[68]

Pennell's quotation continues: 'Why is our fancy to be appalled by terrific perspectives of a hell beyond the grave? Hell stalks abroad; the lash resounds on a slave's naked sides.'[69]

'Mutilated by Yours Truly, John H. Ingram'

John Ingram received Pennell's *Life of Mary Wollstonecraft* manuscript in December 1884, and his first letter to her, on 11 February 1885, must have shocked her. It begins by implicitly blaming her for the late arrival of her just-received letter to him (though this letter is lost, it presumably claimed her right as author to be consulted about any changes he was contemplating) before notifying her that he drastically reduced the size of her manuscript and changed its title. 'I read your work through, and advised my publishers of its acceptance provided I might revise it and cut it down to our limit, viz. about two thirds of original size . . . Naturally, I presumed your consent had been obtained.'[70] The combination of vagueness and passive voice construction here is telling, as is the note of grievance in his next sentence: 'it has been a considerable trouble to reduce the book from 360 to 220 pps., as you may imagine, + one that has been anything but satisfactory to me, and scarcely likely to be so to you'.[71] He goes on to say that he has 'spent much time over the matter'

before stating (without explaining why) 'I shall have to call the book "M. Wollstonecraft <u>Godwin</u>".'[72] He then justifies his cuts, many of which reduced or eliminated quotations from Wollstonecraft's letters, by making a claim that no Wollstonecraft biographer would second: 'her letters are very uninteresting as a rule'.[73] A more plausible rationale for these cuts follows: 'I am not quite sure, and Mr. Kegan Paul seems equally uncertain, who is the holder of their copyright, so that the less we have of them the better.'[74] His final paragraph begins with what seems a note of apology but in fact again blames Pennell for the late arrival of her letter: 'I am sorry – very sorry – that I did not hear from you on this matter sooner.' His final sentence collapses under the weight of its own contradiction, expressing the desire 'that I shall escape your displeasure when you see your book, as it has necessarily been mutilated by yours truly, John H. Ingram'.[75]

Ingram's next letter to Pennell is dated 10 April, and it reveals that she submitted a note to him that she wanted added to the Allen version indicating her biography had been reduced in length. 'Your work will appear shortly, . . . upon consideration, I think you will deem it preferable not to have the note you suggested. I have had to reduce other works but were the fact made public the critics would hint, and the readers believe, that something <u>more</u> than reductions had taken place.'[76] Ingram is intent on suppressing the facts of his editorial decisions, as the next, prevaricating sentence makes clear: 'it is advisable not to make these private matters public, and although I am sorry that you were not consulted as I, and my publishers believe you had been, I do not think you will find more fault than that of abridgement'.[77] Two letters from Ingram follow on 2 and 3 May, the first notifying Pennell that the Allen version of her biography had been printed, the second claiming 'I had no idea, as I believe I have already stated, that you had not been consulted before I was authorized to make abridgements.'[78] He then says he will 'avail myself of the opportunity of giving a note in Preface with regard to the book having been cut down by Editor'.[79] It isn't clear what Ingram is pledging here, since as his previous letter indicated *Mary Wollstonecraft Godwin* had just been printed, but in any case no prefatory note from him appeared, not even in Allen's 1893 reprint of the volume. Pennell finally met Ingram in person on 6 May, before she had seen the results of his excisions (the book appeared in London bookstores on 30 May), and she records in her journal that 'he spoke of the whole affair as a tragedy'.[80] Ingram wrote his last private letter to Pennell on 17 August, after their public feud in the *Athenaeum*. 'I do not think

our <u>Athenaeum</u> correspondence need affect our feeling', adding 'I was bound to answer your 1st letter in terms I did.'[81]

By the time of their feud, Pennell was painfully aware that some of the cuts Ingram made to her original manuscript contributed to the *Athenaeum*'s negative review of her biography, since he removed much material relating to Wollstonecraft's intellectual and political affinities as influenced by pre-revolutionary thought in France. When Blind identified as a 'great defect' of the biography 'its want of background', which is crucial in relation to the 'lives of religious or social reformers or leaders of revolutionary thought',[82] she did not know, for instance, that the Roberts Brothers version of chapter six contained a lengthy discussion of Wollstonecraft's quarrel with Rousseau's ideas about women, most of which Ingram excised. This material is especially important to understanding Wollstonecraft, since Rousseau's radicalism and conception of the social contract resonated deeply with her. This is in fact why Wollstonecraft was so incensed by what Pennell calls Rousseau's 'fundamental misconception of the relations of the sexes'.[83]

Ingram's role in cutting these passages is ironic, since the authors he invited to write for the 'Eminent Women' series were, as Jock Macleod has noted, 'relatively radical, with republican sympathies', and 'largely feminists' – as were the members of the social networks Ingram himself moved among.[84] The series began and ended with biographies by outspoken feminists and suffragists (Blind and Fawcett), and Ingram himself was perceived (and often criticised by male critics and reviewers) as unaccountably promoting the work of women writers. Omnibus reviews of the initial volumes in the 'Eminent Women' series questioned the need for and value of such biographies, as well as Ingram's judgement in launching the project. The *Pall Mall Gazette* used the occasion of the first six biographies in the series to sneer at Ingram's 'fancy principle' of publishing 'criticisms of women by women only', asserting that 'nothing in contemporary literature at present leads us to assume the existence among women of a large body of trained critical capacity'.[85] The following month *The Times* (London) followed suit. Its reviewer asserted that the 'English Men of Letters' biographies are 'written by our best living critics', men who possess 'the breadth of view and trained philosophic power which enable a writer to place his subject in the true historical perspective which belongs to it'. But these qualities, the writer continues, are missing in the first six volumes of 'Eminent Women' biographies.[86] The one signed London review of

Pennell's 'Eminent Women' volume was written by James Ashcroft Noble in *The Academy,* and it adopted a similar tone, claiming that since Wollstonecraft's only 'eminence' derived from her marriage to William Godwin she did not deserve a biography in the series. Despite her stated determination to become 'the first of a new genus', which both versions of Pennell's biography quote, Noble unaccountably strips Wollstonecraft of all agency: 'even her life was made for her rather than by her'. About Pennell's biography Noble claims it contributes nothing that isn't found in Godwin's and Paul's memoirs; 'nor is Mrs. Pennell's literary style in any way attractive'.[87]

Pennell continued to thrive and develop as a writer in the remainder of the decade, despite Ingram's dictatorial decisions and damning criticism from Blind and Noble. But while many of her fellow female aesthetes were becoming more radical concerning the Woman Question (Blind, Olive Schreiner, Dollie Radford, Rosamund Marriott Watson), Pennell's views were taking a conservative turn.[88] Though she would not write another full-length biography for another twenty years, she did return to Wollstonecraft several times, most importantly in her 1890 *Fortnightly Review* article 'A Century of Women's Rights' and her 'Prefatory Note' to the 1892 edition of *A Vindication.*[89] The first of these is interesting primarily because it is so clearly a reply to Blind's 1885 review of *Mary Wollstonecraft Godwin.* (Pennell and Blind knew each other socially and attended many of the same literary salons, but there is no evidence Pennell ever discovered that Blind was the author of this review.[90]) Among other things, as we have seen, Blind's review assails Pennell for spending too much time on Wollstonecraft's childhood and early years and not enough on her relatively late 'awakening of her faculties' during 'the culmination of the great revolutionary drama':

> She was no isolated thinker, or 'philosophizing serpent', to quote Horace Walpole . . . but a woman of a highly sensitive mental organization, and she felt keenly the influence of her time. Her 'Vindication of the Rights of Woman' is the offspring of the same intellectual forces that were producing the Revolution on the other side of the Channel; and it was almost imperative on the biographer of Mary Wollstonecraft to have drawn some comparison between the Englishwoman's way of dealing with this great question and that of her French contemporaries.[91]

Pennell does just this in her *Fortnightly* essay, declaring that *A Vindication* is of 'the utmost interest, not only because it helps one to realize the social change a century has brought, . . . but because of its

relation to the intellectual movement of the age of which it was the product'.[92] She exceeds even Blind in citing Enlightenment and French revolutionary thinkers whose ideas influenced Wollstonecraft, from Voltaire and Rousseau to Condorcet and Emmanuel-Joseph Sieyès, declaring *A Vindication*

> the work of one who had genius enough to foresee the real drift of the new philosophical and political creed, and courage enough to declare in unmistakable . . . language, that truth about women which, once Rousseau's *Contrat Social* had revolutionized the standard of social relations, could not much longer remain concealed.[93]

Having answered Blind's criticisms by demonstrating her historical acumen, Pennell declined to do any revolutionary thinking of her own concerning gendered social relations, especially when the opportunity next presented itself. In her 'Prefatory Note' to the centenary edition of *A Vindication of the Rights of Woman* she once again takes pains to discuss other writers whose ideas were in the air as Wollstonecraft was writing *A Vindication*. This time, however, she consistently diminishes the nature and significance of Wollstonecraft's treatise. She notes, for instance, that it was Mary Astell, not Wollstonecraft, 'who first defended woman's rights'.[94] She also adds such essentialist generalisations as this one: 'Condorcet argued with all the logic of the thoughtful student, Mary Wollstonecraft with all the fire of the impulsive woman.'[95] When emphasising the faults of Wollstonecraft's writing style, she relies on a male authority to claim that 'her whole book, as Mr. Leslie Stephen has well said, is rhetorical rather than speculative. It is without system, without method. It is full of useless repetitions, and is forever neglecting the main argument for trifling side issues.'[96] Next she offers her summary of the central thesis of *A Vindication*, and it becomes clear that her own sexual politics have taken a harder right turn in the thirteen years since she wrote the *Life of Mary Wollstonecraft*. 'Too many of her followers, unfortunately, have failed to grasp the true meaning' of the book, Pennell writes, claiming that it has nothing to do with gender and inequality. Instead, 'her whole book is a protest against shams'.[97] And the greatest contemporary sham, apparently, is the emancipated woman. Resorting to the Victorian stereotype of the bluestocking and also evoking the social purity movement that Millicent Fawcett helped lead, Pennell claims that Wollstonecraft would never have considered women 'emancipated, if, in obtaining recognition as human beings, they ignored their sex altogether'.[98] She continues: 'The main thing was to be done with shams for evermore,

not to substitute for the old sham sensibility of puppetdom the new sham sexlessness of emancipation.' Placing considerable distance between herself and the political activism of the nascent New Woman movement,[99] Pennell concludes of Wollstonecraft: 'she was always an enthusiast, never a fanatic, and this, in our age of sentimental fanaticism, is not the least of her merits'.[100]

One of these New Woman writers was Olive Schreiner, who was in fact the first choice of the publisher Walter Scott to write the introduction to the centenary edition of *A Vindication*. Schreiner agreed to the commission in 1886 and worked at it until 1889, when she abandoned the project. The existing fragment was published in 1994, and the contrast between this fragment and Pennell's 'Prefatory Note' could not be more striking. Carolyn Burdett has described Schreiner's work on the introduction as part of her 'struggle, during the 1880s, to produce a social-evolutionary narrative for women's emancipation',[101] so it is not surprising to read Schreiner's praise for *A Vindication* as a text that foretells r/evolutionary changes in socio-sexual relations:

> The book is a great book because, however vaguely and crudely stated, the woman perceived eighty years ago the mighty sexual change that is coming upon us; saw the necessity for it, saw its end. She saw the width of the phenomena called vaguely the 'woman's movement', its connection with the general social movements with regard to class, its connection with economics; she saw what is not often seen to-day by the defenders of sex-equality, that the smallest change with regard to the position of woman in relation to man must entirely revolutionize society and modify the entire course of human existence on the globe.[102]

In stark contrast to Pennell's gender essentialism, Schreiner writes that

> the full history of the varying protean shapes which sex assumes in its manifestation on the earth has yet to be written; but it is evident, from the most cursory survey, that nothing is more variable than the forms and functions which these, at core unchanging, principles may assume.[103]

As is evident from these passages, and as Burdett notes, Schreiner, like Blind before her, was attempting nothing less than 'to transform a metropolitan and masculine theoretical discourse in the name of women's accession to history'.[104] As if critiquing Pennell's far less fluid view of gender, Schreiner writes that 'the pur-blind inhabitant of a modern social state, seeing no further than the shapes which happen to be for the moment immediately before him, sees in sex

manifestation something unalterably fixed and unchanging as at least a mathematical axiom'.[105] Schreiner is arguing here for a view of gender and sexuality as culturally relative and therefore susceptible of radical rethinking and change.

'They Are a Nuisance to Me'

By the turn of the century, Pennell was turning her back on Wollstonecraft and her legacy. In *Our House and the People in It* (1910), written when she was in her fifties, she wrote that 'life for me has grown crowded enough without politics, and years have lessened the ardour for abstract justice that was mine when, in my youth, I wrote the "Life of Mary Wollstonecraft", and militant Suffragettes as yet were not'.[106] As the tortured syntax of this last phrase suggests, the quality of her support for women's suffrage had become strained. Her own stated position combines antagonism towards the cause with class snobbery:

> Theoretically, I believe that women of property and position should have their vote and that men without should not, but I think it a lesser evil for women to be denied the vote than for the suffrage to become as universal for women as for men.[107]

This put her at odds even with Millicent Fawcett, the more moderate of the English suffrage movement leaders, who became president of the National Union of Women's Suffrage Societies (NUWSS) in 1897 and whose 1891 'Introduction to the New Edition' of *A Vindication* is in sharp contrast to Pennell's 'Prefatory Note'. Fawcett claims Wollstonecraft as the guiding spirit of the movement, the one who first established that 'women need education, need economic independence, need political enfranchisement, need social equality'.[108] She concludes her introduction by proclaiming that 'the women's rights movement in England and America owes as much to her as modern Political Economy owes to her famous contemporary, Adam Smith'.[109]

Fawcett's more militant comrade in the movement, Emmeline Pankhurst, founded the Women's Social and Political Union (WSPU) in 1903, and the confrontational tactics of this wing of the movement draw Pennell's greatest ire.[110] They also cause her writing to descend into caricature and sarcasm:

Every woman is free to make herself ridiculous, and it is none of my business if my neighbors choose to make a public spectacle of themselves by struggling in the arms of policemen, or going into hysterics at meetings where nobody wants them; if they like to emulate bad boys by throwing stones and breaking windows, or if it amuses them to slap and whip unfortunate statesmen who, physically, could easily convince them of their inferiority. But when they make themselves a nuisance to me personally I draw the line. And they are a nuisance to me.[111]

Pennell complains that her and her husband's writing is being increasingly interrupted by militant WSPU members, who pose a threat both to their safety and to the sanctity of their home. This reaches a crisis when a group of WSPU activists gather on the rooftop of the Pennells' building, where they 'elected to send off fire-balloons which, in some way best known to themselves, were to impress mankind with the necessity of giving them the vote'.[112] These women 'have brought pandemonium into the Quarter where once was all pleasantness and peace. Our house is in a turmoil from morning till night with women charging in like a mob, or stealing out like conspirators.'[113]

Conclusion

Pennell's fleeting, valedictory allusion to Wollstonecraft in *Our House*, and her hardening attitude towards the women's rights movement, provide a striking illustration of why, in Kimberly Morse Jones's words, 'it is essential' that Pennell 'be framed as a female aesthete rather than a New Woman'.[114] While these two late-century categories are not necessarily antithetical (Mathilde Blind and Olive Schreiner, to take two examples, married aestheticism and political radicalism in their writing), they were so in the case of Pennell. Talia Schaffer's formulation that 'where New Women agitated for real reforms, female aesthetes described spaces where no reform would be necessary'[115] applies with special force to Pennell, who was most at home in the realm of the aesthetic. By attempting to banish from 'our house' both Wollstonecraft and the activism she engendered, Pennell was seeking escape from the 'mighty sexual change' her first book helped accelerate.

This midlife retrenchment should not, however, diminish or obscure Pennell's importance as a writer whose professional accomplishments and transnational reputation continue to align her with the progenitor who first brought her fame on both sides of the Atlantic. Moreover,

and considered in the context of her fellow women writers' challenges in navigating a literary and publishing landscape still dominated by male editors, Pennell's experiences and shifting attitudes productively complicate our understanding of late-century feminism. In this regard it is worth returning to Schreiner's observation that Wollstonecraft 'saw the width of the phenomena called vaguely the "woman's movement", its connection with the general social movements with regard to class, its connection with economics'.[116] The sometimes dissonant, sometimes harmonious voices of the late-century women writers considered here take one measure of the width as well as the depth of this ongoing movement, reminding us that, in Schreiner's words, 'the full history of the varying protean shapes which sex assumes in its manifestation on the earth has yet to be written'.[117]

Notes

1. Pennell, letter to the editor, *Athenaeum*, 80–1.
2. Ingram to Pennell, Pennell-Whistler Collection, box 374. W. H. Allen's 'Eminent Women' series began in 1883 with Mathilde Blind's *George Eliot* and A. Mary F. Robinson's *Emily Brontë*. It continued until 1895 and ultimately numbered twenty-two volumes. Most of the titles were subsequently published in America by Roberts Brothers under the series title 'Famous Women', often in the same year (though *George Eliot* appeared in 1885, and *Emily Brontë* in 1886). Pennell's Wollstonecraft biography and Julia Ward Howe's biography of Margaret Fuller (Marchessa Ossoli) were the two volumes that appeared first in the 'Famous Women' series before being condensed and published as part of the 'Eminent Women' series. In addition, Caroline Healy Dall's *The Life of Dr. Anandabai Joshee* (1888, a biography of the first Indian woman to earn a medical degree in the US) and Mrs Charles Malden's *Jane Austen* (1896) were both published by Roberts Brothers but not by Allen; and Lucy Madox Rossetti's *Mrs. Shelley* (1890) was published by Allen but not by Roberts Brothers. The other four 'Famous Women' titles that preceded Pennell's volume were Anne Gilchrist Burrows's *Mary Lamb*, Bertha Thomas's *George Sand* and Helen Zimmern's *Maria Edgeworth*, all published in 1883, and Vernon Lee's *Countess of Albany*, which appeared in 1884.
3. Pennell, letter to the editor, *Athenaeum*, 81.
4. Ingram, letter to the editor, *Athenaeum*, 113. In her 25 July journal entry, Pennell called Ingram's *Athenaeum* letter in response to hers 'sneaking and tricky' (quoted in Waltman, *Early London Journals*, 61).
5. Pennell, letter to the editor, *Athenaeum*, 143–4. Many of the women who wrote for the 'Eminent Women' series had similarly negative experiences with Ingram – though none had their manuscripts cut so severely

as Pennell. Pennell reports that Helen Zimmern was 'full of rage' against Ingram and asked Robert Browning and Richard Garnett to intervene when Ingram attempted to revise her 1883 biography of Maria Edgeworth, and that A. Mary F. Robinson 'also had trouble with him' (quoted in Waltman, *Early London Journals*, 87, 93–4). Mathilde Blind had an epistolary feud with Ingram, both about his refusal to pay her more for her biography of Madame Roland (1886) than she was paid for her successful George Eliot biography (1883) and for his insistence that she reduce the length of her Roland manuscript (Diedrick, *Mathilde Blind*, 193–9). While writing *Hannah Moore* (1888), Charlotte M. Yonge exchanged several letters with Ingram, and in a 7 November 1887 letter expresses her frustration at his editorial queries (Yonge). As Jock Macleod has written, Ingram 'was regarded by some as self-seeking and untrustworthy once he had what he wanted' ('Reconstructing', 28).

6. In addition to her 1883 biography of George Eliot, Blind would go on to publish another highly praised volume for the 'Eminent Women' series, *Madame Roland*, in 1886.

7. Blind, Review, 41.

8. Ibid.

9. Ibid. 42.

10. Ibid.

11. Pennell, letter to the editor, *Athenaeum*, 81.

12. Pennell quoted in Waltman, *Early London Journals*, 62. Both these reviews appeared on 25 July. In the same journal entry Pennell described the *St. James Gazette* review, written by the essayist and critic James Ashcroft Noble, as 'vile', and called the notice in the *St. James Gazette* the same day 'another very nasty review'. She described herself after reading these reviews as 'very melancholy all evening in consequence'. Four days after they appeared she wrote in her journal that she discussed with Shelley Society founder Frederick James Furnivall her 'grievance' against *The Academy*, the *St. James Gazette* and W. H. Allen. Furnival 'gave me violent advice', urging her to get an injunction against Allen to stop publication of her abridged biography (Waltman, *Early London Journals*, 64).

13. Pennell to Joseph Pennell, 31 July 1890, Pennell-Whistler Collection, box 305.

14. Buchanan, 'Introduction', xxxii.

15. See Morse Jones, *Elizabeth Robins Pennell*.

16. By one important measure Pennell's biography was a success on both sides of the Atlantic. The 1884 Roberts Brothers version, greeted with mixed reviews, was republished in 1890, and the Allen version in 1893 and 1909 (the 1909 version, published in London by Gibbings and Company, was a reprint of the Allen version). The book continued and contributed to the rehabilitation of Wollstonecraft's reputation in the late nineteenth century that began with C. Kegan Paul's *William Godwin: His*

Friends and Contemporaries in 1876 and culminated in the early 1890s with Pennell's 1890 *Fortnightly Review* essay 'A Century of Women's Rights' as well as two new editions of *A Vindication* – the first published in 1891 with an introduction by Pennell and the second issued a year later with an introduction by Millicent Garrett Fawcett.

17. Pennell, *Our Philadelphia*, 239.
18. Leland had been a successful journalist in Philadelphia and became famous for *The Breitmann Ballads* and a series of books on the Roma, including *The English Gipsies* [sic] *and Their Language* (1873) and *The Gypsies* (1882). He had lived in London in the 1870s and from 1874 to 1876 served as a contributor to and assistant editor of *Johnson's Universal Cyclopedia* (Pennell, *Charles Godfrey Leland*, 2:39), initially published in four volumes in 1876. During his time in London he became friends with Richard Garnett, keeper of printed books in the British Museum, who would give Pennell assistance during her writing of *Life of Mary Wollstonecraft*.
19. Pennell, *Our Philadelphia*, 27.
20. Ibid. 237.
21. Ibid. 240.
22. Pennell later proposed two additional biographies, writing first to Niles about his interest in a book about Catherine of Siena and next to Ingram about a biography of Amelia Opie. Both were rejected (Niles to Pennell, 16 July 1885, Pennell-Whistler Collection, box 375; Ingram to Pennell, 10 April 1885, Pennell-Whistler Collection, box 374). As Dave Buchanan has written, this is evidence of her interest in 'strong, independent women' early in her career (Pennell and Pennell, *A Canterbury Pilgrimage*, 122 n.56). Pennell's choice of Mary Wollstonecraft for her first biography also reflects a lifelong interest in writers and literature of the eighteenth century and the Romantic period. She (and Joseph) wrote travel books based on following in the footsteps of Laurence Sterne and Samuel Johnson, and her writing contains several allusions to Jonathan Swift, Opie, Byron and Shelley.
23. Barnard and Guyot, *First Biennial Supplement*, 42. The entry is remarkable in its unqualified praise for Wollstonecraft, calling the 'famous *Vindication of the Rights of Woman*' a 'presentation of the woman-suffrage ideas', and its author 'a woman of attractive manners and . . . singular courage and independence'. In contrast to many nineteenth-century commentators who claimed that William Godwin's *Memoirs* presented Wollstonecraft in a damning light, the entry's author avers that Godwin does 'full justice to her character'. This is in stark contrast to the 1814 *Chalmers Biographical Dictionary* entry on Wollstonecraft, which, as Pennell notes in her biography, 'was the most influential in perpetuating the ill-repute in which [Wollstonecraft] stood with her contemporaries'. Pennell quotes as an example of its 'scurrilous abuse' the description of Wollstonecraft as a woman of 'ungovernable' passions, a 'voluptuary and sensualist' (*Life of Mary Wollstonecraft*, 7).

24. See Macleod, 'Reconstructing', 12, and Kilgour, *Messrs. Roberts Brothers*, 281.

25. Columbia University Libraries does have selected Roberts Brothers correspondence files in its Roberts Brothers Papers, 1882–1898.

26. As R. M. Janes has noted, when *A Vindication of the Rights of Woman* was published in 1792 nearly every contemporary review was favourable. The backlash against Wollstonecraft and her ideas came in the wake of the French Revolution and the publication of Godwin's memoir (Janes, 'On the Reception', 293–302).

27. Paul, *Mary Wollstonecraft*, v–vi.

28. Ibid. v.

29. Paul was well aware of the complexities of Wollstonecraft and Godwin's religious attitudes. Indeed, *The Genius of Christianity Unveiled* was left unpublished at Godwin's death, but Paul included it in his 1873 edition of *Essays by the Late William Godwin: Never Before Published.*

30. By contrast, Mathilde Blind in her review of Pennell's biography assumes that Wollstonecraft's conduct of her erotic life reflected her radicalism and was in accord with Godwin's opposition to marriage and belief in free unions: 'Godwin, as the author of "Political Justice", had, of course, no scruples or hesitations to contend with in giving an account of his wife's life. His theories and her actions were in complete harmony. He had taught that a fuller development of the individual and a greater amount of happiness for the community would be secured by a readjustment to the relation of the sexes. Mary Wollstonecraft had never promulgated such views in her writings, but had acted as if she held them' (Blind, 'Mary Wollstonecraft', 41).

31. Paul, *Mary Wollstonecraft*, xxvi. In his review of the *Letters to Imlay*, Edmund Gosse writes that Paul's 'Memoir' is written in 'the most pathetic style' and that the letters tell 'the old melancholy story of feminine devotion and unselfish love driven by cold looks and distracted thoughts to a despair which is almost hatred' (Gosse, Review, 573).

32. Blind, Review, 41. In her essay 'The Biographies of Mary Wollstonecraft', Janet Todd adopts the 'whitewashing' metaphor without attributing it to Blind (Todd, 'Biographies', 724).

33. Paul to Pennell, Pennell-Whistler Collection, box 374.

34. Ibid.

35. Ibid.

36. Blind, 'Shelley'.

37. Diedrick, *Mathilde Blind*, 35–70.

38. Blind, 'Mary Wollstonecraft', 395, 405.

39. Paul to Pennell, Pennell-Whistler Collection, box 374.

40. Ibid.

41. Ibid.

42. Clarke, *Critical Voices*, 118.

43. Niles to Pennell, Pennell-Whistler Collection, box 375.

44. Ibid.

45. Ibid. According to the Bureau of Labor Statistics consumer price index, $200 in 1885 would be roughly the equivalent of $5,300 in 2020. The English women who wrote for the Allen series received £50, or roughly $220.
46. Leland had written a note introducing Pennell to Garnett that she enclosed in a letter she wrote to him from America, which Garnett opens his 26 January 1884 reply by acknowledging: 'I have received your letter together with Mr. Leland's. It will give me extreme pleasure to be of any service to you' (Garnett to Pennell, Pennell-Whistler Collection, box 375). Pennell's biography of Leland documents several letters exchanged between Leland and Garnett during the years Leland was working in London on Johnson's *Cyclopaedia* (Pennell, *Charles Godfrey Leland*, 2:177, 354).
47. Pennell, quoted in Waltman, *Early London Journals*, 32. During this eventful month she also attended several literary salons and met fellow writers A. Mary F. Robinson, Vernon Lee, Anne Gilchrist and Mathilde Blind (ibid. 27–40).
48. Pennell, quoted in ibid. 40.
49. In contrast to the subsequent Allen edition, which Ingram reduced to 209 pages, the Roberts Brothers edition filled 360 pages. Some of the disparity in length is accounted for by differences in font size and line spacing. The standard 'Famous Women' series pages contain twenty-nine lines on each page, compared to thirty-four in the 'Eminent Women' volumes.
50. Clarke, *Critical Voices*, 119.
51. Pennell, *Life and Letters*, 1:121. Pennell sent Paul a copy of the *Life of Mary Wollstonecraft* in early 1885, and his 16 February 1885 letter of thanks is entirely positive: 'I am very much obliged to you for sending me your *Life of Mary Wollstonecraft*, and for the pleasant way in which you mention me throughout' (Paul to Pennell, Pennell-Whistler Collection, box 374).
52. Pennell, *Life of Mary Wollstonecraft*, 1. Elsewhere in the biography she claims, without support, that 'religion was as important to her as it was to a Wesley or a Bishop Watts' (97).
53. Ibid. 10.
54. Ayres, *Betwixt and Between*, 58. Ayres's analysis of the ways in which Pennell strives to make Wollstonecraft 'safe' for a bourgeois readership is valuable, though she gets many of her facts wrong, confusing the two versions of Pennell's biographies, asserting that Pennell wrote a third version (possibly because the 1890 Roberts Brothers reprint was retitled *Mary Wollstonecraft*), and claiming that both versions were 'instantly successful on both sides of the Atlantic' (53). In fact, Niles wrote to Pennell on 16 July 1885 that while the *Life of Mary Wollstonecraft* 'has been well noticed as a whole', it 'does not, I am very sorry to say, meet

with great favor by the public if that may be judged by the sales' (Niles to Pennell, Pennell-Whistler Collection, box 375).

55. Pennell, *Life of Mary Wollstonecraft*, 38.
56. Ibid. 140.
57. Ibid.
58. Paul to Pennell, Pennell-Whistler Collection, box 374.
59. Wollstonecraft, *Vindication*, xxxiii.
60. Pennell, *Life of Mary Wollstonecraft*, 169–70. In passages like these Pennell is doing to Wollstonecraft what Ingram himself would later do to E. B. Browning in his 1888 biography of the poet for the 'Eminent Women' series. As Elizabeth Way has written, Ingram's biography 'subjugates an in-depth analysis of Barrett Browning's poetry to feminine Victorian standards in the manner of Coventry Patmore's "The Angel in the House" and the ideology of separate spheres' ('Stuck Through With a Pin', 152).
61. Blind, Review, 398.
62. Pennell, *Life of Mary Wollstonecraft*, 89. Ingram cut this passage in preparing the manuscript for republication in the 'Eminent Women' series.
63. Ibid. 90.
64. Ibid. 92.
65. Ibid. 113.
66. Ibid. 116.
67. Ibid. 43.
68. Ibid. 132.
69. Ibid. 133. Many mainstream American newspaper reviewers accused Pennell of special pleading on behalf of a justly damned sinner against social morality. The anonymous *New York Tribune* reviewer, for instance, calls Pennell a 'preposterous biographer' for defending Wollstonecraft's 'integrity of motive'. Proclaiming that 'in this world we do not allow people to set up private systems of morality', the writer concludes 'the book before us assumes that we do; and its conspicuous foolishness saves it from being more mischievous than ever were the writings of Miss Wollstonecraft herself' (Review, *New York Tribune*, 6). See also the *San Francisco Chronicle*, 14 December, 1884, 6, and *The Literary World: A Monthly Review of Current Literature*, 13 December 1884, 452. On the other hand *The Dial*, the distinguished literary magazine whose first editor was Margaret Fuller, proclaims Wollstonecraft a pioneer of women's rights and Pennell a biographer who 'writes with feeling, yet with candor and dignity, impressing one with the conviction that the sympathy she accords her subject is thoroughly deserved' (January 1885, 246).
70. Ingram to Pennell, Pennell-Whistler Collection, box 374.
71. Ibid.

72. Presumably because her prenatal marriage to Godwin rendered this her legal name.
73. Ingram to Pennell, Pennell-Whistler Collection, box 374.
74. Ibid.
75. Ibid. In *Life and Letters*, Pennell describes what Ingram did to her manuscript as a kind of murder, writing that her original version was 'cruelly cut down by the editorial hand' (149). *Mary Wollstonecraft Godwin* appeared the same year as the Pennells' joint publication *A Canterbury Pilgrimage*; in the wake of its immediate success Joseph diminished the importance of Ingram's actions in a letter to Elizabeth, writing at the end of a paragraph about the success of their co-written book 'don't you bother about Ingram' (Pennell, *Life and Letters*, 1:151).
76. Ingram to Pennell, Pennell-Whistler Collection, box 374.
77. Ibid.
78. Ibid.
79. Ibid.
80. Pennell, quoted in Waltman, *Early London Journals*, 56.
81. Ingram to Pennell, Pennell-Whistler Collection, box 374.
82. Blind, Review, 42.
83. Pennell, *Life of Mary Wollstonecraft*, 137. Ingram deleted this passage in preparing the manuscript for its republication in the 'Eminent Women' series.
84. Macleod, 'Reconstructing', 26, 19–25.
85. Review, *Pall Mall Gazette*, 4.
86. Review, *The Times* (London), 4.
87. Review, *The Academy*, 54–5.
88. Elizabeth and Joseph were inveterate salon attendees and *salonnieres*. Elizabeth's London Journals detail their attendance at, and hosting of, gatherings in the late 1880s that included leading poets, painters, journalists and activists of the late century. Among the progressive women writers and activists Elizabeth records meeting in these years are Annie Besant, Clementina Black, Mathilde Blind, Mona Caird, Millicent Fawcett, Dollie Radford, Rosamund Marriott Watson and Elizabeth Sharp (Waltman, *Early London Journals*, 272–88).
89. Wollstonecraft reappears, briefly, in Pennell's 1904 *Lippincott's* essay 'The Woman Question in Utopia', but by this time the pioneering feminist is merely a footnote to Socrates. Of all the utopian thinkers, Pennell writes, Socrates was the most progressive when it came to the equality of the sexes, since he believed 'woman was to be considered first not as a woman, but as a human being' (439). Of this formulation, Pennell writes that 'a woman could do no better', adding that 'Mary Wollstonecraft, in her less logical and more bombastic way, used the same argument many years afterwards in her "Vindication of the Rights of Woman"' (439).

90. Blind wrote three letters to Pennell in the spring and summer of 1887 inviting her and Joseph to salons at her home; in her third letter, written on 25 July, Blind apologies for the late notice: 'I only heard of your address yesterday from Mrs. Leland or would have sent to an invitation to my at Home before this' (Blind to Pennell, Joseph and Elizabeth R. Pennell Papers, box 1 Folder 3).
91. Blind, Review, 42.
92. Pennell, 'Century', 408.
93. Ibid. 408–9.
94. Pennell, 'Prefatory Note', xx.
95. Ibid. xxii.
96. Ibid. xx.
97. Ibid. By 'shams' Pennell means suffocating social conventions that have come to be regarded as social realities. In declining to stress Wollstonecraft's emphasis on the ways in which such conventions diminish and disadvantage women far more than men, Pennell effaces the feminist core of *A Vindication*.
98. Ibid. xxiii.
99. Although the term 'New Woman' didn't enter the language until the early 1890s, its roots reach back to the early feminism of Wollstonecraft. By the 1880s, women like Mathilde Blind, Vernon Lee, Olive Schreiner, Rosamund Marriott Watson and Mona Caird were living lives and writing literature that embodied nascent New Woman ideas, including a commitment to women's emancipation and independence (as opposed to the stereotypical ideal of female self-sacrifice), sexual nonconformism, and participation in the public sphere. Although some of Pennell's behaviour (smoking, cycling, appearing in public unchaperoned) aligned her with New Woman behaviours and freedoms, she remained antagonistic towards the women's movement of her time. As Dave Buchanan has written, 'any association we may wish to see between Elizabeth Robins Pennell and Victorian feminism is in her deeds more so than in her political commentary' ('Introduction', xli).
100. While Pennell does everything in her power here to distance Wollstonecraft from contemporary supporters of women's rights, Millicent Fawcett took exactly the opposite tack in her own introduction to T. Fisher Unwin's 1891 reissue of *A Vindication*. While Fawcett also genuflects before the altar of Victorian respectability, stressing what she calls Wollstonecraft's 'keen appreciation of the sanctity of women's domestic duties' ('Introduction', 3–4), she insists that Wollstonecraft speaks directly to late-century realities: 'The remarkable degree in which she was ahead of her time is shown on almost every page of "The Vindication". She claims for women the right to share in the advantages of representation in Parliament, nearly seventy years before women's suffrage was heard of in the House of Commons' (ibid. 24). Fawcett's purpose in her introduction, she says,

is 'to consider the character of the initiative which she gave to the women's rights movement in England' (ibid. 29–30).

101. Burdett, 'Difficult Vindication', 181.
102. Schreiner, 'Introduction', 190.
103. Ibid. 191.
104. Burdett, 'Difficult Vindication', 182.
105. Schreiner, 'Introduction', 191.
106. Pennell, *Our House*, 330.
107. Ibid. 329. Eight years after Pennell wrote these words, Parliament passed a partial suffrage act, granting all British men and some 8.4 million British women the right to vote – provided the women were aged over thirty, householders, the wives of householders, occupiers of property with an annual rent of £5, or graduates of British universities. All other British women would have to wait until 1928 to gain their suffrage.
108. Fawcett, 'Introduction', 30.
109. Ibid.
110. Recent studies of the suffrage campaign, while no longer claiming that the WSPU was responsible for women's suffrage, view it as embodying a radical form of feminism that, like the writings of Blind, Schreiner and Caird, sought to liberate women from the male-centred gender system. See Smith, *British Women's Suffrage Campaign*, 34.
111. Pennell, *Our House*, 330.
112. Ibid.
113. Ibid. 330–1.
114. Morse Jones, *Elizabeth Robins Pennell*, 33.
115. Schaffer, *Forgotten Female Aesthetes*, 25.
116. Schreiner, 'Introduction', 190.
117. Ibid. 190.

Bibliography

Ayres, Brenda. *Betwixt and Between: The Biographies of Mary Wollstonecraft*. New York: Anthem Press, 2017.

Barnard, Frederick A. P. and Guyot, Arnold. *First Biennial Supplement to Johnson's New Universal Cyclopaedia: A Scientific and Popular Treasury of Useful Knowledge*. New York: Alvin J. Johnson, 1880.

Blind, Mathilde. 'Mary Wollstonecraft'. *New Quarterly Magazine* (10 July 1878): 390–412.

Blind, Mathilde. [unsigned] Review of *Mary Wollstonecraft Godwin*. *Athenaeum* (11 July 1885): 41–2.

Blind, Mathilde. 'Shelley'. Review of *The Poetical Works of Percy Bysshe Shelley. A Revised Text, with Notes and a Memoir, by William Michael Rossetti. Westminster Review* (July 1870): 75–97.

Buchanan, Dave. 'Introduction'. In *A Canterbury Pilgrimage / An Italian Pilgrimage*, by Elizabeth Robins Pennell and Joseph Pennell, ed. Dave Buchanan, ix–xlii. Edmonton: University of Alberta Press, 2015.

Burdett, Carolyn. 'A Difficult Vindication: Olive Schreiner's Wollstonecraft Introduction'. *History Workshop* 37 (April 1994): 177–87.

Clarke, Meaghan. *Critical Voices: Women and Art Criticism in Britain, 1880–1905*. Aldershot: Ashgate, 2005.

Diedrick, James. *Mathilde Blind: Late-Victorian Culture and the Woman of Letters*. Charlottesville: University of Virginia Press, 2016.

Fawcett, Millicent Garrett. 'Introduction to the New Edition'. In *A Vindication of the Rights of Woman*, by Mary Wollstonecraft, 1–30. London: T. Fisher Unwin, 1891.

Gosse, Edmund W. Review of *Mary Wollstonecraft: Letters to Imlay. With Prefatory Memoir*, by C. Kegan Paul. *The Academy* (21 December 1878): 578–9.

Ingram, John. Letter to the Editor. *Athenaeum* (25 July 1885): 113.

Janes, R. M. 'On the Reception of Mary Wollstonecraft's *A Vindication of the Rights of Woman*'. *Journal of the History of Ideas* 39, 2 (1978): 293–302.

Kilgour, Raymond L. *Messrs. Roberts Brothers Publishers*. Ann Arbor: University of Michigan Press, 1952.

Macleod, Jock. 'Reconstructing W. H. Allen's "Eminent Women": The Cultural Formation of a Late Victorian Biography Series'. *Publishing History: The Social, Economic and Literary History of Book, Newspaper and Magazine Publishing* 76 (2016): 7–33.

Morse Jones, Kimberly. *Elizabeth Robins Pennell: Nineteenth-Century Pioneer of Modern Art Criticism*. Burlington, VT: Ashgate, 2015.

Noble, James Ashcroft. Review of *Mary Wollstonecraft Godwin*, by Elizabeth Robins Pennell. *The Academy* (25 July 1885): 54–5.

Paul, C. Kegan. *Mary Wollstonecraft: Letters to Imlay. With Prefatory Memoir by C. Kegan Paul*. London: C. Kegan Paul, 1879.

Paul, C. Kegan. *William Godwin: His Friends and Contemporaries*. Boston: Roberts Brothers, 1876.

Pennell, Elizabeth Robins. 'A Century of Women's Rights'. *The Fortnightly Review* (September 1890): 408–17.

Pennell, Elizabeth Robins. *Charles Godfrey Leland: A Biography*. 2 vols. Boston: Houghton Mifflin, 1906.

Pennell, Elizabeth Robins. Letter to the Editor. *Athenaeum* (18 July 1885): 80–1.

Pennell, Elizabeth Robins. Letter to the Editor. *Athenaeum* (1 August 1885): 143–4.

Pennell, Elizabeth Robins. *Life of Mary Wollstonecraft*. Boston: Roberts Brothers, 1884. [Reissued as *Mary Wollstonecraft*. 1890.]

Pennell, Elizabeth Robins. *The Life and Letters of Joseph Pennell, vol. 1*. Boston: Little, Brown, 1929.

Pennell, Elizabeth Robins. *Mary Wollstonecraft Godwin*. London: W. H. Allen, 1885. [Reissued 1893.]

Pennell, Elizabeth Robins. *Mary Wollstonecraft Godwin*. London: Gibbings, 1909. [Reissue of 1893 W. H. Allen edition]

Pennell, Elizabeth Robins. *Our House and the People in It*. Boston: Houghton Mifflin, 1910. [Reissued as *Our House and London out of Our Windows*. Boston: Houghton Mifflin, 1912.]

Pennell, Elizabeth Robins. *Our Philadelphia*. Philadelphia: Lippincott, 1914.

Pennell, Elizabeth Robins. 'Prefatory Note'. In *A Vindication of the Rights of Woman*, by Mary Wollstonecraft. London: Walter Scott, 1892.

Pennell, Elizabeth Robins. 'The Woman Question in Utopia'. *Lippincott's Monthly Magazine* (April 1904): 436–47.

Pennell, Elizabeth Robins and Pennell, Joseph. *A Canterbury Pilgrimage / An Italian Pilgrimage*, ed. Dave Buchanan. Edmonton: University of Alberta Press, 2015.

Pennell, Joseph and Pennell, Elizabeth Robins. Joseph and Elizabeth R. Pennell Papers, 1832–1951. Harry Ransom Center. University of Texas at Austin.

Review of *The Life of Mary Wollstonecraft*, by Elizabeth Robins Pennell. *The Dial* (January 1885): 246.

Review of *The Life of Mary Wollstonecraft*, by Elizabeth Robins Pennell. *New York Tribune* (27 January 1885): 6.

Review of *Mary Wollstonecraft Godwin*, by Elizabeth Robins Pennell. *The Academy* (25 July 1885): 54–5.

Review of *Mary Wollstonecraft Godwin*, by Elizabeth Robins Pennell. *Pall Mall Gazette*, 3 December 1883.

Review of *Mary Wollstonecraft Godwin*, by Elizabeth Robins Pennell. *The Times* (London), 9 January 1884.

Schaffer, Talia. *The Forgotten Female Aesthetes: Literary Culture in Late-Victorian England*. Charlottesville: University of Virginia Press, 2000.

Schreiner, Olive. 'Introduction to the *Life of Mary Wollstonecraft* and *The Rights of Woman*'. *History Workshop* 37, 1 (1994): 188–93.

Smith, Harold L., *The British Women's Suffrage Campaign, 1866–1928*. London: Pearson, 2009.

Todd, Janet. 'The Biographies of Mary Wollstonecraft'. *Signs* 1, 3 (Spring 1976): 721–34.

Waltman, John Lawrence. *The Early London Journals of Elizabeth Robins Pennell*. Dissertation, University of Texas at Austin, 1976.

Way, Elizabeth. '"Stuck Through With a Pin, and Beautifully Preserved": Curating the Life of Elizabeth Barrett Browning (1806–1861)'. In *Biographical Misrepresentations of British Women Writers: A Hall of Mirrors in the Long Nineteenth Century*, ed. Brenda Ayres, 149–67. Cham: Palgrave Macmillan, 2017.

Wollstonecraft, Mary. *A Vindication of the Rights of Woman. By Mary Wollstonecraft. With an Introduction by Elizabeth Robins Pennell*. London: Walter Scott, 1892. [Though this is the actual subtitle, Pennell's essay is listed on the contents page and begins under the title 'Prefatory Note'.]

Yonge, Charlotte Mary. *The Letters of Charlotte Mary Yonge (1823–1901)*, ed. Charlotte Mitchell, Ellen Jordan and Helen Schinske. Accessed 12 January 2020. https://c21ch.newcastle.edu.au/yonge/2869/to-john-henry-ingram-2

'Sentiment Might Do for a Post-Chaise, but [It Is] Impossible on a Tricycle': Elizabeth Robins Pennell's Dialogue with Sterne in *Our Sentimental Journey*

Una Brogan

In September 1885, Elizabeth Robins Pennell and her husband Joseph embarked on their third long-distance tandem tricycle journey, which, like the previous two, would result in the publication of an illustrated travel account. After retracing Chaucer's pilgrims' route in *A Canterbury Pilgrimage* (1885) and riding from Florence to Rome in *An Italian Pilgrimage* (1887), the writer–illustrator couple set out to follow in the tracks of Laurence Sterne's *A Sentimental Journey through France and Italy* (1767). Beyond the titular shift from an indefinite article to a possessive pronoun lies a complex dialogue between the eighteenth-century sentimental travel writing classic and a late-Victorian cycle narrative. The rich intertextual relationship between the two texts carries on a Sternean approach to narrative in its reliance on parody and allusion. Yet in attempting to use Sterne's book as a sentimental travel guide, Pennell exposes at once the futility of such a task and the gulf between her own approach to travel writing and that of her 'Master'.[1]

The Journey

The Pennells were pioneers of the cycle-touring genre, being among the first to publish illustrated narratives of their journeys awheel and, according to Dave Buchanan, helping 'to invent the idea of leisure cycle-touring'.[2] Although the title pages of most of the Pennells' cycle-touring books attribute the works to both Elizabeth and Joseph (with Elizabeth's name appearing after her husband's), it was widely recognised by their contemporaries that Elizabeth was the author in

the partnership, while Joseph illustrated the volumes.[3] It was perhaps Joseph's greater renown as an illustrator – or the patriarchal practices of publishers – that led to the decision to print both names on the title page of each volume, flouting publishing conventions by placing the name of the illustrator in a more prominent position than that of the author. For the purposes of this chapter I will refer to Elizabeth as the author and Joseph as the illustrator.

Our Sentimental Journey, like the Pennells' previous two cycling books, was innovative in offering an account of a long-distance journey by means of what was still a relatively new technology, and ascribing new meanings to this form of travel. In adopting Sterne's text as their guide, the Pennells were also participating in a much broader practice of literary tourism which flourished in the period from 1880 to 1920, according to Nicola Watson. Watson examines how at the turn of the century tourists began to make journeys to locations connected to the biographies or works of authors such as Dickens and Hardy 'in search of spots infused with sentiment'.[4] While cyclists were undoubtedly a minority among literary tourists, Dave Buchanan has shown how the Pennells actively contributed to, and interacted with, this emerging sub-genre of travel writing. As Buchanan highlights, the Pennells' published works 'illustrate how cycling in the late Victorian period was seen by some as having imaginative overtones connecting writers of the past with riders, writers, and readers of the present'.[5] Moreover, in choosing Sterne as their template, the Pennells were contributing to a flourishing sub-genre of travel narratives specifically inspired by *Tristram Shandy* (1759–67) and *A Sentimental Journey*. Throughout the nineteenth century, writers in many countries published works borrowing from Sterne in more or less explicit manners.[6]

Yet as Pennell notes in her biography of her husband, literary considerations were not foremost in their minds when deciding on this trip; rather, reaching the Alps had been the initial motivation for making this journey through France. In 1884 Joseph had been commissioned by the *Century Magazine* to make sketches of cathedrals in England and France, a task which first brought the couple to London and had motivated their inaugural tandem-tricycle journey to Canterbury. Joseph was still working on this commission in 1885, and after completing drawings of Merton cathedral 'the decision was for High Savoy which, if a journey had to be made, was an excellent excuse for us to cycle, as we longed to, across its good poplar-lined roads, from Calais into Switzerland'.[7] Looking back from a distance of some forty years, Elizabeth recalls the literary

motivation for their journey as secondary and almost incidental, recounting that

> We bought a new tandem, we borrowed Sterne's route to save the trouble of mapping one out for ourselves and we started, August thirtieth, on 'Our Sentimental Journey'. When, at the end of it, Pennell tramped off with High Savoy as his goal, I waited in a pension among orchards above Villeneuve on Lake Geneva.[8]

It was no easy task to adopt *A Sentimental Journey* as a literary travel guide, since very few details are given about Sterne's route through France and Italy. We know that the book was loosely based on Sterne's two extended stays in continental Europe, in 1762–4 and 1765–6. Yet as Tim Parnell notes, there is little relation between Sterne's actual journey and the fictional one made by Yorick, since 'Sterne's real interest is in the commonplaces and conventions of travel *writing* and not in . . . detailed accounts of French and Italian culture that form the focus of genuine travel books'.[9] Untangling the traces of Sterne's route is further complicated by the fact that the influence of his travels also filtered into *Tristram Shandy*, whose final volumes contain passages closely resembling the later account of Yorick's travels. In contrast to Sterne's complex and diverging refractions of real and fictional journeys, the Pennells' actual trip clearly forms the basis for the text that resulted from it, as Elizabeth was writing 'a genuine travel book' rather than challenging contemporary practices in order to experiment with a new literary form. Yet one interesting point of resemblance between the Pennells' travels and those of Sterne is that the cycling couple had also made two separate journeys to Europe prior to the publication of this volume, in October 1884 and September 1885. Moreover, both *Sentimental Journeys*, in spite of their titles, include no account of travelling in Italy. Indeed, as Pennell recognises in her preface, their Italian trip had been made the previous year, and resulted in the publication of a separate book, *An Italian Pilgrimage*.[10] While Sterne had also travelled in Italy, his omission of this country from his account can be attributed to his untimely death in March 1768, before he had time to write the last two of four planned volumes.

Whereas Sterne lists only a handful of places on Yorick's route (namely Calais, Montreuil, Nampont, Amiens, Paris, Versailles, Moulins, Lyon, St Michel and Modane), Pennell furnishes a more comprehensive account of the localities she and Joseph passed through on their tricycle. Joseph's humorous map included at the

Figure 3.1 Joseph Pennell, map from *Our Sentimental Journey through France and Italy* (1888) by Joseph and Elizabeth Robins Pennell

start of the volume provides a visual illustration of their route, including annotations indicating the meteorological conditions, the quality or steepness of the road and the portions of the journey they made by train (see Figure 3.1). In spite of the scarcity of practical information provided in their 'sentimental guide-book'[11] the Pennells made a clear attempt to visit the places mentioned in Sterne's text, especially in northern France where more detail is provided. They pass through Calais (where they keep an eye out for a monk, and eventually see one), Montreuil (where they consider following Sterne's example of distributing money to beggars) and Nampont (where they try to locate the post-house at which the

dead donkey's master told his sad tale). When considering which route to take from Neuchâtel to Paris, Pennell invokes 'sentiment', in their fidelity to Sterne's text, as their main consideration, claiming that 'at that stage of our enthusiasm where sentiment was concerned we were inflexible – Mr. Sterne, on his way to Amiens and Paris, passed by Montreuil. To Montreuil, therefore, we must go.'[12]

Yet many additional localities are described in Pennell's text, and the cyclists are also willing, for reasons of practicality, not to pass through places mentioned in *A Sentimental Journey*. This is the case for Versailles, for instance, which does not lie on a direct south-easterly route out of Paris towards the Alps. Pennell dismisses a visit to the former seat of the French monarch on the grounds that it 'was on business connected with his passport Mr. Sterne went to Versailles. We had no passport; therefore it would be absurd to follow him thither.'[13] Although Sterne's text ostensibly provides the structure and motivation for their own journey, the desire to progress in a straight line towards their destination takes precedence over literary considerations. Moreover, the reader often gets the sense that the cyclists are relieved to be liberated from the 'duty' to stick to Yorick's route. This is the case on their departure from Nampont; thanks to the fact that Sterne's hero falls asleep at this point, 'there was no sense of sentimental duty to oppress us'.[14] Therefore, due both to the nature of Sterne's text and to the temperament of the Pennells, the eighteenth-century narrative can only be considered to provide the itinerary for this cycle journey in the very loosest sense.

Textual and Stylistic Borrowings

Pennell's text is peppered with echoes from both *Tristram Shandy* and *A Sentimental Journey*. There is a clear sense that these cherished books have been read and re-read, to the point where quoting them becomes an almost unconscious reflex. In her dedication to Sterne, Pennell justifies her free use of his texts in the following terms: 'as you will recognize your own words without our pointing them out, we have not even put them into quotation marks, an omission which you of all men can best appreciate'.[15] Indeed, it takes a keen eye to spot all the instances when Sterne's words have been carefully woven into Pennell's text. Plagiarism and parody were common currency in the eighteenth century, in contrast to the more proprietary approach to texts that developed alongside copyright law in the Victorian period. Sterne's writing style is deeply intertextual, and he shows no

qualms about freely borrowing from or parodying other authors; Pennell follows suit in seamlessly incorporating citations from Sterne into her narrative. Her borrowings are too many to list in full; yet a consideration of a small selection of them allows us to appreciate the way in which Pennell makes use of Sterne's texts as a background refrain to her own.

The opening pages of Pennell's account closely follow the structure and syntax of Sterne's text, while adapting the content to fit the realities of a tricycle journey. The enigmatic first line of *A Sentimental Journey* – 'They order, said I, this matter better in France'[16] – is mirrored in the exclamation that opens Pennell's book: '"The roads", said I "are better in France"', and the exchange between Yorick and his 'gentleman' is transformed into one between Joseph and Elizabeth, which results in the same decision: to go to France to see for themselves. Snippets of Sterne's first chapter are paraphrased in the description of the couple's packing and departure for Dover; and on reaching France they share Yorick's sense of outrage at having to pay dues to the French state. Yorick's is a theoretical outrage, as he rails about the fact that a foreigner who dies in France must bequeath all his possessions to the French monarch; but for the Pennells paying dues on arrival is a reality: '"To pay a shilling tax for the privilege of landing in France", cried J –, fresh from his "Sterne", "by heavens, gentlemen, it is not well done!"'[17] The cyclists are further dismayed on discovering they must pay a partly refundable (if they leave within three months) road tax of fifty francs.[18] Sterne's narrative skips over the 300 km separating Paris from Moulins; Pennell, on the other hand, documents the places they pass through on their way (nonetheless quoting Sterne when the occasion presents itself), and on reaching the Bourbonnais, 'the sweetest part of France',[19] she expresses pleasure that 'for the first time since we had left Paris we could look to Mr. Sterne for guidance'.[20] Yet Sterne's depiction of the abundance of the grape harvest is cited only to stress its lack of similarity with what the Pennells saw, since they passed through before 'the heyday of the vintage'.[21] As Buchanan notes in relation to the Nampont donkey episode, there is a clear sense of anticlimax and disappointment on visiting a place of such literary importance and finding it lacking in significance.[22]

Pennell returns to Sterne's structure for inspiration in the closing pages of her narrative. Mirroring Sterne's tantalising conclusion of the second volume of *A Sentimental Journey* – when Yorick grasps hold of the Fille de Chambre's hand in the darkened bedroom of an inn near the Italian border – Pennell also cuts her narrative short, yet in doing so fails to revive the erotic excitement of Sterne's ending. The

Pennells stay in a hotel in Rives, where in ironic reference to Sterne they are welcomed by an unfriendly 'middle-aged *fille-de-chambre*'[23] and spend a restless night being woken by the other guests. Planning to make an early start, Elizabeth is interrupted in her packing by Joseph, who announces, '"We cannot go on"' and whose explanation for this sudden change of plan gets no further than the closing word '"because – "'.[24] This abrupt ending clearly seeks to imitate the open-ended structure of Sterne's text. Due to the absence of any sexual tension, however, it is a much weaker ending than Sterne's, and leaves the reader feeling puzzled rather than titillated. Indeed, the erotic undercurrent that runs through, and in many ways defines, Sterne's *Journey* is glaringly absent from the married couple's experience. While Pennell often references Sterne's interest in encountering members of the opposite sex (in the preface, for instance, she claims Sterne would like their tandem since 'You would still have a place for "the lady"'[25]), she is unable to imitate the sensuality of her predecessor, whose journey focuses on the romantic experiences he enjoys along the way. Moreover, in Sterne's sexually charged closing scene, he denies his reader 'finality of interpretation, narrative, even of syntax'[26] as part of his wider project of subverting literary conventions and jolting the reader into reacting to his text, as Joseph Chadwick notes. As well as being less sexually charged than Sterne, Pennell has no such ambition, and her adaptation of his memorable conclusion falls flat as a result.

In addition to these structural borrowings, Pennell recycles certain Sternean themes, events or characters in her narrative. For instance, the character of Maria, whom Sterne depicts in both *Tristram Shandy* and *A Sentimental Journey*, makes an appearance in Pennell's text. The Maria episode is an example of the complex intertextual dialogue between Sterne's fictional creations, since she first appears in the earlier novel and is reincarnated in honour of Yorick's passage through the Bourbonnais. As Tim Parnell notes, this episode points to Sterne's flagging inspiration for *Tristram Shandy* and 'is sometimes seen as an advertisement for the later work'.[27] We first encounter Maria in the ninth volume of *Tristram Shandy*, when the hero hears her playing her pipe and is told by his coachman that the beautiful young woman lost her mind after she was unable to marry her lover. It is on reading Shandy's account that Yorick feels moved to seek out the young woman in *A Sentimental Journey*.[28] Similarly, the Pennells, 'having read the story over the night before',[29] keep an eye out for Maria, or more specifically the little bridge at which first Shandy, then Yorick, stopped to speak with her and listen to her playing her pipe. This sequence is perhaps the only occasion on which the

Pennells manage to contribute imaginative energies to reviving an episode from Sterne, and as such come close to the emotionally rich experience of a sentimental traveller. Whereas previous attempts to connect with places that marked Sterne's characters resulted in frustration at not locating the exact place, or disappointment at finding it less moving than expected, here the Pennells enthusiastically imagine each poplar-lined stream they cross as a possible resting-place for Maria. In this manner, paraphrasing Sterne, they 'lingered lovingly in the sweet Bourbonnais', imagining they 'had a dozen times wiped [Maria's] eyes with Mr. Sterne, and felt the most indescribable emotions within us'.[30] Pennell's trademark sarcasm is never far away, however; she claims their intense engagement was 'a serious tax upon sentiment',[31] and states that they were glad to be able to eventually calm their imaginative efforts and ascertain with certainty on entering Moulins that 'there can be no doubt that just here they walked together, her arm within his'.[32] In spite of Pennell's derisive closing comment on sentiment, it seems that the cyclists' active engagement with the site of Maria's appearance, and their contribution of their own imaginative energies to it, transform them momentarily into sentimental travellers, actively seeking out encounters and emotional engagement.

Sentimental Travellers?

Beyond retracing the route taken by Sterne, Yorick, Shandy or all of the above, Pennell claims to be interested in emulating a sentimental *approach* to travel. In his definition of the genre, Leo Braudy argues that: 'the sentimental novel opposes intuition to rationality; disjuncture, episode, and effusion to continuity and plot; artlessness and sincerity to art and literary calculation; and emotional to verbal communication'.[33] If we adopt these criteria, Pennell's text seems in no way sentimental at first glance; her approach to both travel and narrative is much more pragmatic, rational and linear. Buchanan attributes Pennell's failure to espouse Sternean sentiment to 'her desire to keep moving along and her natural tendency towards sarcasm', as well as the incompatibility between sentiment and their modern machine.[34] There is certainly a gulf between the effusive and emotional nature of Sterne's text (and, by extension, the sentimental novel) and the modern, cold-headed approach of the cycling couple. Yet while falling short of penning a sentimental text herself, Pennell nonetheless engages in a compelling dialogue with the sentimental genre.

A great lover of eighteenth-century literature, Pennell seeks to enter into an exchange with Sterne and adopt elements of the sentimental traveller's aesthetic. Pennell claims in the preface that cycling offers a unique means to reconnect with the pace, sensations and emotions of travel in the eighteenth century. She champions her favoured mode of transport against her contemporary John Ruskin, who viewed cycling as too modern and rapid a means of travel. Indeed, Ruskin railed against mechanical aids to locomotion such as the bicycle, and was claimed to have argued that 'nothing in the training of the human mind with the body will ever supersede the appointed God's ways of slow walking and hard working'.[35] Pennell quotes Ruskin's attack on 'bi-, tri-, and 4–5–6 or 7 cycles'[36] in the preface, and again in the narrative,[37] in order to contest such an outlook. From Pennell's point of view, cycling, far from being an excessively rapid means of conveyance, offers a chance to reconnect with the slow pace of travel known in Sterne's century, which, she claims, was 'destroyed on the coming of the railroad'.[38] Pennell expresses the firm conviction that Sterne would have appreciated their chosen vehicle, addressing him directly in the preface where she argues 'in these degenerate days, you, Sir, we are sure, would prefer it to a railway carriage, as little suited to your purposes as to those of Mr Ruskin'.[39] For Pennell, Ruskin is mistaken in lumping cycling together with other modern, mechanised means of transport such as the railway. She shares his belief in the value of slow, contemplative travel, and argues that cycling offers a means to reconnect with a pre-industrial pace of movement. This tendency to focus on the anti-modernity of cycling, and its capacity to help travellers slow down in an era of acceleration, is confirmed in Pennell's critique of those who see cycling only as an opportunity for 'hanging around race-tracks',[40] encouraging her readers to adopt the sober, 'sentimental' rhythms of cycle-touring rather than the frenetic pace of cycle-racing.

Sterne too, in his *A Sentimental Journey*, was actively participating in contemporary debates around the meaning and purpose of travel and travel writing. His narrative defies the conventions of eighteenth-century travel literature, openly mocking works such as Tobias Smollett's *Travels through France and Italy* (1766) and Samuel Sharp's *Letters from Italy* (1766) in order to foreground emotion and human encounter rather than clinical observation. Yet critics have long struggled to define Sterne's book, puzzling over its status as the founding text of a new sentimental genre, or rather a parody of sentimental literature. If, as Judith Frank has argued, 'parody is essential to the very production of the sentimental',[41] it

seems fitting that a nineteenth-century sentimental traveller should, in her turn, parody Sterne's text in order to weave her own.

Indeed, despite its professed intentions, Pennell's narrative is far from adopting the sentimental stance of Sterne's hero Yorick. Where Yorick focuses on the emotions experienced and encounters made during his journey (lingering especially on those with the opposite sex), Pennell adopts the businesslike approach of a nineteenth-century tourist, interested in efficient sightseeing and reaching pre-selected destinations on schedule. She expresses little desire to engage emotionally with the people she encounters, and her attempts to revive Sterne's moving experiences with deceased-donkey owners or beggars fall flat. It is telling that the two books the couple carry on their tricycle are 'our 'Sterne' and our 'Baedecker'.[42] The popular and pragmatic travel guide series published by Baedecker seems to represent the antithesis of Sterne's typically quixotic approach to travel. Pennell's imposture towards Sterne, and perhaps her parody of it, is in attempting to use his amorphous and indefinable text as a travel guide, and in posing as a sentimental traveller while in fact adopting an approach based more on reason than emotion. While Pennell claims to belong to 'the class of Sentimental Travelers, of which [Sterne] must ever be the incomparable head',[43] we are left to wonder in which of the eleven categories of traveller described in *A Sentimental Journey* Sterne himself would have placed the Pennells, or whether he would have thought up a new one for them.[44]

It would be easy to apply Sterne's satire of contemporary travel writers such as Smollett to Pennell herself. In *Tristram Shandy*, Sterne complains of writers who insist on providing tedious descriptions of each place they pass through, noting that: 'I think it very much amiss – that a man cannot go quietly through a town, and let it alone, when it does not meddle with him.'[45] Pennell is aware of this passage – she even paraphrases it in her account of Calais – yet she does not refrain from providing descriptions of people, sights and landscapes here and throughout the journey. Moreover, Pennell's propensity towards grumbling and sarcasm recalls attitudes towards travel that Sterne disapproved of among his contemporaries. Pennell complains frequently, whether it be about cobblestones ('the ruin of a good machine and a better temper'[46]), the French peasantry (she glares at 'the cows, great white stupid creatures going home from pasture, and their drivers stupid as they'[47]), French towns ('Moulins is a stupid town with a very poor hotel'[48]), mechanical failures, the weather, the quality of food and lodging or the cost of things. Her plaintive tone recalls the infamous grumbling of Sterne's contemporary and nemesis Smollett, who

summarised the south of France in the following terms: 'the inns are cold, damp, dark, dismal and dirty; the landlords equally disobliging and rapacious; the servants awkward, sluttish, and slothful; and the postillions lazy, lounging, greedy, and impertinent'.[49] Sterne reacted to the tendency of writers such as Smollett to complain about their travel experiences with the sarcastic comment 'I do not think a journey through France and Italy, provided a man keeps his temper all the way, so bad a thing as some people would make you believe.'[50] Yet Pennell does not always manage to keep her temper, and the result is a narrative that left one contemporary reviewer of Our *Sentimental Journey* asking, in a Sternean vein, 'Is not suffering humanity overburdened with the hardships of travellers who arrive at a full hotel in which madam gives them an improvised shakedown at a slightly higher charge than would be fair for a bed-room?'[51] Despite her best intentions, when faced with the realities of a cycling trip, Pennell fails to be sentimental, and ultimately sounds more like Sterne's enemies than Sterne himself.

Yet the occasional moments of sheer joy experienced in the saddle seem to point to a specific cycle-touring aesthetic that – while distinct from Sterne's sentimental outlook – does suggest that Pennell may have removed herself from a rational, consumerist, Baedecker-carrying approach and been a kindred spirit of Sterne's after all. In the chapter 'With the Wind' Pennell recounts an exhilarating 120-km ride to Lyon, when the intense experience of riding at speed causes the couple to lose geographical and temporal bearings, focusing only on movement and sensation. 'We rode so fast', Pennell describes, 'we only knew we were flying through this beautiful green world'.[52] Joseph exclaims in his joy 'Hang blue china and the eighteenth century, Theocritus and Giotto and Villon, and all the whole lot! A ride like this beats them all hollow!'[53] Despite her husband's disregard for the eighteenth century, Pennell finds a Sternean justification for their euphoria, observing that 'Rest seemed an evil to be shunned. For that afternoon at least we agreed with Mr. Tristram Shandy, that so much of motion was so much of life and so much of joy; – and that to stand still or go on but slowly is death and the devil.'[54] This passage is Sterne's riposte to those (such as Bishop Hall) who disagreed with the principle of going on a Grand Tour.[55] Although it may provide one of Sterne's justifications for travelling, it cannot fairly be said to reflect a sentimental traveller's approach, which is based on digression, meandering and emotional encounter rather than speedy progress. Yet it seems that Yorick's moments of emotional elation when feeling the pulse of a *grisette* or watching a peasant family dance

can be compared to the Pennells' exhilaration when flying through countryside at speed on their tricycle. In both of these states the traveller is focused on and transported by an intense physical experience which permits a closer connection to others or the world around.

To take this comparison a step further, it is interesting to note the mechanical dimension of both the cyclist's movement and that of the sentimental traveller. Alex Wetmore argues that at a time when popular fascination with the automaton was at its peak, the sentimental novel's 'man of feeling draws attention to the porous borders separating human identity and machines in eighteenth-century Britain'.[56] Wetmore argues that 'sentimental novels . . . consistently align men of feeling with mechanistic behaviors strikingly similar to those of automata', insofar as sentimental travellers are moved by mechanistic behaviour (that of the speaking starling in *A Sentimental Journey*, for instance) and react physically to external stimuli (such as with increased heart rate and blushing).[57] In the late nineteenth century, the cyclist was a striking example of the unclear boundaries between man and machine; this human-powered technology extended our natural locomotive capacity while mechanising human movement. This led contemporary journalists, doctors and writers such as H. G. Wells and Alfred Jarry to imagine the uncanny hybrids of man and machine that could result. Perhaps the most famous literary example of this troubling connection between man and machine occurs in a later text, Flann O'Brien's *The Third Policeman* (1967), in which cyclists exchange atoms with their bicycles and gradually come to resemble them.[58] O'Brien's 'Atomic theory' can be likened to a passage from *Tristram Shandy*, in which Sterne describes Uncle Toby's obsession with war fortifications. Although Sterne's concept of a 'hobby-horse' is a figurative one, it is interesting that he chose the same term that would be used to designate one of the world's first two-wheelers (Denis Johnson's 1818 model[59]):

> by means of the heated parts of the rider, which come immediately into contact with the back of the HOBBY-HORSE, – By long journeys and much friction, it so happens that the body of the rider is at length filled as full of HOBBY-HORSICAL matter as it can hold; – so that if you are able to give but a clear description of the nature of the one, you may form a pretty exact notion of the genius and the character of the other.[60]

Sterne uses the image of a rider and a horse to convey the way in which people can become indistinguishable from the inanimate objects of their passion and obsession. Where Sterne imagined a fluid

exchange between human and non-human elements, the 'iron horse' ridden by the Pennells embodied contemporary fear and fascination about human–machine exchanges. Although Pennell was not among the authors who directly explored this in their writing, it is compelling to note the comparison between the mechanistic reactions of a sentimental subject when exposed to certain situations (tears, trembling, blushing, elation), and the exhilaration of the mechanised cyclist moving at speed.

Middle-Class Travellers

In Sterne's time, the difficulty and expense of travel meant that relatively few indulged in the activity. Only the wealthy travelled for pleasure or instruction, while the poor travelled out of necessity, seeking work or sustenance. Yet this state of affairs was gradually changing; according to Judith Frank, *A Sentimental Journey* bears witness to the birth of 'an alternative travelling subject'[61] at a time when the European Grand Tour was becoming accessible to the English middle class. Frank argues that sentimentalism functioned as an ideology that allowed the bourgeois subject to distinguish himself from the lower orders and formulate his own set of codes distinct from those created by and for the aristocracy. From this perspective, Sterne's sentimental traveller's project is seen as 'the spying of the hearts of others in the service of bourgeois self-improvement and self-empowerment'.[62] When read in this light, there are interesting parallels to be drawn between the class dimension explored in Sterne and Pennell's narratives. Although the context of travelling had evolved considerably in the century since Sterne wrote his travel narrative, notably through the multiplication of modes of transport which made travel increasingly accessible to various strata of society, these middle-class travellers were also seeking empowerment and recognition through their novel approach to travel.

In her cycle-touring narratives, Pennell often conveys a sense of feeling like a social pariah. The attention and at times ridicule to which the Pennells are subjected was undoubtedly due to several factors, including the novelty of their form of conveyance, the clothing that went with it, Elizabeth's gender and their status as foreigners in Europe. Pennell complains on arrival in Calais that it 'is a rude world, I think, when the wearer of a cycling suit (even if it be old and worn) cannot go forth to see the town but instantly he is stared at and ridiculed by the townspeople'.[63] While women's cycling dress was the

source of much controversy in this period, Elizabeth did not adopt the 'rational' costume (consisting of bloomers and leggings) that some contemporary women cyclists championed. As Dave Buchanan points out, Pennell kept aloof from the ferment of feminist advocacy going on in late-nineteenth-century London.[64] Unlike some of her contemporaries, she appears not to have associated women's accession to cycling with the demand for suffrage or the clothing reform movement. Pennell does not describe her own cycling garb, but in Joseph's illustrations she is dressed in a full-length skirt and coat. It is Joseph's cycling suit that attracts most attention from passers-by in Calais and at various stages along their route. While her dress is not singled out for ridicule, Elizabeth is subject to occasional remarks from people who are surprised or shocked to see a woman cycling.[65]

The kind of attention and ridicule the Pennells were subject to is partly attributable to the fact that riding a tandem tricycle was an uncommon pursuit in 1885, yet it also points to questions of class. Just as Sterne's narrative contributed to the emergence of a bourgeois traveller, the Pennells took an active part in carving out a new space for the middle-class cycle-tourer. From the beginning of *Our Sentimental Journey*, Pennell does not seek to hide her and her husband's relatively modest means. In her preface, Pennell dismisses the railways as unsentimental, and chaise travel 'a luxury we . . . cannot afford',[66] explaining to the deceased Sterne that 'The only vehicle by which we could follow your wheel-tracks along the old post-roads was our tricycle, an ingenious machine of modern invention.'[67] When they take the train, the Pennells travel third-class,[68] and throughout their journey they stay in simple lodgings, often grumbling about the expense of accommodation, food or repairs. It should be recalled that the initial cost of the tricycle was high, and well beyond the budget of the majority of people.[69] Yet this was an investment for Elizabeth and Joseph, allowing them to make a living as a writer and illustrator respectively. In addition to material concerns, their desire to travel slowly and simply was also motivated by their passion for the nomadic way of life of the Roma people, whom they sought to emulate. In *Our Sentimental Journey*, Elizabeth's introduction of herself as 'a Gipsy come from over the seas' and attempt to speak Romani to a couple sitting by a cart results in a humorous exchange with the perplexed pair, who insist: 'We're not Gipsies . . . we live in Boulogne, and we're busy.'[70] This passion would be the source of inspiration for a later cycling trip to Hungary, recounted in *To Gipsyland* (1893).

The Pennells' material situation and philosophical outlook meant that they did not aspire to travel as aristocrats; rather, they looked

for simplicity and even hardship in their travelling experience. Sterne was a wealthier traveller than the Pennells – employing a valet and distributing alms to the poor along his way – yet he distanced himself from the typical aristocratic traveller by focusing on his encounters with a variety of people, especially those from lower social classes (for instance the *grisette* in Paris, the farming family he dines with, the peasant girl Maria). The Pennells, similarly, did not seek to pose as aristocrats and even conceived of their means of travelling as a form of 'tramping', in common with other 1880s cycle-travel writers such as Thomas Stevens and Charles Edward Reade, as Buchanan notes.[71] Buchanan quotes an article written by Elizabeth in Joseph's voice for the *Century Magazine* in September 1884, in which she complained that some landlords 'do not understand that men and women of leisure and means can find amusement in putting on rough clothes and tramping or wheeling it up hill and dale'.[72] Yet in spite of this desire to travel simply and humbly, in *Our Sentimental Journey* Elizabeth conveys a keen sense of injustice at the difference in treatment they experience on the basis of their perceived class status. This is most vividly conveyed by an episode in Neuchâtel, where the cycling couple are roundly ignored by the staff of their boarding house when a group of upper-class huntsmen and ladies arrives. Elizabeth remarks,

> These were people of quality, it was plain. They had come in a carriage, and a private dressing-room was found for them. But for us, who had arrived on a machine we worked ourselves, a basin was set in the fireplace.[73]

This disparity of treatment continues through the evening, with the hunting party being served a dinner of several courses in a fine dining room, while the Pennells (who had ordered cutlets) are eventually served a simple omelette, in the kitchen. 'Seldom have we felt class distinctions so bitterly', Pennell concludes.[74] Thus, in spite of the Pennells' apparent desire to imitate the practices of marginal figures such as tramps and gypsies, it is clear that they resent being treated as outcasts when in the company of the wealthy.

The particular form of tourism adopted by the Pennells and the narratives they published participate in a wider attempt to carve out a place for cyclists as respectable members of society. Pennell distances herself from cycle-racing in the preface, an activity associated with the working class, and seeks to establish a cycle-touring etiquette that resembles that of other turn-of-the-century literary cycle-tourists such

as F. W. Bockett. In his book on cycle-touring, Bockett makes no secret of his determination to raise cycling to the status of a 'Gentle Art' for 'gentle folk'. He traces the contours of a cycling etiquette, relating to dress, diet and behaviour, formulating certain rules on the 'ethics of coasting' and consistently reminding readers that the cyclist 'is also a gentleman'.[75] His sworn enemy is the speed-crazed cyclist, who is 'a scorcher and not a cyclist, and . . . before long he will be as extinct as the old bone-shaker'.[76] Pennell's disdain for those who prefer 'hanging around race-tracks'[77] is comparable to Bockett's condemnation of scorchers; both professional racing and fast riding were connected with the working class, and these middle-class touring cyclists sought to distance themselves from such associations. Where Sterne sought to articulate a sentimental approach to travel that allowed the bourgeois subject to distinguish himself from both working-class itinerants and aristocratic tourists, Pennell was a key player in helping to define the contours of a middle-class approach to genteel cycle-touring. She sought to foreground the humility of the act of cycling while demanding greater recognition and respect for converts to the wheel from society at large.

Conclusion

The unenthusiastic public response to the Pennell's third cycling narrative can perhaps be attributed to Elizabeth's failure to embrace and revive Sternean sentiment, as Dave Buchanan argues.[78] As we have seen, her tendency towards sarcasm and complaint, her disinterest in establishing emotional connections with those she meets and her rational, linear approach to both travel and narrative exclude her from the class of sentimental travellers. Yet despite its poor contemporary response, Pennell's text has merit to readers today in that it both provides a pioneering account of cycle-travel writing and proposes a compelling dialogue with Sterne's earlier text. The constant background refrain of quotations and paraphrase from Sterne pays tribute to the structure of the latter's fictional creations, which are characterised by a complex intertextuality. Moreover, the moments of sheer visceral joy the Pennells experience on their tricycle may be likened to Sterne's depictions of sentiment; both experiences are rooted in intense corporal sensations, yet entertain uncanny links to the machine. Finally, Pennell, like Sterne, was defending a new and controversial practice in penning her text. While Sterne sought to carve out a place for bourgeois pleasure travellers, Pennell was instrumental

in creating a social and literary space for the new category of cycle-tourists. Both exulted in the democratisation of travel they witnessed and participated in, sharing the conviction that 'so much of motion is so much of life, and so much of joy'.[79]

Notes

1. Pennell and Pennell, *Our Sentimental Journey*, 14.
2. Buchanan, 'Pilgrims on Wheels', 22.
3. See, for instance, reviews of *Our Sentimental Journey* in the *Pall Mall Gazette*, 10 February 1888, and the *Morning Post*, 21 March 1888. The author of the latter plainly states, 'The journey was simply a sketching tour enjoyed by Mr. Joseph Pennell, who drew the pictures, and Mrs. Elizabeth Robins Pennell, who wrote the story.' As Buchanan notes, Elizabeth's diaries make clear her leading role in writing the co-published volumes, and even some articles solely attributed to Joseph (Buchanan, 'Introduction', xxviii–xxx).
4. Watson, *Literary Tourist*, 132.
5. Buchanan, 'Pilgrims on Wheels', 20.
6. See Howes, *Sterne*.
7. Pennell, *Life and Letters*, 1:153.
8. Ibid. 1:154. Although the travel narrative includes no account of their stay in the Alps at the end of this trip, the Pennell archives at the Harry Ransom Center, University of Texas, contain a text by Elizabeth entitled 'A Dinner at the Pension, Villeneuve September 1885', providing a lively portrait of the guests staying there.
9. Parnell, 'Introduction', xxiv.
10. Pennell, *Our Sentimental Journey*, v.
11. Ibid. 15.
12. Ibid. 40–1.
13. Ibid. 117.
14. Ibid. 51.
15. Ibid. xiii.
16. Sterne, *Sentimental Journey*, 3. This utterance is purposefully enigmatic, but certain critics have provided possible explanations of it. Ian Jack claims it refers to the custom of making after-dinner toasts (Jack, 'Introduction', xi) while Martin C. Battestin suggests it may be an allusion to the materialism of certain French philosophers ('Sterne among the *Philosophes*', 27–8.
17. Pennell and Pennell, *Our Sentimental Journey*, 4.
18. Ibid. 7.
19. Sterne, *Sentimental Journey*, 94.
20. Pennell and Pennell, *Our Sentimental Journey*, 205.

21. Ibid. 206.
22. Buchanan, 'Pilgrims on Wheels', 27.
23. Pennell and Pennell, *Our Sentimental Journey*, 266.
24. Ibid. 268.
25. Ibid. xi.
26. Chadwick, 'Infinite Jest', 204.
27. Parnell, 'Introduction', xxi.
28. Sterne, *Sentimental Journey*, 94.
29. Pennell and Pennell, *Our Sentimental Journey*, 207.
30. Ibid. 209.
31. Ibid. 210.
32. Ibid.
33. Braudy, 'Form of the Sentimental Novel', 13.
34. Buchanan, 'Pilgrims on Wheels', 28.
35. 'Tit-Bits of General Information', 399.
36. Pennell and Pennell, *Our Sentimental Journey*, vi.
37. Ibid. 56, 67.
38. Ibid. vi.
39. Ibid. xi.
40. Ibid. vi.
41. Frank, 'A Man who Laughs', 120.
42. Pennell and Pennell, *Our Sentimental Journey*, 2.
43. Ibid. x.
44. Sterne, *Sentimental Journey*, 8–9. Perhaps Sterne would have classed the Pennells as 'Inquisitive Travellers', or 'Proud Travellers'?
45. Sterne, *Tristram Shandy*, 462.
46. Pennell and Pennell, *Our Sentimental Journey*, 30.
47. Ibid. 264.
48. Ibid. 211.
49. Smollett, *Miscellaneous Works*, 5: 562.
50. Sterne, *Tristram Shandy*, 599.
51. Review of *Our Sentimental Journey*, *Morning Post*, 2.
52. Pennell and Pennell, *Our Sentimental Journey*, 231–2.
53. Ibid. 232.
54. Ibid.
55. Sterne, *Tristram Shandy*, 471.
56. Wetmore, 'Sympathy Machines', 52.
57. Ibid. 46.
58. O'Brien, *Third Policeman*, 89.
59. See Herlihy, *Bicycle*, 21–31.
60. Sterne, *Tristram Shandy*, 99.
61. Frank, 'A Man who Laughs', 98.
62. Ibid. 97.
63. Pennell and Pennell, *Our Sentimental Journey*, 8.
64. Buchanan, 'Introduction', xli.

65. Pennell and Pennell, *Our Sentimental Journey*, 264.
66. Ibid. xi.
67. Ibid.
68. Ibid. 2.
69. David Herlihy notes that 'with all its extra hardware, the three-wheeler was even more expensive than a bicycle', at a time when the high-wheeler bicycle cost in the region of $90 (Herlihy, *Bicycle*, 195, 212). An 1885 advertisement for the Humber tandem tricycle ridden by the Pennells lists its price as $260 (Veteran Cycle Club Library).
70. Pennell and Pennell, *Our Sentimental Journey*, 31.
71. Buchanan, 'Cycling and the Picturesque', 71.
72. 'From Coventry to Chester', 647.
73. Pennell and Pennell, *Our Sentimental Journey*, 36.
74. Ibid. 37.
75. Bockett, *Some Literary Landmarks*, 37.
76. Ibid. 5.
77. Pennell and Pennell, *Our Sentimental Journey*, vi.
78. Buchanan, 'Pilgrims on Wheels', 29. On the lukewarm reception of *Our Sentimental Journey*, see reviews in *Morning Post*, 21 March 1888, and *Pall Mall Gazette*, 10 February 1888.
79. Sterne, *Tristram Shandy*, 471.

Bibliography

Battestin, Martin C. 'Sterne among the *Philosophes*: Body and Soul in *A Sentimental Journey*'. *Eighteenth-Century Fiction* 7, 1 (October 1994): 17–36.

Bockett, F. W. *Some Literary Landmarks for Pilgrims on Wheels*. London: J. M. Dent, 1901.

Braudy, Leo. 'The Form of the Sentimental Novel'. *Novel* 7, 1 (1973): 5–13.

Buchanan, Dave. 'Cycling and the Picturesque: Illustrated Cycle-Travel Writing of the 1880s'. *Cycle History* 19 (2008): 67–72.

Buchanan, Dave. 'Introduction'. In *A Canterbury Pilgrimage / An Italian Pilgrimage*, by Elizabeth Robins Pennell and Joseph Pennell, ed. Dave Buchanan, ix–xliii. Edmonton: University of Alberta Press, 2015.

Buchanan, Dave. 'Pilgrims on Wheels: The Pennells, F. W. Bockett, and Literary Cycle-Travels'. In *Culture on Two Wheels: The Bicycle in Literature and Film*, ed. Jeremy Withers and Daniel P. Shea, 19–40. Lincoln: University of Nebraska Press, 2016.

Chadwick, Joseph. 'Infinite Jest: Interpretation in Sterne's *A Sentimental Journey*'. *Eighteenth-Century Studies* 12, 2 (Winter 1978–9): 190–205.

Frank, Judith. '"A Man who Laughs is Never Dangerous": Character and Class in Sterne's *A Sentimental Journey*'. *ELH* 56, 1 (Spring 1989): 97–124.

'From Coventry to Chester on Wheels'. *Century Magazine* 28, 5 (September 1884): 643–55.

Herlihy, David. *Bicycle*. New Haven: Yale University Press, 2004.

Howes, Alan B. *Sterne: A Critical Heritage*. London and Boston: Routledge and K. Paul, 1974.

Jack, Ian. 'Introduction'. In *A Sentimental Journey through France and Italy by Mr. Yorick*, by Laurence Sterne, ed. Ian Jack, vii–xx. Oxford: Oxford University Press, 1968.

O'Brien, Flann. *The Third Policeman*. London: Paladin, 1988.

Parnell, Tim. 'Introduction'. In *A Sentimental Journey and Other Writings*, by Laurence Sterne, ed. Ian Jack and Tim Parnell, vii–xxxiii. Oxford: Oxford University Press, 2003.

Pennell, Elizabeth Robins. *The Life and Letters of Joseph Pennell*. 2 vols. Boston: Little, Brown, 1929.

Pennell, Joseph and Pennell, Elizabeth Robins. *Our Sentimental Journey through France and Italy*. London: Longman, Greens, 1888.

Review of *Our Sentimental Journey*, by Joseph and Elizabeth Robins Pennell. *Morning Post*, 21 March 1888.

Review of *Our Sentimental Journey*, by Joseph and Elizabeth Robins Pennell. *Pall Mall Gazette*, 10 February 1888.

Smollett, Tobias. *The Miscellaneous Works of Tobias Smollett*, M.D. 6 vols., ed. Robert Anderson, M.D. Edinburgh: Stirling and Slade, 1820.

Sterne, Laurence. *The Life and Opinions of Tristram Shandy*, ed. Graham Petrie. London: Penguin, 1967.

Sterne, Laurence. *A Sentimental Journey and Other Writings*, ed. Ian Jack and Tim Parnell. Oxford: Oxford University Press, 2003.

'Tit-Bits of General Information'. *Tit-Bits*, 31 March 1888.

Veteran Cycle Club Library. 'Humber Tandem Tricycle Advertisement 1885'. Accessed 3 November 2018. http://www.veterancycleclublibrary.org.uk.

Watson, Nicola J. *The Literary Tourist: Readers and Places in Romantic & Victorian Britain*. Houndmills: Palgrave Macmillan, 2007.

Wetmore, Alex. 'Sympathy Machines: Men of Feeling and the Automaton'. *Eighteenth-Century Studies* 43, 1 (Fall 2009): 37–54.

Over the Alps in a Bad Mood: Elizabeth Robins Pennell as Contrarian

Dave Buchanan

Over the Alps on a Bicycle (1898), written by Elizabeth Robins Pennell and illustrated by Joseph Pennell, describes the highlights of the couple's five-week, 1,000-kilometre bicycle trip through the French, Swiss and Italian Alps in the summer of 1897.[1] In her biography of her husband, Elizabeth explains the simple rationale behind the trip: 'Our object was to see how many high Alpine passes we could climb on our wheels.'[2] The Alps adventure was also the final phase of an ambitious scheme hatched in 1884: to cycle – in stages, not necessarily in order – from the Pennells' home in London all the way to Rome. The English leg they accomplished first, part of it related in *A Canterbury Pilgrimage* (1885); next came the Italian stretch between Florence and Rome (*An Italian Pilgrimage* (1887)), followed by their crossing of France, recounted in *Our Sentimental Journey through France and Italy* (1888). The Pennells completed all three of those trips on a tandem tricycle. The Alps, however, were the missing link in the Pennells' route and for an obvious reason. Tandem tricycles were heavy machines, and although crossing the Alps on them wasn't impossible, it was certainly a daunting prospect.[3] But by the early 1890s, the Pennells had switched to new, lighter safety bicycles, and with this technological advance, riding over mountains had become a much more manageable, if still arduous, task.[4]

Today, *Over the Alps on a Bicycle* may well be Pennell's best-known cycling book.[5] It continues to be read, reviewed and even used as a guide even though it's been out of hard-copy print for decades.[6] That's probably because the journey it describes is unique in the Pennells' oeuvre of cycling writing. It sets out to

do something extraordinary: ride bicycles over the most famous mountains in the world, something that in 1897 not many people had done, and that, possibly, no woman had ever done.[7] She states on the first page that she was seeking a 'record', by being the first woman to cycle over the Alps. In keeping with the spirit of Alpinism that drew so many to the Alps, being the first – whether to climb on foot or cycle – mattered. However, *Over the Alps on a Bicycle* is, I argue, the most uncharacteristic of Pennell's cycle-travel writing, as it largely defies the modus operandi of the rest of her writing about cycling trips. In her other cycling writing, Pennell employed a successful formula: breezy, literary, keenly observed accounts of leisurely travels.

But the Alps book is different, not only because Pennell, uncharacteristically, seeks a 'record' – a motivation she mocks elsewhere.[8] It is also, by far, her most cynical cycling book. While there's almost always an element of gentle satire in all of her travel writing, as she loves to poke fun at tourists, locals, fellow cyclists, her husband and even herself, there's something sharper in the tone of this book. Elsewhere there's a counterbalancing optimism and appreciation of the small pleasures of travel – the charms not only of new places and people but also of the cycling experience. But in *Over the Alps on a Bicycle*, that balance is out of whack. The tone of the book is almost entirely negative; Pennell's default mode is grumpiness, whether she is describing the scenery, the people or even the cycling in the Alps. There are some exceptions, of course, moments of pleasure and delight here and there amongst the grousing and griping, but, generally, Pennell goes over the Alps in a rotten mood.

She may have had good cause for her general bad-temperedness in Switzerland. The place was crowded with tourists, the service notoriously bad and the cycling incredibly difficult. But my argument is that Elizabeth's crankiness in this book is largely for show, a kind of rhetorical pose; she adopts the persona of an anti-Swiss, anti-tourist cycling contrarian, though she does so in a typically literary way, using a series of texts as foils and inspiration, positioning herself as part of a select crowd of literary co-conspirators in grumpy travel. The result is a contrarian style that's a marked departure from her other cycling writing but still hugely entertaining, in a 'delightfully scathing' way.[9]

In her biography of her husband, Elizabeth explains how she and Joseph pitched the cycling-the-Alps book idea to their publisher,

Unwin, as 'a companion volume of the successful "Canterbury Pilgrimage"',[10] their first book together, published in 1885. This comment, along with other evidence, suggests that the Pennells thought of *Over the Alps* as a kind of closing of the circle, not just on their London-to-Rome adventure but, on their cycle-travel careers, in general. The Pennells were getting older – Joseph was forty when they rode over the Alps, Elizabeth forty-two – and although Elizabeth continued to write magazine pieces about cycling until 1902, their cycling days were numbered. Joseph was increasingly interested in a new darling, motorcycles,[11] and a fall from a motorised tricycle in 1904 made him swear off 'cycles of any kind' for good.[12] The Pennells' 1897 essay 'Twenty Years of Cycling' has a retrospective tone, looking back on their cycling adventures as if they were approaching an end. In this context, *Over the Alps on a Bicycle* is a kind of capstone to Elizabeth's cycle-travel writing career.

Since Pennell herself mentions *Over the Alps on a Bicycle* as a 'companion volume' to *A Canterbury Pilgrimage*, it's worth looking at the stark contrast between the books. These two works, published thirteen years apart, have enough in common to make them appear bookends of sorts: both are slim volumes, describing relatively short cycling trips through well-established tourist areas, written in Elizabeth's trademark wry, literary style and illustrated with Joseph's charming images. However, those superficial similarities aside, the two books couldn't be more different: in how they describe places and people, as well as the act of cycling itself.

The predominant tone of *A Canterbury Pilgrimage* is a literature-inspired optimism and innocence. The Pennells delight in the landscape and people they encounter on their three-day trip from London to Canterbury, through the Kentish countryside. They had only lived in England for a few months. As Pennell writes, '[O]ur enthusiasm was fresh.'[13] Like many North Americans at the time, the Pennells knew rural England primarily through English literature. As a result, they view the landscape through the literary filters of Chaucer, Dickens and Shakespeare – on the watch for traces of pilgrims, David Copperfield and Falstaff. To Pennell, it's an idyllic world: 'golden meadows', 'ease-loving cattle' grazing, and 'hills in the distance [that] seemed to melt into a soft purple mist hanging over them'.[14] The vegetation, the light – it's all a revelation: 'the trees threw soft shadows over the white road, and everywhere the air was sweet with the scent of clematis'.[15] The landscape consists of classic picturesque scenes of windmills, cherry orchards, winding rivers, and scenes of pastoral bliss that recall for Pennell the Greek myths of Daphnis and Menalcas.[16]

Almost all of the people they encounter en route to Canterbury are figures of romance or comedy. The itinerant labourers, gypsies and 'tramps' on the road seem to possess an aura of rustic genuineness: 'poor, honest women', old men smoking pipes, and children frolicking and innocently questioning travellers.[17] Even when Pennell is critical of the people they meet, there's a droll detachment in her voice. Pennell seems amused by these characters, by both how they look and how they talk. She displays a journalistic ear for capturing people's speech patterns. A tramp on the road outside Dartford jokes '"'ere's a lady and gen'leman on a happaratus a-runnin' over us!"'[18] Like all travellers, the Pennells do encounter some mildly annoying figures – such as a grouchy hansom cab driver in London – but these are offered as mildly comic figures.[19] So too are the other cyclists they encounter: 'scorchers' of the 'time-making species', out to set land speed records, are gently mocked for being oblivious to the 'beauty' all around them.[20]

Similarly, the Pennells' experience of actual cycling in southern England is almost entirely positive. Even though they rode a relatively clunky tandem tricycle, Pennell focuses on the positive, revelling in the freedom and independence that cycling allowed. It was, after all, one of their first multi-day cycling trips together, so their excitement is understandable. Going up hills was a chore and sometimes required walking and even pushing the machine, but Pennell treats this all as part of the grand adventure. ('Oh, the hills!', she says, at one point, but the beauty of the countryside distracts her from any discomfort.[21]) Their pace was casual, the sights charming, and the summer air warm and dreamy: 'We rode on with light hearts. An eternity of wheeling through such perfect country and soft sunshine would, we thought, be the true earthly paradise. We were at peace with ourselves and all mankind.'[22]

In *Over the Alps on a Bicycle*, however, the tone is strikingly different, especially when it comes to how Pennell talks about the places and people who form the backdrop to their trip: primarily Switzerland, the Swiss and tourists. The satire in this book is of a different magnitude and a harsher, more cynical, tone than anything she had written previously. Pennell's scathing assessment of everything Swiss – from innkeepers, to merchants, to custom houses, to roads – is relentless. In fact, almost every contemporary reviewer of *Over the Alps on a Bicycle* remarked on this negativity. *The Academy* called her 'a good hater of the Swiss',[23] and *The Spectator* remarked, 'we hope Mrs. Pennell's rides will not deter other tourists'.[24]

Pennell had several beefs with Switzerland, beginning with the country's notorious bureaucracy.[25] From the start, she is irked by the

Figure 4.1 Joseph Pennell, *The Road to the Hospice, Great St. Bernard*, illustration from *Over the Alps on a Bicycle* (1898) by Elizabeth Robins Pennell

entrance tax, whereby 'the thrifty Swiss Government might extract from us eighteen francs for the privilege of coming into the country and spending about 1,800'.[26] As she points out several times, the Swiss government was completely dependent on tourism, yet that same government went out of its way to make it difficult – and expensive – for tourists to enter the country. Later, crossing back into Switzerland from Italy via the Splügen pass, Pennell complains of being detained at the custom house for no good cause, 'kicking our wheels for an hour and a half, for no apparent reason except to make us feel at home in Switzerland again'.[27]

This Swiss tendency to make travel deliberately difficult extended to the road conditions. Pennell notes that after Napoleon oversaw the construction of 'decent' roads, Switzerland had, in the early nineteenth century, a good reputation in this regard. But eighty years on, the roads were 'going to rack and ruin', having been neglected and overused. Again, she chastises the Swiss authorities, who 'would never have had anything worth having but for the foreigner and when they get a decent thing [Napoleon's roads] they do

not know enough to take care of it'.[28] French roads are wonderful, even Italian roads are fine, but the ones in Switzerland are poorly engineered, she claims, and badly maintained.[29]

But what makes Pennell most irritable is the Swiss themselves. Only a couple of pages into the book, she starts with anti-Swiss barbs. Recounting her visit to an inn on the Col de la Faucille, she remarks, 'We were not yet in Switzerland, but the manners of the French in this part of the world were quite Swiss: they had none.'[30] This Oscar-Wilde-worthy punchline is just the beginning of a darkly humorous assault on Swiss character, which targets not just poor manners but also greediness, 'the impetuous beggarly itch to make anything from a penny to a dollar that characterizes every Swiss at home or abroad'.[31] Several times, Pennell accuses the Swiss of squeezing tourists for every last buck, of putting 'a turnstile at the mouth of his gorges'.[32]

Then there are the tourists. Pennell remarks repeatedly on the sheer number of travellers they encounter in Switzerland. She conveys her disgust with these masses through conventional imagery of insect plagues. For instance, Joseph reports that the St Bernard pass is 'swarmed with tourists', as are the San Bernardino and the St Gotthard, while the Rhone Valley is 'infested' with them.[33] Even the top of mountain passes were 'alpenstocked of tourists'.[34] She complains of tourists' noisiness, stupidity (walking down the middle of the road, oblivious to all other road users) and bad manners (at the Simplon hospice, she observed tourists 'eating and drinking like pigs').[35] One reviewer took issue with the intensity of these 'gratuitous gibes at the harmless tourist'.[36]

Even the actual cycling doesn't sound like much fun. Much of each day – sometimes seven hours or more – was spent slogging up mountain roads. On the Furka, it was 'always walking, always pushing'.[37] Muddy conditions on the Tête Noire made cycling impossible. 'I walked, I shoved, and I pushed through the mud and mist.'[38] That day, even the pushing was brutal: 'It was beastly. It would have been easier to carry my machine than to push it.'[39] The first few days of this, especially, make Pennell exasperated. At one point, ascending the Simplon, plodding slowly in the heat and dust, she is 'furious' at being passed on the road by a woman pushing 'a perambulator with a baby in it'.[40]

If climbing mountains on a bicycle was arduous, going down them was downright dangerous. While Pennell describes a couple of 'splendid' descents with 'stunning' views of never-ending coasts, generally she finds the downhills terrifying.[41] The poor road conditions (sand, mud and loose stones), hairpin turns and a range of obstacles on the roads, ranging from livestock (goats, cows), to

the stage-coach diligence, to oblivious tourists on foot, made for a treacherous route.[42] Add in the somewhat primitive braking technology of the bicycles the Pennells were riding (pneumatic brakes and the technique of 'back pedaling'[43]) combined with the steep inclines, and going downhill could be a hazardous ordeal. Just looking down at the 'monstrous serpent' of sharply curved zigzagging roads was 'alarming'.[44] Navigating these descents took so much concentration that Pennell claims to have forgotten that 'there was a view' to see at all.[45] '[T]he machines were about all we could attend to.'[46]

And don't get her started on other cyclists she encounters, almost all of whom she describes negatively: from the fat French cyclist who falls in the mud; to the clownish 'German cycler, in yachting cap' who had tied a wooden plank to his rear wheel as a makeshift braking device; to the 'foolhardy wheelman' bombing down the Simplon in a cloud of dust; and to the Swiss rider she encounters on the first pass, the Col de la Faucille, whom she mocks for his accent.[47] There are a few exceptions, such as the two likeable American women cyclists they meet on the Italian side of the Splügen.[48] But, generally, the other cyclists they meet in the Alps are portrayed as ridiculous figures.

Over the Alps on a Bicycle is dominated by such negativity. So why such a difference in tone between Pennell's first cycling book and her last? It's tempting to chalk this up to the cynicism of being older, to see the late-1890s Pennell as having become jaded about a place she once spoke fondly of, about fellow travellers and about a mode of travel that, in her younger days, she championed as a delightful way to see the world. While it's certainly true that the innocence and optimism of *A Canterbury Pilgrimage* are replaced by cynicism and pessimism in *Over the Alps on a Bicycle*, I argue that it's a mistake to see the latter as the result of Pennell becoming misanthropic and wheel-weary. There's something else going on here.

For one thing, the Pennells' other writing about the very same Switzerland trip contradicts the account in *Over the Alps on a Bicycle*. In the summer of 1897, shortly after returning from their 1,000-kilometre journey, the Pennells mention it in the essay 'Twenty Years of Cycling', published in the *Fortnightly Review* under both of their names. Curiously, the short account given here of their Swiss adventure is entirely positive.

> The Alps are higher [than in Austria], but there is hardly a place in Switzerland to which one cannot cycle with comparative ease. The roads are not only possible, but delightful over all the passes still in use, and almost universally excellent in the valleys and on the lower hills.[49]

Figure 4.2 Joseph Pennell, *Waterfalls on Splügen*, illustration from *Over the Alps on a Bicycle* (1898) by Elizabeth Robins Pennell

Here the Pennells highly recommend cycling in Switzerland. They suggest putting on 'an extra pneumatic brake, which will enable you to descend a pass without paralyzing your arms',[50] but they make no mention at all of the various hazards and annoyances that fill the pages of *Over the Alps on a Bicycle*, published a year later.

So how to account for the discrepancies between these two drastically different versions of the Pennells' cycle-tour in Switzerland? One possibility is that although the *Fortnightly Review* piece is signed by both of them, it is, in fact, primarily Joseph's take on their trip, which differs markedly from Elizabeth's in *Over the Alps on a Bicycle*. But this explanation seems unlikely. Their jointly signed writing is generally a euphemism for *her* writing produced with some collaboration with her husband. And the *Fortnightly* essay has all the trademark qualities of Elizabeth's prose: it's full of literary allusions and rhetorical flourishes – 'For whom now does the dome of St. Peter's float, a misty shadow on the horizon above the swells of the Campagna, but the cycler?'[51] – that are much more consistent with her other writing than his. My theory is that Elizabeth was writing with two very different purposes and audiences in mind. In the *Fortnightly* piece, the

Pennells present themselves as pioneers and veterans of, as well as advocates for, cycle-touring, which means accentuating the positives and downplaying – or omitting – the negatives. In *Over the Alps on a Bicycle*, though, their audience is more literary and the purpose entertainment. To that end, I submit, Elizabeth chooses to adopt, and experiment with, a persona that allows her to approach her trip from a fresh literary perspective.

The adoption of a literary persona is something Pennell tried with great success in her food writing of the 1890s. Her essays which had appeared in the *Pall Mall Gazette* in the column 'The Wares of Autolycus' were written in a voice and style markedly different from anything else she had written up to that point. This food writing features a fiercely confident, over-the-top flair as Pennell expanded her stylistic range. The food writing was such a tremendous hit that a collection of these columns was published as a book, *The Feast of Autolycus*, in 1896. Given the success she experienced using a persona in her food writing especially, it shouldn't be surprising that she chose a similar strategy, though a very different persona, in her book-length account of the Alps trip.

Although Pennell herself was, by all accounts, known for her grace and good manners in the London literary-social scene, she was, throughout her life, drawn to contrarians, both in literature and in life. Her choice of Mary Wollstonecraft as the subject for her first biography is revealing in this regard. Wollstonecraft was a controversial figure, especially in England, for having challenged so many of the prevailing orthodoxies of her day, and although Pennell's biography downplays much of Wollstonecraft's radicalness, there was something about that contrarian aspect that clearly appealed to Pennell. In Pennell's personal life, the most obvious contrarian presence was her husband, Joseph. He was notoriously outspoken and obstinate, frequently getting himself into difficult situations, even feuds, speaking what he deemed the truth, even if it meant social awkwardness or ostracism. Her friend Whistler, too, whom Elizabeth later championed and defended, cultivated a contrarian reputation, relishing in making enemies in the art world. Elizabeth effectively surrounded herself with contrarians of various kinds, so it's no wonder that she would be intrigued by the idea of experimenting with a contrarian persona herself.

Over the Alps on a Bicycle, then, is Pennell's most audacious rhetorical move: the adoption of the persona of a cranky contrarian. But in typical Pennell fashion, she does so in a literary way, rejecting a clichéd tradition of pro-Swiss writing and writers, and instead allying

herself with a cadre of critics and nay-sayers, fellow grumps and grumblers in the literary tradition.

The pro-Switzerland literary tradition emerged in the eighteenth century with a series of idealised depictions that eventually caught the attention of the rest of Europe and beyond. In 1728, the German poet Albrecht von Haller extolled the rustic simplicity and purity of Swiss mountain life, portraying it as an exception to the general corruption of so-called civilised society in the industrialising cities of Europe. This idealistic view of Swiss rusticity slowly built up steam in the following decades and exploded after the publication of Jean-Jacques Rousseau's *Julie, ou le Nouvelle Héloïse* in 1761. Rousseau's love story, set against the mountains and meadows of the Alps, was a literary sensation, which led to one of the earliest known examples of frenzied literary tourism, with pilgrims seeking an 'unspoilt Arcadia in the Swiss mountains'.[52] Thousands flocked to Switzerland to visit the setting of Rousseau's story, some of them purportedly responding to the meadows and vistas with the same kind of emotional intensity as Rousseau's characters.[53] (Pennell makes light of this with her remark that '[a]fter Rousseau set the fashion, people wept over the sublimities of Nature which they could not see for their tears'.[54])

In the Romantic period, the literary mythology of the Swiss Alps deepened, with works by Helen Maria Williams, William and Dorothy Wordsworth, and Lord Byron furthering the 'cult of rusticity' and, in the case of Byron, especially, a romanticised mountain gloominess that drew even more travellers.[55] In the post-Napoleon period, British tourists, in particular, flooded Switzerland, inspired, at least in part, by the work of these poets and other writers. In turn, as Swiss tourism infrastructure – inns, guides, transport – developed in response to demand, a new kind of literature emerged to assist travellers abroad.[56] In 1838, John Murray published the first title in his series of modern travel guidebooks, *Murray's Handbook for Travellers in Switzerland*, which made travel easier still.[57]

Some of these early tourists wrote their own accounts of their visits to the Alps, and while most of these were positive, praising the beauties of the mountain vistas and clean air, we also begin to see some critical commentary, mainly about high prices and poor service. As Bernard explains, 'As early as 1795 a German traveler complained about the large numbers of Swiss who had taken it upon themselves to turn the beauties of Swiss scenery into a quick profit, and English travel journals are full of similar lamentations.'[58] Even the rustic Swiss peasant gained a reputation for 'cut-throat'

money-grubbing, an unfortunate but almost inevitable effect of mass tourism.[59] Henry Matthews, for instance, writing in 1824, put it this way: 'The more one sees of Switzerland, the more one is pleased with the country and the less one is pleased with the inhabitants.'[60] Early editions of *Murray's Handbook* call the Swiss 'deserving of our study and admiration', on the one hand, while warning readers of the 'villainies of [Swiss] waiters and couriers' on the other.[61] English traveller Philip Stanhope, visiting Switzerland in the 1830s, was disappointed by the mercenary attitude of Swiss peasants squeezing tourists for profit, a far cry from 'the simple, virtuous, patriarchal race that their forefathers were'.[62]

Pennell aligns her account with this minority camp of Swiss-sceptical contrarians, and in doing so, positions herself against one of the most influential English advocates for Switzerland: the English art critic John Ruskin. She mentions in the first chapter that she and Joseph were following 'in the footsteps of Ruskin',[63] the writer who, perhaps more than anyone, explained Switzerland to English readers. Born in 1819, Ruskin visited Switzerland twenty-eight times during his life, going there nearly every other year for fifty-five years.[64] As a young man he wrote in his diary that the Alps, along with Venice, were 'the two bournes of Earth' for him, and in his memoir, *Praeterita*, he calls the Swiss Alps 'one of the centres of my life's thought'.[65] He first went there as a young man on a family holiday in 1833, something of a romantic traveller, with idealistic notions of Switzerland informed by the poetry of Wordsworth and the paintings of Turner. He had seen in Samuel Rogers's illustrated poem 'Italy' Turner's renderings of the mountains, but such picturesque images did little to prepare Ruskin for seeing the Alps in person. In *Praeterita*, he recollects how in his first, dramatic sighting, the mountains were

[i]nfinitely beyond all that we had ever thought or dreamed, – the seen walls of lost Eden could not have been more beautiful to us; . . . Thus, in perfect health of life and fire of heart, not wanting to be anything but the boy I was, not wanting to have anything more than I had; knowing of sorrow only just so much as to make life serious to me, not enough to slacken in the least its sinews; and with so much of science mixed with feeling as to make the sight of the Alps not only the revelation of the beauty of the Earth, but the opening of the first page of its volume.[66]

After several more visits, Ruskin would, during the 1840s and 1850s, go on to write about these mountain landscapes in *Modern Painters*,

volumes I and IV, essentially explaining what made them beautiful and terrifying, worth visiting and contemplating. In fact, this work was so influential that it 'stimulated an avalanche of interest in exploring the Alps'.[67] As Douglas Freshfield, President of the Alpine Club from 1893 to 1895, explains,

> Ruskin saw and understood mountains, and taught our generation to understand them in a way no one – none even of those who had been born under their shadows – had even understood before . . . No writer had added so much to our enjoyment of Alpine scenery as Ruskin.[68]

Pennell certainly knew her Ruskin. He was the pre-eminent art critic of the Victorian period, and she makes reference to him and his work four times in *Over the Alps* and frequently in her other writing. But she and her husband had a complicated relationship with Ruskin's work and legacy.[69] As influential as Ruskin's writing was, she was no blind follower of his ideas; in fact, she came to vehemently oppose many of his tenets of art criticism. Elizabeth's account of the Pennells' first mountain ascent, up the Col de la Faucille, both nods to and takes a poke at Ruskin's famously poetic description of his experience on that Col from 1835, when he was sixteen years old, which he claims was a transformative experience that 'opened to me in distinct vision the Holy Land of my future work and true home in this world'.

> And all that [the landscape] rose against and melted into the sky, of mountain and mountain snow; and all that living plain, burning with human gladness – studded with white homes, – a milky way of star-dwellings cast across its sunlit blue.[70]

While Ruskin had been fortunate to get a clear view that day, sixty years later Pennell wasn't so lucky. She explains:

> The road zigzagged down the mountain side, pine forests grew toward heaven, a flat, grey-green streak of country stretched away below, a whitish line filled the distance, and instead of Ruskin's stargirt, glistening white, village-crowned, glacier-bound chain of Alps, were vast cloud banks.[71]

This anti-climactic start to the Pennells' Alpine adventure sets the tone for the rest of the book. Ruskin's magical vista contrasts sharply with Pennell's disappointing non-view view. In fact, this is a running

joke for Pennell. While the big draw of Switzerland is the promise of stunning mountain scenery, she doesn't see much of anything there but clouds. Speaking of Mont Blanc, in particular, she wryly notes that despite visiting the Alps three times, she's never actually seen it for the clouds: 'I began to wonder if, like the Swiss waiter, it had gone abroad to make its fortune.'[72]

Whereas Ruskin wrote about his early visits to the Alps as spiritual revelations, Pennell opts for ironic detachment. Describing her first encounter with another tourist, a 'Swiss from Geneva', also on a bicycle, whom she catches up on the climb, she invokes the poetry of Longfellow's 'Excelsior' only to immediately undercut it.

> He addressed me with what breath was left him almost in the words of Longfellow: not, 'Beware the pine-tree's withered branch; Beware the something avalanche!' but 'Look out fur dem last dree kilometer. He shteep.'[73]

This is Pennell's comic-literary style: allusive but ironic. Her account will be no Ruskinesque spiritual love-in with the peaky landscape. In fact, it will be almost exclusively anti-Ruskinesque.

The only time she mentions Ruskin in an approving way is in reference to his concerns about the unintended effects of tourism in Switzerland. Decades after first visiting the Alps, Ruskin came to worry about the destructive effects of mass tourism in Switzerland. He decried the tourist infection spread, to a large extent, by British travellers like him and his family. The Switzerland that Ruskin loved so intensely was disappearing, 'its beauties and its lessons destroyed by hotels and railways'.[74] Ruskin blamed himself and others like him, lamenting, '[W]e have taught them [the Swiss] all the consuming white leprosy of new hotels and perfumers' shops' and a 'fondness of the modern lust of wealth'.[75] Pennell calls this Ruskin's 'prophesy' – 'that the tourist would ruin the country and the people'.[76]

Overall, though, Ruskin's views serve as a kind of foil to Pennell's take on Switzerland in *Over the Alps on a Bicycle*. And in her contrarian stance, she has some literary allies to help her take on the pro-Swiss mythology of Rousseau and Wordsworth. She opts instead for literary rebels Percy Shelley and Lord Byron, both of whom had complicated relationships with Switzerland and had offered highly critical opinions of the place. Percy Shelley, notorious atheist and anarchist – a contrarian himself – visited Switzerland for an extended tour in 1816 with his partner Mary, on a trip that inspired her novel *Frankenstein* and one of his best-known poems,

'Mont Blanc', which appears in their travel narrative, *History of a Six Weeks' Tour through a part of France, Germany, Switzerland, and Holland* (1817). While Percy Shelley was profoundly influenced by his time in the sublime mountain landscape of the Alps, he had harsh things to say about Swiss hospitality – long before the great explosion of Swiss tourism. The Swiss were, he says, 'a people slow of comprehension and of action', with 'disgusting' manners and 'brutal rudeness'.[77] Pennell quotes Shelley's claim that the Swiss population, like parasites, 'subsisted on the weakness and credulity of travelers as leeches subsist on the sick'.[78]

Pennell's other Romantic poet ally in Swiss-bashing is Lord Byron, who spent time in Switzerland with the Shelleys and used the Alps as the setting for several works, including his dramatic poem *Manfred* and his narrative poem *The Prisoner of Chillon*. Byron was famously moody and difficult, so it's not that surprising that he found Swiss society uninteresting and uncivilised. In the course of a rant about how the 'Swiss do nothing for which there is not a direct return', Pennell quotes the first part of this infamous passage from Byron's letter to Moore, from Ravenna, on 19 September 1821: 'Switzerland is a curst selfish, swinish country of brutes placed in the most romantic region of the world. I never could bear the inhabitants, and still less the English visitors.'[79] Pennell argues that, given this context – her literary wingmen Byron and Shelley having said much worse – her 'absolutely truthful remarks' about Swiss degeneracy are actually quite 'mild'.[80]

But Pennell's models of literary contrarianism aren't all English. As much as Pennell owes to the British Romantics, she's also indebted to a contemporary American tradition of irreverent travellers. David Sloane argues that following the Civil War, a strain of comic scepticism arose in certain kinds of travel writing, displacing a more wholly sentimental one.[81] One example Pennell certainly knew is Mark Twain's *The Innocents Abroad* (1869).[82] Early in his career, Twain adopted in his travel writing a tone that Sloane calls a 'breezy air of literary comedy and social irreverence'.[83] Twain offers a patriotic scepticism that has some parallels in Pennell's travel writing. Take his description of Lake Como. One moment he's describing an idyllic scene of swimming and stargazing to a soundtrack of 'distant laughter, the singing, the soft melody of flutes and guitars that comes floating across the water from pleasuring gondolas'.[84] The next, he's complaining that Como is far inferior to California's Lake Tahoe: Como is small, its water 'dull' compared with 'the wonderful transparence of Lake Tahoe!'[85] (Twain called this daring to knock over sacred cows of foreign culture his 'Vandal Abroad' mood.[86]) Twain's mixture of occasional praise and

irreverent critique of one of the Alps' most famous sights is typical of his approach, at times playing the new-world naïf, at other times the straight-shooting American who dared to tell it like he saw it. Many readers appreciated what Dewey Garzel calls this 'rambunctious Americanness' or what W. D. Howells called the 'delicious impudence' of Twain's commentary.[87]

Pennell is closest to Twain in this regard when she talks about the Americans she encounters in Switzerland. By the 1860s, American travellers had started coming to the Alps in great numbers, taking advantage of recent advances in steamship travel and package tours offered by Thomas Cook and others, which made European travel more affordable and less daunting for residents of the United States.[88] Switzerland had a particular appeal for many Americans, and not just because of its stunning scenery. The Swiss had a reputation for catering to British and American tourists, in particular, offering English-speaking concierges and other American-friendly amenities difficult to find elsewhere in Europe.[89] However, the stereotype of the American tourist in Europe in the late nineteenth century was largely negative, the classic being that of the unrefined, uncultured innocent. (In the 1830s, Charles Sumner described his fellow Americans in Europe as unkempt and uncultured, with their 'dirty shirts – their nasal conversations – their want of manners'.[90] Henry James's assessment was blunter: American travellers were 'vulgar, vulgar, vulgar'.[91])

But in Pennell's contrarian telling, American travellers in the Alps come across in an almost wholly positive light. Pennell was herself American, and though she had lived in London for fourteen years by this time, she still refers to Americans she meets as her 'fellow-countrymen'.[92] And while the Americans she describes meeting in Switzerland do come across as a little uncouth, they are also refreshingly unpretentious. She clearly likes them. When, on the Furka Pass, a man pops onto the road out of nowhere as the Pennells are ascending, the first thing out of his mouth, in a familiar accent, is, '[S]ay! . . . Have you seen my sister?' Pennell melts. 'It was sublime – 7,000 feet – and we felt, with a thrill of patriotism, American.'[93] In fact, of the few entirely pleasant exchanges Pennell has with other tourists on the trip, most involve Americans. In addition to the man who keeps losing his sister on the Furka, there are the two American women cyclists Pennell describes meeting in the Italian leg of their trip, who are spared Pennells' usual savage description;[94] and the only innkeeper she doesn't complain about is the landlady of the inn en route to the Brunig: 'She did not look at us with hungry eyes of calculation, but lavished her attentions out

of pure goodness of heart.' Turns out she had 'lived long enough in America to forget her Swiss manners'.[95]

Interestingly, for a fluent French speaker, Pennell admires the American tourists' insistence on speaking English wherever they go – a quality Americans abroad were often ridiculed for. While the English tourists 'will try to speak a language they do not understand', the American 'always speaks one he does and gets along just as well'.[96] Although Pennell is well aware of the presumptuousness of this claim, she seems to appreciate its boldness nonetheless. In fact, after hearing American tourists speaking English everywhere they go in the Alps, she predicts the inevitable spread of the language, and the significant role of Americans in that proliferation, cheekily referring to English, at one point, as 'our great universal language' and at another as 'the common language of the Alps'.[97]

In fact, it is the polyglot Swiss whom the contrarian Pennell finds annoying. She makes fun of the linguistic predicament of the Swiss, who tended to speak either French, German or Italian depending on the region. Pennell takes a jab at this: 'the Swiss have no language of their own, and are therefore compelled to express themselves with equal clumsiness in three others, as may be discovered in any hotel or cuckoo shop of their country'.[98] Elsewhere she seems to resent the multilingual skills of the Swiss, for example when she meets a Swiss cyclist who converses with her by switching back and forth between German and French. After she ditches him, she says, 'It was a blessing to be rid of this polyglot.'[99]

Pennell's anti-Swiss, pro-American contrarianism has some affinity with Twain's patriotism. He liked to measure foreign sights against familiar American ones (Como versus Tahoe), often finding the American ones superior, no doubt to the horror of Europeans. She, meanwhile, draws attention to linguistic contrasts, finding American monolinguism perversely preferable to European polyglottism. Both claims are irreverent, hyperbolic, out to get a rise and, perhaps, a laugh from readers.

Pennell's contrarianism sets her against the pro-Switzerland literary tradition of Rousseau, Wordsworth and Ruskin, instead allying her with the likes of Shelley, Byron and Twain. But there is one other significant oppositional act in *Over the Alps on a Bicycle*, and it has to do with cycling. In this case, the writer she sets herself up against is none other than herself. The approach to cycling in *Over the Alps on a Bicycle* is an almost complete repudiation of her own cycling ethos articulated in her other books and magazine articles about cycling.

Her other cycling writing positions her firmly as a leisure-touring cyclist, whose aim was aesthetic and physical pleasure, taking in the landscape and interacting with people, stopping to explore cultural points of interest – and not to set records for speed or endurance. In an 1894 essay, for instance, Elizabeth sets out a kind of manifesto of her approach to cycling. In it, she asserts that 'travelling is the chief end of the cycle', not speed, and she laments how some cyclists 'have turned the highway into a race course'.[100] Bicycle-racing and record setting may get all the attention in the press, she observes, but cycle-touring is the real deal, for 'the true function of the cycle is to contribute to the amusements and not the duties of life, and it is in touring that this end is best fulfilled'.[101]

Part of the appeal of cycle-touring, Pennell argues there and elsewhere, is the way it allows one to truly see the world in a way that is different from travelling by any other means. Looking around while pedalling allows for 'the charm of seeing the country in the only way in which it can be seen'.[102] Not beholden to the stopwatch or the main road, the touring cyclist's is 'a journey of discovery through little forgotten villages and lovely farmhouses where the sight-seer is unknown'.[103] Stopping to take in the scenery and ponder the literary legacy of a place is part of the leisure-cycle-touring experience. In her 1889 article 'Outings for Thin Pocket Books', Elizabeth explains:

> If the country is uninteresting, you ride fast and leave it quickly behind; if it is beautiful, you stop altogether and sit for hours perhaps by the way. I shall never forget how we rested on the Hog's Back in Surrey, our tricycle drawn up by the roadside, while we lay stretched under a tree, looking away into the misty distance where we knew was the Isle of Wight, and nearer to the country where Tennyson wandered, and Blake lived, and George Eliot wrote one at least of her novels.[104]

This approach – as well as its opposite – is certainly evident in *A Canterbury Pilgrimage*, for instance, when Elizabeth describes how she and Joseph were taking a break at the side of the road, Joseph sketching a scene, when they were passed by three cyclists 'of the time-making species, for whom the only beauty of the road is that of speed'. She can't help but crack a joke at their expense: 'Looking at them, and then at the sheep in a field beyond, I thought the latter were having the best of it.'[105]

Fifteen years later, though, in *Over the Alps on a Bicycle*, Elizabeth seems to have crossed over to the dark side. Not that she's become a 'scorcher' exactly, but she seems suddenly interested in milestone

accomplishments. The first sentence of the book announces that she is setting out 'deliberately to make a record' and achieve a kind of immortality by being the first woman to climb the Alps on a bicycle.[106] She makes it clear that she's not in Switzerland to see the sights, not even the famous cols, or to interact with the locals, as she's done on previous cycling adventures. This trip is, in the spirit of Alpinism, purely about bagging peaks. In fact, the book is structured around the ten mountain passes the Pennells traversed, a chapter devoted to each one, emphasising that it's the 'records' that really matter. (The book is even dedicated, somewhat cheekily, 'To the Alpine Club, to whom I should like to point out that there is another and more delightful method of climbing'.)

In fact, cycling in the Alps doesn't seem to be about pleasure at all. There are a couple of isolated moments of joy recounted in the book, such as the stunning view of the 'wonder' that is the St Gotthard railway,[107] but, in general, aesthetic concerns are secondary to athletic ones. Elsewhere the Pennells observe that 'the cycler is far more free to make an outdoor picture' than travellers in a carriage or train.[108] But in the Alps book, Pennell doesn't talk much at all about stopping to take in the scenery or make pictures, even though the illustrations in the book suggest that she and Joseph must have taken breaks for sketching. Her narrow focus on the cols, at the expense of the views, defies her own stance of the previous year when she claimed, 'There is no glory to be got from hard work in cycling. You might as well amuse yourself.'[109]

Yet glory seems to be precisely what Pennell is after in the Alps. In this, she's once again defying John Ruskin, who had famously criticised the Alpinist movement which he had, inadvertently, helped create. Ruskin chastised the members of the British Alpine Club who had turned the Swiss Alps into the world's first mountaineering centre:

> [Y]ou have made race-courses of the cathedrals of the earth . . . the Alps themselves, which your own poets used to love so reverently, you look upon as soaped poles in a bear garden, which you set yourselves to climb and slide down again with 'shrieks' of delight.[110]

The pleasure-and-beauty-seeking Pennell of *A Canterbury Pilgrimage* might well have agreed with Ruskin on this point, but instead, on this trip, she actually seems to adopt the mentality of the Alpinists. Being the first woman to get to the top on a bicycle will give her the kind of immortality that Alpinists dream of.[111]

This all sounds so uncharacteristic of Pennell that she can't possibly be serious. Rather, it is the most outrageous component of Pennell's contrarian performance: playing against type – against herself, in fact – adopting, this one time, the role of uber-serious Alpinist-cyclist: the anti-Pennell. When considered in the context of Pennell's other cycling writing, *Over the Alps on a Bicycle* is a total outlier. Both her essay 'Twenty Years of Cycling', published a year before, and the handful of cycle-travel articles Pennell wrote after are consistent with the rest of her cycling writing, espousing the same relaxed leisure-cycling ethos that is the opposite of what we find in *Over the Alps on a Bicycle*. In a 1900 essay 'One Way to See the Paris Exposition', for instance, Pennell writes about the virtues and pleasures of leisure-cycle-travel in much the same way as she did in 1885. Riding a bicycle, she suggests, is the best way to experience and see the sights and take in the culture of Paris. She makes no mention of records. The highlight is, rather, 'those perfect interludes that, every now and then, repay the cycler' for her efforts.[112] Two final cycling articles about trips in Italy, published in 1901 and 1902, are much the same, focusing on how the bicycle allows her to experience the rich literary and artistic milieu of this 'Garden of Eden' – with nary a mention of cycling glory. The Alps book stands alone, a one-time literary experiment in which Pennell engages in the ultimate contrarian gambit: refuting even one's own views.

Near the end of *Over the Alps on a Bicycle*, Pennell feels a need to justify what she's done: 'People may object that I rode too fast. But I had not come out to play the enthusiast and record my emotions on postcards. I had come to ride over the Alps on a bicycle.'[113] The key word in this no-nonsense rationale (emotion is for wimps and amateurs; serious cyclists just do it) is 'play'. It highlights the performative aspect of the whole book – and of so much of her writing about cycling. Pennell may not have been 'playing' the role of leisure-cycle-touring enthusiast here as she usually does, but she *is* playing a role nonetheless. It's just a new one for her: that of the grumpy, head-down, cycling contrarian.

Notes

1. The narrative of the trip appeared first, in condensed form, in an article for the *Century Magazine* in the United States, in April of 1898, and then was published in an expanded book version by T. Fisher Unwin in England later the same year. Thank you to Victoria Throckmorton for her assistance in researching the critical response to Pennell's book.

2. Pennell, *Life and Letters*, 1:317.
3. See, for instance, Marsh, 'First Tricycle Run'.
4. Written accounts of high-wheel-bicycle crossings of the Alps begin to appear in the early 1880s. See, for instance, Parkhurst, 'Bicycle Tour in Tyrol and Switzerland'. Since 1889, American cycle-tour operator Frank Elwell had offered guided safety-bicycle-tours in the Alps. By 1895, such tours had, according to Duncan R. Jamieson, become 'an established feature of summer vacations' in the Alps (*Self-Propelled Voyager*, 98).
5. Most of the time I refer to Elizabeth Robins Pennell by her last name, Pennell, except in contexts where her husband is also mentioned, in which case I use their first names to distinguish between Pennells.
6. See for instance, https://www.podiumcafe.com/2012/12/5/3727160/book-reviews-over-the-alps-on-a-bicycle-1898 and http://www.sheila-hanlon.com/?p=1501. The book has even inspired cyclists to follow the Pennells' route: https://www.crazyguyonabike.com/doc/?doc_id=14661. An ebook reprint of the book was put out by Eltanin in 2014 with a Foreword by Sheila Hanlon.
7. Other women had certainly cycled in the Alps. As Pennell herself noted in 1894, 'Mrs Harold Lewis of Philadelphia, once, with her husband, travelled on a tandem from Calais across France and Switzerland, and over some of the highest Swiss passes' ('Cycling', 263). In the same article, she mentions how 'women have more than once been in the party' led by the American tour operator Frank Elwell through the Alps (263–4). As well, in *Over the Alps on a Bicycle*, Pennell describes meeting another female cyclist crossing the Splügen in the opposite direction, having already crossed the Maloja (58). However, it may well have been true that no woman had crossed all of the passes Pennell did.
8. In her 1894 essay 'Cycling', she claims that record setting on a bicycle is something to which she attaches 'no value', whether by men or women (261–2).
9. The Magpie, 'Chatter', 570.
10. Pennell, *Life and Letters*, 1:320.
11. Ibid. 1:319, 340, 343.
12. Ibid. 2:5.
13. Pennell and Pennell, *A Canterbury Pilgrimage*, 7.
14. Ibid. 13.
15. Ibid.
16. Ibid. 22.
17. Ibid. 11.
18. Ibid. 12.
19. Ibid. 20.
20. Ibid. 22.
21. Ibid. 27.
22. Ibid. 23.

23. 'Mountaineering on Wheels', 8.
24. Review of *Over the Alps*, *The Spectator*, 285.
25. The Pennells had been to Switzerland at least three times before, though never on cycles. They'd written about Switzerland in a *Century* article 'Play and Work in the Alps' in 1891. Elizabeth wrote the play part and Joseph wrote the work part. She begins her piece with a satirical tone, poking fun at the English Alpinists who swarmed to Zermatt, but she ends up being won over by the charms of the Alps: 'I know of no lovelier place to go for a month's holiday' (204).
26. Pennell, *Over the Alps*, 17.
27. Ibid. 65.
28. Ibid. 17.
29. Ibid. 24, 40.
30. Ibid. 14.
31. Ibid. 24.
32. Ibid. 102.
33. Ibid. 32, 67, 77, 35.
34. Ibid. 35.
35. Ibid. 35, 68, 45.
36. Review of *Over the Alps*, *Saturday Review*, 218.
37. Pennell, *Over the Alps*, 90.
38. Ibid. 23.
39. Ibid. 27.
40. Ibid. 40.
41. Ibid. 16.
42. Ibid. 99, 93.
43. In her 1894 essay 'Cycling', Pennell describes how 'Nothing could be more dangerous than to lose control of a machine on a down grade. Some of the most serious accidents have been the result of the rider's letting her cycle run away with her in coasting.' She emphasises the importance of backpedalling, that is, pressing on the pedal 'when it is coming up instead of when it is going down' (257).
44. Pennell, *Over the Alps*, 65.
45. Ibid. 15.
46. Ibid. 17.
47. Ibid. 20, 39, 15.
48. Ibid. 57.
49. Pennell and Pennell, 'Twenty Years', 196.
50. Ibid. 197.
51. Ibid. 191.
52. Rash, 'Early British Travellers', 112.
53. Bernard, *Rush to the Alps*, 19.
54. Pennell, *Over the Alps*, 84.
55. Bernard, *Rush to the Alps*, 88.
56. Heafford, 'Between Grand Tour and Tourism', 28.

57. In *Our Philadelphia*, Pennell recalls reading the letters written by her grandfather who had visited Switzerland as part of his Grand Tour (222). By then, it was a well-established stop on the European circuit.
58. Bernard, *Rush to the Alps*, 90–1.
59. Rash, 'Early British Travellers', 121.
60. Matthews quoted in Bernard, *Rush to the Alps*, 91.
61. Murray quoted in Simmons, 'Introduction', 15–16.
62. Stanhope quoted in Rash, 'Early British Travellers', 121.
63. Pennell, *Over the Alps*, 12.
64. Helsinger, 'Lessons of History', 187.
65. Ruskin, *Praeterita*, 35.156.
66. Ruskin quoted in Hilton, 'Introduction', 26.
67. Hill, 'Perfection, I should call it', 57.
68. Freshfield quoted in Lunn, *Switzerland and the English*, 106.
69. While Ruskin and Pennell seemed to share some ideas about the importance of the picturesque and the aesthetic value of leisurely travel, Ruskin's ridiculing of cycling as an unnatural activity and his infamous feud with the Pennells' friend Whistler raised the ire of the Pennells.
70. Ruskin, *Praeterita*, 150.
71. Pennell, *Over the Alps*, 15–16.
72. Ibid. 18.
73. Ibid. 14. Longfellow's original reads 'Beware the pine-tree's withered branch! / Beware the awful avalanche!'
74. Helsinger, 'Lessons of History', 204.
75. Ruskin quoted in Lunn, *Switzerland and the English*, 110.
76. Pennell, *Over the Alps*, 27.
77. Shelley quoted in Rash, 'Early British Travellers', 130, 118.
78. Pennell, *Over the Alps*, 27. Elizabeth and Joseph were members of the Shelley Society in London, and they knew Sir Percy Florence Shelley, the son of Mary Godwin Shelley and Percy Bysshe Shelley. At one point, the Pennells considered undertaking a literary pilgrimage on the trail of Percy Shelley, at the suggestion of their friend Dr Furnivall, but this project seems not to have gone anywhere (Pennell, 'Diaries', 16 January 1886).
79. Byron quoted in Coolidge, *Swiss Travel*, 62.
80. Pennell, *Over the Alps*, 27.
81. Sloane, 'Afterword', 6.
82. The Pennells and Twain knew of each other and crossed paths a few times. In a letter dated 21 September 1887, Elizabeth writes to Joseph that she met Twain at a dinner at Macmillan's. 'He said he did not know how many times he had been on the point of meeting Mr. and Mrs. Pennell' (Pennell-Whistler Collection, box 305).
83. Sloane, 'Afterword', 5.
84. Twain, *Innocents Abroad*[, 201.

85. Ibid. 204.
86. Sloane, 'Afterword', 4.
87. Garzel and Howells quoted in Sloane, 'Afterword', 15.
88. Bernard, *Rush to the Alps*, 103. Dulles, *Americans Abroad*, 58, 106.
89. Dulles, *Americans Abroad*, 62.
90. Sumner quoted in ibid. 66.
91. James quoted in ibid. 111.
92. Pennell, *Over the Alps*, 24.
93. Ibid. 89.
94. Ibid. 57–8.
95. Ibid. 107.
96. Ibid. 24.
97. Ibid. 53, 89,
98. Ibid. 14.
99. To be fair, it is not only the Swiss of whom Pennell is critical. Her negative commentary extends to the British, Italians and, especially, Germans.
100. Pennell, 'Cycling', 247, 261.
101. Ibid. 264, 265.
102. Ibid. 264.
103. Ibid. 265.
104. Pennell, 'Outings for Thin Pocketbooks', 573.
105. Pennell, *A Canterbury Pilgrimage*, 22.
106. Pennell, *Over the Alps*, 11.
107. Ibid. 77.
108. Pennell and Pennell, 'Twenty Years', 191.
109. Ibid. 197.
110. Ruskin quoted in Lunn, *Switzerland and the English*, 110.
111. Pennell, *Over the Alps*, 11. In her article 'Play and Work in the Alps' published in *Century* in 1891, about her stay in Zermatt, a centre for English Alpinists, Pennell pokes fun at mountain climbers' desire to slog up mountains 'with eyes fixed upon the ground: Where was the pleasure?' (199).
112. Pennell, 'One Way to See', 778.
113. Pennell, *Over the Alps*, 108.

Bibliography

Bernard, Paul P. *Rush to the Alps: The Evolution of Vacationing in Switzerland*. New York: Columbia University Press, 1978.

Coolidge, W. A. B. *Swiss Travel and Swiss Travel Guidebooks*. London: Longmans, Green, 1889.

Dulles, Foster Rhea. *Americans Abroad: Two Centuries of European Travel*. Ann Arbor: University of Michigan, 1964.

Heafford, Michael. 'Between Grand Tour and Tourism: British Travellers to Switzerland in a Period of Transition, 1814–1860'. *Journal of Transport History* 27, 1 (March 2006): 25–47.

Helsinger, Elizabeth. 'Lessons of History: Ruskin's Switzerland'. In *Creditable Warriors: English Literature and the Wider World 1830–1876*, vol. 3, ed. Michael Cotsel, 187–208. Atlantic Highlands, NJ: Ashfield, 1990.

Hill, David. '"Perfection, I should call it": John Ruskin's Personalized Guide to Switzerland, 1843'. *British Art Journal* 13, 1 (Spring/Summer 2012): 54–67.

Hilton, Tim. 'Introduction'. In *Praeterita and Dilecta*, by John Ruskin, ed. Tim Hilton, ix–xxvi. New York: Alfred A. Knopf, 2005.

Jamieson, Duncan R. *The Self-Propelled Voyager: How the Cycle Revolutionized Travel*. Lanham, MD: Rowman & Littlefield, 2015.

Lunn, Arnold. *Switzerland and the English*. London: Eyre and Spottiswoode, 1944.

The Magpie. 'Chatter'. Review of *Over the Alps on a Bicycle*, by Elizabeth Robins Pennell. *Cycling* (25 June 1898): 570.

Marsh, John B. 'The First Tricycle Run Over the Alps'. *Outing* 4, 2 (May 1884): 120–5.

'Mountaineering on Wheels'. Review of *Over the Alps on a Bicycle*, by Elizabeth Robins Pennell. *The Academy* 54 (1898): 8.

Murray, John [and William Brockedon]. *Murray's Handbook for Travellers in Switzerland* [1838]. New York: Humanities Press, 1970.

'Our Editorial Table'. Review of *Over the Alps on a Bicycle*, by Elizabeth Robins Pennell. *The British Journal of Photography* 47, 2102 (1900): 525.

Parkhurst, H. E. 'A Bicycle Tour in Tyrol and Switzerland'. *The Wheelman* 3, 2 (November 1883): 133–8.

Pennell, Elizabeth Robins. 'Cycling'. In *Ladies in the Field: Sketches of Sport*, ed. Lady Greville, 247–65. New York: D. Appleton, 1894.

Pennell, Elizabeth Robins. 'Diaries'. Unpublished. Joseph and Elizabeth R. Pennell Papers, 1832–1951. Harry Ransom Center. University of Texas at Austin.

Pennell, Elizabeth Robins. *The Life and Letters of Joseph Pennell*. 2 vols. Boston: Little, Brown, 1929.

Pennell, Elizabeth Robins. 'One Way to See the Paris Exposition'. *Lippincott's Monthly* 65 (May 1900): 777–83.

Pennell, Elizabeth Robins. *Our Philadelphia*. Philadelphia: Lippincott, 1914.

Pennell, Elizabeth Robins. 'Outings for Thin Pocketbooks'. *The Chautauquan* 9 (July 1889): 571–4.

Pennell, Elizabeth Robins. *Over the Alps on a Bicycle*. London: T. Fisher Unwin, 1898.

Pennell, Elizabeth Robins. *Over the Alps on a Bicycle*, foreword Sheila Hanlon. Kindle edn. Eltanin, 2014.

Pennell, Elizabeth Robins. Pennell-Whistler Collection. Special Collections, Library of Congress, Washington, DC, box 307.

Pennell, Elizabeth Robins and Pennell, Joseph. *A Canterbury Pilgrimage / An Italian Pilgrimage*, ed. Dave Buchanan. Edmonton: University of Alberta Press, 2015.

Pennell, Elizabeth Robins and Pennell, Joseph. 'Play and Work in the Alps'. *Century* 42 (May–October 1891): 194–211.

Pennell, Joseph, and Pennell, Elizabeth Robins. 'Twenty Years of Cycling'. *Fortnightly Review* 68 (o.s.) 62 (n.s.) (August 1897): 188–97.

Rash, Felicity. 'Early British Travellers to Switzerland, 1611–1860'. In *Exercises in Translation: Swiss–British Cultural Interchange*, ed. Joy Charnley and Malcolm Pender, 109–38. Oxford: Peter Lang, 2006.

Review of *Over the Alps on a Bicycle*, by Elizabeth Robins Pennell. *Saturday Review of Politics, Literature, Science and Art* 86 (1898): 218.

Review of *Over the Alps on a Bicycle*, by Elizabeth Robins Pennell. *The Spectator* 81, 3661 (27 August 1898): 285.

Review of *Over the Alps on a Bicycle*, by Elizabeth Robins Pennell. *The Wesleyan-Methodist Magazine* 123 (1900): 952.

Ruskin, John. *Praeterita and Dilecta*, ed. and intro. Tim Hilton. New York: Alfred A. Knopf, 2005.

Simmons, Jack. 'Introduction'. In *Murray's Handbook for Travellers in Switzerland by John Murray [and William Brockedon]* [1838], 9–29. New York: Humanities Press, 1970.

Sloane, David E. E. 'Afterword'. In *The Innocents Abroad* by Mark Twain [1869], ed. Shelley Fisher Fishkin. 1–21. Oxford: Oxford University Press, 1999.

Twain, Mark. *The Innocents Abroad* [1869], ed. Shelley Fisher Fishkin. Oxford: Oxford University Press, 1999.

The Modern Woman as a 'Scholar-Gipsy': Elizabeth Robins Pennell's *To Gipsyland*

Holly A. Laird

To Gipsyland rewrites prior narratives of quest for 'the gypsy's' origins, especially George Borrow's *Lavengro: The Scholar, the Gipsy, the Priest* (1851) and Matthew Arnold's 'The Scholar-Gipsy' (1853), to place a woman narrator at the centre. As popular as the gypsy trope had become as a literary figure earlier in the century, Elizabeth Robins Pennell's strategy has more in common with Borrow's autobiographical persona of 'Lavengro' than with Arnold's unnamed literary protagonist (itself a rewriting of a seventeenth-century tale). Though not particularly successful upon its first publication in 1851, Borrow's narrative became a popular success after its republication in 1881, so it is no surprise to find Borrow receiving prominent mention in Pennell's opening pages.[1] Much as Borrow was captivated by Romani travellers whom he encountered in the English countryside, Pennell was intrigued by the Romani's first wave of migration to the US in the late nineteenth century. She strove to debunk both the negative stereotypes and literary abstractions of 'the gypsy' in a record of her encounters with actual Romani. Yet Pennell had also admired Arnold's writing in her youth,[2] and his literary 'scholar-gypsy' shadows her narrative. *To Gipsyland* does not elude Arnold's literary distancing of the people now called 'the Roma',[3] and whereas Borrow deromanticises the gypsies he encounters, Pennell reproduces Arnold's more conventional depiction of the gypsy as a mysterious race, 'wild' and 'free', though enduring extreme poverty as well as social marginality. She unfortunately also mirrors the eugenic preconceptions of her times in remaining unconscious, to the end, of her own racial stereotyping. Pennell nonetheless distinguishes her narrative from both Arnold's and Borrow's, not only by aspiring to become a scholar-gypsy herself – as a modern woman – but also by

re-envisaging the Romani man she seeks as an inspired artist – a mes-
merising musician.

Arnold's poem – the most famous narrative today of the scholar-
gypsy figure – places any 'real gipsy'[4] at two or three removes, imagin-
ing others and himself in pursuit of a previous Oxford scholar who
sought and, as if never dying, might still be seeking the real gypsies
and their magic; moreover, in lines 31–40, Arnold acknowledges a lit-
erary source for his scholar-gypsy in a tale included in a 1665 treatise
by Joseph Glanvill.[5] Arnold's speaker meets actual gypsies only once,
and his sole question for them is whether they have seen the elusive
'scholar-gypsy'. His scholar-gypsy seeks the gypsies' 'strange arts'[6] –
that is, the magic through which they 'rule as they desired / The work-
ings of men's brains, . . . and bind them to what thoughts they will'.[7]
Like Glanvill's gypsy, both Arnold's speaker and his scholar-gypsy seek
the 'heaven-sent moments' of this magic: 'the spark from heaven . . .
Yes, we await it!'[8] More even than this mental magic, the thought of
the 'scholar-gypsy' himself, 'free', 'hope[ful]' and ever-youthful,[9] mag-
netises the latter-day scholar-poet Arnold, self-reflexively. Ironically,
in yet another gesture of removal, the narrating 'I' urgently warns this
scholar-gypsy to 'fly' from 'contact' with those who seek him.[10] The
scholar-gypsy of his quest must stay invisible to the modern eye if he
is to remain free and uncontaminated by modern un-ease; and the
speaker never sights him. In contrast, Pennell, like Borrow's Lavengro,
seeks the gypsy's freedom for herself. She does this through develop-
ing an intimate relationship to 'the real gipsy'.[11] Their magic for her
resides in the actual, lived art of their music and in their freedom to
embrace their art for its own sake. But, like Arnold, she also continu-
ally distances herself from the gypsy and presents 'the real gypsy' as an
ever-retreating figure of the past.

Pennell's narrative choices reflect nineteenth-century preoccu-
pations with the spiritual and the occult, with philological and
anthropological studies, with democratisation and, towards cen-
tury's end, with aestheticism. In nineteenth-century modernity, the
gypsies' reputed mind-bending magic, to which Arnold alludes,
and their obscure language, which Lavengro endeavours to mas-
ter, made the Roma a rich nexus for both romanticising mythol-
ogy and new knowledge. Pennell acknowledges and, to varying
degrees, follows those avenues. Taking her lead from Borrow, she
becomes a gypsy scholar, studying the gypsies closely, but she stops
well short of becoming the 'philologist' that Lavengro calls him-
self,[12] for she yearns to be a scholar-gypsy. While Pennell and her
husband, the famous artist Joseph Pennell, sought information

directly from the gypsies, observing them closely and subsequently contributing to what was known about them through publication of *To Gipsyland* (including detailed illustrations by Joseph), this quest becomes quite personal for Pennell's persona – as for the scholar-gypsy figure in Arnold's tale. The gypsies' apparent 'freedom' and 'wild' music captivate her. Their music becomes a counter-cultural art, literally enchanting Elizabeth and rivalling with its sublimity and ethereality the modern etching and picturesque writing of Joseph and Elizabeth, respectively, who can produce only the dimmest echoes of such music. Like Arnold, however, Pennell is also plagued throughout by the problem of modernity; dogged by the modern, her aesthetic gypsy's 'reality' proves disenchantingly elusive.

As Deborah Nord notes, nineteenth-century historians and folklorists identify the quest for the original gypsy folk as distinguishing the gypsy narrative from other racial story-lines, including even close relatives such as that of the Jew.[13] When Pennell's narrative reverses the path of Hungarian gypsies' emigration to the eastern US coast, to travel 'back' into Eastern Europe, she raises the critical question of origin. Though rarely referenced by Pennell scholars, *To Gipsyland* also retells Pennell's vexed, personal origin story as a writer and a romantic.[14] But it ultimately exposes such origins as always already lost in time and space, residual myths belonging symptomatically to modernity. Ironically too, Pennell may be best known for the modern sport of bicycling, and it was as a pioneering woman bicyclist that she made her way through Hungary. Joseph Pennell frequently captures the modern spectacle of this late Victorian full-skirted woman with her bike in Hungarian 'gipsyland' in the book's illustrations. As she tracks the 'free' gypsy on a bicycle, Pennell's text also explores the critical question of individual freedom and a democratic culture. But she ends her text, no less ironically, with a rhetorical flourish and a joke directed at herself and her misbegotten quest for the free gypsy. It is with the conjunctions, then, not only of scholar with gypsy, of the New Woman with the pre-modern, manly, indigenous man and his Dionysiac music, but also of modernity with its presumed 'others' that this analysis will be concerned.

Although born and educated in the US, Pennell was drawn to foreign lands and peoples and left America with her husband Joseph shortly after their marriage, to live for the next thirty-three years in London. From London, this scholar-gypsy travelled, first, through the English countryside, then south to France and Italy, north to Scotland's Hebrides and, ultimately, to Hungary, which she saw as

the cradle of 'the gipsy'. Out of these 'sentimental journeys'[15] through time and space, the Pennells jointly produced numerous books, including the travel-romance *To Gipsyland* (1893).[16] Writing this at the age of thirty-seven, with her reputation established as a professional woman, art critic, travel writer and woman cyclist, she looks back at a transformative decade, in her twenties, when her uncle launched her career, in part, by recommending her for a collaboration with Joseph Pennell (on Philadelphia) for the *Century Magazine*. Bored and penned in, after returning home from convent schools in her late teens to a stepmother and her father, she had become disillusioned with prim respectability. She found adventure with her uncle, a world-wide traveller, folklorist and author. Soon after publishing her first book, a pioneering biography of Wollstonecraft in 1884, she married Joseph when she was twenty-nine and he twenty-seven.[17] At thirty years old, her dream of leaving America for London and Europe came true. In *To Gipsyland*, the older narrator relates to that younger self much as the elder narrating Jane Eyre relates to her heroine when apologising for the latter's naivety and emotionalism. It is that younger woman who nonetheless becomes the sympathetic centre of the book and whose credibility enables the gypsy to become a 'reality' for the reader.

Emphasising her youth and, by implication, her relative lack of scholarly sophistication, *To Gipsyland* begins, 'It was from Philadelphia that I first wandered into Gipsyland.' Capturing the voice of her younger 'I' as a bored urban debutant and romantic naïf, Pennell says, 'In those days the town seemed so dull.'[18] She sought 'something new, something strange, something different to give it the touch of romance which I believed it lacked so sadly' – 'romance I thought I found in the gypsies'.[19] Despite this first impression, Pennell's self-effacing gesture is more than counterbalanced in the following chapters which immerse the reader in a blow-by-blow account of her encounters with gypsies. She also complicates this self-portrait by undercutting its 'romance' with phrases like 'I thought I found' and, in her first paragraph, by hinting at her credentials as an amateur folklorist. Pennell tries her skill as an anthropological chronicler by casting Philadelphia into a scenic past with its own quaint customs and costumes:

> Now that I have been many years away, I feel the charm of its prim streets lined with endless red brick, and white marble, and green shutters; the charm of the fine colonial mansions long since forsaken by fashion; the charm of the old churches with their little strip of green grave-yard, of

the quiet meeting-houses overshadowed by great trees where gray-shawled women Friends, their sweet faces looking mildly from plain bonnets, and men Friends, in broad-brimmed hats and plain coats, linger when meeting is out on First-Day morning. I feel it all now until my own city seems lovelier and more picturesque than many a world-famed town.[20]

Pennell makes comparable gestures of self-distancing, framing and ironic juxtaposition throughout her narrative as, gradually, she becomes a gypsy scholar and, more importantly, the closest thing to 'the real gipsy' of her own quest – a 'scholar-gypsy'.

Pennell elaborates her credentials in the second paragraph by introducing her eminent uncle as her mentor, a man so famous she calls him by his nickname first, 'the Rye' (i.e., a Romani man): 'We used to go and see them [the gypsies], the Rye and I.' She proceeds to describe the Rye as a father figure, reputable author and gypsy expert: 'my uncle, Hans Breitmann, Mr. Leland, whom all the Romani know'. In addition to invoking her reputable uncle by nickname, pseudonym and patronymic, Elizabeth places him in an important circle of gypsy folklorists. She then invests the lorists themselves with vulnerability to the romance of the gypsy. Far from being alone in falling under the 'spell' of the gypsies, her uncle and she share this enchantment with, among others, 'Borrow in England' and 'an arch-duke in Austria'.[21] Just three years earlier in 1888 (though Pennell does not mention this), Leland had joined the Archduke Joseph of Austria-Hungary and others to establish the Gypsy Lore Society.[22] When the gypsy is beloved by men as 'wise' as these, Elizabeth asks, 'why should I be ashamed to say that, in the years so long past, the curl of the white smoke among the trees could set my heart to beating?'[23]

The gypsy she seeks inhabits as venerable a position as that of the greatest modern man. Pennell finds a contemporary modern analogue even for the cultural mystique or, when stereotyped, the cult-like secrecy of the Romani: 'these freemasons from the home of strange, secret brotherhoods'. Pennell must literally pass by not only the Academy of Fine Arts and 'the big, pretentious houses of the rich up-town people', but Philadelphia's fortress-like 'Masonic Temple', in order to reach the outskirts of park and meadow where the nomadic Romani family 'the Costelloes' are encamped, pausing on their trek up the east coast for the summer season.[24] These two peoples share the world, in effect producing a co-habitation of the civilised with the nomadic, of the metropolis with its peripheries, of European with Roma cultures. Still, the two remain apart, never merging, as if opposites, paralleling each other in artistic and social

prowess. Pennell yearns for this 'other', in the deeper tale of this book, as if longing for a better, earlier, freer, lost self, only to find herself phobically repelled by the gypsy 'other'. Like George Eliot, as Nord explains, Pennell is drawn to the Romani because they do 'not quite fit in', and like Eliot's protagonists, Pennell 'struggled with the desire for both acceptance and escape': Eliot (and Pennell) 'imagines' them 'marked by physical difference – an un-English swarthiness', thus 'represent[ing] difference and unassimilability'.[25]

When Pennell mentions, in passing, 'the gipsy tramp I like the best' in the present tense, she implicitly becomes a 'gipsy tramp'. 'Follow[ing]' in tempo with the gypsies as the seasons change, the 'tramp' she most enjoys takes her through Philadelphia into New Jersey, in autumn, to visit 'Davy Wharton and the Boswells'.[26] With this tramp, we learn of the gypsies' linkage, not only by comparison or proximity but by direct engagement, with European culture makers – with poets, authors and artists. Turning to the 'stray' American poets, among other worthies, whom she meets along the way, she strikes notes both of democratising informality and of aggrandising name-dropping. This list begins with George (Henry) Boker, whose ironic epithet, Elizabeth adds, is 'Philadelphia's only poet, as he called himself'.[27] Boker, though little known today, was a successful poet and advocate for unionisation during the Civil War, after which he became a US minister to Turkey and then Russia; he had died only two years before this book's publication. After Boker, Elizabeth cites the then-famous publisher George W. Childs and his financier Anthony Joseph Drexel (whom she calls 'Tony' Drexel). 'Between them', Childs and Tony escort the 'inevitable stray prince, or author, or clergyman from England' on their walks. For its finale, her list reserves Walt Whitman – as frequent a traveller in these walks as her uncle and herself. It is Whitman who 'always had a friendly word', not just for her uncle and her, but 'about the travelers who made their autumn home so near his'.[28] Emphasising that juxtaposition – and the neighbourhood – of Whitman with the Boswells, she ends with the following scenic moment:

> I never think of idle Davy Wharton or pretty Susie Boswell, lounging on the sunlit grass, without seeing the familiar figure of the good gray poet, leaning on his stick, his long white beard hiding and showing the loose open shirt, his soft gray felt hat shading the kindly eyes.[29]

Elizabeth eventually believes that glimpses of Roma may be gleaned wherever one walks, not only at the end of a deliberate trek: 'Now and then, in the crowded street, we caught the gleam of a gipsy smile;

now and then, in country walks, we came suddenly upon a tent by the wayside.'[30] While Pennell's gypsies resemble Arnold's scholar-gipsy in being 'seen by rare glimpses', Pennell's 'chance meetings' disclose this figure's paradoxically elusive omnipresence.[31]

Pennell soon offers more detail for the Romani's 'enchantment' beyond being mysterious to their modern followers: she is entranced by

> the life these people led, wandering at will from the pine forests of Maine to the orange groves of the far south; pitching their tents now in blossoming orchard, now under burning maple; sleeping and fiddling and smoking away their days while the rest of the world toiled and labored in misery and hunger.[32]

As much as Borrow and his protagonist, Lavengro, love nature, they associate it with varied peoples, with the Irish and Danes, for example, not exclusively with gypsies.[33] Borrow depicts his gypsies realistically and mildly satirically, as proud of owning horses, for instance, or becoming Romani kings at a young age, and 'shif[ting]' for themselves.[34] In contrast, Pennell's gypsies are free to 'live' however they wish: to 'wander at will'; to inhabit nature at its most vital, 'in blossoming orchard' or 'under burning maple'; and to rest and enjoy themselves as they play their fiddles or smoke their pipes, while 'the rest of the world' 'labor[s]' and 'hunger[s]' under Adam's curse.[35] Pennell appears entirely unconscious of her simplistic re-mythologisation at moments like this.

Her uncle laughs away this impression, however, and Elizabeth's emphasis on the 'unexpected' forecasts the gypsy figure's tenacious distance from the seeking 'I'.[36] As close as she has come to the Roma – as if to equal citizens of the US – they now seem farther away than ever. Her uncle insists one must travel to Hungary to find the live, 'free' gypsy and their art or to experience gypsy 'magic': the Hungarian gypsies he vouches for 'were wilder and freer, and all the strange beauty and poetry of their lives they put into their music when they played. There was magic in it.' It is 'the real gipsy's' 'magic' she seeks rather than a second-hand, modernised version. Another brief encounter in Philadelphia – tellingly, on a Sunday – legitimates her uncle's words when she sees

> three of the wildest, most beautiful creatures I had ever imagined. They were tall and lithe and muscular, and their dark faces, with the small, delicate, regular features, were lovely as those that look out from many an old Florentine picture of Christ and the saints . . . They seemed as out of place in our proper Chestnut street as ghosts at mid-day.[37]

In the era of Carlylean muscular Christianity – the model then upheld for European masculinity[38] – these three Hungarian gypsies' manhood dazzles her. While Pennell herself might be perceived as disturbing femininity by her adventurous cycling, she does not follow the earlier writers described by Nord and Abby Bardi in 'destabilizing' the gypsy figure's 'masculinity'.[39] Yet Pennell's gypsies also seem as unreal and ethereal as 'ghosts'. She perceives them as spiritual beings: the very 'picture of Christ and the saints'. Later, she describes the gypsy teenage boys of sixteen to eighteen as 'these wild creatures of the mountains and the plains' and as 'beautiful as the archangels'. 'The real' gypsies are 'perfect Sebastians', 'wild-eyed prophets'. 'Indeed', she says, 'in more than one, we recognized the Christ of modern canvases'.[40]

A 'crowd of idlers' pesters these men with nosy questions, 'unbearabl[y]', of 'who' and 'what' they are and 'what' they 'are saying' – propelling them to flee. But are these not Pennell's questions? This moment officially marks the start of Elizabeth's insistent pursuit of 'the gypsy' all the way to Hungary: 'This was the beginning of it. After meeting the real gipsy I felt that I never could be content until I had gone to the real gipsy-land – to Hungary.'[41] The 'charm' had gripped her with this glimpse of the 'real gipsy', and like Arnold's 'scholar-gipsy', she will travel far and wide to find the real 'gipsyland'. In the meantime, she inclines to poetry to express her desire for the gypsy's 'natural' freedom, in lines derived from an English translation of poetry by Vassili Alexandri, a Romanian Romani.[42] Four lines become a recurrent refrain in Pennell's text, with only slight variations: 'Free is the bird in the air, / And the fish where the river flows; / Free is the deer in the forest, / And the gipsy wherever he goes.'[43] Functioning in this quatrain like the fourth and final element in the Biblical Creation story, this gypsy joins his proper kindred among bird, fish and deer on a prelapsarian earth. (This bit of Christian re-mythologisation seems, again, presented by Pennell utterly unironically.) Indeed, Pennell no longer believes in the American gypsies she had hitherto sought: in Costelloes and Boswells alike, 'something – I could hardly say what – had gone from them forever'.[44] But, as actually transpires, she will come closer to 'the real gipsy' in Philadelphia than she ever comes in her dreamed-of trip, years later, to their Hungarian homeland.

Even in this dream, however, Pennell is beset by a characteristic conundrum of the late-nineteenth-century aesthete, who was constantly bumping up against the bourgeois, the boring and the inartistic, crowded around the mysterious, the exotic and the beautiful. Thus the opening chapter ends by anticipating this further Philadelphian

gypsy encounter in mixed terms, as Pennell stumbles on the announcement of a Hungarian gypsy band in a newspaper account: they will perform at an uptown German-American beer garden where, she tells us, no respectable Philadelphian of mid-town Chestnut Street should go. To visit would mean not only lowering herself but earning the label of 'fast'.[45] Determining not to be stopped, she claims to go, not for the vision of another gorgeous gypsy, but to experience first-hand her uncle's promise: the gypsies' actual magic, their music.

To a contemporary reader's ear today, however, Pennell registers not only an erotic motivation, but a proclivity for racial and national stereotyping in what follows. Despite her emphasis heretofore on the wild freedom of the music-making gypsy, the question of how to recognise or identify 'the gipsy' appears to hinge, for Elizabeth and her brother Ned, who escorts her to the beer garden, on recognising not a kindred free soul, but racialised signifiers of facial colour and feature. When 'two or three dark men lounged out' from a nearby house, she 'knew them', though they 'wore no sheepskin caps or silver buttons' and 'their hair was uncurled'. She knows them because they are 'darker, swarthier' even than 'Seth Lovell or Davy Wharton', and she can 'see the gipsy in their eyes and their every feature'.[46] (For an incisive critique of the insidiously omnipresent racism in this text, see Bachman-Sanders's chapter in this volume.) The gypsy thus acquires opposite valences for the European gazer and reader of this text – as both masculine paragon and dangerous, 'dark' stereotypical other.

If Pennell is, in turn, to be 'known' to the gypsies, though, she realises – thanks, possibly, to her Uncle Leland's work – that she cannot depend on looking a part. Instead, she must speak Romani to establish rapport with them.[47] *To Gipsyland* owes most to its precursor in *Lavengro* at this juncture. The 'I' of that text – never called 'George' – bears a name given him by the gypsies, and 'Lav-engro' means 'Word Master'.[48] He endows himself with the honorific of 'philologist' and comes to see the Romani language of his friends, rather than the Latin and Greek of his compulsory education, as the gateway to the origin of the European languages.[49] Rediscovering the signs of a Proto-Indo-European language, he becomes enamoured with tracking uncanny coincidences of sound and vocabulary and their variations, and he embraces the Roma's poverty to pursue these linguistic clues. In contrast, Pennell wants only to be accepted as an equal, 'a gipsy sister'; for her, their magic lies not, principally, in their language, but in their music.[50]

Her uncle had told her that 'half the pleasure' of gypsy music happens when they 'play[] for you alone, "into the ear"'.[51] It is to

induce them to play for her alone that she learns their language. An amusing scene ensues when the Roma, Ned and Elizabeth struggle to understand each other's 'Romani', until one gypsy is 'inspire[d]' to count from one to three, accompanied by the appropriate number of fingers.[52] With this little of their abc's established, the Roma break into welcomes and turn their attention to her as they play. She is admitted to 'the fierce passion and unutterable sadness, the love and rage in the voice of violin and cymbal' and to 'all the gipsy beauty, all the gipsy madness I had ever dreamed, and more'. This is the aesthetic sublime, in its contrarious extremes, 'music divine and passionate'.[53]

Meanwhile, Pennell's countervailing disdain for modernity is nowhere more obvious than in her equally racist view of the setting in which she has encountered such sublimity. The background for this music is, in her view, ironically all wrong, with its 'stolid' modern German Americans and their 'evil' smiles and 'dingy beer-garden'.[54] Similarly, looking back at Philadelphia from a verdant park beyond the city, where the Roma have re-established themselves in summertime, she condemns 'the million eyes of Philadelphia's "magnificent mediocrity"', imagined from a distance.[55] In the face of such ugly modern spectacles, as if 'conscious, [she] think[s]', of this 'difference', the 'violins grew more plaintive, fiercer', and 'they could scarce tear themselves from their music', striking 'the last note, again and again', until 'they were whirling in the dance' – lacking only the crazed ravaging of the Bacchae to complete the analogy to the Dionysian.[56] This 'strange', 'unaccustomed' music beats until it breaks into wild rapture. While 'their black eyes glowed, their cheeks aflame, the frenzy seized them', and now they were 'shouting with their violins'.[57] Music is, of course, like her gypsy, elusive, ever-changing, haunting, and almost as suddenly as the climax comes, 'their voices were hushed as the sudden, wild low wail'. The remainders of this 'ecstasy' linger as a 'drunkenness': 'In the end they were as men drunk with music.' In this case, though, irony does not rise to govern the narrative, for the last, traditional Hungarian song and 'summons' that they play, the Rakotzy (a march), functions as a call, not to war, but again to sublimity: '[t]o their feet, they sprang as they fairly beat out of violins and cymbal the fierce, stirring summons of the Rakotzy'. This call to ecstasy stirs desire so intense that she is 'too excited to go to bed' that night.[58]

During these summer evenings – when she is accompanied sometimes by Ned, at other times by the cryptically abbreviated 'J – ' – the Roma wait to play 'only' for her, sit with her, take long walks with her,

escort her part-way home afterwards, and confide their own yearning for their homeland in the 'broad Hungarian plain' and 'wild Karpathian valleys'. One day, her new friend Rudi regrets that just one week remains of their stay in Philadelphia and begs her to return to hear them 'play as they never had before'.[59] When she arrives, the band leader squires her 'with unwonted ceremony' to a table 'they called hers', where his wife waits. Elizabeth 'knows' them 'so well by now that before they spoke I was conscious of their unusual excitement': 'What did it mean?' she wonders, and feels 'uneasy' without being able to 'explain why', wishing she 'had not come'.[60] Rudi's words prove true as 'never before had [she] heard all that violins and cymbals can tell' in this 'entirely Hungarian' music.[61] Wondering momentarily if they had been 'intoxicat[ed]' by their Hungarian wine, she chides herself for the derogatory thought, then finds 'something far more alarming in the solemnity with which the leader filled the glasses' for a toast to her. As they 'cr[y] aloud their *"Servus, viva, eljen"'*, she becomes so 'uneasy' at 'these uncanny sounds' (though 'harmless' ones, as the elder narrative voice remarks) that she 'determine[s] to leave the garden as soon as the gipsies return[] to the band-stand, and not to wait for the last friendly farewell after the Rakotzy['s] . . . dismissal' – repelled by their strangeness.[62]

This pivotal juncture in the typical 'romance' of a female protagonist parallels a proposal in Borrow's text – once Lavengro is on speaking terms with a Roma family – for marriage to a 'sister'. The gypsies' 'mother' loudly rejects this proposal, abandoning her family at the mere suggestion, while Lavengro says nothing at all. Borrow treats the incident as merely an amusing anecdote.[63] In contrast, this is the first, extended interpersonal interaction of *To Gipsyland* and Elizabeth is beseeched not to go by the older woman gypsy, who grabs Elizabeth's hands, while the band's music changes to 'a remonstrance'.[64] In the end, Elizabeth receives a marriage proposal by proxy on behalf of one of the band leader's brothers (which one she never learns). Like the ingenue in a Victorian novel, she had not guessed, or so she confides to the reader: 'This then was what it meant. I had been living my own romance in their music; they had been making one for me.' 'Living' her 'romance' as the narcissistic centre of their collective attention, enchanted by the unnamed fantasies their music provoked, at a stroke, her dream dissolves. With no desire (so she thinks) to be 'romanced' by an actual gypsy, she flees. As Bardi explains, 'projection' of sexual anxieties, or Kristevan 'abjection', is characteristic of nineteenth- and twentieth-century narratives of gypsies.[65] 'Regret' strikes Pennell, but she admits only to anthropological

'curiosity', not 'desire': 'was ever a woman's curiosity put to so cruel a test?' She wonders which of the 'swarthy men' it was.[66] Yet 'desire' of some sort remains, as she cries, 'Never now will I know the lover with whom I might have wandered from land to land, at whose side, under the starlit skies of Hungary, I might forever have listened to gipsy music.'[67]

As her reader knows, however, Pennell does experience all those things. Did she not marry a man (a lover) who accompanied her on her own gypsy excursions: 'J – '? Was he not courting her during these excursions? If so, that further 'romance' with Joseph is not enough to satisfy desire: 'Naturally, from that day forward', she is 'full of a longing for Hungary' – a longing that, we have learned, is as much for 'nature' and 'freedom' as for a specific place.[68] As she never again sees or hears the Hungarians of this life-changing summer, 'longing' becomes an obsession: she 'could not easily have got the gipsies out of [her] head'. The passage that conveys the breadth of that obsession is redolent of girlish fantasy, and the elder Pennell laces it with self-effacing irony:

> Who has not been foolish once, and the better for his folly? I began to dream of Hungary as a sort of earthly paradise, where the real gipsy, with long black hair curling to his shoulder, and silver buttons on his coat, wandered, violin in hand, through the cool wood and over the vine-clad hillside, or sometimes into the towns, above all to Budapest, which in my fancy was an enchanted city of the East, with domes and minarets, with marble terraces and moonlit waters – a Venetian Cairo on the Ganges. It was a trifle romantic and silly, I admit.[69]

Her fantasy of Budapest – the storied, 'enchanted city' of the Orientalism so prevalent in Western literature – reappears to her wittier, older eye as a clichéd and touristic pastiche of increasingly eastward sites, from Italy through Egypt to India. But if, as the opening sentence implies, she has found character-building improvement in youthful folly, she seems no 'better for' her folly; she is more obsessed than ever. Nearly ten years later, this desire remains so strong that she is undertaking the long journey to Hungary, the 'earthly paradise' where 'the real gipsy' with the 'long hair curling to his shoulders' and the violin is to be found, still 'wander[ing]'.

Prior to that trip, some coincidental encounters exacerbate her desire, deepening the divide between 'romance' and herself. She hears from 'J', visiting Paris, that magic had struck again at a venue aptly called 'Eden Theatre':

in the foyer he had heard that low, sweet wailing to which together we had listened many a summer night at the Männerchor, and had seen the Romany faces, the red breeches, and the blue coats. They were very like our friends, and for the sake of old times he had gone up and said 'Latcho divvus Prali!' and they had kissed him, and welcomed him as a brother, and played for him alone.[70]

The music takes Joseph back in memory to the Philadelphian German beer garden, with its 'lights blazing in the shell-shaped bandstand' and 'the cry of "zwei bier"', 'under the withering trees, and the jangling of the street-car bells up Eighth street'. Are those last details Joseph's, or is this Pennell's memory, denigratingly noting the 'withering trees' and the 'jangling of the street-car'? She concludes: 'It' made her 'homesick, as [she] read' his letter, not for the beer garden, but 'for the Hungary I had never seen'.[71]

After comically failing, in chapter three, to pass as Roma during their 'wedding journey' by cart and by foot into the countryside around Philadelphia, then, in chapter four, to do more than glimpse gypsies in the crowds of London or debasingly modernised in social gatherings, the Pennells head for Hungary in chapter five. That fundamentally anti-climactic journey charts a lengthy series of frustrated yearnings in which either they miss their target or it disappoints their hopes. They catch 'the first call' of the Rakotzy 'drowning the church bells, stirring the whole place into life' before they reach Hungary, while they are 'wheel[ing] our bikes into Pirna' in Austria, 'for, as gipsies should, we were travelling by road'. But Pennell fears this may be merely a 'town band' with modern 'top hats and black coats'.[72] When they pass a seemingly authentic camp, they refuse an invitation to stop, distrustful in the 'night that was black'. Reaching Hungary, the gypsies in another camp 'seem free enough to match their song' but again the Pennells ignore it, 'too tired to care who or what they were'.[73]

'A steady process of disenchantment' ensues.[74] On a Danube steamboat, 'a weak, shaky, puny little wail' assaults their ears, and they avoid conversing: 'in Gipsyland ... we were always making excuses not to speak to the Romany'. When they do converse, they find themselves pursued by indigent Romani 'begging for kreutzers'.[75] These 'would have bartered all the freedom of the deer in the forest, if they possessed it, for kreutzers'.[76] Even the Roma in their hotels, who are disappointingly 'correct and commonplace in stiff linen and black coats', ritually pass the plate for money. As for Budapest, 'the newness of the place itself was aggressive'.[77] In one instance, the ritual

encounter becomes 'a hollow mockery all around'. The csardas they play sounds 'screechy'.[78]

Only in glimpses may 'the real gipsy' be found. They catch a musician delivering a genuine serenade when a male gipsy in the audience begins to weep. Then there is Racz Pal, a formidable musician and descendant of a great Romani warrior: 'There was the scent of dried rose-leaves in [his band's] music, the windings of the river in the moonlight, the voice of love' – not the love of a man for a woman, but a plural 'their' 'love' for a fellow gypsy man.[79] But this music leaves Pennell incomplete, feeling that their 'quest' could have been reached 'if only':

> if Racz Pal and the others had only worn curls and silver buttons, and had been playing like that in camp by quiet stream or in lonely woodland, and we had come upon them by chance, our ideal [would have] been realized, our quest over.[80]

She takes comfort in rediscovering the 'real' music while in Budapest, and that music defies conventional modern understanding of the Roma: 'They say the Romanies have no music of their own, but never have I heard a song as strange and savage as the gilli sung by the violins in the moonlight, among the swinging lanterns.'[81] Still, Racz Pal's music sends her thoughts, not forward with new dreams, but back into her youthful past, as she says ironically of herself: 'at times, I had dreamed dreams of Hungary; but now it was in the past I lived. We are young but once.' Without the real gipsy in his native garb and setting, discovered 'by chance', this music is not enough. With that recognition, 'we came to our senses'.[82]

They have not learned their entire lesson of disappointment, however, for they now have to encounter the starkest, most encompassing spectacle of modernity of the book, as they witness the results of Western imperialist conquest. At Racz Pal's advice, in chapter six (the longest of the text), they trek into the Hungarian hinterlands, to and through eastern Transylvania, in search of the '*Romany chals*'.[83] What confronts them here is the near-extinction of the Roma by imperialist domination and modern capitalism. Pennell departs sharply from both Borrow and Arnold in representing modernity in those terms. Vast gypsy troops walk the dusty roads with 'scythes', then wait to be hired for the infantry: the 'picturesque peasant [was] transformed into a commonplace soldier'; 'the air was full of the call of bugles and the hated *recht, links eins* of the Austrian commands'.[84] These 'slaves' live in huts instead of tents due to laws against pitching tents. As for

the women, it is doubtful a girl from Philadelphia would have made such a fuss over the men, as happens here.[85] Every trail ends in failure: 'never were there any gipsies'.[86] The racial hierarchy governing – and her racist understanding of – the gypsies' plight is detailed when, for example, 'the worst'

> was when we met a gipsy with wild sad eyes, and long black curls hanging about his weary, drawn face, bent double under the bags of a Jew in caftan, who walked just behind to see that he did not lag. The sun shone, birds flew over the corn-fields, close by were woods where one could lie sleeping all day in the green shade. But on, in the white dust of the road, in the glaring sunshine, toiled the gipsy at the beck and call of the taskmaster who already holds half the Wallachs in that part of the Karpathians in his power.[87]

When they do want to speak to someone, language also fails them. Pennell continues to think language important, 'as half the secret of their survival as a separate race during all these long ages', and the rural peasants who 'have picked up a few Romany words ... are better gipsy scholars, without knowing it, than the learned Romany Ryes in the town'.[88] But she rarely understands them or can make herself understood due to the innumerable dialects.[89] The farther the Pennells travel, the more they miss. These Roma have no music:

> there was something more than freedom missing from the life of these gipsies, whose beautiful faces and fantastic dress went so far beyond our dreaming. And this something was the music which we had hoped to hear as we wandered over the hills and through the forests.[90]

Late in her narrative, Pennell notes they were also 'always' encountering 'some new, undreamt-of characteristic', as when 'a furious protest came hissing across the room' directed at a gypsy musician who has passed the plate while Joseph is drawing: 'They did not know us; but J – was an artist; they were artists too; that was enough.'[91] After the first two chapters, Pennell has rarely mentioned the 'unexpected'. Yet in her role as travel guide, she has, in fact, continually introduced the non-gypsy-scholar reader to new people, places, customs and bits of Romani language. She has delivered on the promise of this text, neither as a successful quest story, nor as a new bit of mythology or romance, but as a picaresque memoir and a semi-modern travel narrative.

The two most startling of the new bits occur, first, when she draws attention to how far this narrator is from being the young debutante

of her early pages, and, second, when she claims sisterhood with a Roma fortune-teller. Midway through her quest, she reveals herself as the famous 'New Woman' she had become when a renowned Hungarian colonel 'praised me – I blush a little now, remembering it – as the brave sportswoman who had cycled all the way from Calais to Budapest'.[92] The second instance seems all the more surprising after the first – when she pronounces herself a 'witch'. Meeting a 'grisly old hag' bent on 'tell[ing] our fortune', Pennell claims, 'I too am a *bori chovihāni* (a great witch).' Those words instantly, if momentarily, transform her also into a 'friend[]', whom the 'hag' eagerly greets in Romani.[93] But the ideal gypsy of *To Gipsyland* looks the part of an 'archangel' and 'prophet' and is always a man. Rarely described, the women gypsies barely stand out as individuals; still more rarely are the women beautiful (though 'witches' are mentioned only in passing). Thus, Pennell's moment as a witch seems jarring. Does Pennell identify most with a hag-like witch? If so, she possesses no more actual magic than the 'hag'. But their sisterhood passes fleetingly.

That witch contrasts not only with Pennell's glamorising references to the male archangel and prophet gypsies but with the third term in *Lavengro*'s subtitle, *The Scholar, the Gipsy, the Priest*. These three figures in Borrow's work correspond neatly to three prominent characters: Lavengro the scholar, his friend Petulengro the gypsy, and a hated, 'humbug' Roman Catholic who is the priest. Although Borrow declares in a preface that 'these three' do not 'form one', he proceeds:

> Should there be something of the Gypsy manifest in the Scholar, there is certainly nothing of the Priest. With respect to the Gypsy – decidedly the most entertaining character of the three – there is certainly nothing of the Scholar or the Priest in him; and as for the Priest, though there may be something in him both of scholarship and gypsyism, neither the Scholar nor the Gypsy would feel at all flattered by being confounded with him.[94]

Yet while Lavengro is anti-papist, his self-narration immerses us in the Protestant conscience and forward-looking inner thoughts of his persona. So also does the liberal-minded, semi-pagan narrative of Pennell, but only until it is utterly undermined in its conclusions.

Pennell undercuts both herself and her spiritual quest for the gypsy. In seeking to 'see' the Roma both as they are and as, romantically and democratically, she had hoped, Pennell has worked hard to identify intimately with them and thereby reshape derogatory gypsy

stereotypes. In the closing pages, however, a final set of ironic self-removals awaits the reader when Pennell writes that Joseph and she have remained 'at heart such Philistines' that they probably 'missed' the one 'real gipsy' they had encountered: 'perhaps' it was an 'old man fiddling for himself in the broad Burzenland'. If so, 'we had not recognized him until it was too late'. Recalling their enjoyment of Racz Pal's music earlier, she reports 'now' that 'old Racz Pal is dead' and recollects the feeling he had evoked as having 'set[] one dreaming back one's old broken dreams' of youth.[95] The Pennells, she implies, have grown too 'old' for such dreams. As for any democratisation, Pennell cynically equates all the dimensions of the Roma's modernisation with 'degrad[ation]', as they are 'being fast elevated into farmers and labourers, fast degraded into serfs' and 'the musicians send their children to school and talk of their mission and their profession'. 'Our gipsy', she declares, has 'vanished from Hungary forever'.[96]

Pining for her youth, it is the older woman she now derides. Still more ironically, she decides it was in America – which she calls 'home' in concluding – that 'our ideal had been most nearly realized'.[97] Self-reflexively, it is Joseph and she who have been 'free' all this time, not the gypsies:

> It had been at home that our ideal had been most nearly realized. Davy Wharton at the Camden reservoir, Rudi in the Männerchor Garden, Mattie Cooper at Hampton Wick, and not Pongratz of Koloszvar, Goghi of Bestercze, Racz Pal of Budapest, were the tacho Romany chals. But to learn this we have wandered so long and so far, we have seen men everywhere working so hard, that sometimes we wonder if we ourselves are not the only human beings now who are
>> Free as the deer in the forest,
>> As the fish where the river flows,
>> Free as the bird in the air![98]

Although ending with the near repetition of those three verse lines, claiming 'freedom' for all the creatures who live close to nature, this conclusion turns her quest on its head. Only the modern, yearning, Anglo Pennells are, possibly, 'free' in the world, not the Hungarian gypsy. Despite this recognition of the yawning socio-economic gap between the Roma and herself, Pennell still seems oblivious to the role played by her own tourism in the Roma's loss of freedom. When she acknowledges her relative freedom in these lines of poetry, she realises their situation is the opposite of what she had thought and that the Roma have lost something profound, but she thus also

exposes the blind spot in her understanding once again – remaining as distant at the end as Arnold's scholar-gypsy.

Notes

1. Pennell, *To Gipsyland*, 2. Pennell used the word 'gypsy' and its variation 'gipsy', as was customary at the time, to refer to the people we now know as Roma or Romani/Romany.
2. See, for example, Pennell, *Our Philadelphia*, 343–4.
3. Sutherland, *Roma*, 1.
4. Pennell, *To Gipsyland*, 10.
5. Glanvill, *Scepsis Scientifica*, 96–7.
6. Arnold, 'Scholar-Gypsy',' l. 135.
7. Ibid. ll. 45–7.
8. Ibid. ll. 50, 171, 181.
9. Ibid. ll. 211, 213.
10. Ibid. ll. 221, 231.
11. Pennell, *To Gipsyland*, 10.
12. Borrow, *Lavengro*, 79.
13. Nord, *Gypsies*, 7. Although Nord does not discuss Pennell, she tracks parallel themes, particularly the dual mystification and racialisation of the gypsy in nineteenth-century literature. Like Jane Austen in *Emma* and George Eliot in *The Mill on the Floss*, Pennell gradually demystifies the conventional, literary conflation of the mythic with the actual gypsy, and like Eliot in *The Spanish Gipsy* and George Borrow in *Lavengro*, Pennell ultimately supplants the gypsy with the 'alienated writer' herself as the centre of attention (Nord, *Gypsies*, 15–16).
14. Despite the existence of extensive archival collections of the Pennells' gypsy folklore, I have found only one reference in prior literary criticism to *To Gipsyland*: Malpezzi Price, 'Elizabeth Robins Pennell', 15.
15. The Pennells borrowed the title of Laurence Sterne's eighteenth-century narrative *A Sentimental Journey through France and Italy* (1765) for their own travel narrative of France and Italy, published in 1888.
16. *To Gipsyland* appeared serially, first, in three issues of *Century Illustrated Magazine*, from November 1892 to January 1893. Two subsequent book editions, typeset in New York, appeared in 1893: the first produced by the Century Company in New York City, the second by T. Fisher Unwin in London. My thanks go to Mark Samuels Lasner for this information.
17. Linda K. Hughes characterizes this marriage as a 'professional partnership' with the emphasis on the 'profession', in *Graham R.*, 84.
18. Pennell, *To Gispyland*, 1.
19. Ibid. 2.
20. Ibid. 1–2.

21. Ibid. 2.
22. Nord, *Gypsies*, 195 n. 3.
23. Pennell, *To Gipsyland*, 2, 5.
24. Ibid. 5.
25. Nord, *Gypsies*, 99.
26. Pennell, *To Gipsyland*, 6.
27. Ibid. 7.
28. Ibid.
29. Ibid. 7–8.
30. Ibid. 8.
31. Arnold, 'Scholar-Gypsy', l. 54.
32. Pennell, *To Gipsyland*, 8.
33. Borrow, *Lavengro*, 5.
34. Ibid. 121–2.
35. Pennell, *To Gipsyland*, 8.
36. Ibid.
37. Ibid. 9.
38. This ideal was promoted less by Carlyle himself than by his youthful male interpreters: see Putney, *Muscular Christianity*.
39. Bardi, 'Gypsy', 38.
40. Pennell, *To Gipsyland*, 149, 189, 152.
41. Ibid. 10.
42. Pennell herself does not cite a source for these lines; this attribution derives from 'Gypsy Song' in Charles Godfrey Leland's *The Gypsies*, 81–8.
43. Pennell, *To Gipsyland*, 10.
44. Ibid. 10.
45. Ibid. 11. In her studies of the gypsy trope in women's writing, Bardi emphasizes the destabilisation of sexual norms and gender in texts by Austen, Charlotte Brontë and Woolf (Bardi, 'In Company', 40–50). In contrast, Pennell's gypsy is unambiguous in gender, and she continually stops short of destabilising sexual mores.
46. Pennell, *To Gipsyland*, 14.
47. In addition to narrating the importance of language in cultural encounters, Pennell emphasises the cultural difference and integrity of Romani by rarely translating it into English.
48. Borrow, *Lavengro*, 126.
49. Ibid. 95.
50. Pennell, *To Gipsyland*, 15. Although Pennell describes herself as seeking the gypsies' magic, specifically, in their music rather than in their language, an argument can be made for her having found some magic also in their language, for as Dave Buchanan pointed out to me, Joseph and she adopted Roma words in their personal correspondence, almost as a secret code.
51. Ibid.

52. Ibid. 16.
53. Ibid. 17.
54. Ibid.
55. Ibid. 28.
56. Ibid. 29.
57. Ibid. 23.
58. Ibid. 23, 25.
59. Ibid. 30.
60. Ibid. 31–2.
61. Ibid. 32.
62. Ibid. 33.
63. Borrow, *Lavengro*, 127.
64. Pennell, *To Gipsyland*, 34.
65. Bardi, 'Gypsy', 32.
66. Pennell, *To Gipsyland*, 35.
67. Ibid. 36.
68. Ibid. 37.
69. Ibid. This paragraph ends with a teasing allusion to an essay, 'The Lantern-Bearers', by Robert Louis Stevenson, suggesting that modern young men are also susceptible to sexually symbolic, secretive adventures: 'But in our time, we have all, like Stevenson's lantern-bearers, carried our farthing dip, and exulted as if it were a ten-thousand-candle-power electric light' (37).
70. Ibid. 39.
71. Ibid.
72. Ibid. 75.
73. Ibid. 77, 78.
74. Ibid. 84.
75. Ibid. 80.
76. Ibid. 101.
77. Ibid. 83, 86.
78. Ibid. 99, 100.
79. Ibid. 103, 104, 108.
80. Ibid. 109.
81. Ibid. 113.
82. Ibid. 107, 109.
83. Ibid. 110.
84. Ibid. 118, 220.
85. Ibid. 134.
86. Ibid. 160.
87. Ibid. 143.
88. Ibid. 145, 146.
89. Ibid. 176.
90. Ibid. 169–70.
91. Ibid. 231–2.

92. Ibid. 111.
93. Ibid. 190.
94. Borrow, *Lavengro*, n.p.
95. Pennell, *To Gipsyland*, 236, 234, 235.
96. Ibid. 236, 239.
97. Ibid. 239.
98. Ibid. 239–40.

Bibliography

Arnold, Matthew. 'The Scholar-Gypsy'. In *The Poems of Matthew Arnold*, 2nd edn, ed. Kenneth and Miriam Allott. 331–44. London: Longman, 1979.

Bardi, Abby. 'The Gypsy as Trope in Victorian and Modern Literature'. *Romani Studies* (series 5), 16, 1 (2006): 31–42.

Bardi, Abby. '"In Company of a Gipsy": The "Gypsy" as Trope in Woolf and Brontë'. *Critical Survey* 19, 1 (2007): 40–50.

Borrow, George. *Lavengro: The Scholar, the Gipsy, the Priest*. London: Oxford University Press, 1909.

Glanvill, Joseph. *Scepsis Scientifica, or the Vanity of Dogmatizing*. 1885. *Ex-Classics Project* (2011). Accessed 27 January 2011. https://www.exclassics.com/glanvil/glanvil.pdf

Hughes, Linda K. *Graham R.: Rosamund Marriott Watson, Woman of Letters*. Athens: Ohio University Press, 2005.

Leland, Charles Godfrey. *The Gypsies*. Boston: Houghton Mifflin, 1882.

Malpezzi Price, Paola. 'Elizabeth Robins Pennell (1855–1936): Pioneer Bicycle Tourist in Italy, Travel Writer, and Cycling Advocate for Women'. *Lingua Romana* 11, 2 (2013): 4–20.

Nord, Deborah Epstein. *Gypsies and the British Imagination, 1807–1930*. New York: Columbia University Press, 2008.

Pennell, Elizabeth Robins. *Our Philadelphia*. Philadelphia: Lippincott, 1914.

Pennell, Elizabeth Robins. *To Gipsyland*. New York: Century, 1893.

Putney, Clifford. *Muscular Christianity: Manhood and Sports in Protestant America, 1880–1920*. Cambridge, MA: Harvard University Press.

Sutherland, Anne H. *Roma: Modern American Gypsies*. Long Grove, IL: Waveland, 2016.

Elizabeth Robins Pennell's *To Gipsyland*: Intimate Invasions and Nostalgic Longings

Christine Bachman-Sanders

In 1891, Elizabeth Robins Pennell set out with her husband, Joseph Pennell, and her bicycle to search for an authentic embodiment of unconventional freedom: the 'gipsy'.[1] Already a seasoned cycle-tourist and travel writer, Pennell published the travelogue *To Gipsyland* in 1892, an account of perhaps 'the most significant of many pilgrimages for the Pennells' because of the deep sense of kinship both Elizabeth and Joseph felt towards the (romanticised) 'gipsy' existence.[2] The travelogue details her early self-described 'infatuation' with Romani people and culture and culminates in an extensive bicycle and train trip through parts of Austria, Hungary and present-day Romania with the solitary mission of finding 'my real gipsy'.[3]

The text is organised into six sections, with the first four parts dedicated to offering background about Pennell's motivation for travelling in search of the 'real gipsy', and parts five and six providing an account of the eventual trip abroad. She credits her early interest to her uncle, Charles Godfrey Leland, who also wrote extensively about Roma culture. She describes her young adulthood living in Philadelphia, during which she made it her mission to cross paths with the Roma caravans that journeyed between Florida and Maine each year. In addition to these seasonal encounters, Pennell cultivated her appreciation for Romani music at various beer gardens in the less-than-posh neighbourhoods of Philadelphia (she proudly boasts). This exposure to Roma culture and music inspired the Pennells to scheme about joining a passing 'gipsy' caravan for their wedding journey – a plan that did not come to fruition. But their commitment to exploring gipsy culture was not swayed, and some years later, they finally departed for their several-month tour by bicycle to the

origins of the Roma people where the wildest 'gipsies' supposedly still roamed free.[4]

And yet, Pennell's quest is tainted almost from the beginning with bitter disappointment: her 'real gipsy' – an imaginary figure with long hair, traditional costume, violin in hand, and free-spirited – is nowhere to be found, and she mourns the loss of her fantasy, supposedly ruined by a combination of modernity and influences of Western civilisation, spoiled by greed, and enslaved by an enforced lifestyle of rooted labour and servitude. Indeed, Pennell concludes her travelogue with the tongue-in-cheek suggestion that she and her husband may in fact be 'the only human beings now who are Free as the deer in the forest / As the fish where the river flows / Free as the bird in the air!'[5] These closing words imply that the Pennells themselves are the *real gipsies* they have been seeking all along – that they are the representation of unconventional freedom that had so excited and enticed them to travel eastward and towards a fictional past that eschews the material troubles and social expectations of modernity. It is, however, a conclusion that refuses to recognise the role that they themselves have played in creating an exoticised fantasy of Otherness, and in maintaining power relations that keep the East/West binary solidly intact, even as Pennell insists upon her and her husband's unconventionality.

Pennell was clearly inspired to embark upon her cycle-tour by the admiration and connection she felt towards unconventional and nomadic travel. As we shall see, her amateur 'infatuation' with Romani culture and people and her desire to achieve some kind of intimacy and connection with them has the potential to confound traditional methods of knowledge production; and yet, her actions and rhetoric are consumed as expert knowledge and consistently serve to reinforce rather than complicate narratives of Orientalism and white supremacy. Her travelogue, then, serves to advance the steady imperial progress of the modern West, even as the journey itself was designed to escape and reject modernity. Moreover, Pennell fails to recognise her role in this steady imperial progress, mourning the loss of her fantasy without stopping to question her own role in making it happen.

'Hunting After the Real Gipsy'

Pennell's fantasy of the 'real gipsy'[6] is well developed and consistent throughout her text. She is first introduced to the Roma people by her

Uncle Leland, who had long studied Romani culture and language. As a young woman living in Philadelphia, Pennell found in her first encounters with the Roma an exciting newness and 'romance', which her otherwise conventional life in Philadelphia lacked.[7] Reflecting on her early memories of interacting with gipsy caravans along the east coast, she reminisces:

> I thought nothing could be more enchanting than the life these people led, wandering at will from the pine forests of Maine to the orange groves of the far south; pitching their tents now in blossoming orchard, now under burning maple; sleeping and fiddling and smoking away their days while the rest of the world toiled and labored in misery and hunger.[8]

Here, Pennell describes an ideal life of leisure, nomadic travel and connection with nature – a life that is in stark contrast to industry and modernity. Deborah Epstein Nord writes that the 'gipsy' became a popular trope in American and British literature and popular culture, 'easily absorbed into pastoral imagery as citizens of a green and better world'.[9] The 'gipsy' as an idea representing unconventional freedom from social and economic expectations was 'a trope for nonproductive work, refusal of ambitions, and the delicacy and softness – the implied effeminacy – of the unsalaried and unharnessed male'.[10] A useful trope, the 'gipsy' became 'an object of fascination' for the British Gypsy Lore Society, and more generally to writers, historians, reformers, investigative journalists, anthropologists and others eager to 'stud[y] the relationship between the primitive – so-called – and the modern'.[11] Both Pennells and Leland were part of this community of eager students – and masters – of Romani culture, language and movement. Like so many others, they found in the 'gipsy' idea 'dreams of escaping from stifling respectability'.[12]

Pennell found escape at the less-than-reputable beer gardens and outdoor cafés in Philadelphia where the Roma played music. She describes the intense connection she felt with the Roma musicians when she first heard them play a 'Czárdás': 'I only felt – felt the fierce passion and unutterable sadness, the love and rage in the voice of violin and cymbal. In it was all the gipsy beauty, all the gipsy madness I had ever dreamed and more.'[13] But, according to Leland, the 'Hungarian gipsies . . . were wilder and freer, and all the strange beauty and poetry of their lives they put into their music when they played. There was magic in it.'[14] Thus was the desire to travel to 'the real gipsyland' first planted in Pennell's imagination.[15]

Upon her arrival in Hungary a decade later, Pennell searched in vain for the physical representation of her fantasy. Based on her

experience with the Roma musicians in Philadelphia, she imagines her 'real gipsy' with

> long black hair curling to his shoulder, and silver buttons on his coat, [as he] wandered, violin in hand, through the cool wood and over the vine-clad hillside, or sometimes into towns, above all to Budapest which in [her] fancy was an enchanted city of the East, with domes and minarets, with marble terraces and moonlit waters.[16]

This ideal image of the gipsy was so firmly established that Pennell consistently dismissed any person who failed to satisfy each and every requirement of this supposed authenticity. Thus, throughout her entire cycle-tour 'hunting after the real gipsy', she found him only once, 'by the roadside, in the middle of the plain . . . sitting in the grass, playing on his violin . . . to the sun and to the birds and to himself'.[17]

The gipsy's apparent objective of pure pleasure – without payment – is what most set him apart from his inauthentic counterparts in the cities and tents the Pennells visited, endlessly seeking compensation. Indeed, according to Pennell, he was 'the only man in all that broad plain . . . who was idle and heedless of to-day and the morrow!'[18] For Pennell, idleness is strongly associated with pleasure and with a simpler, natural kind of freedom, whereas begging or playing music in exchange for monetary compensation betrays the 'degradation' by modernity of the 'real gipsy'.[19]

Most of the Roma people the Pennells encounter are dismissed as inauthentic due to their participation in some form of economic exchange. For example, at the first hotel they visit in Budapest in search of the 'real gipsy' the Pennells are met with a 'gipsy' band. But from the very beginning, they are disappointed by what Pennell identifies as the inauthenticity of this group of musicians. In contrast to the passion she felt for the Roma musicians in the beer gardens of Philadelphia, she describes the band at this tourist hotel standing 'correct and commonplace in stiff linen and black coats, the leader with his violin facing the audience as he stood grinning as if in bored resignation'.[20] Upon playing a set, the group fan out into the audience to collect tips from the guests. This, above all else, disgusts Pennell, as she incredulously describes the scene:

> Eagerly they bent over as [one musician] counted the money and laid it to one side. Then on the empty plate he put one gulden note – about fifty cents – as a decoy, and stepping down, he passed from table to table, smiling and bowing, actually begging! The real gipsy, who calls no man master, who plays but for his own delight, begging in the *boro ketchema* of the *gorgio!*[21]

Here, Pennell expresses outrage at the desecration of the authentic 'gipsy' as a common beggar. Holly Laird, in this collection, argues that Pennell's text uniquely points to 'imperialist domination and modern capitalism' as important contributors to the 'near-extinction of the Roma'. It is true that Pennell describes here and elsewhere the effects of imperialism and capitalism upon the Roma, but I also see evidence in her text of deep disappointment in the Roma for failing to perform 'gipsy' authenticity. Pennell's outrage is directed at the musicians themselves, and not at the tourists, hotel managers or larger structural realities of tourism, imperialism and capitalism. In fact, when one musician approached her table, she recounts:

> instead of a rapturous Romany greeting, we gave him a twenty-kreutzer piece. I almost wished he would throw it back in our faces: but he did not; he bowed and smiled superciliously as the coin fell silently on the pile of notes. The collection over, they played again, but there was no magic in music bought for a few kreutzers. It was dull and lifeless.[22]

Pennell's revulsion at the arrogant yet obsequious behaviour of the musicians led to an insulting tip, and to refraining from offering a Romani greeting, thereby refusing an opportunity for connection. She sought no connection with people whom she had decided did not match her ideal of 'real gipsy' authenticity. Perhaps the economic component reminded her of her class privilege and identified her too closely with the '*gorgios*', or non-gipsies, from whom she consistently attempted to distance herself. Ironically, the Pennells were not strangers to working their craft – writing and illustration – to fuel their passion for travel. Yet ultimately, labour, whether in the form of musicians collecting tips at a high-end hotel, or peasants farming the land, bore the taint of modernity and therefore remained antithetical to the kind of pleasure, freedom, romantic idleness and primitive simplicity that Pennell required of her 'real gipsy'.

This requirement of a certain kind of idle pleasure is also associated with the racialised wildness that Pennell identifies as signs of gipsy authenticity. The language Pennell uses throughout her travelogue to describe the 'strange' people she encounters on her journey is highly racialised. For Pennell, the image of the 'real gipsy' is associated with the exotic strangeness of the East, 'where men wear impossible costumes' and where 'the crowd suggested nothing so much as an illustrated ethnological catalogue'.[23] She frequently describes the Roma she meets (and imagines) as 'wild', 'savage' 'creatures'. The colour of their skin is 'dark' – the 'darker and wilder' the more likely that they might

approach Pennell's ideal. The images of dark, semi-naked 'savages' remind Pennell of the most exotic Other – the African. On one memorable 'gipsy-hunting' excursion in Hungary, Pennell describes coming across a gipsy encampment where 'an old brown witch' sat near 'three boys . . . brown and naked, like little imps of darkness', and

> a young man in a pair of wide drawers, but stripped to the waist, as coal-black as a negro. It was a family party an explorer would not have been surprised to find in Africa. They were far wilder than any gipsies we had ever met upon the roads at home.[24]

Although Pennell's tone communicates desire rather than disgust at her 'discovery' of these 'imps of darkness', her language, its meaning and its impact nevertheless reinforce logics of white supremacy.

This kind of highly racialised language and the associations between 'darkness' and 'savagery' were familiar to white Americans like Pennell during this period. For example, Louise Michele Newman attests that 'white visitors to the Chicago Exposition [in 1893] were acutely sensitive to this discourse of racial exoticism that linked blackness with primitivism and used such moments to define and position themselves in relation to primitive peoples'.[25] Nord suggests that, like white Americans of this period, 'Europeans favored the notion of Gypsy homogeneity because it reassured them about their own distinctness and national or "racial" integrity.'[26] Throughout Pennell's text, we see examples of how she engages in essentialised representations of a racially distinct and homogeneous 'gipsy' to signal her difference from the people she 'hunts'. However, Pennell, like her lorist contemporaries, makes it clear through her use of tone and language that this difference is attractive, rather than repellent.

In fact, Nord argues, 'The Gypsy lorists' fascination with [Gypsy] authenticity . . . led them to fetishize a notion of racial purity and to romanticize the primitive.'[27] It may, therefore, be helpful to understand Pennell's desire for her 'real gipsy' as a form of fetishism. Stuart Hall clarifies the ways in which racialised representations of the Other become fetishised, and, therefore, make it possible for 'a double focus to be maintained'.[28] This 'double focus' allows an object to be both desired and despised; in fact, 'What is declared to be different, hideous, "primitive", deformed, is at the same time being obsessively enjoyed and lingered over *because* it is strange, "different"', exotic.'[29] Pennell's obsessive enjoyment of the Roma should theoretically indicate to her readers her own unconventional

positioning in relation to dominant narratives of modernity, white supremacy and imperialism.

And indeed, Pennell offers numerous examples of how she and her husband Joseph were uninterested in upholding conventional class expectations that she associates with modernity and Western civilisation, favouring instead (an imagined) freedom from convention as embodied by the nomadic gipsy traveller. For example, when the Pennells decided to marry, they planned to join a gipsy caravan outside of Philadelphia for their wedding journey. Rejecting the expectations of their class and race, the Pennells delighted in their unusual 'bridal finery' consisting of 'old clothes, disreputable hats, bright bandana handkerchiefs, flaring neckties'.[30] Clothes, of course, are an important, though unreliable 'marker of class and sexual identities', allowing here for the Pennells to 'cast off . . . the constraints though not the privileges of their social status'.[31] In this section of her text, Pennell uses humour and irony to distance herself from the majority: 'Our freedom would begin where that of most men and women ceases. We too should become free as the bird in the air, as the deer in the forest, for we would follow the gipsy wherever he goes.'[32] Of course, their attempts to 'follow the gipsy wherever he goes' were met with one obstacle after another, from rain to the inability to actually track down the caravan they had hoped to meet. So, raising their umbrella, 'one of our concessions to civilization', Pennell recounts with a weak attempt at humour, 'we have our wish. No one could call this a conventional way of making a wedding-journey!'[33] This image of the newly wed couple, soaking and abandoned, is nevertheless one that Pennell recalls with pride. She tells this story early in her travelogue to signal to the reader that she is committed to defying convention – with a few 'concessions to civilization' perhaps thrown in.

It may at first appear as though Pennell was flouting expectations of whiteness and modern civilisation; Laird acknowledges the familiarity Pennell registers with the Roma communities passing through Philadelphia, indicating a certain romance – even unity – with the 'gipsies' she encountered. However, Laird also notes the dependence Pennell places upon Othering the Roma, using racialised signifiers to determine the 'realness' of the 'gipsies' she desires. Indeed, complicating Pennell's claims to unity and intimacy with the 'real gipsy', I suggest here that Pennell remained invested in logics of white supremacy, foreclosing opportunities for true intimacy with the Roma. For example, in addition to their umbrella, for their wedding journey in America the Pennells also brought along an African

American hired servant, another of her 'concessions to civilization', which confirms participation in certain racial and class expectations. Pennell explains their decision:

> In the end we had to hire Henry, a darkey, who had a large new wagon, and knew a man from whom he could borrow a tent. He could drive; he could sing, and play the banjo; he was not afraid of gipsies; and he could keep a secret. Moreover, all these accomplishments were at our disposal for the modest sum of $5.00 a day. The Lovells, who in their way are swells, have a faithful black to wait on them. Therefore a servant would not seem altogether out of keeping with the new life we were to follow.[34]

Pennell justifies their rather conventional decision to hire a Black man by pointing to the Lovells, the Roma family they had intended to meet on their journey. Perhaps Pennell's claims to unconventionality would not be compromised by hiring Henry, if other 'gipsies' were allowed the same indulgences? And can we not accept her infatuation with Roma culture as proof that she operates outside of conventional binaries that represent the 'real gipsy' as perpetually strange?

Indeed not. Although her desire for the 'real gipsy' does in a sense challenge the binary that places the Roma in a despised category, this reversal of the stereotype – Pennell's 'celebration . . . of difference' – does not escape 'the contradictions of the binary structure of racial stereotyping'.[35] As Hall's 'double focus' suggests, Pennell's obsession with the Roma's exotic and erotic Otherness is consumed and incorporated into whiteness and logics of empire. The language that Pennell uses to describe the many racialised Others she encounters throughout her text, from Henry to the 'wild' musicians she later seeks in Budapest, participates within the framework of established racial stereotypes and logics of white supremacy at the turn of the twentieth century, thus seriously complicating her professed desire for authentic connection and intimacy with the exotic Others she seeks.

Amateur or Expert?

It remains, however, difficult to dismiss Pennell's desire for unconventional connection, and, therefore, to dismiss any suggestion that her travelogue may offer a new way of gathering knowledge. Her infatuation with all things Romani may remind us of Carolyn Dinshaw's understanding of amateur knowledge, which is motivated by desire,

rather than discipline.[36] Dinshaw explains the fundamental difference between amateur and expert knowledge: 'In fact, not "scientific" detachment but constant *attachment* to the object of attention characterizes amateurism.'[37] Desire, attachment, even love form the basis for amateur knowledge production. With this definition in mind, it is possible to see Pennell's desire for an intimate knowledge of the 'real gipsy' as a kind of amateur approach to an exotic subject. We might even concede that this '[a]mateurism . . . is itself a bit queer, defined by attachment in a detached world'.[38] For Dinshaw, amateur knowledge 'shows the potential for shifting the whole system of credentializing, of judging who gets to make knowledge and how'.[39]

If we are to understand Pennell as an amateur, gathering and producing knowledge about the subjects to whom she feels intimately attached, then Dinshaw allows that such knowledge may indeed allow for queer forms of world-making. Queer, in this context, does not refer to non-heteronormative sexualities, but instead offers itself as a term to denote a variety of non-traditional possibilities, including knowledge production that strays from traditional methods of objective data collection, and instead relies on attached experiences, desires and intimacies. Dinshaw, therefore, identifies the amateur, driven by desire, as a potentially rich site for queer knowledge production. In addition, Dinshaw's amateurism relies upon a queer engagement with time and attachment. While Dinshaw assigns expert knowledge to modern, linear time, she associates amateurism with 'nonmodern ways of apprehending time'.[40] Pennell, like the Gypsy Lorists of the period, operated with a sense of urgency in the face of an aggressive passage of time. Resisting the steady march of modernity, these 'gypsiologists' sought to preserve a 'premodern world' with their 'extraordinary discoveries' about a disintegrating culture.[41] For these lorists, knowledge produced about the Roma was a final attempt to 'salvage what was left of a people' with whom the lorists craved kinship.[42] Amateurism's attachment to bodies, spaces and times that exist in heterogeneous temporalities requires the amateur's embrace of a queer, attached, nonlinear approach to knowledge production.

To that end, Dinshaw suggests that for the amateur, '[t]raveling east is better understood as traveling toward and into more explicitly heterogeneous temporalities'.[43] Pennell's adventurous foray into the foreignness of the East offers many examples of this potentially queer, heterogenous temporality. In her descriptions of the exotic East, she consistently recognises hints of Western civilisation, complicating her temporal expectations. For example, she remembers that entering one town, Nagy Bánya, was

to step across centuries of civilization, from the midst of the wild sheep-skins, into a house where etchings by Rembrandt, and drawings by Victor Hugo, and rare old tapestries hung on the walls; where the latest books lay within easy reach; and where London tailors and Paris milliners had set the fashion.[44]

This observation illustrates the heterogeneous temporality that Pennell encountered, moving across centuries and finding both old and modern in one space. Such heterogeneity simultaneously fascinated Pennell and disturbed her fantasy of a pure Otherness.

Rich with queer potential though it may be, this particular non-linear temporality relies upon the divide between a modern Europe defined by forward-moving progress, and an anachronistic, temporally heterogeneous East. Therefore, the divide between the West and the East is reinforced, as 'cultural differences get turned into temporal distance'.[45] Furthermore, to borrow from Anne McClintock, while Westerners possess the privilege of 'panoptical time', which describes 'the image of global history consumed – at a glance – in a single spectacle from a point of privileged invisibility', the exotic Others of the East exist in 'anachronistic space', where they 'do not inhabit history proper but exist in a permanent anterior time within the geographic space of the modern empire as anachronistic humans, atavistic, irrational, bereft of human agency – the living embodiment of the archaic "primitive"'.[46] Ultimately, Pennell's 'temporal distancing' serves to reify the anachronistic East against the modern West.[47]

Edward Said describes this divide as Orientalism. To the contemporary American reader, the Orient may be more easily associated with the Far East; however, Said acknowledges that a European perspective (especially British and French) names the spaces adjacent to Western Europe as the Orient.[48] Pennell clearly saw her travels to Hungary and Romania as a journey to the East, even citing Budapest as the 'enchanted city of East'.[49] Indeed, Pennell was undoubtedly drawn to her quest to find the 'real gipsy' precisely because he was understood as Eastern and Other. Early in her travelogue, she explains: 'I wanted something new, something strange, something different . . . in my eyes [the gipsies] brought with them all the glamour of the East, all the mystery of the unknown.'[50] It is thus useful to consider how Pennell's text – as a form of *racialized knowledge of the Other* (Orientalism) [is] deeply implicated in the operations of power (imperialism)'.[51] Indeed, this racialised Orientalism, Said argues, is essential to creating, maintaining and increasing Western power over the Orient.[52]

If Orientalism is fundamentally concerned with an imperial/ Western authority over the Orient, then Western knowledge production about the Orient is Orientalism's most powerful weapon. Said reminds us that 'the Orientalist, poet or scholar, makes the Orient speak, describes the Orient, renders its mysteries plain for and to the West'.[53] Pennell's encounters with this Oriental 'unknown' are chronicled and, according to Mary Louise Pratt, 'discovered' through the text of her travelogue. Pratt suggests that the concept of a new discovery is 'made' through 'the seeing, and the writing of the seeing'.[54] In this way, travel writing is, therefore, a form of mastery over the Other. Of course, most Victorian travelling and writing was undertaken by men; but Pratt points to a few key examples of Victorian women travellers and writers to suggest that (white) women also engaged in a 'monarchic . . . discourse of domination and intervention', but that the 'female voice . . . asserts its own kind of mastery even as it denies domination and parodies power'.[55] This delicate combination of asserting mastery over the Other *while* distancing oneself from hegemonic power – even parodying it – is similarly achieved in Pennell's travelogue, thus requiring a closer examination to determine what kind of knowledge she offers.

When we examine Pennell's travelogue through the lenses of Said and Pratt, the distinction between the amateur and the expert necessarily collapses. Both amateur and expert are undeniably attached to their Orientalist desires, as 'the modern Orientalist does not, as he believes and even says, stand apart from [the Orient] objectively'.[56] However, as Said argues, '[a] text purporting to contain knowledge about something actual . . . is not easily dismissed. Expertise is attributed to it.'[57] Because the Orient is always already imagined as the binary opposite of the West, its fundamental foreignness is common sense, requiring only rich description as confirmation of this truth. Said further insists that these discourses of Orientalist description 'can *create* not only knowledge but also the very reality they appear to describe'.[58] In accordance with Said's argument about the power of Orientalist description to create both knowledge and reality, Pratt similarly demonstrates that the travel book *makes* the discovery real.

Therefore, knowledge about the Orient and Oriental Other is a Western artefact masquerading as description of fact, ensuring that 'the Oriental is *contained* and *represented* by dominating frameworks'.[59] Thus, for all her supposed rejection of convention and modernity, and her exploration of heterogeneous temporalities, Pennell's text nevertheless offers itself as an authority on the subject of 'gipsies'. For example, she takes care to describe and differentiate between the various racial

types of Roma and ethnicities of the peasants she and Joseph encounter in their travels, describing:

> his dark oval face with its delicate features – the sensitive mouth; the nose something like that of the old Assyrian; the unmistakable eye of his people; the fawn-like ears peeping from under the curls – would have stamped him as the stranger he is among the low-browed, swarthy Wallachs, the fair, high-cheeked Hungarians, the stolid Saxons, and the greasy, cringing Jews.[60]

Accompanied with detailed illustrations, these descriptions conform to and maintain dominant ideologies about race. Indeed, once a race, community or culture is made discernible it is conquerable. Joseph Pennell's sketches of the 'types' he and Elizabeth encounter on their 'gipsy-hunt' contribute to an '*imperial* genre'.[61] McClintock attests that 'the notation of types and specimens was characteristic of the travel ethnographies being written at the time by men who were taking a good look at the marketplace of empire'.[62] Joseph's 'generating gaze' is combined with Elizabeth's 'language of discovery' to offer their readers a voyeuristic spectacle of a 'vanishing species'.[63]

As we have seen, racialised knowledge produced about the Other is easily consumed as truth. In particular, Hall reminds us that '[a]dventuring was one means by which the imperial project was given visual form in a popular medium, forcing the link between Empire and the domestic imagination'.[64] Pennell's travelogue, then, complete with rich description and illustrations of the gipsy Others she seeks, brings the discovery of the 'real gipsy' into being and thus becomes a source of expert knowledge.

With the amateur/expert binary collapsed in the context of Orientalism, Pennell sheds her queer potential as an amateur, and instead moves through the Orient as a passionately attached amateur-made-expert. She was not alone in straddling the line between professionalism and amateurism when it came to knowledge-gathering about the Roma. Nord writes extensively of the semi-professional status of the British Gypsy Lore Society: 'The lorists hovered between amateurism and semiprofessional aspirations, a pattern common to a variety of late-nineteenth century scholars whose work took place outside of academic institutions.'[65] For example, Nord situates Pennell's uncle, Charles Godfrey Leland, within a larger community of British Gypsy Lorists, most of whom were men who chafed against the social norms of their gender and class positions to embrace a version of Romani counter-culturalism.[66] This in-between space was perhaps

more conducive to participation by women of the era. The 'extra-institutional setting' of fields like folklore, anthropology or, indeed, travel writing was more 'hospitable to women . . . They were allowed to act as intermediaries of a sort between acknowledged male professionals and objects of study or charity.'[67] An intermediary role ideally allowed for the possibility of genuine connection – and not only objective study – of one's subject.[68]

This kind of immersive experience, muddying the waters between work and pleasure, became a popular style of journalism for both men and women in the late nineteenth century.[69] Seth Koven points to the 'amateur-casual' style of journalism, popularised by James Greenwood and then expanded to women by Elizabeth Banks in both the UK and the US, in which journalists would disguise themselves to more fully experience and understand the lives or working conditions of working-class, homeless or otherwise 'Othered' populations.[70] Similarly, Audra Simpson highlights the importance of 'mimetic play' to the origins of American anthropology.[71] She argues that the 'inventive activities of "playing Indian," of approximating Indianness . . . donning the garb, writing speeches, doing as one thinks Indians do (or, rather, did) in that particular time' were fundamental to the intimacy demanded by and made possible through anthropology, defined as 'a practice of documentation, of theorization, of desire'.[72]

Pennell was neither a professional journalist or anthropologist, nor self-consciously abandoning her identity to temporarily go undercover as a 'gipsy'. Nevertheless, her style of writing and of travelling (among the Roma, desirous of belonging to and discovering an authentic 'gipsy' community) resembles the mimetic play and semi-professional/'amateur-casual' approach to unconventional objects of study. In this way, the Pennells' attempts to temporarily join a caravan and later to embark on a months-long bicycle-tour of the 'real gipsy-land' was akin to a somewhat conventional pastime of 'slumming' or 'tramping', in which white middle-class people would enter working class or highly racialised spaces to observe and sometimes to 'pass' as a 'gipsy', 'tramp', or person of colour.[73]

Fundamentally, the relation of power between Pennell and her object of desire was not diminished by her status as amateur or, as Pratt reminds us, by her gender, as the text she produced offers the 'monarchic female voice' of the Victorian travel writer, which carries its own kind of mastery over the Other in the form of knowledge and expertise. Furthermore, Pennell's relationship with the potential queerness of heterogeneous temporalities of the East was made static when she consistently understood the 'real gipsy' as lost. The Orient comes into being in the Western imagination as a perpetual past:

Said demonstrates that the Orient 'was disappearing; in a sense it had happened, its time was over'.[74] Pennell's disappointment in how the effects of modernity complicate her vision of a pure 'gipsy' suggest that her experience of the East is indeed one in which the East is less full of the possibility of heterogeneous temporalities, and exists instead as a space of loss whose 'time was over'.

A Disenchanted End

The overwhelming message of *To Gipsyland* is Pennell's sense of 'disenchantment' with the ever-illusive 'real gipsy' and his or her foreign world.[75] The source of this disenchantment is modernity – the influences of Western Civilisation upon a time, place and people that were expected to be perpetually wild, free and untouched by the material realities of our world. The 'Romani ryes' and lorists were largely united in blaming modernity for encroaching upon the supposed purity and primitivism of authentic 'gipsy' life. Nord writes: 'The lorists' obsession with purity is difficult to separate from their quarrel with modernity and their habitual search for origins.'[76] Believing that the Roma language and people 'contain in their culture clues to essential humanity that might otherwise be lost', the lorists felt moved to identify, record and preserve all things Roma before the regulatory machine of modernity threatened their existence.[77] Thus, the lorists imagined a pristine purity of race and language and developed a strong sense of nostalgia for a pre-modern era.

Pennell, too, blamed this loss largely on modernity's influence of 'aggressive newness' – or, as Laird calls it, the influences of imperialism and capitalism – upon the region, which has led to the Roma being

> hunted and hounded from their old haunts in the green forest and by the quiet stream . . . who are settled, and housed, and taxed, until they need but the visit of the extension lecturer and the patronage of the amateur missionary to complete their degradation.[78]

Remembering the one encounter the Pennells had with a 'real gipsy', Pennell mourns:

> He was the only gipsy left in Transylvania, where the Romanies no longer travel *apré o drom*, but are being fast elevated into farmers and laborers, fast degraded into serfs; where the musicians send their children to school and talk of their professions. Our gipsy had vanished from Hungary forever.[79]

Echoing the Gypsy Lorists' sense of loss and fervent need for pres-
ervation, Pennell's disenchantment is predominantly expressed as a
kind of mourning or nostalgia for a way of life that has been lost.

Renato Rosaldo's now classic 'Imperialist Nostalgia' captures
Pennell's relationship to those she encounters well. Reflecting on his
own time spent with the Ilongots in the Philippines as an anthropolo-
gist doing fieldwork, Rosaldo identifies 'a kind of nostalgia, often
found under imperialism, where people mourn the passing of what
they themselves have transformed'.[80] Key to this dynamic is the sense
of innocence that is (problematically) attributed to the mourner, in
which they 'attempt to use a seemingly harmless mood as a mask
of innocence to cover their involvement with processes of domina-
tion'.[81] Their complicity in creating the conditions of change to a
place or people is seemingly forgiven or distanced from self due to
the regret, longing and nostalgia they carry for the 'traditional' ways
now gone. Rosaldo points to examples in which these mourners feel
that 'nostalgia for things as they had been ... absolved [them] of
guilt and responsibility'.[82] It is clear throughout Pennell's text that
she felt little or no personal responsibility for the 'disappearance' of
the Roma people. Instead, as I argue above, she occasionally placed
blame on the descendants of the Roma who succumbed to begging
and labouring. While Pennell may not have been directly to blame
for the political and economic changes that led the Roma to a more
rooted lifestyle, she was part of the tourist economy upon which the
Roma learned to survive. Thus, her unequivocal claim to innocence
was short-sighted. She imagined herself a champion of true 'gipsy'
culture, lamenting what she calls 'this show of civilization' without
recognising the role she played in creating this dynamic.[83]

Pennell's relationship to civilisation and modernity was complex:
as we have already seen, she took great care to distance herself from
'conventional' expectations of modernity, but she does not deny that
'civilisation' plays an important role in modern society. Her regret is
its totalising effects:

> Once, when men were little less savage than the brutes, it was best that
> the many were tamed; but to-day, that the many are modeled after one
> peaceful pattern, why not spare the few who still feel the true poetry of
> life, who still love 'the tent pitched beside the talking water, the stars
> overhead at night, the blest return of morning, the peep of day over the
> moors, the awakening birds among the birches'? Who would want to
> turn every lark and bluejay, ever oriole and nightingale, into the little
> twittering brown sparrow of our town gardens?[84]

Here, Pennell mourns for the loss of 'the true poetry of life', even as she acknowledges the importance of a 'civilised' majority. Moreover, her sorrow at the loss of some idealised version of 'savagery' (falsely) affirms her innocence. She refuses complicity in this process of modernity, even as her tourist's gaze, her writer's pen and her eager consumption of all things 'authentically' gipsy play a crucial role in transforming the gipsy into a market to be consumed by adventurous and unconventional travellers (and readers).

Pennell's complicated relationship with modernity and nostalgia is further illuminated by geographer Bruce Braun's extension of Rosaldo's concept of 'imperialist nostalgia' to argue that, in addition to 'operat[ing] as an apologetics for domination', this mourning for the destruction that has been brought about by the effects of modernity 'is an irreducible element of *being* modern'.[85] Braun might therefore argue that despite Pennell's frequently articulated disenchantment with modernity, and even her adventurous mode of travel, her sense of nostalgia 'work[s] to *conserve* the modern bourgeois subject, not to disrupt or traumatize it'.[86]

Caren Kaplan's *Questions of Travel* also sheds light on the relationship between travel and modernity. She argues that travel and tourism are closely linked to modernity and to histories of colonialism. Like Braun, Kaplan suggests that 'travel affirms modernity', despite the insistence that travel, tourism or even exile offers an escape from the modern world.[87] For indeed, the boundaries that the modernist traveller wishes to transgress 'are boundaries that the tourist participates in creating; that is, an economic and social order that requires "margins" and "centers" will also require representation of those structure distinctions'.[88] The modernist traveller, or exile, as described by Kaplan, shares much with Pennell's desire to travel to locate the 'real gipsy'. Kaplan writes: 'the expatriate modernist writer and the vacationer may share the same desire for new experiences or places in order to "see" or "feel" differently'.[89] Occupying the status of both expatriate writer and cycle vacationer on a quest to experience 'something new, something strange, something different', Pennell exemplifies Kaplan's modernist traveller.[90]

Pennell, like the modernist exile Kaplan studies, sought 'metamorphoses in form through the fruitful chaos of displacement'.[91] Indeed, Pennell sought distance from conventionality, and intimacy with a particular myth of nomadic freedom, represented by the wandering gipsy. However, Kaplan suggests that this desperate 'search for authenticity' – a 'belief in a truer, more meaningful existence somewhere else' – is perhaps a 'response to the generalized anxiety of

modernity'.[92] Thus, Pennell's distaste for modernity and her longing for a simpler, pre-modern time, space and people cement her identity as a modernist traveller.

Conclusion

Throughout Pennell's *To Gipsyland*, we see the unexpected ways that domination can be expressed. Unlike brute force, imperialist nostalgia conceals complicity with a 'mask of innocence', and unlike the male monarchic voice of domination, Pratt points to the ways that women explorers and travel writers parody power even as they engage in its dominating effects upon the people and places they 'discover' and describe. Moreover, Said demonstrates that the Orientalist's descriptions become a form of 'expertise', wielding authority over an object of study, even desire. So, too, does Pennell engage in forms of domination over her object of desire: the 'real gipsy'.

This isn't to say that Pennell's feeling of intimacy with and desire for the 'real gipsy' was altogether artificial or malevolent. Rosaldo allows that the nostalgic mourner 'surely manifests authentic and deeply felt sentiments, yet even such moments of "pure subjectivity" do not remain untouched by social force and dominant ideologies'.[93] Here, Rosaldo reminds us that even authentically expressed desire and attachment do not automatically detach us from the ideologies of our time, nor do they absolve us of wrongdoing. While Pennell's relationship to Roma culture may not have been maliciously intended, her complicity with ideologies of white supremacy and imperialism is nevertheless an important factor throughout her 'discovery' and her text.

This is an important – and unintentional – lesson of *To Gipsyland*. Pennell's travelogue is not so very different from contemporary examples of travel writing or adventure tourism. An interest in experiencing people, place and culture very different from one's own should not necessarily be discouraged, nor should we assume such intentions are bad. On the contrary, Dinshaw allows for an opportunity for the amateur traveller to create new ways of thinking and engaging intimately with different times and spaces. But as Pennell's travelogue demonstrates, neither the potential for new world-making nor one's apparent commitment to unconventional ways of interacting with people and place can guarantee absolution from participation in structures of domination. Pennell's travelogue stands as an example of how one woman's lack of responsibility and recognition of her role in modernist structures

of power resulted in maintaining rather than undermining hegemonic power. Her claims to unconventionality become empty and even harmful when they are backed by imperialist nostalgia rather than conscientious recognition of the material realities of her world and the spaces through which she is privileged to travel.

Notes

1. Pennell, like many of her contemporaries, uses the term 'gipsy' or 'gypsy' to refer to the Roma people. Today, this terminology is largely considered derogatory, although some Roma communities prefer to refer to themselves as 'gypsies'. Throughout this chapter, I will use Pennell's term 'gipsy' to describe the Roma people in order to highlight Pennell's exoticised and racialised Othering of this community, which is central to her experience of the 'real gipsy'. I will not use this terminology when speaking more generally about the Roma people or the Romany language.
2. Buchanan, 'Introduction', xxvii. Pennell writes in her biography of Joseph Pennell: 'No more beautiful month of our life together can I recall' (ibid. xxvii).
3. Pennell, *To Gipsyland*, 71–2.
4. *To Gipsyland* is not the only one of Pennell's travelogues to feature her interest in Roma culture, music and people. For example, in *Our Sentimental Journey* (1893) she seeks out and attempts to communicate with a couple she assumes are gipsies, declaring, '*Me shom une Romany chi*'' ('I'm a Gipsy') . . . in [her] best Romany.' But this potential connection with authentic gipsies is quashed when the woman responds that she is no gipsy, leaving Pennell feeling 'snubbed' (ibid. 39–40).
5. Pennell, *To Gipsyland*, 240. Pennell quotes this verse frequently throughout her text, a sort of mantra that describes the essence of her 'real gipsy'. She probably learned of the poem from her uncle Charles Godfrey Leland, who published the full 'Gypsy Song' in his book *The Gypsies* (1882). For the full text, see Leland, *Gypsies*, 81–2.
6. Ibid. 176.
7. Ibid. 2.
8. Ibid. 8.
9. Nord, *Gypsies*, 67.
10. Ibid. 14.
11. Ibid. 1, 138.
12. Ibid. 6.
13. Pennell, *To Gipsyland*, 17.
14. Ibid. 9.

15. Ibid. 10.
16. Ibid. 37.
17. Ibid. 176, 211–12.
18. Ibid. 212.
19. Ibid. 166.
20. Ibid. 83.
21. Ibid. 84. Pennell occasionally inserts Romany words and phrases into her text. This appears to be a tactic to demonstrate her intimate knowledge of the people and culture. A favourite word is '*gorgio*', which translates as a person who is non-Roma. Pennell uses it primarily to refer to white Euro-Americans, usually in a derogatory way. She avoids referring to herself as a '*gorgio*' and takes pleasure in being mistaken for a 'gipsy sister'.
22. Pennell, *To Gipsyland*, 84.
23. Ibid. 121.
24. Ibid. 77, 134–6.
25. Newman, *White Women's Rights*, 7.
26. Nord, *Gypsies*, 23.
27. Ibid. 150. Audra Simpson similarly argues that anthropologists of this time sought to 'authenticate . . . rather than analyze' their objects of study (*Mohawk Interruptus*, 104).
28. Hall, 'Spectacle', 268.
29. Ibid.
30. Ibid. 49.
31. Koven, *Slumming*, 19.
32. Pennell, *To Gipsyland*, 41.
33. Ibid. 50–1.
34. Pennell, *To Gipsyland*, 46.
35. Hall, 'Spectacle', 272.
36. Dinshaw, *How Soon Is Now?*, xiv.
37. Ibid. 22.
38. Ibid. 31.
39. Ibid.
40. Ibid. 24.
41. Nord, *Gypsies*, 134, 45.
42. Ibid. 132. The desire to 'salvage what was left of a people' is closely related to a form of 'salvage anthropology' popular among scholars of American Indians at the turn of the twentieth century. This practice was also closely tied to 'fears about industrialization and the loss of a raced, white manliness associated with the taming of the frontier' (Simpson, *Mohawk Interruptus*, 77; Deloria, *Playing Indian*, 95–127). For more on 'salvage anthropology' and its relationship to mimetic play and anxieties about modernity see Simpson, *Mohawk Interruptus* and Deloria, *Playing Indian*.
43. Dinshaw, *How Soon Is Now?*, 78.

44. Pennell, *To Gipsyland*, 129.
45. Dinshaw, *How Soon Is Now?*, 103.
46. McClintock, *Imperial Leather*, 37, 30.
47. Dinshaw, *How Soon Is Now?*, 92.
48. Said, *Orientalism*, 1–2. In defining Orientalism and justifying its application to the Near East, Said writes: 'Americans will not feel quite the same about the Orient, which for them is much more likely to be associated very differently with the Far East (China and Japan, mainly). Unlike the Americans, the French and the British – less so the Germans, Russians, Spanish, Portuguese, Italians, and Swiss – have had a long tradition of what I shall be calling Orientalism, a way of coming to terms with the Orient that is based on the Orient's special place in European Western experience. The Orient is not only adjacent to Europe; it is also the place of Europe's greatest and richest and oldest colonies, the source of its civilizations and languages, its cultural contestant, and one of its deepest and most recurring images of the Other. In addition, the Orient has helped to define Europe (or the West) as its contrasting image, idea, personality, experience' (ibid. 1–2).
49. Pennell, *To Gipsyland*, 37.
50. Ibid. 2.
51. Hall, 'Spectacle', 260, emphasis his.
52. Said, *Orientalism*, 32.
53. Ibid. 20–1.
54. Pratt, *Imperial Eyes*, 202.
55. Ibid. 209.
56. Said, *Orientalism*, 104.
57. Ibid. 94.
58. Ibid.
59. Ibid. 40, emphasis his.
60. Pennell, *To Gipsyland*, 149. In addition to Pennell's frequent racial stereotyping, her anti-Semitism throughout the text is especially pronounced and disturbing. Such anti-Semitism is an important example of how Pennell relies upon and maintains logics of white supremacy, yet her treatment of Jews is different from that of other ethnic Others in that she *does not* desire or admire the Jew; however, she *does* profess to admire and desire the 'real gipsy'. Thus, her participation in anti-Semitism is much more straightforward than her participation in logics of white supremacy in relation to other ethnic minorities she meets.
61. McClintock, *Imperial Leather*, 81, emphasis hers.
62. Ibid. 81.
63. Ibid. 122, 121, 130.
64. Hall, 'Spectacle', 240.
65. Nord, *Gypsies*, 130.
66. Leland, author of *The English Gipsies and Their Language* (1873), among other texts and novels featuring the Romany, considered himself

to be a 'Romany rye', a master of the Romany language who developed a close kinship with Romany people through language and through an affinity for a nomadic or bohemian lifestyle (Nord, *Gypsies*, 13). These wandering 'Romany ryes', lorists and independent scholars 'devoted [themselves] to the preservation of Gypsy lore and abandoned – even for a brief time – settled English life for a nomadic sojourn among the peripatetic Gypsies', which offered an opportunity to 'escape from time, and live a pastoral existence' and for some to experiment with 'ostentatious heterosexuality' (Nord, *Gypsies*, 71, 131).

67. Nord, *Gypsies*, 148.
68. For more on the relationship between objectivity and intimacy or '*distance* and *difference*' in the field of anthropological study, see Simpson, *Mohawk Interruptus*, 87.
69. Koven, *Slumming*, 157.
70. Ibid.
71. Simpson, *Mohawk Interruptus*, 77.
72. Ibid. 77, 69. See also Deloria, *Playing Indian*.
73. The phenomena of 'slumming' or 'tramping' was often meant precisely to move oneself from amateur to professional. By dressing as/engaging with an othered population, the slummer then claims intimate and authentic knowledge of that population. That authentic knowledge then forms the basis of the claim to authority and expertise. For more on 'slumming' in the late nineteenth century, particularly as it relates to gender, class, race, and sexuality, see Murphy, *Political Manhood*; Koven, *Slumming*; Heap, *Slumming*; Walkowitz, *City of Dreadful Delight*.
74. Said, *Orientalism*, 1.
75. Pennell, *To Gipsyland*, 85.
76. Nord, *Gypsies*, 135.
77. Ibid. 9.
78. Pennell, *To Gipsyland*, 86, 166.
79. Ibid. 236–9.
80. Rosaldo, 'Imperialist Nostalgia', 108.
81. Ibid. 120.
82. Ibid. 114.
83. Pennell, *To Gipsyland*, 169.
84. Ibid. 169.
85. Braun, *Intemperate Rainforest*, 136, 137, emphasis his.
86. Ibid. 142, emphasis his.
87. Kaplan, *Questions of Travel*, 58.
88. Ibid.
89. Ibid. 59.
90. Pennell, *To Gipsyland*, 2. In addition to Pennell's frequent travels, she lived much of her adult life in London, a true expatriate writer.
91. Kaplan, *Questions of Travel*, 29, 64, 29.
92. Ibid. 60.
93. Rosaldo, 'Imperialist Nostalgia', 117.

Bibliography

Braun, Bruce. *The Intemperate Rainforest: Nature, Culture, and Power on Canada's West Coast*. Minneapolis and London: University of Minnesota Press, 2002.

Buchanan, Dave. 'Introduction'. In *A Canterbury Pilgrimage / An Italian Pilgrimage* by Elizabeth Robins Pennell and Joseph Pennell, ed. Dave Buchanan, ix–xliii. Edmonton: University of Alberta Press, 2015.

Deloria, Philip J. *Playing Indian*. New Haven: Yale University Press, 1998.

Dinshaw, Carolyn. *How Soon Is Now? Medieval Texts, Amateur Readers, and the Queerness of Time*. Durham, NC, and London: Duke University Press, 2012.

Hall, Stuart. 'The Spectacle of the "Other"'. In *Representation: Cultural Representations and Signifying Practices*, ed. Stuart Hall, 223–90. Milton Keynes: Sage and Open University, 1997.

Heap, Chad. *Slumming: Sexual and Racial Encounters in American Nightlife, 1885–1940*. Chicago and London: University of Chicago Press, 2009.

Kaplan, Caren. *Questions of Travel: Postmodern Discourses of Displacement*. Durham, NC, and London: Duke University Press, 1996.

Koven, Seth. *Slumming: Sexual and Social Politics in Victorian London*. Princeton and Oxford: Princeton University Press, 2004.

Leland, Charles Godfrey. *The English Gipsies and Their Language*. New York: Hurd and Houghton, 1873.

Leland, Charles Godfrey. *The Gypsies*. Cambridge: Riverside Press, 1882.

McClintock, Anne. *Imperial Leather: Race, Gender and Sexuality in the Colonial Contest*. New York: Routledge, 1995.

Murphy, Kevin P. *Political Manhood: Red Bloods, Mollycoddles, & the Politics of Progressive Reform*. New York: Columbia University Press, 2008.

Newman, Louise Michele. *White Women's Rights: The Racial Origins of Feminism in the United States*. New York and London: Oxford University Press, 1999.

Nord, Deborah Epstein. *Gypsies and the British Imagination, 1807–1930*. New York: Columbia University Press, 2006.

Pennell, Elizabeth Robins. *To Gipsyland*. New York: Century, 1893.

Pennell, Joseph and Pennell, Elizabeth Robins. *Our Sentimental Journey through France and Italy*. 2nd edn. London: T. Fisher Unwin, 1893.

Pratt, Mary Louise. *Imperial Eyes: Travel Writing and Transculturation*. 2nd edn. New York: Routledge, 2008.

Rosaldo, Renato. 'Imperialist Nostalgia'. *Representations* 26 (Spring, 1989): 107–22.

Said, Edward. *Orientalism*. New York: Vintage, 1979.

Simpson, Audra. *Mohawk Interruptus: Political Life Across the Borders of Settler States*. Durham, NC: Duke University Press, 2014.

Walkowitz, Judith R. *City of Dreadful Delight: Narratives of Sexual Danger in Late-Victorian London*. Chicago: University of Chicago Press, 1992.

The Gourmand as Essayist: Irony and Style in the Culinary Essays of Elizabeth Robins Pennell

Alex Wong

For just over two years, between late 1893 and early 1896, Elizabeth Robins Pennell made frequent and at times regular contributions to a column in the *Pall Mall Gazette* headed 'The Wares of Autolycus'. These contributions, all on culinary topics were written alongside her frequent pieces on fine art for *The Star* and *Woman*.

'The Wares of Autolycus' was a column, Pennell herself tells us, 'daily written by women and I daresay believed by us to be the most entertaining array of unconsidered trifles that any Autolycus had ever offered to any eager world.'[1] The title refers to *The Winter's Tale*, evoking roguish associations as well as implying that the miscellaneous articles were more or less slight. Often on relatively 'light' subjects, some of which, such as fashion and decor, were matters conventionally assumed to appeal to women, they also on occasion took a more strident, if humorous, tone about societal and political matters concerning women. The column's precursor was a section entitled 'Ladies' Corner' which appeared in 1890, while W. T. Stead was editor. The 'Wares' began in 1893, under the editorship of Henry Cust, and ran almost (but not always) daily for several years, petering out from 1896, and discontinued in 1900. By that time it was no longer reserved exclusively for women; but in its prime, when Pennell and an impressive company of other authors wrote for it, including Alice Meynell, Violet Hunt and Katherine Tynan, the unsigned column was a prestigious space for women journalists to write with witty elegance on an eclectic range of themes, from literary criticism to the fine arts of cooking and eating. Free of her more serious critical responsibilities, Pennell adopted an extravagantly playful style in the culinary articles.

In 1896 a selection of Pennell's pieces from the 'Wares' was published by John Lane, whose list included many of the most important aesthetically minded writers of the time. This substantial book in small octavo, elegantly printed with one of the publisher's characteristic engraved title pages, was called *The Feasts of Autolycus: The Diary of a Greedy Woman* and was to be reissued several times during the author's lifetime. A 'second edition', still bearing the 1896 publication date, was published by John Lane in partnership with the Merriam Co. in New York, with *The Feasts of Autolycus* on the title page but *A Guide for the Greedy* on the spine. Later editions in the United States, adopted other names, probably because American readers were not presumed to know anything about the 'Wares' column: the collection was published as *The Delights of Delicate Eating* in 1901, and in 1923 a new American issue, with the addition of a new and much longer introduction by the author, was published as *A Guide for the Greedy by a Greedy Woman*. The number of editions and reprints is some attestation of the popularity and longevity of the book, long after the column must have been largely forgotten, and overseas where the latter had never been widely known.

One modern critic has called it 'essentially a cookbook'. At least one other has concurred.[2] But though large portions of *The Feasts of Autolycus* superficially resemble a cookbook, it is far from being one 'essentially', as those who attempt to cook from it will discover. Pennell's descriptions of the preparation of particular dishes, whimsically expressed in highly figurative prose, are scarcely even 'recipes', since she usually neglects – except when quoting verbatim from a quaintly historical source – to give necessary details as to quantities and is loftily vague about procedures. Often the descriptions are just sufficient to guide a person already well versed in culinary techniques, but the interference of the style with the practicality suggests that Pennell was more eager to appeal to the reader as a reader than as a cook. And this is hardly surprising when we consider that the sophisticated middle-class readership at which the *Pall Mall* chiefly aimed would have been composed overwhelmingly of those who employed cooks to prepare their food. Few of these readers can have been sufficiently experienced and competent in the kitchen to profit from the 'recipes' as such, even if under certain circumstances they did from time to time venture to cook for themselves, or, more commonly, supervise in the kitchen.

It is, therefore, an important aspect of Pennell's tone and humour that the articles generally persist in addressing the reader as though they might themselves undertake the recipes. These very seldom

allude to the domestic circumstances familiar to the majority of her readers. In 'A Dish of Sunshine', exceptionally in the pieces collected in the *Feasts*, brief mention is made of hired cooks, but even here the implication is strangely ambiguous: 'Another word of advice: never break or cut the *macaroni* into small pieces; the cook who dares to disobey in this particular deserves instant and peremptory dismissal.'[3] At first the reader is addressed as though they might actually make the fatal mistake themselves; but immediately the fantasy is dispelled, as we consider instead the prospect of dismissing our employee. Clearly, then, we are not making our own *macaroni*. Perhaps, just at this moment, Pennell is trying to address two kinds of reader simultaneously – one who might personally attempt a dish of pasta, another who would ask the cook to do it for them; or perhaps she is really thinking, here and throughout, of those who do little or no cooking themselves but who enjoy indulging the fantasy of doing so, as imaginative gourmands rather than as prospective cooks.

Indeed, in the same essay she gives another hint of the sort of reader she has in mind, when, in speaking of the price and availability of vegetables, she refers to 'the morning's conference with the greengrocer's boy, or even the conscientious visit to the greengrocer's shop or the ramble through the market'.[4] We will talk to the grocer's boy, perhaps in consultation with the cook, about what we would like – maybe something special about which we have read in the *Pall Mall*; but to go to the grocer's shop would be particularly 'conscientious', and if one went to the market one would be *rambling* at leisure, as an amusement, not shopping as a daily chore. We are probably not a very grand lady, who would be unlikely to speak with the delivery boy herself, and in the fantasy, we are very unlikely to be a man, though we may be a male reader. We probably have a cook or maid to receive our grocery orders and cook what we have selected; but we may, inspired by what we have read, take something of a hobbyist's interest in the act of selection itself.

In a slightly later work, *My Cookery Books* (1903), Pennell throws some useful if indirect light on her putative intentions with the 'Wares' articles. She explains why the later works on culinary literature in her personal collection have been excluded from consideration in the book. She speaks of a 'change' that had taken place, as she judges, 'by the end of the eighteenth century'.

> In the nineteenth century there were, on the one hand, the cookery books, prosaic as primers, that, with their business-like, practical, direct methods, were more useful in the kitchen than entertaining in the library; on

the other hand, the books about cookery, so literary in flavor that they were not adapted to the kitchen at all. The new writers, of whom Grimod de la Reynière was the first great master, brought about such a revolution in not only the style, but the very attitude of writers on cookery, that I prefer to consider their work by itself.[5]

This theory of the historical career of culinary literature shows us the terms in which Pennell thought of the tradition in which, by writing on the subject, she had placed herself. In her own century's putative bifurcation between pragmatic cookbooks on the one hand and literary gastronomy on the other – the belletrist meditations of the gourmand – it is clear enough that her own articles belonged to the latter prong: the tradition in which Grimod de la Reynière and Brillat-Savarin had made their marks, and various literary personages had dabbled.

Thus, although she was in the habit of referring to her pieces 'on cookery',[6] this does not imply that she claimed any practical expertise in the kitchen; still less that she aimed to convey it to her readers. As she puts it in the original introduction to the *Feasts*, 'The collection, evidently,' – and it *is* evident –

> does not pretend to be a 'Cook's Manual,' or a 'Housewife's Companion' . . . It is rather a guide to the Beauty, the Poetry, that exists in the perfect dish, even as in the masterpiece of a Titian or a Swinburne.[7]

Thinking about the composition of the articles, she would later recall, with the gentle irony of the memoirist, her having fancied herself a 'brilliant authority on Eating' – not on cooking.[8]

There are many indications throughout the articles that Pennell was primarily addressing a notionally female reader, and that she took her own status as a woman writer to be highly significant. Frequent consideration of matters specially concerning women (the 'New Woman' is invoked several times), and Pennell's posture as *soi-disant* 'greedy woman' jovially flouting conventions of ladylike becomingness, often seem distinctly pointed in the articles, though the continual adjustments of irony make these pieces too ambiguous to be really polemical. Their basic premise, spelled out in the original preface to the *Feasts*, was the most plainly polemical thing about them, and even this is archly and provocatively ironic:

> In such trifling matters as politics and science and industry, I doubt if there be much to choose between the two sexes. But in the cultivation

and practice of an art which concerns life more seriously, woman has hitherto proved an inferior creature.

For centuries the kitchen has been her appointed sphere of action. And yet, here, as in the studio and the study, she has allowed man to carry off the laurels.

A list of famous chefs, all men, follows. 'Woman, moreover,' she continues, 'has eaten with as little distinction as she has cooked'.

It seems almost – much as I deplore the admission – as if she were of coarser clay than man, lacking the more artistic instincts, the subtler, daintier emotions.

I think, therefore, the great interest of the following papers lies in the fact that they are written by a woman – a greedy woman.[9]

What the culinary 'Wares' represent is an exercise of the gastronomic imagination, socially significant in itself (as coming from a woman's pen), light-hearted in tone, but slipperily pretending to earnestness in its celebration of the edible – an earnestness we are invited to take as basically sincere, in a way which does not compromise the light tone but adds tension to the resulting humour. It relies on an irony of commitment, shades of whimsicality competing with real love of food but never cancelling it out; and this delicate balance is aided by the fact that food is the kind of thing about which one *can* be whimsically serious and seriously whimsical, as earlier writers had been – especially French gastronomes such as Brillat-Savarin and Pennell's particular favourite, Grimod de la Reynière.

But in this she also made use of the language and sentiments of the dandiacal wits and decadent aesthetes of her own day who similarly mixed whimsy and high seriousness in speaking, usually, of the 'higher' arts. Oscar Wilde, also a contributor to the *Pall Mall* (in the 1880s, a little before Pennell) is, of course, now the figure best remembered for such utterances, and he too sparked wit from ironised earnestness and ambiguous commitment on the topic of food – as when Algernon Moncrieff, in *The Importance of Being Earnest* (1895), avers: 'I hate people who are not serious about meals. It is so shallow of them.'[10] This is not unlike the diffused irony of Pennell's articles, which also flirt with the suggestion that their own declared seriousness about meals might be thought shallow, trivial or – especially in a respectable woman – vulgar. Their overstatements invite this accusation but rebuff it by the sheer grossness of their exaggeration, showing the author is perfectly conscious of the possible charge and actively provoking it in

jest. It is in the less hyperbolic moments that the articles communicate a genuine enthusiasm, which makes the more *outré* moments tonally productive and ensures that the total result is more than mere satire or burlesque.

The main route taken by the articles towards the gastronomic imagination of the reader is through descriptions of dishes. These generally assume the form of recipes, not, I think, because readers were expected to make use of them, but largely because the description of the preparation of a dish allows for the exploitation of narrative interest, whereas the description of the finished result lacks drama. Many of the articles are interspersed with literary or historical titbits culled from Pennell's old cookbooks. Most often she wends through passages of witty conversational prose in the tradition of the 'familiar essay', from one hazily outlined recipe to another, each decocted and paraphrased from sources generally unspecified. For these 'recipes' she uses a self-consciously *précieux* language, which gives a vague impression of parody, though much of it – the elevated tone and archaic syntax – is not really a parody of anything in particular. There are, however, many moments in which the sentiments expressed, and the terms in which they are articulated, do become genuinely parodic, imitating the aestheticist and decadent writers of the time.

The central literary figure in British Aestheticism, by whom such younger aesthetes as Wilde – and Pennell's friend and fellow art critic George Moore – were profoundly influenced, was Walter Pater, an important forerunner in English thought of those, like the Pennells, who came to espouse an aesthetic formalism in the criticism of art. Pater's highly distinctive style is not closely mimicked in Pennell's food writing, but some of the thoughts and sentiments famously associated with him appear from time to time, clothed in the more buoyantly witty idioms of his flamboyant followers.

'Gluttony', Pennell writes in the piece that opens the *Feasts*, 'is ranked with the deadly sins; it should be honoured among the cardinal virtues.' Here she is in the realm of the brash Wildean dictum. But when she explains that 'the Dark Ages of asceticism' are responsible for the 'contempt' with which love of food has since been regarded, complaining that 'cheerfully, and without a scruple' the 'selfish anchorites' of that unenlightened age 'would have sacrificed beauty and pleasure to their own superstition',[11] she begins in a general way to connect her ironised epicureanism with the aestheticism of Pater, whose celebration of 'beauty' and (within certain limits) 'pleasure'

was associated specifically with the humanism of the Renaissance, the revival of the 'Greek spirit' of the classical world interrupting the Christian asceticism of the Middle Ages. 'Poor deluded humans', Pennell says, 'ever so keen to make the least of the short span of life allotted to them!'[12] – and here many of her aesthetically minded readers must have felt, more or less dimly, the memory of Pater's most infamous passage stirring in their memories: the 'Conclusion' to his first book, *Studies in the History of the Renaissance*, with its injunction to make the most of the 'counted number of pulses' we are given on earth.

> Well! we are all *condamnés*, as Victor Hugo says: we are all under sentence of death but with a sort of indefinite reprieve . . . we have an interval, and then our place knows us no more. Some spend this interval in listlessness, some in high passions, the wisest, at least among 'the children of this world', in art and song. For our one chance lies in expanding that interval, in getting as many pulsations as possible into the given time.[13]

Exchanging Pater's wistful melancholy for a more boisterous tone, 'bless the day that you were born', Pennell says, 'predestined, as you were, from all eternity for this one interval of rapture'.[14] 'Interval' is Pater's word; and those for whom the Paterian resonances were set ringing may have felt that Pennell's 'rapture' corresponded with Pater's 'ecstasy' in the same famous passage: 'To burn always with this hard, gemlike flame, to maintain this ecstasy, is success in life.'[15]

But what is the 'rapture' she is commending to us? One occasioned by a '*ragoût* of mushrooms'.[16] It is as though she were answering the same question that had troubled Pater: how to get 'as many pulsations as possible into the given time'. Her humour is to be bathetically pragmatic and banal about the means to that end: not 'art and song', but, say, a fricassée of mushrooms – 'which, if you have your own happiness at heart, you cannot afford to despise. Secure then, without delay – for who would play fast and loose with happiness? – a quart of fresh mushrooms.'[17] 'However they may be served and eaten,' she exhorts the reader in closing, 'mushrooms you must make yours at any cost' –

> To say that you do not like them is a confession of your own Philistinism. Learn to like them; will to like them, or else your sojourn on this earth will be a wretched waste. You will have lived your life in vain if, at its close, you have missed one of its finest emotions.[18]

This is a kind of Pater à la Wilde, a parody of an idiom which had already become ironically self-aware. Nevertheless, the application of the serious Paterian mode, however modulated by fashions, to mere food produces a new sort of irony, deliberately playing with banality, even vulgarity, while humorously inflating the tone of high-mindedness. She seems to ask her reader to remember the kinds of things Pater and others had commended as pursuits in the aesthetic life; note Pater's closing paragraph of the same 'Conclusion', above all, in which he asks us to be sure we are pursuing the right kinds of experience:

> Great passions may give us this quickened sense of life, ecstasy and sorrow of love, the various forms of enthusiastic activity, disinterested or otherwise, which come naturally to many of us. Only be sure it is passion – that it does yield you this fruit of a quickened, multiplied consciousness.[19]

'Only be sure it is passion'. With that in mind, what are we to make of the mushrooms? 'Let Ruskin rave of Turner's sunsets, let the glory of the Venetians be a delight among art critics', Pennell writes, now invoking the still more earnest figure of Ruskin; 'but when did Turner or Titian or Tintoret invent a finer scheme of colour than egg and mushroom thus combined for the greater happiness of the few?'[20] Ruskin and the Utilitarians are dismissed at a stroke, and we are addressed as by a burlesque Paterian hedonist – Pater as absorbed by a younger generation of flashier ironist-provocateurs. Pennell's overstatements are designed to let us be sure she is joking, but the existence of the kind of wit used by writers such as Wilde and Moore in the context, in their cases, of arguments and avowals that were fundamentally serious allows her to add these touches of the absurd, and to take literary advantage of them, without implying that her enthusiasm for food is not, beneath it all, authentic. So the irony, to repeat, is an irony concerned with personal commitment. That she applies criteria associated with *beauty*, which, as Kantian aesthetics has it, we tend to think universal (a judgement on beauty implying more than just an expression of individual predilection), to the matter of food – which we are more accustomed to think subject only to personal *tastes* (for which there need be no accounting) – raises the stakes further, intensifying the irony.

But parody is perhaps not the most interesting way in which these articles engage with contemporary culture. In the pieces collected in

Feasts, allusions range from Velazquez to Whistler, from Theocritus to Henry James: a sophisticated but not too arcane sphere of reference for a sophisticated but not uniformly erudite readership. It is the engagement with literary traditions and conventions that is of primary concern in what remains of the present chapter.

The novelist and poet George Meredith, celebrated for his intellectual art-prose, and often drawn to the topic of food and wine, may not be the most obvious point of comparison with Pennell's stylistic strategies, but there is a telling likeness. His name is mentioned, significantly, in the articles as a symbol of the increasingly highbrow tastes of readers: in the article 'On Salads' (a topic about which English diners were beginning, Pennell thought, to see the light, leaving behind pure vinegar dressings), she explains:

> The coming of the salad in England marks the passing of the Englishman from barbarous depth to civilized heights. Has he not exchanged his old-love Frith for Whistler, and has he not risen from G.P.R. James to George Meredith? Not a whit less important in the history of his civilization is his emancipation from that vile, vinegar-drenched abomination to the succulent tomato, the unrivalled potato.[21]

Meredith, with Whistler, apparently stands for progressive high culture and superior taste.

Meredith and his characters tended to become rhapsodic on the subject of wine more often than food. In *The Ordeal of Richard Feverel*, Sir Austin, baronet, goes to visit his lawyer, Mr Thompson, to discuss some worries concerning his son; but Mr Thompson, having fortified himself for the interview with a glass of his favourite port, can bring himself to speak of nothing but the quality of the wine:

> The old lawyer sat down to finish his glass, saying, that such a wine was not to be had everywhere.
>
> They were then outwardly silent for a space. Inwardly one of them was full of riot and jubilant uproar: as if the solemn fields of law were suddenly to be invaded and possessed by troops of Bacchanals: and to preserve a decently wretched physiognomy over it, and keep on terms with his companion, he had to grimace like a melancholy clown in a pantomime.
>
> Mr. Thompson brushed back his hair. The baronet was still expectant. Mr. Thompson sighed deeply, and emptied his glass. He combated the change that had come over him. He tried not to see Ruby. He tried to feel miserable, and it was not in him.[22]

The approach to humour – leaving aside Meredith's larger comic purposes – is comparable with Pennell's, with elaborate quasi-conversational prolixity, ironic hyperbole, choice and sometimes archaic or formal diction, and far-fetched or jostling fields of reference (here, law courts, Greek mythology and pantomime), all playing their parts in the determination of a jaunty tone. And the tone is ironic with that same irony of uncertain commitment. There is, on the one hand, the enthusiasm for port into which Meredith's narrator enters, sympathetically with Mr Thompson; on the other, the ironical observation of the onlooker amused by the exaggeration, and required simultaneously to look at the proceedings from Sir Austin's point of view. What helps to keep a tense and humorous balance is the ambiguous status of the 'jubilant uproar' and its source. The passage does not invite the reader to think the enthusiasm for this fine old port an ignoble or tawdry prepossession; the question is whether or not we believe that Thompson has more important matters to be attending to. Something like this is always under the surface of Pennell's gastronomic writing, with the added frisson, in her case, of the avowed and exploited fact that a late-Victorian woman taking a serious interest in food runs a greater risk of being thought vulgar than a late-Victorian man taking a serious interest in wine.

When Pennell waxes enthusiastic, she can produce a similar kind of humour through a not dissimilar kind of prose, with fanciful imagery and an ironised use of high register. Take for example her celebration of 'the soul-inspiriting berry', coffee:

> And while they thus dwelt in sorrowful ignorance, shepherds leading their flocks through sweet pasture-land, paused in their happy singing to note that the little kids and lambs, and even staid goats and sheep, waxed friskier and merrier, and frolicked with all the more light-hearted abandonment after they had browsed upon a certain berry-bearing bush. Thyme and lavender, mint and marjoram, never thus got into their little legs, and sent them flying off on such jolly rambles and led them into such unseemly antics. And the shepherds, no doubt, plucked the berry and tasted it and found it good.[23]

The pastoral theme answers to Meredith's appeal to 'troops of Bacchanals', and the conversationally self-propelling, polysyndetic sentences here produce a sense of urbanely controlled excitability, elegant surplusage, comparable with Meredith's serenely accumulating excesses in the passage above. Pennell is, in a sense, inviting us to suppose the existence of a putative Sir Austin, baffled

and dismayed, in his attempt to discuss serious business, by his interlocutor's rapturous involvement with mere wine – in Pennell's case, mere food; but she does not suppose us to *be* Sir Austin. His imaginary presence (as it were) is important to the impression of a knowing, playful complicity that her tone gives: we may have a little Sir Austin within us, as we read her, but he must not attain the upper hand.

Unlike Meredith, Pennell has no fictional characters through which to channel these sentiments. For Meredith, even in the most ambiguous passages of 'free indirect', the imagined character provides the basis for comedic material; in Pennell, the comic elements are absorbed into her own belletristic persona. It is probably because of this that her exaggerations can seem crude: in order to keep an ironic tension alive, with only her own assumed 'voice' and vague hints of parody to work with, she must sometimes speak so as to seem sincere, and sometimes lurch to the other extreme and reassure us that she is not always, or wholly, so. Otherwise, though there is no real chance that anyone could take it as totally *un*ironic, the ambiguous middle ground might be taken entirely as parody, with no genuine gastronomic enthusiasm at all: a mistake which would make the writing much less compelling.

We are more used to hearing a Meredithian character's urbane raptures about wine (that being a topic more readily associated with seriousness and refinement) than Pennell's similar raptures applied, say, to cheese; not that cheese is less dear to the connoisseur, but that an exaggerated love for it implies motives of appetite which may seem gross by comparison. There is a homeliness about cheese; it is associated with smelliness – reminiscent sometimes of corporeal odours – and, from a digestive point of view, richness. These associations, together with the notion of greediness in its devotees, are exploited by Pennell in her piece 'Indispensable Cheese', compounding the hints of jovial vulgarity in her pose as 'greedy woman' whilst revelling in delicate literary references. Evoking the Greek pastoral verse of Theocritus, 'there must ever linger about it [cheese]', she says, 'sweet echoes of Sicilian song sung under the wild olives and beneath the elms'.[24] And Pennell subtly brings into the bounds of her tone the frisson of the homelier associations: 'Port Salut', she writes, 'is a cheese that smells of the dairy; that, for all its monastic origin, suggests the pink and white Hetty or Tess with sleeves well uprolled over curved, dimpling arms'.[25] Now we are in the world of an Eliot or Hardy novel; and 'pink and white' complexions and 'dimpling arms' exposed by rolled-up sleeves introduce a note of ironised sensuality which melds

with the odorous plumpness of the cheese to create a feeling of slight embarrassment. This is surely Pennell's purpose. 'Cheese-fed were the shepherds who piped in the shadow of the ilex tree', she says elsewhere, with pastoral poetry again in mind, 'while the calves were dancing in the soft green grass'. But here she goes on, again playing up the embarrassing aspects of cheese in all its materiality: 'cheese-scented was the breath of the fair maidens and beautiful youths they loved'.[26] From the milkmaid fantasies of the other passage, smacking of seventeenth-century poetry or Hardyesque fiction, we shift to a strange version of the frolicsome *eroticism* of the classical bucolic; but by the time we have heard 'cheese-scented', the maidens and youths seem somewhat less fair and beautiful. Indelicacy is what Pennell is playing with here, as in so much of her other culinary writing.

It is curious that one of G. K. Chesterton's best-remembered essays, the one on 'Cheese' in *Alarms and Discursions*, as well as offering a parallel to the passages in which Pennell uses gastronomy to glance at social questions (since 'Modern Life' is Chesterton's ulterior topic), also takes good advantage of the same hard-to-define indelicacy of cheese. He too pushes ironically at cheese's poetical, or unpoetical, credentials:

> Poets have been mysteriously silent on the subject of cheese. Virgil, if I remember right, refers to it several times, but with too much Roman restraint. He does not let himself go on cheese. The only other poet that I can think of just now who seems to have had some sensibility on the point was the nameless author of the nursery rhyme which says: 'If all the trees were bread and cheese' – which is indeed a rich and gigantic vision of the higher gluttony. If all the trees were bread and cheese there would be considerable deforestation in any part of England where I was living.[27]

It makes a difference that Chesterton was well known to be a man of large dimensions and rotund physique; the author is playing up his own image as a person given to 'the higher gluttony' (a phrase very much in Pennell's vein). Pennell as 'greedy woman' is doing something similar to what Chesterton does in the guise of a jovially overweight man; but she makes it a matter of sex. In *My Cookery Books* she refers to her 'weekly column on cookery' as an undertaking for which her 'only qualifications were the healthy appetite and the honest love of a good dinner usually considered "unbecoming to the sex"'.[28] Cheese, in particular, being both indefinably indelicate and at the same time a savant's dream of subtle and endless variation (an indelicate delicacy), is a foodstuff particularly suited to her purposes in making tension from the position she adopts.

One influence shared by Pennell with Chesterton and Meredith – palpable in the choice archaic diction and artificial syntax – is Charles Lamb. The *Essays of Elia* are notable for the way in which Lamb, through his alter ego Elia, uses exquisite irony to negotiate potential embarrassment, vulgarity, coarseness and personal frailties in a compellingly ambiguous way, skirting around difficult or private matters while giving an impression of both confidentiality and evasiveness, sometimes with hints of an adoptive loftiness or glibness which operates as a parodic smokescreen. They are a good example, then, for Pennell in her guise of 'greedy woman', unbecomingly gluttonous, sometimes parodic, sometimes more or less candid, always humorously ironic. Lamb, in an essay called 'Newspapers Thirty-Five Years Ago', gives a brilliant representation of delicate indelicacy:

> What an occasion to a truly chaste writer, like ourself, of touching that nice brink, and yet never tumbling over it, of a seemingly ever approximating something 'not quite proper'; while, like a skilful posture-master, balancing betwixt decorums and their opposites, he keeps the line, from which a hair's breadth deviation is destruction; hovering in the confines of light and darkness, or where 'both seem either;' a hazy uncertain delicacy.[29]

And in Lamb, too, the theme of eating was recognised as one conducive to his mode of irony. In 'Grace Before Meat' he mixes sexual innuendo and eroticism into his depiction of a lavish meal, partly, no doubt, so as to make the potential indelicacy of *gourmandise* more sensibly and productively indelicate. He speaks as a voluptuary of food. Yet, although the extravagant language and the confessional tone make the reader believe readily that Elia really knows and relishes the pleasures he is describing, the hedonistic feelings evoked are there only to be disrupted by the observation that the saying of grace at such a meal is somehow improper:

> When I have sate (a *rarus hospes*) at rich men's tables, with the savoury soup and messes steaming up the nostrils, and moistening the lips of the guests with desire and a distracted choice, I have felt the introduction of that ceremony to be unseasonable. With the ravenous orgasm upon you, it seems impertinent to interpose a religious sentiment. It is a confusion of purpose to mutter out praises from a mouth that waters. The heats of epicurism put out the gentle flame of devotion . . . You are startled at the injustice of returning thanks – for what? – for having too much, while so many starve.[30]

The final words of this extract, with its delayed but sudden arrival at a serious point of ethics, are all the more poignant because the 'epicurism', though cast into moral doubt, is not denied or condemned, but confessed in good humour.

Unlike cheeses, the radish evokes lightness, crispness – delicateness, in fact. How would one remedy this, for purposes of the kind of humour Pennell seems to like? In 'A Perfect Breakfast' she wants us to imagine 'the tiny, round radish, pulled in the early hours of the morning, still in its first virginal purity, tender, sweet, yet peppery, with all the piquancy of the young girl not quite a child, not yet a woman'.[31] Even with so unpromising a topic as the radish, she brings sex into the prospect. 'Tender' implies both the softness of maiden flesh and the relaxation of erotic morals (*tendresse* in its more voluptuous or euphemistic sense). 'Peppery' suggests a zesty, perhaps sensual temperament. And the 'piquancy' of the virgin, between childhood and womanhood, is proposed in a tone of worldly platitude, evoking a libertine perspective. This loitering around an indelicate theme is something one sees often in Lamb, master of unsardonic irony. But here the lightly suggested hints of prurience are also elided with the inevitable suggestion of eating: to eat something that has been elaborately compared with a 'young girl' is potentially unsettling. Consumption of the radish is now associated with sexual enjoyment (of a dubious kind). Out of this awkward or embarrassing complex of notions, Pennell raises humour.

The barbarism – after we have digested the simile and its implications – of crunching up the tender young radish, and the oddly ambiguous authorial tone, is reminiscent of one of Lamb's most famous essays, his 'Dissertation Upon Roast Pig'. In a memorable passage, he labours (as Pennell will do with the virginal radish) the tender youthfulness of the piglet, while summoning thoughts of impure love in which the rest of us, author and reader alike, are presumed to share, and revelling in the awkward feelings of cruelty and prurient sensualism his appetite incites:

> a young and tender suckling – under a moon old – guiltless as yet of the sty – with no original speck of the *amor immunditiæ*, the hereditary failing of the first parent, yet manifest – his voice as yet not broken, but something between a childish treble and a grumble – the mild forerunner, or *præludium*, of a grunt.
>
> *He must be roasted.* I am not ignorant that our ancestors ate them seethed, or boiled – but what a sacrifice of the exterior tegument![32]

This last thought leads him to a gleeful meditation on the sensation of biting into the crackling:

> the very teeth are invited to their share of the pleasure at this banquet in overcoming the coy, brittle resistance – with the adhesive oleaginous – oh, call it not fat! – but an indefinable sweetness growing up to it – the tender blossoming of fat – fat cropped in the bud – taken in the shoot – in the first innocence – the cream and quintessence of the child-pig's yet pure food.[33]

Evidently Lamb is playing, as Pennell will, with the tension between gross appetite and elegant gastronomic connoisseurship; and, like Pennell with the radish or the cheese-breathed maidens, he makes deliberate use of erotic associations. 'Coy' is the most revealing word in this respect, though much else is heightened by the suggestion of voluptuousness. It makes the grossness of the fat – 'adhesive and oleaginous'! – more disquieting. All this is compounded by the self-aware barbarism of Elia's insistence on the childlikeness of the piglet. 'See him in the dish, his second cradle', he says later, 'how meek he lieth!' – which mixes the canonical cannibalism of Swift's *Modest Proposal* with shades of the baby Jesus.[34]

Pennell's girl-radish, waiting to be consumed, has its comparably disturbing connotations, before which the fleeting image stops just short – 'hovering in the confines of light and darkness', as Lamb has it. Indeed, what it stops just short of, given the time and place and organ in which it was published, is perhaps even more disconcerting, because its latent implication had a more current and topical applicability. Any further and it would sharply cease to be funny. With its merging of sexual and ingestive appetites, it risks summoning hints of the Minotaur allegory proposed famously by W. T. Stead in 'The Maiden Tribute of Modern Babylon', his headline-making, law-changing series of investigative pieces on child prostitution in the metropolis, a series published in 1885 – in his own, and soon to be Pennell's, *Pall Mall Gazette*.

Finally, leaving the topic of food – with its special opportunities for ironies of commitment, confession, embarrassment – it is worth thinking of Pennell's approach in relation to one more of her contemporaries: R. L. Stevenson, a fellow writer for the *Pall Mall* during the 1890s.[35] I will take only one point of comparison, though many could be found.

In an 1884 essay in *The Magazine of Art*, 'A Penny Plain, Two-pence Coloured', Stevenson reminisces about his childhood love of the toy theatre plays published as 'Skelt's Juvenile Drama'. As is often the case in Stevenson, boyishness and childhood enthusiasms make for a delicate, kindly irony, in which the author stands somewhat apart from himself as a boy, but also reinhabits his old self and confesses to continued or rekindled experiences of the boyish kinds. The way he handles this, with ironic but confessional and excitable tones, is some-times very similar to Pennell. The sub-Elian archaism and extrava-gance of diction are once more in evidence: 'with reverence be it said'; 'O, how I would long to see the rest!'; or, of his dream of visiting again the shops in which he used to procure the plays: 'I buy, with what a choking heart – I buy them all, all but the pantomimes; I pay my mental money, and go forth; and lo! the packets are dust.'[36] In such sentences and phrases, the tone and the strategies by which it is achieved are conspicuously similar to Pennell's. Having discovered a shop which still sells the beloved articles, Stevenson advises the reader: 'If you love art, folly, or the bright eyes of children, speed to Pollock's, or to Clarke's of Garrick Street.'[37] Compare this tone of address with Pennell's genially authoritative instructions: 'Secure then, without delay – for who would play fast and loose with happiness? – a quart of fresh mushrooms.'[38] And so on. Stevenson knows that not all lov-ers of 'art' will be inclined to share his 'folly', just as Pennell knows that her cultivated art-loving readers, who can appreciate references to Whistler and Wagner, will not be universally ready to enter with the correct spirit into her enthusiasm for tomatoes or onions: 'The plod-ding painter looks upon a nocturne by Whistler, and thinks how easy, how preposterously easy! A touch here, a stroke there, and the thing is done. But let him try! And so with sauce Soubise.'[39] Like Pennell with her everywhere-implicit awareness of her status as 'greedy woman', Stevenson shrewdly acknowledges the risk of ridicule and the half-formed feelings of shame, and then overrides them with unapologetic enthusiasm:

> I was just well into the story of the Hunchback, I remember, when my clergyman-grandfather (a man we counted pretty stiff) came in behind me. I grew blind with terror. But instead of ordering the book away, he said he envied me. Ah, well he might![40]

The posture here is comparable with that in which Pennell speaks of her collection of cookery books: with mingled enthusiasm and, if not embarrassment, at least a consciousness that her enthusiasm

might be thought misplaced or risible by others. 'Friends smile upon me indulgently when I mention my collection, as they might upon a child bragging of paper dolls or marbles.'[41] She portrays herself as the object of her friends' patronising indulgence, compounding the sense throughout the articles that she is putting the reader in an uncertain position: her tone half implies that we, like her, will have a natural taste for the finer things in life, and smile contemptuously with her at those who are immune to such secrets; but at the same time she almost continually implies, as 'greedy woman', that she is also asking for *our* indulgence of her extravagant fancies and appetites.

The ideal reader, perhaps, is one who recognises this tone, this posture, and enjoys the relationship in which it places them with the writer, but for whom no great contribution of charitable indulgence is really necessary. We are to recognise a touch of ironic archness or superiority, but also sympathise primarily with Pennell (as against her bemused acquaintances), when she goes on: 'To talk to such people of my *incunabula* would be throwing my pearls before the outsider.'[42]

Reminiscing about the days of the 'Wares', and about her commissioning editor, Henry Cust, Pennell later wrote with nostalgia that 'editing with him was the pastime of a moment', explaining that 'because he was an amateur in editing, Cust helped his contributors to turn journalism into play'.[43] Pennell's pieces for the 'Wares' were rapidly written, and can, sometimes, particularly when encountered in the complete book, feel as though they relied too heavily on a small box of rhetorical tricks. But if we read them as 'journalism', and also as 'play' (since really they are both), and imagine them dashed off weekly, as they were, by a highly sophisticated writer, we will be best able to appreciate the often subtle ways in which they use modes of irony and humoristic styles which her readers would have met, in different forms, elsewhere; the ways in which elements of parody sustain a recurrent but ambiguous and inconsistent relationship with fashionable aspects of aestheticism and decadence; and, perhaps most subtly of all, the ways in which the special status of food and drink is exploited for a compelling tone of amusing confessionalism. Half apologetic, half defiant, she skirts potential embarrassments with considerable panache. She makes the most of the indecorums and sensitivities occasioned by the subject, hinting at the indelicate, whether by worldly cynicism or false innocence, in her talk of the delicacies of the table.

Notes

1. Pennell, *Nights*, 158.
2. Michie, *Flesh Made Word*, 17; Horrocks, 'Camping in the Kitchen'.
3. Pennell, *Feasts*, 187.
4. Ibid. 182.
5. Pennell, *My Cookery Books*, viii.
6. See Pennell, *Guide for the Greedy*, 1; *Nights*, 142. See also *My Cookery Books*, 2; *Nights*, 158.
7. Pennell, *Feasts*, vi.
8. Pennell, *Nights*, 143.
9. Pennell, *Feasts*, v–vi.
10. Wilde, *Importance of Being Earnest*, 10.
11. Pennell, *Feasts*, 1.
12. Ibid. 2.
13. Pater, *Renaissance*, 252–3.
14. Pennell, *Feasts*, 145.
15. Pater, *Renaissance*, 251.
16. Pennell, *Feasts*, 145.
17. Ibid.
18. Ibid. 154–5.
19. Pater, *Renaissance*, 253.
20. Pennell, *Feasts*, 148.
21. Ibid. 195.
22. Meredith, *Ordeal*, 118.
23. Pennell, *Feasts*, 253–4.
24. Ibid. 225.
25. Ibid. 22; this quotation from another essay, 'Two Breakfasts'.
26. Ibid. 226.
27. Chesterton, *Alarms and Discursions*, 57.
28. Pennell, *My Cookery Books*, 2.
29. Lamb and Lamb, *Works*, 2: 221.
30. Ibid. 2:92.
31. Pennell, *Feasts*, 12.
32. Lamb and Lamb, *Works*, 2: 123.
33. Ibid. 2: 123–4.
34. Ibid. 2: 124.
35. 'Mr. Stevenson' is quoted once in *Feasts* ('A Dish of Sunshine', 145). Another, more regular contributor was his cousin, the art critic Robert Alan Mowbray Stevenson, a friend of the Pennells who is affectionately portrayed at some length in *Nights* (160ff.).
36. As reprinted in Stevenson, *Memories and Portraits*, 203–16, 211, 205, 216 respectively.
37. Ibid. 215.
38. Pennell, *Feasts*, 145.

39. Ibid. 165.
40. Stevenson, *Memories and Portraits*, 207.
41. Pennell, *Guide for the Greedy*, 3.
42. Ibid.
43. Ibid. 2, 1.

Bibliography

Chesterton, G. K. *Alarms and Discursions*. London: Methuen, 1910.

Horrocks, Jamie. 'Camping in the Kitchen: Locating Culinary Authority in Elizabeth Robins Pennell's *Delights of Delicate Eating*'. *Nineteenth-Century Gender Studies* 3, 2 (Summer 2007). Accessed 15 June 2018. http://ncgsjournal.com

Lamb, Charles and Lamb, Mary. *The Works of Charles and Mary Lamb*, ed. E. V. Lucas. 8 vols. London: Methuen, 1912.

Meredith, George. *The Ordeal of Richard Feverel* [1859]. 1896 edn. London: Constable, 1918.

Michie, Helena. *The Flesh Made Word: Female Figures and Women's Bodies*. Oxford: Oxford University Press, 1987.

Pater, Walter. *The Renaissance: Studies in Art and Poetry*. 3rd edn. London: Macmillan, 1893.

Pennell, Elizabeth Robins. *The Delights of Delicate Eating*. New York, Akron, and Chicago: Saalfield, 1901.

Pennell, Elizabeth Robins. *The Feasts of Autolycus*. London: John Lane at the Bodley Head, 1896.

Pennell, Elizabeth Robins. *A Guide for the Greedy by a Greedy Woman*. Philadelphia: Lippincott, 1923.

Pennell, Elizabeth Robins. *My Cookery Books*. Boston and New York: Houghton Mifflin, 1903.

Pennell, Elizabeth Robins. *Nights: Rome, Venice, in the Aesthetic Eighties; London, Paris, in the Fighting Nineties*. London: Heinemann, 1916.

Stevenson, Robert Louis. *Memories and Portraits*. London: T. Nelson & Sons, [1887].

Wilde, Oscar. *The Importance of Being Earnest*. London and New York: Methuen, 1966.

Culinary Ekphrasis: Writing Against Science in Elizabeth Robins Pennell's *The Delights of Delicate Eating*

Bonnie Shishko

In a series of food essays written for the *Pall Mall Gazette* and later published as the collection *The Delights of Delicate Eating* (1901), Elizabeth Robins Pennell dedicates one chapter to a single fish: 'The Simple Sole'.[1] The chapter opens with an equally simple question: 'Have you ever considered the sole?'[2] In an era that saw an unprecedented rise in culinary instruction, it would seem that the answer should be 'yes'.[3] Indeed, a peek into the two most popular cookbooks of the Victorian period reveals a thorough discussion of this particular fish. Full of grisly recipes ('the dark skin of the sole must be stripped off, when it is fried'), Eliza Acton's 1845 *Modern Cookery* details how to clean, carve, stew and bake a sole.[4] In her bestselling 1861 *The Book of Household Management*, Isabella Beeton adds on bits of cultural and natural history, a description of flavour and an account of 'How Soles Are Caught'.[5] Both writers also teach readers how to detect a spoiled fish. 'The cook should be well acquainted with the signs of freshness and good condition', Acton writes,

> as they are most unwholesome articles of food when stale, and many of them are also dangerous eating when they are out of season. The eyes should always be bright, the gills of a fine clear red, the body stiff, the flesh firm, yet elastic to the touch, and the smell not disagreeable.[6]

Beeton echoes this advice: 'This fish should be both thick and firm. If the skin is difficult to be taken off, and the flesh looks grey, it is good.'[7]

In contrast, Pennell frames the sole not as an animal awaiting preparation and consumption, but as an object of the marketplace awaiting aesthetic contemplation:

> Have you ever considered the sole: the simple, unassuming sole, in Quaker-like garb, striking a quiet grey note in every fishmonger's window, a constant rebuke to the mackerel that makes such vain parade of its green audacity, of the lobster that flaunts its scarlet boldness in the face of the passer-by? By its own merits the sole appeals . . . Flat and elusive, it seems to seek retirement.[8]

Like Acton and Beeton, Pennell's description foregrounds the visual qualities of the fish. Yet, in Pennell's hands, these 'merits' take on new meaning. A fish's colours are 'good', to use Beeton's word, not because they signify health but because they please the eye. The act of looking at this food source thus in turn becomes one not of culinary responsibility but of visual discrimination.

In this chapter, I propose that Pennell's culinary writing trains readers to judge food as works of visual art. To make this argument, I spotlight the pictorial vocabulary that undergirds the recipes scattered throughout her essays. In doing so, I uncover Pennell's work to remediate the culinary recipe into instructions for what Kate Flint has called a 'visual act': an intentional, trained method of observation.[9] The Victorians, as Flint has demonstrated, were preoccupied with looking: at the urban landscape, at the natural world, at the commodities of other cultures – and especially at works of visual art.[10] Around mid-century, the rise of the public museum had begun to put increasing pressure on the notion that art belonged exclusively in the homes of the wealthy.[11] As art took its place in the public sphere, so too did the art critic. Instruction in aesthetic spectatorship increasingly became an established feature of the print marketplace, as critics produced a new discourse bent on, in Flint's words, 'translating the visual into the verbal for the non-specialist spectator'.[12]

By the time Pennell published her food column in the 1890s, the professional art critic had thus gained significant purchase in the Victorian aesthetic landscape. A growing body of scholars has made exciting headway in uncovering the expanse of Pennell's critical influence within this landscape and recovering her position as a central figure in the construction of controversial late-Victorian aesthetics and taste. These scholars have largely worked along two lines of inquiry. One line, led by art historians Kimberly Morse Jones and Meaghan Clarke, has analysed Pennell's art criticism, particularly the press art journalism she produced as a member of the controversial group known as the 'New Art Critics'. As Morse Jones has established, Pennell's choice of foregrounding the formal properties of art rather than its story exploded traditional Victorian notions of

the moral and aesthetic sanctity of narrative art.[13] A second line of inquiry, led by Talia Schaffer, Jamie Horrocks and Alice McLean, has mapped Pennell's counter-cultural taste-making work in another area of her oeuvre: her food essays.[14] By teasing out the masculine discourses of aestheticism and gastronomy embedded within *Delights*, these scholars have illuminated Pennell's efforts to reshape a domestic genre – the cookbook – in order to aestheticise two domestic and thus 'déclassée' subjects: cookery and female appetite.[15] These scholars thus show that, in *Delights*, women's work and women's eating are featured as pathways to aesthetic discrimination, 'intellectual appreciation' and bodily pleasure.[16]

Taken together, these lines of inquiry chart a path through Pennell's oeuvre that exposes her practice of using controversial rhetorics (formalism, aestheticism, gastronomy) to champion controversial subjects (avant-garde art, the female appetite, domestic cookery). In doing so, these scholars have established Pennell as one of the edgiest, yet most prolific and influential, taste reformers of her day. What remains to be uncovered, however, is the extent to which Pennell's formalist language of art spectatorship underwrites the architecture of her culinary recipes. In this chapter, I expand these critical considerations of Pennell's reformist aesthetics by revealing that in *Delights* Pennell develops the Victorian eye through what I call 'culinary ekphrasis': recipes that formally describe the dish to be prepared as if it is a painting. In *Delights*, readers learn to see art as a formalist critic would by learning to visually analyse ingredients figured as the properties of a painting. What I ultimately show is that, by discursively representing the private acts of cooking and eating as an act of formalist art spectatorship, Pennell claims the domestic recipe – and the domestic woman – for the discourse and practices of the New Art Criticism.

'Educated Cooking'

In her consideration of 'The Simple Sole', Pennell follows her reflections on the sole's visual beauty with a recipe for *Sole au gratin*:

> Let your first care be the sauce, elegantly fashioned of butter and mushrooms and shallots and parsley; pour a little – on your own judgment you have best rely for exact quantity – into a baking-dish; lay the sole upon this liquid couch; deluge it with the remainder of the sauce, exhilarating white wine, and lemon juice; bury it under bread-crumbs, and bake it until it rivals a Rembrandt in richness and splendour.[17]

By the 1890s, Victorian readers would have been unsurprised to find a recipe in a daily paper. The expansion of the press in nineteenth-century England meant that, beyond a steep rise in the number of cookbooks published, recipes and columns on cookery appeared in an increasingly wide range of popular journalism.[18] Yet not this sort of recipe. By the 1890s, the widespread call to represent cookery as a 'scientific' process had driven most culinary writers to prune their recipes of any extraneous, subjective detail. This call was not new in Pennell's moment. Around mid-century, complaints began to bubble up across a variety of print venues about the state of English cookery. Writers unanimously insisted that traditional working- and middle-class women prepared unwholesome food that cultivated disease, threatened the family structure and perpetuated poverty. Gaining particular purchase was the notion that such problematic cookery could be eradicated if women would only learn the 'first principles', or the chemistry of food.[19] In 1871, for example, an article in *The Ladies' Treasury* argued that '[a] lady who understands the simple rules of cookery produces, by her careful and reasoning thought, a healthful, appetising compound or simple and inexpensive aliment'. A woman who is 'ignorant of such knowledge, or of the scientific application of a few simple rules', on the other hand, 'in her blind efforts produces waste, "villanous [*sic*] compounds", sickness, and misery, because she did not use her intellect – she worked without thought'.[20] In his 1874 cookbook, adapted from his cookery lectures at the Third International Exhibition, chemist John Buckmaster concurred. 'Educated cooking', he insists, 'is as much a science as chemistry . . . This exercise of a woman's faculties is itself an education of the highest order.'[21]

As historians of the cookbook have documented, the Victorian cookbook – and particularly the recipe – shapeshifted in an effort to present cookery not as a technical craft but as an 'educated' enterprise.[22] Perhaps the most famous revisions occurred under the pens of none other than Eliza Acton and Isabella Beeton. As Nicola Humble argues, Beeton 'tried to put cooking on a logical, scientific basis' by revising both the form and content of the recipe.[23] Building from Acton's 'rationalist innovations' of structure, Beeton replaced the recipe's traditional paragraph form with concise craft directions and lists.[24] Through the inclusion of exact temperatures, cooking times and measurements, furthermore, Beeton implanted into the recipe a new level of 'scientific' precision.[25] Caroline Lieffers has argued that this larger trend towards 'quantification and precision' was meant to frame the domestic cookbook as a 'scientific treatise' backed by professional rather than domestic experiential authority.[26]

Given this seepage of scientific rhetoric into the forms and content of the cookbook, what, then, can account for Pennell's 'recipe' for *Sole au gratin*? For there are no lists, and, through parenthetical dashes, Pennell takes pains to visually underscore the absence of numbers: 'pour a little – on your own judgment you have best rely for exact quantity – into a baking-dish'.[27] Her baking instructions are similarly unquantified. Once readers 'deluge' the fish 'with the remainder of the sauce' and 'bury it under bread-crumbs', she instructs them not to 'bake for 20 minutes'[28] – as Beeton does in her recipe for 'Baked Soles' – but rather to 'bake it until it rivals a Rembrandt in richness and splendour'.[29]

I argue that in recipes such as those for *Sole au gratin*, Pennell writes against science, reclaiming for Art the very textual form through which Victorian writers rationalised cookery. In this example, she strips the recipe of its visible claim to scientific authority, wedging pictorial description into the textual spaces where readers would expect to encounter numbers. Other scholars have zeroed in on these numeric silences, arguing likewise that they function as a key site in Pennell's aestheticising labours. Schaffer, for example, reads such passages as a 'compromis[e] between the cookbook genre and the critique', arguing that this 'rhetorical sleight-of-hand' enabled Pennell to distance herself from the cookbook and thus preserve her aesthetic standing.[30] Horrocks, in contrast, finds in such numeric gaps an embrace rather than a rejection of the recipe. Unlike Beeton, she argues, Pennell uses 'imprecise suggestions, multiple options, and only the vaguest of actual directions' in order to lead readers in an 'ethical cultivation' of taste defined by equal parts of indulgence and restraint.[31] Horrocks thus demonstrates that within *Delights*, 'the preparation and consumption of food can become a means of serious self-cultivation'.[32]

Like these scholars, I share an investment in parsing the recipe's place in Pennell's cultivating work. What's missing from these accounts, however, is a reckoning with how Pennell reconstructs the recipe with formalist language in order to install aesthetic sight over scientific law as a foundational epistemology of the Victorian kitchen. To do so, as I discuss at length below, she turns to the structure of the classical recipe – what Robert Appelbaum describes as 'a sequence of actions . . . prescribed by way of a series of imperatives'.[33] If we parse *Sole au gratin* carefully, we can tease out that structure. One sentence contains five imperatives: 'pour', 'lay', 'deluge', 'bury' and 'bake'. Through a series of semi-colons, furthermore, Pennell creates a classic recipe sequence; semi-colons suggest not a full stop, but a

series of steps. In the final step, Pennell borrows the sentence structure of a traditional recipe ('bake it until') but replaces numbers with ekphrasis: a visual description of the baking dish as though it is a painting. Here, Pennell leads the cook in a visual rather than a scientific analysis. To successfully bake *Sole au gratin*, the reader cannot watch the clock, but must turn inward to her mind's eye. She must conjure up an image of a Rembrandt painting, checking *its* 'richness' and 'splendour' against that of the dish baking in her oven.[34]

In Pennell's hands, then, the recipe retains the Victorian vision of cookery as 'educated' rather than technical. But whereas Buckmaster insisted that the 'exercise of a woman's faculties' through science 'is itself an education of the highest order',[35] Pennell argues for a readership 'educated to look upon food and drink' as 'might the painter regard his colours, the sculptor his clay and marble – as means only to a perfect artistic end'.[36] What I thus want us to see is that formalist description of food in *Delights* represents not only an attempt to aesthetically intellectualise cooking and eating, as scholars have already productively argued.[37] Rather, I argue that we ought to read Pennell's culinary ekphrases as indicative of what Michael McKeon, in his work on the novel, has called an 'epistemological crisis', or a shift in beliefs about methods of representation and the 'truths' or knowledges they signify.[38] By presenting recipes wherein the pictorial overwrites the scientific, Pennell looks to overwrite notions of culinary 'truth' that served as the generic raison d'être of many foundational culinary texts of the Victorian era.

Yet her purpose in doing so is not only to cultivate what Rachel Teukolsky calls a 'literate eye'. For, while Pennell might disdain the *kinds* of knowledge Victorian cookbook writers entrenched, she nevertheless joins the chorus of disapproval over how British women prepared food. '[I]n the cultivation and practice of an art which concerns life more seriously', she writes in her introduction, 'woman has hitherto proved an inferior creature'.[39] Rattling off a list of famous male chefs, Pennell complains that although '[f]or centuries the kitchen has been her appointed sphere of action . . . here, as in the studio and the study, she has allowed man to carry off the laurels'.[40] Indeed, 'three times a day there is a work of art, easily within her reach, to be created', and yet, 'the kitchen still waits its Sappho'.[41] Like Buckmaster and other advocates of scientific cookery, Pennell makes clear in her introduction her plans to school women's 'faculties' and thus their food practices. 'Therefore let her be brought face to face with certain fundamental facts', she writes, 'and the scales

will fall quickly from her eyes, and she will see the *truth* in all its splendour'.[42]

As McKeon's foundational work on the novel makes clear, shifts in belief accompany shifts in the representation of that belief.[43] In what follows, I spotlight a series of culinary ekphrases that instruct through visual – rather than scientific – precision. As Pennell herself explains, her column 'does not pretend to be a "Cook's Manual" or a "House-wife's Companion": already the diligent, in numbers, have catalogued *recipes*, with more or less exactness'.[44] The classical recipe, despite its newfound 'exactness', cannot teach women alimentary 'truth'. What *can*, however, is the 'guide' Pennell constructs 'to the Beauty, the Poetry, that exists in the perfect dish, even as in the masterpiece of a Titian or a Swinburne'.[45] Schaffer has noted Pennell's choice of the word 'guide', arguing that it positions her 'as a guide to Beauty rather than a cookbook author'.[46] I add that it also frames *Delights* itself as the kind of critical text that worked to dictate Victorian practices of art spectatorship. The Victorians, as Teukolsky has argued compel-lingly, learned how to look at art not only by visiting galleries, but also by reading about looking at art. Indeed, '[t]he Victorian experi-ence of art', she explains, 'was shaped by a flurry of accompanying captions, poems, guidebooks, and other linguistic signs, producing a wholesale entwining of writing and seeing'.[47] The explosion of what Teukolsky calls 'scripts of art writing' in the second half of the era was thus 'not merely incidental to spectatorship, but in fact worked to construct the Victorian art experience'.[48]

Such scripts were not confined to a single genre; instead, Meaghan Clarke has identified the 'heterogeneity' of the forms of criticism produced by women critics in the late-Victorian era.[49] I argue that, in *Delights*, Pennell adds the recipe to this heterogeneous 'flurry', using the textual form of the culinary ekphrasis to 'script' a formal-ist 'art experience' in the kitchen. Let us now look at those scenes in *Delights* wherein women learn 'educated cooking' by learning to analyse not the chemical or numeric but the visual qualities of food.

Culinary Ekphrasis

Pennell, scholars agree, had a complicated relationship with what she called the 'modern' recipe. Noting its reverence for quantification – '"Take so much of this, add so much of that", . . . as the dull case may be' – Pennell complained that the recipe had, in the hands of nineteenth-century writers, been made 'blunt to the point of brutality'.[50] Scholars

have focused on her consequent efforts to avoid the directional preci-
sion of the 'modern' recipe.[51] Indeed, many of Pennell's recipes are, at
first glance, full of instructional holes. Consider the following direc-
tions for a mushroom omelette, or *Oeufs brouillés aux champignons*,
from her chapter 'Two Breakfasts':

> Sweet symphonies in brown and gold are the dishes their union yields . . .
> The eggs, scrambled and rivaling the buttercup's rich gold, are laid deli-
> cately on crisp toast, and present a couch, soft as down, for a layer of mush-
> rooms. Let Ruskin rave of Turner's sunsets, let the glory of the Venetians
> be a delight among art critics; but when did Turner or Titian or Tintoret
> invent a finer scheme of colour than egg and mushroom thus combined? . . .
> A silver dish or one of rarest porcelain should be frame for a picture so
> perfect . . . [V]ary the arrangement to your own profit. Make a *purée* of
> the mushrooms, as rich as cream permits, and offer it as a foundation for
> eggs poached deftly and swiftly: a harmony in soft dove-like greys and pale
> yellow, the result.[52]

Like the recipe for *Sole au gratin*, this paragraph contains nary a
number; its explanation of culinary method is likewise all but nil. A
recipe for *Sole farcie aux crevettes* continues this pattern:

> In this case it is wise to fillet the sole and wrap each fillet about the
> shrimps, which have been well mixed and pounded with butter. A rich
> *Béchamel* sauce and garniture of lemons complete a composition so
> masterly that, before it, as before a fine Velasquez, criticism is silenced.[53]

Here, as in *Oeufs brouillés aux champignons* and *Sole au gratin*,
Pennell begins by describing the composition of a dish and ends by
presenting the completed dish as a work of visual art.

Given these lapses in generic convention, can such vague instructions
'count' as a recipe? I propose that such passages illustrate Kyla Tomp-
kins's point that '[t]he recipe is an evolving textual form with a history
of its own' and that these very lapses put pressure on Victorian – and,
indeed, contemporary – notions of what a recipe ought to look like and
what it seeks to do.[54] As scholars of the recipe have shown, the recipe,
at its core, is an imperative genre; its function is always to prescribe.
William Eamon, for example, explains that a recipe 'is a prescription
for taking action: *recipe* is the Latin imperative "take". Because it pre-
scribes an action, . . . [a] recipe is a prescription for an experiment, a
"trying out".'[55] Yet Robert Appelbaum has argued for a more compli-
cated understanding of its narrative function. The recipe, he argues, is

a form of rhetoric – one that seeks to 'persuade its readers to adopt' not *only* certain culinary methods, but also 'a certain epistemology of food'.[56] Recipe instructions, he explains, thus dictate 'not only ways of doing but also ways of knowing'.[57]

Pennell's culinary directions, I argue, do not conform to 'modern' Victorian conceptions of the recipe as a textual form because the 'epistemology of food' she writes from within likewise does not conform. If we run the above directions not through a rationalist rubric but through one valuing the pictorial, what we find are recipes deliberately constructed to dictate 'ways of doing' that extend from and cultivate visual 'ways of knowing': how to envision – and simultaneously compose – a series of visual masterpieces. Through a sequence of action verbs, the passages command readers to combine certain ingredients ('brown and gold' and 'soft dove-like greys and pale yellow', or mushrooms and eggs; sole, shrimp and butter); dictate how the ingredients should be prepared (eggs 'scrambled', but not well done, for they must be 'rich gold' and 'soft as down', or 'poached deftly and swiftly'; sole 'fillet[ed]'); explain how done to make the toast ('crisp'); and, in the first recipe, even dictate which serving dish should be used as a 'frame' (silver 'or one of rarest porcelain').

Far from being vague, these recipes teem with precise instructions. But, for her directions, Pennell replaces rationalist with formalist precision. Culinary instruction comes to readers not in numbers and lists, that is, but in formalist ekphrases – vivid description that compels readers to imagine ingredients as the formal elements in a painting. Lest readers miss their cue, Pennell alludes to James McNeill Whistler, to Velasquez and to Ruskin's famous ekphrases of Turner's paintings, as a hint that she, too, is walking them around a work of art, pointing out its formal elements of colour, texture and medium.

At first glance, Pennell seems to be deploying ekphrasis in its modern sense: a linguistic description of a work of visual art.[58] But these dishes are not, in fact, paintings. Indeed, there is no material object to describe, for they do not (yet) exist. Instead, I suggest that the culinary ekphrases in *Delights* follow the rhetorical pattern set out by the ancient Greeks: what Ruth Webb defines as 'the use of language to try to make an audience imagine a scene'.[59] Webb explains that, unlike a modern ekphrasis, the ancient ekphrasis did 'not seek to represent' a pre-existing aesthetic object, but instead sought 'to have an effect in the audience's mind that mimics the act of seeing'.[60] In this ancient understanding of the rhetorical function of ekphrasis, 'the impact of the ekphrasis is visual . . . Mere words are credited with the ability to make absent things seem present', and thus 'to control

the contents of the most intimate of faculties, the imagination'.[61] As an ancient rhetorical practice, an ekphrasis was therefore 'credited with the ability to place "before the eyes" and 'to make listeners into "spectators"'.[62]

In the above passages, Pennell's pictorial language transforms readers into spectators, gradually 'mak[ing] absent things seem present' in the mind's eye of her reader.[63] Crucially, the culinary ekphrasis does not narrate something that exists already. Instead, step by step, ingredient by ingredient, the passage constructs in the reader's imagination images of dishes to be made and consumed in the future. ('You: do this', as Tompkins puts it.[64]) The rhetorical functions of the ekphrasis and the recipe merge; as a result, the culinary ekphrasis refuses to heed distinctions between the rhetoric of food preparation and the rhetoric of aesthetic spectatorship. In turn, it implies that these two acts – cooking and looking – are epistemologically synonymous. Both, that is, require and, indeed, cultivate what Clarke calls the 'authoritative gaze' deployed by professional women critics in the Victorian era.[65] Following Lynda Nead, Clarke explains that, while Victorian ideals of femininity urged women to adopt 'superficial', 'demure or absent looks' in the public gallery, women critics 'were *employed* to look'.[66] As such, these women cultivated modes of looking that allowed them to join their male counterparts in 'conveying the visual through print culture'.[67] Morse Jones has demonstrated that Pennell established her own 'authoritative gaze' through criticism born of the 'intense observation' of technique and 'handling of material'.[68] Morse Jones explains that Pennell and her fellow New Art Critics, eschewing the trendier mode of 'objective' looking that boasted a 'close scientific scrutiny of anatomical parts depicted in painting', preferred a purportedly more 'subjective' method: the identification of form, technique and treatment of material as practised by the individual artist.[69]

In *Delights*, Pennell builds her culinary ekphrases with the vocabulary born of this formalist critical gaze. Indeed, as Morse Jones notes, *Delights* is rife 'with aesthetic tropes, such as references to formal elements, delicacy, beauty, harmony and pleasure'.[70] At first glance, this can seem a matter of mere copying. 'Schemes of colour', 'harmonies' and 'arrangements' – the latter two words lifted from Whistler[71] – dot her reviews and food essays alike. (Pennell presents the egg and mushroom omelette above, for example, as a 'scheme of colour', just as she remarked in her review of Whistler's 'Six Projects' that his 'floating draperies give the work its "scheme of colour".'[72])

Yet, if we look closely, we find that Pennell, in fact, transplants her critical formalist vocabulary quite deliberately. Once grafted into the

framework of the recipe, these words take on the narrative function of ekphrasis, transforming the ingredients for her proposed dishes into the formal elements of an imagined painting. As she walks the reader through meal plans, Pennell's culinary ekphrases in turn cause readers to scrutinise the dishes' ingredients using the same formalist 'authoritative gaze' Pennell herself employed. In 'Two Breakfasts', for example, Pennell summons up 'a fine symphony in gold', rhetorically framing the meal as an alimentary counterpart to Whistler's *Symphony in Red and White*.[73] The ensuing passages construct a mental picture of the meal – element by element, dish by dish. The main dish of this 'symphony', *omelette aux rognons*, 'must be frothy, and strong in that quality of lightness which gives the keynote to the composition as a whole. Enclosed within its melting gold, at its very heart, as it were, lie the kidneys elegantly minced and seasoned with delicate care.'[74] Next comes *Pilaff de volaille á l'indienne*, chosen because it presents

> a new and more stirring symphony in the same radiant gold. For golden is the rice, stained with curry, as it encircles the pretty, soft mound of chicken livers, brown and delicious . . . The curry must not be too hot, but rather gentle and genial like the lovely May sunshine.[75]

When instructing readers to include peas to succeed the pilaf, she writes, 'Now, a pause and a contrast. Gold fades into green. As are the stalks to the daffodils, so the dish of *petits pois aux laitues* to *pilaff*' [the above course] and *omelette*' (the first course).[76] To complete the 'symphony', 'Graves is the wine to drink with daffodil-crowned feast – golden Graves . . . Coffee completes the composition nobly, if it be black and strong.'[77]

By representing ingredients as formal elements in a Whistlerian 'symphony', the most deliciously prepared food becomes rhetorically indistinct from the most visually beautiful art. In *omelette aux rognons*, a centrepiece of daffodils 'prove[s] motive to a fine symphony in gold'. The omelette must achieve 'lightness' – a word that evokes both colour and texture – because it 'gives the keynote to the composition as a whole', while the kidneys, once 'elegantly minced and seasoned with delicate care', are to be centred in the omelette, 'within its melting gold', as visual contrast.[78] In *pilaff de volaille á l'indienne*, Pennell suggests mixing or 'stain[ing]' the rice with curry so that it becomes 'golden'; the curry's preparation, in turn, is determined by colour, its taste rendered inextricable from its visual appearance by a simile ('The curry must not be too hot, but rather gentle and genial

like the lovely May sunshine'). And, finally, colour compatibility determines drinks: '[G]olden Graves' 'is the wine to drink with daffodil-crowned feast', coffee will 'complete[] the composition nobly, if it be black and strong. And for liqueur, Benedictine, in colour and feeling alike, enters most fittingly into the harmony.'[79]

The decision to train a formalist lens on food was a bold choice for Pennell, not only because it presented food as art – as scholars have established[80] – but because it forced the objects and rituals of everyday life into one of the most rancorous aesthetic debates of the Victorian era. The late-Victorian aesthetic landscape was deeply divided by what Teukolsky calls 'the battle over what kind of criticism is best': that which elucidated and valued a painting's story or its elements of form.[81] Embedded in these questions, as Morse Jones explains, was a larger, more urgent question concerning 'the very nature and function of art as it had been understood in the Western world for centuries'.[82] Did art exist to offer a story or moral? Or did it exist simply *pour l'art* – for the sake of the beauty it brought into the world? While established institutions such as the Royal Academy reified representational art, what Walter Pater called 'aesthetic painting', Teukolsky explains, 'emphasizes sensuous form – drawing, color, or composition'.[83]

As Morse Jones and Clarke have established, Pennell's reams of formalist art journalism helped usher in 'a new standard for art criticism in Britain'.[84] In *Delights*, Pennell makes use of the quotidian – the material ingredients of food, cookery and eating – to further expand this appreciation of 'sensuous form' over representational art. The culinary ekphrasis, that is, requires readers to imaginatively scrutinise food paintings that exemplify not real life (as in a still life) but what Pennell called 'the beauty of colour or form'.[85] As a counterpart to the above 'symphony in gold', for example, Pennell offers a second 'scheme' organised around the red tones cast by 'a bunch of late tulips, scarlet and glowing':

> Open with that triumph of colour which would have enchanted a Titian or a Monticelli: the roseate salmon of the Rhine, smoked to a turn, and cut in thin slices, all but transparent . . . [W]hat better suited for ensuing course than *oeufs brouillés aux pointes d'asperges*? the eggs golden and fleecy as the clouds in the sunset's glow . . . Cloudlike, the loveliness gradually and gracefully disappears, as in a poet's dream or a painter's impression.[86]

Unlike Acton's fish recipe ('the dark skin of the sole must be stripped off'), Pennell depicts no scales, or eyes, or flesh. The animal's fishiness

is instead converted into aesthetic form – a 'triumph of colour', which fades and becomes 'transparent' when sliced well. Recalling Pater's reverence for 'the play of sunlight',[87] the yolks and whites of eggs are likewise figured through a simile into colour and texture ('eggs golden and fleecy as the clouds in the sunset's glow'). Yet the following sentence erases the image the simile has created of a sunset scape, filtering out the referent into pure formal technique: 'Cloudlike, the loveliness gradually and gracefully disappears, as in a poet's dream or a painter's impression.'[88] Through two additional similes, the referential egg-cloud dematerialises altogether, freezing at last into brush strokes.[89] To borrow Emily Allen's words from her analysis of Victorian wedding cakes, this is food for 'ocular, not oral consumption'.[90]

But where does this 'ocular consumption' leave what Pennell calls 'the love of good eating', which she insists 'gives an object to life'?[91] For, as deeply imagistic as *Delights* is, scholars have also uncovered its efforts to, as Schaffer puts it, 'reclaim women's appetite as a natural and valid bodily response'.[92] Alice McLean agrees, noting that Pennell counters the Victorian angst regarding female hunger by promoting 'an educated, aesthetically nuanced female appetite'.[93] Yet both also point to moments in *Delights* where Pennell elides women's eating; they argue that she frequently toggles into aesthetic language in order to de-emphasise the 'sensual pleasures' of the mouth.[94] Schaffer notices a similar narrative silence around culinary labour. Even as Pennell elevates domestic work as art, she replaces culinary with aestheticist language in order to 'play down its physical labor' and foreground its intellectual potential.[95] McLean takes this point a step further, arguing that Pennell, in fact, 'eschewed the cookbook genre altogether'.[96]

On the one hand, the ocular emphasis of the culinary ekphrasis can certainly be read as an attempt to sidestep female consumption and domestic labour. As McLean notes, 'As an "artist in words", Pennell transforms sensual pleasures into language, using lush, evocative prose to paint a verbal picture.'[97] But I suggest that we can also, at times, find that the culinary ekphrasis binds ocular to 'oral consumption'. To illustrate this point, let us return to our opening question: 'Have you ever considered the sole?'[98] Pennell follows her opening ekphrastic description – which mandates ocular consumption of the sole, dressed in its 'Quaker-like garb' – with a series of recipes, which mandate domestic production and, subsequently, consumption. Some of these recipes are quite conventional. Pennell transcribes in full a recipe for *fricasey soals white*, for example, commanding readers to 'skin, wash, and gut your soals very clean, [and]

cut off their heads'.[99] Others, however, continue the narrative pattern of the culinary ekphrasis. One, for 'brown *fricasey*', bookends culinary direction with two formalist valuations:

> If for variety you would present a brown *fricasey*, an arrangement in browns as startling as a poster by Lautrec or Anquetin, add anchovy to your seasoning, exchange white wine for red, and introduce into the mixture truffles and morels, and mushrooms, and a spoonful of catchup.[100]

The conditional sentence structure directly links culinary labour and aesthetic form: *if* readers wish to make a 'startling' 'arrangement in browns', *then* take these steps. ('You: do this'.[101]) Immediately following her culinary directions, Pennell gives a second formalist description of the proposed dish. Here, through a semi-colon, she links visual form not with culinary labour, but with ocular and oral consumption: 'The beauty of the colour none can deny; the subtlety of the flavour none can resist.'[102] If prepared, this 'arrangement in browns' – a classic Whistlerian title – ensures visual and gustatory pleasure alike. A discriminate eye exists not in opposition to but in tandem with a pleased mouth.

What I want us to see in closing is that, in moments such as these, the ocular does not overwrite or even transcend either the labour of cooking or the pleasures of eating. Rather, the culinary ekphrasis activates a visual judgement of food's material form that prompts culinary labour in order to, finally, achieve oral satisfaction. Housed in the structure of the domestic recipe, the visual, the culinary and the gustatory feed each other.

Notes

1. Pennell, *Delights*, 89. Originally written in the 1890s for the *Pall Mall Gazette*'s hit column 'Wares of Autolycus', Pennell's essays were later released as *The Feasts of Autolycus* (England, 1896), and *The Delights of Delicate Eating* (United States, 1901).
2. Pennell, *Delights*, 89.
3. See Attar, *Bibliography*, and Driver, *Bibliography*. Margaret Beetham also discusses the diversification of culinary genres in Victorian England, particularly in relation to Beeton. See Beetham, 'Of Recipe Books'.
4. Acton, *Modern Cookery*, 62.
5. Beeton, *Household Management*, 160.
6. Acton, *Modern Cookery*, 48–9.

 7. Beeton, *Household Management*, 157.
 8. Pennell, *Delights*, 89.
 9. Flint, *Victorians*, 22.
10. See Flint, *Victorians*, 1–5 and chs 7–8. See also Teukolsky, *Literate Eye*, 10–20 and chs 2–3.
11. Teukolsky, *Literate Eye*, 11–14, and Flint, *Victorians*, 4.
12. Flint, *Victorians*, 5. See also Teukolsky, *Literate Eye*, esp. 12–16 and ch. 3, and Prettejohn, 'Aesthetic Value'.
13. Morse Jones, *Elizabeth Robins Pennell*; Clarke, 'Bribery'; and Clarke, *Critical Voices*, 139–55.
14. Schaffer, 'Importance'; McLean, *Aesthetic Pleasure*; and Horrocks, *Gospels*.
15. Schaffer, 'Importance', 107.
16. Ibid. 105.
17. Pennell, *Delights*, 93–4.
18. Beetham, 'Of Recipe Books', 16–19.
19. For excellent accounts of the rise of 'scientific cookery' in Victorian England, see Attar, *Wasting Girls' Time*; Sillitoe, *History*); Yoxall, *History*; and Manthorpe, 'Science or Domestic Science?'. See also Humble, *Culinary Pleasures*, 27–8.
20. 'Social Science', 62.
21. Buckmaster, *Buckmaster's Cookery*, 145.
22. See, for example, Humble, *Culinary Pleasures*, 27–8; Beetham, 'Of Recipe Books', 21–2; and Lieffers, 'Present Time'.
23. Humble, *Culinary Pleasures*, 10.
24. Ibid. 10–11.
25. Ibid. 10. See also Beetham, 'Of Recipe Books', 21–2, and Lieffers, 'Present Time', 938–43.
26. Lieffers, 'Present Time', 938, 947.
27. Pennell, *Delights*, 93.
28. Beeton, *Household Management*, 157.
29. Pennell, *Delights*, 93–4.
30. Schaffer, 'Importance', 110, 119.
31. Horrocks, 'Camping', 59–60.
32. Ibid. 66.
33. Appelbaum, 'Rhetoric', 13.
34. Horrocks likewise compares Pennell's recipes to Beeton's, and has also explored the ways in which such open-ended directions cultivate taste (Horrocks, *Gospels*, 59). Horrocks reads these moments as indicative of Pennell's efforts to use cooking and eating in order to remake readers into 'an aesthete fashioned after the manner of a gastronome; a model of indulgent restraint' (60). I am interested in exploring how Pennell cultivates visual discrimination through a replacement of quantification with the pictorial in the recipe.
35. Buckmaster, *Buckmaster's Cookery*, 145.

36. Pennell, *Delights*, 77.
37. See Schaffer, 'Importance', 105–6, Clarke; 'Bribery', 139; and McLean, *Aesthetic Pleasure*, 51–2, for example.
38. McKeon, 'Generic Transformation', 383.
39. Pennell, *Delights*, 7.
40. Ibid.
41. Ibid. 12, 7.
42. Ibid. 11.
43. McKeon, 'Generic Transformation', 383.
44. Pennell, *Delights*, 8.
45. Ibid. 8.
46. Schaffer, 'Importance', 119.
47. Teukolsky, *Literate Eye*, 16.
48. Ibid. 16.
49. Clarke, *Critical Voices*, 8. See also Prettejohn, 'Aesthetic Value', 71–2, 79.
50. Pennell, *My Cookery Books*.
51. See Schaffer, 'Importance', 118–20; Horrocks, 'Camping', 60; McLean, 'Generic Transformation', 2; and Williams, 'Introduction', viii, x, xx.
52. Pennell, *Delights*, 148.
53. Ibid. 93.
54. Tompkins, 'Consider', 444.
55. Eamon, *Science*, 131.
56. Appelbaum, 'Rhetoric', 31.
57. Ibid. 21–2.
58. Webb, *Ekphrasis*, 1.
59. Ibid.
60. Ibid. 38.
61. Ibid. 38, 8.
62. Ibid. 20.
63. Ibid. 2.
64. Tompkins, 'Consider', 439.
65. Clarke, 'Bribery', 142.
66. Ibid. 141.
67. Ibid. 143.
68. Morse Jones, *Elizabeth Robins Pennell*, 114–15.
69. Ibid.
70. Ibid. 39. For a consideration of Pennell's use of aestheticist rhetoric more broadly, see Schaffer, 'Importance', and Horrocks, 'Camping'.
71. Morse Jones, *Elizabeth Robins Pennell*, 43.
72. Pennell and Pennell, *Life*, 105.
73. Pennell, *Delights*, 27.
74. Ibid. 27.
75. Ibid. 27–8.
76. Ibid. 28.
77. Ibid. 29.

78. Ibid. 27.
79. Ibid. 29.
80. See especially Schaffer, 'Importance', 117–19.
81. Teukolsky, *Literate Eye*, 110. For more on these debates, see ibid. esp. ch. 3; Flint, *Victorians*, chs 7–8; and Prettejohn, 'Aesthetic Value'.
82. Morse Jones, *Elizabeth Robins Pennell*, 8.
83. Teukolsky, *Literate Eye*, 110.
84. Morse Jones, *Elizabeth Robins Pennell*, 54. For more on the gender implications surrounding Pennell's role in this debate, see Clarke, *Critical Voices*, esp. 130–53.
85. Pennell quoted in Morse Jones, *Elizabeth Robins Pennell*, 70.
86. Pennell, *Delights*, 29–30.
87. Walter Pater quoted in Teukolsky, *Literate Eye*, 124.
88. Pennell, *Delights*, 30.
89. Ibid.
90. Allen, 'Culinary Exhibition', 465.
91. Pennell, *Delights*, 11.
92. Schaffer, 'Importance', 105.
93. McLean, *Aesthetic Pleasure*, 53.
94. Ibid. 55. See also Schaffer, 'Importance', 111, 123–4.
95. Schaffer, 'Importance', 122.
96. McLean, *Aesthetic Pleasure*, 2.
97. Ibid. 55. Clarke has also noted Pennell's tendency to fold 'sensorial experience' – including the ocular – into aesthetic taste. See Clarke, 'Bribery', 139–41.
98. Pennell, *Delights*, 89.
99. Ibid. 94.
100. Ibid. 95.
101. Tompkins, 'Consider', 439.
102. Pennell, *Delights*, 95.

Bibliography

Acton, Eliza. *Modern Cookery: In All Its Branches*. Philadelphia: Lea and Blanchard, 1845.

Allen, Emily. 'Culinary Exhibition: Victorian Wedding Cakes and Royal Spectacle'. *Victorian Studies* 45, 3 (Spring 2003): 457–84.

Appelbaum, Robert. 'Rhetoric and Epistemology in Early Printed Recipe Collections', *Journal for Early Modern Cultural Studies* 3, 2 (2003): 1–35.

Attar, Dena. *A Bibliography of Household Books Published in Britain 1800–1914*. London: Prospect Books, 1987.

Attar, Dena. *Wasting Girls' Time: The History and Politics of Home Economics*. London: Virago Press, 1990.

Beetham, Margaret. 'Of Recipe Books and Reading in the Nineteenth Century: Mrs Beeton and her Cultural Consequences'. In *The Recipe Reader: Narratives Contexts, Traditions*, ed. Janet Floyd and Laurel Forster, 15–30. Burlington, VT: Ashgate, 2003.

Beeton, Isabella. *The Book of Household Management*. Lewes: Southover Press, 1998.

Buckmaster, John. *Buckmaster's Cookery: Being an Abridgement of Some of the Lectures Delivered in the Cookery School at the International Exhibition for 1873 and 1874*. London: Routledge, 1874.

Clarke, Meaghan. '"Bribery with Sherry" and "the Influence of Weak Tea": Women Critics as Arbiters of Taste in the Late-Victorian and Edwardian Press'. *Visual Culture in Britain* 6, 2 (December 2005): 139–55.

Clarke, Meaghan. *Critical Voices: Women and Art Criticism in Britain, 1880–1905*. Aldershot: Ashgate, 2005.

Driver, Elizabeth. *A Bibliography of Cookery Books Published in Britain, 1875–1914*. London: Prospect Books, 1989.

Eamon, William. *Science and the Secrets of Nature: Books of Secrets in Medieval and Early Modern Culture*. Princeton: Princeton University Press, 1994.

Flint, Kate. *The Victorians and the Visual Imagination*. Cambridge: Cambridge University Press, 2000.

Horrocks, Jamie. 'Camping in the Kitchen: Locating Culinary Authority in Elizabeth Robins Pennell's *Delights of Delicate Eating*'. *Nineteenth-Century Gender Studies* 3, 2 (Summer 2007). Accessed 12 March 2018. http://ncgsjournal.com

Horrocks, Jamie. *The Gospels of Aestheticism*. Ann Arbor: Proquest, UMI Dissertation Publishing, 2011.

Humble, Nicola. *Culinary Pleasures: Cookbooks and the Transformation of British Food*. London: Faber and Faber, 2006.

Lieffers, Caroline. '"The Present Time is Eminently Scientific": The Science of Cookery in Nineteenth-Century Britain'. *Journal of Social History* 45, 2 (2012): 936–59.

McKeon, Michael. 'Generic Transformation and Social Change: Rethinking the Rise of the Novel'. In *Theory of the Novel: A Historical Approach*, ed. Michael McKeon, 382–99. Baltimore: Johns Hopkins University Press, 2000.

McLean, Alice. *Aesthetic Pleasure in Twentieth-Century Women's Food Writing: The Innovative Appetites of M.F.K. Fisher, Alice B. Toklas, and Elizabeth David*. New York: Routledge, 2012.

Manthorpe, Catherine. 'Science or Domestic Science? The Struggle to Define an Appropriate Science Education for Girls in Early Twentieth-Century England'. *History of Education* 15 (1986): 195–213.

Morse Jones, Kimberly. *Elizabeth Robins Pennell: Nineteenth-Century Pioneer of Modern Art Criticism*. Burlington, VT: Ashgate, 2015.

Pennell, Elizabeth Robins. *The Delights of Delicate Eating*. Urbana and Chicago: University of Illinois Press, 2000.

Pennell, Elizabeth Robins. *My Cookery Books*. Boston and New York: Houghton Mifflin, 1903. Library of Congress Digitized Rare Books. https://www.loc.gov/rr/rarebook/catalog/pennell/pennell-home.html.

Pennell, Elizabeth Robins and Pennell, Joseph. *The Life of James McNeill Whistler*. Philadelphia: Lippincott; London: Heinemann, 1911.

Prettejohn, Elizabeth. 'Aesthetic Value and the Professionalization of Victorian Art Criticism, 1837–78'. *Journal of Victorian Culture* 2 (1997): 71–93.

Schaffer, Talia. 'The Importance of Being Greedy: Connoisseurship and Domesticity in the Writings of Elizabeth Robins Pennell'. In *The Recipe Reader: Narratives Contexts, Traditions*, ed. Janet Floyd and Laurel Forster, 105–26. Burlington, VT: Ashgate, 2003.

Sillitoe, Helen. *A History of the Teaching of Domestic Subjects*. London: Methuen.

'Social Science'. *The Ladies' Treasury*, 1 November 1871.

Teukolsky, Rachel. *The Literate Eye*. Oxford: Oxford University Press, 2009.

Tompkins, Kyla. 'Consider the Recipe'. *J19: The Journal of Nineteenth-Century Americanists* 1, 2 (2013): 439–45.

Webb, Ruth. *Ekphrasis, Imagination and Persuasion in Ancient Rhetorical Theory and Practice*. New York: Routledge, 2016.

Williams, Jacqueline Block. .Introduction'. In *The Delights of Delicate Eating*, by Elizabeth Robins Pennell, vii-xxv. Urbana and Chicago: University of Illinois Press. Yoxall, Alisa. *A History of the Teaching of Domestic Economy. Written for the Association of Teachers of Domestic Subjects in Great Britain*. Bath: Cedric Chivers, 1913

The Curious Appetite of Elizabeth Robins Pennell

Alice L. McLean

To eat is to eschew all prose, to spread the soul in glad poetic flight.[1]

Elizabeth Robins Pennell

Throughout the nineteenth century, a rigid divide separated women's and men's food writing. Women wrote domestic cookbooks that codified the tastes of middle-class housewives and detailed the production of dishes. Men wrote cookbooks for professional chefs or contributed to a growing body of gastronomic literature, a genre of writing concerned with nourishing and articulating the pleasures of the table. Into this divide stepped the art critic Elizabeth Robins Pennell. Hired in the 1890s to write a 'cookery column' for London's *Pall Mall Gazette*, Pennell chose instead to write about the art of eating, embracing the sensually grounded languages of aestheticism and gastronomy. By depicting her column as an artistic medium and showcasing the link between an educated palate and creative expression, Pennell shifted her own position from art critic to literary artist of the appetites, a move that initiated the figuration of female pleasure in English-language food writing.

In her contribution to this anthology, Bonnie Shishko illuminates Pennell's reliance on visual descriptions to elevate recipe writing and cookery to an aesthetic endeavour, one in which the recipe writer offers a critical eye and an aesthetic sensibility that enable her to fix an imaginary dish in her reader's mind. This chapter extends Shishko's analysis to argue that, in addition to the visual arts, Pennell relied heavily on the performing arts and on gastronomic literature in order to articulate the physical and intellectual pleasures of eating.

As Dave Buchanan writes in Chapter 1 of this volume, Pennell approached travel writing as a 'well-read amateur'. This approach

applies as well to her cookery column, which showcases the link between the pleasures of dining and creative expression. Pennell's focus on the art of gastronomy rather than on the practicality of cooking aligns her food writing with the male-authored genre of gastronomic literature. The authors of this genre, also known as gastronomes, defined themselves as amateurs in the kitchen and artists of the table. Like the authors of gastronomic literature, Pennell wrote about the art of dining – the ordering of menus, the interplay of flavours and textures, the decoration of the table and the seasonality of ingredients. Like the gastronome, Pennell worked to educate her readers in matters of taste.

Situating Pennell's food writing within the tradition of gastronomic literature enables a revaluation of the work it performs as well as its place in the literary pantheon. Shifting the scholarly angle from the domestic to the public sphere transforms Pennell's food writing from a reluctant, unruly home cooking column to a learned, parodic contribution to gastronomic discourse, a discourse that helped facilitate the transition of dining from the private to the public realm. Because Pennell's columns broke ground in their contribution to a male-authored genre, this chapter will dwell at times on the difficulties Pennell encountered imagining herself as a 'greedy woman' within a literary tradition that defined the female as a cook or servant or as an innocent beauty undefiled by bodily appetites. Pennell's attempt to transform the domesticated woman into a cosmopolitan gourmand – a shift from producer to consumer of pleasures – was a complicated and not always successful task. Nevertheless, it pioneered a territorial expansion of women's food writing into the public realm of gastronomy, previously the sole preserve of men.

The Rise of Gastronomic Discourse

In its depiction of eating as an art form, Pennell's cookery column participates in the aesthetic discourse of gastronomy that developed in post-revolutionary France. As Pennell herself writes in the introduction to *My Cookery Books*, a work devoted to describing the 1,000-volume library she amassed, 'The new writers, of whom Grimod de la Reynière was the first great master, brought about such a revolution in not only style, but the very attitude of writers on cookery.'[2] Pennell includes Jean Anthelme Brillat-Savarin and Alexandre Dumas among the masters of this literary and culinary revolution. She would draw considerable inspiration from each

of these authors when fashioning her cookery column for the *Pall Mall Gazette*.

In 'A Cultural Field in the Making: Gastronomy in 19th-Century France', Priscilla Parkhurst Ferguson lays out the development of a French national cuisine following the Revolution. It was after the fall of the *ancien régime* that 'the culinary arts moved into public space and acquired a public consciousness'.[3] As former chefs of the aristocracy shifted into the public realm to open restaurants, they spread gastronomy to the wider public. These chefs congregated in Paris, where the population doubled between 1800 and 1850, and the number of restaurants rose to 3,000 by the 1820s (up from around 100 in the 1790s).[4] As gastronomy flourished in the public space, so too did the discourse on taste. While restaurants institutionalised gastronomy within the public sphere, gastronomic literature created the structure needed to form a cultural field, providing the 'textual discourse that continually (re)negotiates the systemic tension between production and consumption . . . Culinary culture and the restaurant world take us to food; the gastronomic field points us toward other cultural fields and particularly toward the arts.'[5]

Gastronomic literature sprang to life in 1803 with the publication of Alexandre Balthazar Laurent Grimod de la Reynière's *Almanach des Gourmands*. Published annually for eight years, the *Almanach* pioneered food criticism as we know it today, containing restaurant reviews, critiques of prepared foods and their purveyors, and reflections and directives on the art of eating. By 1803, Grimod had lived such an eccentric and flamboyant life that the *Almanach* would become 'one of the great literary and publishing successes of its day'.[6] Grimod had a flair for the dramatic, hosting a series of theatrical dinners so outlandish that people flocked to his home hoping to catch a glimpse of the entertainment. On one occasion, he invited twenty-two guests to a 'burial and supper' at his palatial family estate on the Champs Elysées. The guests dined at a table transformed to resemble a coffin. By dessert, 300 onlookers had been admitted to watch the spectacle unfold. As one food historian succinctly surmises, 'The coffin reminded all present that progress toward death, like digestion, is democratic' and the spectacle itself made a mockery of 'aristocratic pretension'.[7]

In addition to hosting macabre, satiric dinners, Grimod caroused and dined about Paris with leading actresses and served as a theatre reviewer for several Republican journals. Grimod's extravagant lifestyle and withering, parodic wit fuelled his celebrity. They also enraged the French state, which often found itself on the receiving end

of Grimod's biting satire. In 1798, the administration was so outraged by his political criticism that it shut down his theatre magazine, *Le Censeur dramatique*. Not one to be silenced, Grimod channelled his considerable energy into creating a new literary genre, transforming the drama review into food criticism to evoke 'a world where restaurateurs and pastry chefs were the equivalent of theater entrepreneurs and playwrights'.[8]

The *Almanach* was addressed, in large part, to the *nouveau riche* created by the redistribution of wealth in post-revolutionary France. Writing to educate the growing body of wealthy in France, many of whom journeyed to Paris to dine at its ever-expanding number of restaurants, Grimod wrote eloquently about gastronomy as an art form and helped establish a language of dining criticism. Thirteen years after the final volume of Grimod's *Almanach* was published, Jean Anthelme Brillat-Savarin's *Physiology of Taste* (1825) provided a less eccentric, more reflective disquisition on gastronomy. Whereas Grimod dined at an aristocratic height and wrote in a bold, satiric style, Brillat-Savarin approached gastronomy from a decidedly middle-class perspective, imbuing his writing with a philosophic bent. His *Physiology*, which owes a tremendous debt to Grimod, added a unique depth to gastronomy, articulating its capacity to impart spiritual wisdom, poetic inspiration and social enlightenment.[9] According to Brillat-Savarin, 'gastronomical knowledge is necessary to every man, because it tends to add to the sum of his predestined pleasure'.[10] It nourishes 'an especial well-being' within the individual, sating the hungers of 'both soul and body'.[11] Such pleasures not only create a sense of well-being, they likewise stimulate the intellect and the imagination. Brillat-Savarin repeatedly aligned gastronomy with creativity to state that when a true gourmand experiences a 'well-savored meal', 'his spirit grows more perceptive, his imagination flowers'.[12] Like Grimod before him, Brillat-Savarin infused the gourmand with cosmopolitan sophistication and wit, portraying him as a man at home in the world who enjoys an appetite for international flavours and has the knowledge needed to savour dishes from around the world.

Beginning with Grimod, the term 'gourmand' was used to designate an individual well practised and well educated in the art of eating. Over the course of the nineteenth century another term was coined to designate the author of gastronomic literature – the gastronome. According to sociologist Stephen Mennell, the gastronome not only cultivates his own 'refined taste for the pleasures of the table' but also, by writing about it, helps to cultivate other people's too. 'The gastronome is more than a gourmet – he is also a theorist and a

propagandist about culinary taste'.[13] Nineteenth-century gastronomic literature, as it developed in France – and eventually England and the United States – worked to create a readership of cultivated palates and to codify gastronomy as art. The genre, which was written for and by men, defined the gourmand as an artist with a cultivated, cosmopolitan and nuanced palate. He was, above all, a connoisseur of taste, keenly attuned to the aesthetic pleasures of gastronomy, pleasures that nourish poetic expression.

Finding Her Muse

By the time Pennell began to write her column, the fusion of restaurants with theatre fuelled and was fuelled by urban, cosmopolitan appetites. Sprung from the Enlightenment and its debate on the aesthetics of taste, gastronomic discourse and the appetites it defined were first articulated and codified by Grimod, whose food criticism would set the stage for the coming century. The founding works of · Grimod and Brillat-Savarin would launch a distinct literary genre, which flourished alongside and in conjunction with theatres and restaurants, the latter of which 'emerge[d] as the dedicated space of food theatre'.[14] Gastronomic discourse, drama and restaurants nourished one another to such an extent that by the *fin de siècle* gastronomy itself would become a protagonist on stage, where elaborate dinners were often scripted as forms of cultural and political critique. As drama scholar Laurence Senelick explains:

> the proliferation of stage meals reflected the rise of dining out, or the public performance of gastronomy. The development of a complex cuisine, based on well-provisioned markets and the affluence of money and leisure, were dependent on the growth of cities. So was the evolution of the restaurant and, for that matter, the permanent playhouse. Urban culture nurtured phantasms of luxury and sensual pleasure.[15]

Asked to write a *fin-de-siècle* cookery column, Pennell dived into this thriving sensual realm, fashioning her aesthetic after the playful, witty language of both literary aesthetes and gastronomes.

She came to the task as a cosmopolitan art critic who had travelled throughout Europe and the United States and who enjoyed a deep familiarity with the Parisian art scene. Given her experience as an art critic and her role within the aesthetic movement, her columns are steeped in allusions to works of art and artists. In addition to

a wide array of painters, poets abound, including Virgil and Ovid, Dante and Milton, Théophile Gautier and Heinrich Heine. Pennell likewise folded the words and recipes of French professional chefs such as Carême, Giles Rose and Jules Gouffé into her columns and drew on the epigrams, recipes and meditations of Brillat-Savarin for inspiration. Because Pennell wrote during a time when theatre and dining intermingled both on and off the stage, her columns reference dramatists ranging from Shakespeare to Ibsen and from Balzac to Wagner. She even includes a dish named for the American performer Loie Fuller, whose innovative modern dance inspired the likes of Toulouse-Lautrec and Rodin.

Pennell was one of several anonymous female aesthetes who contributed to the column 'Wares of Autolycus', which featured prominent women writers, each of whom was assigned a designated topic. While Pennell wrote a cookery column, Alice Meynell wrote literary criticism, Rosamund Marriott Watson wrote on interior design, and 'George Fleming' (Constance Fletcher) wrote on fashion. In *The Forgotten Female Aesthetes*, literary scholar Talia Schaffer places the column within the aesthetic movement to argue that

> the Autolycus writers dignified women's domestic life by rewriting it in the newest artistic vocabularies and literary forms. Fleming, Pennell, Meynell, and Marriott Watson employed historical allusions, archaic language, epigrams, and daringly sensual references to their physical pleasure in the clothing and food they recommended.[16]

Although Pennell was assigned what was meant to be a domestic 'cookery column', she took hold of the opportunity to stake her place within the male-authored tradition of gastronomic literature, turning away from the practical instruction offered by the domestic cookbook to embrace the pleasures of eating. Pennell's playful, ornate essays were popular enough for her columns to be gathered and published in book form, first as *Feasts of Autolycus* in England in 1896 and five years later in the United States as *The Delights of Delicate Eating: The Diary of a Greedy Woman*.[17]

Pennell's stylistic embrace of aesthetic pleasure and rejection of practicality required her to differentiate herself from the recipe writer and domestic cook – both roles traditionally aligned with women. Instead, her column focuses on the pleasures of dining and on the aesthetic composition of dishes and meals as art rather than on the kitchen labour of the domestic cookbook. Within the introduction to *Delights*, for example, Pennell singles out one of the most popular

domestic cookbooks of the eighteenth and nineteenth centuries, Hannah Glasse's *Art of Cookery Made Plain and Simple* (1747), noting that it achieved fame not so much for its 'merit' as for 'its extreme rarity in the first edition'.[18] Despite such disparagement, Pennell quoted frequently from *The Art of Cookery*. In a column on 'The Simple Sole', for example, Pennell draws attention to the laborious, at times gruesome language of practical instruction, incorporating a lengthy passage from Glasse's recipe for fricassée 'Soals White'. Whereas Glasse commands her readers to 'gut your soals very clean, [and] cut off their heads . . . then carefully cut the flesh from the bones and fins on both sides . . . take the heads and bones, then put them in a saucepan', Pennell urges her readers to travel to Marseilles and stroll along the quays in the early morning, where they will find

> [i]n sunlight and in shadow are piled high the sea's sweetest, choicest fruits; mussels in their sombre purple shells; lobsters, rich and brown; fish, scarlet and gold and green. Lemons, freshly plucked from near gardens, are scattered among the fragrant pile, and here and there trail long sprays of salt, pungent seaweed . . . The feeling of *Bouillabaisse* is everywhere, and tender anticipation illumines the faces of passers-by.[19]

Pennell refuses to cook in her own 'cookery column'. Instead, she relies on Glasse to perform the linguistic drudgery for her, to describe the laborious details of gutting and beheading a sole. Scholars have remarked on Pennell's refusal to provide a reproducible recipe. For Talia Schaffer, it amounts to a 'coy' manoeuvre, in which Pennell 'withholds' the necessary information from her reader.[20] Jamie Horrocks uses far stronger wording to state that Pennell 'aborts the majority' of the recipes included in *Delights*'.[21] This chapter argues that Pennell's repeated occlusion of practical recipe instruction can also be understood as a gesture of liberation. By 'withholding' or 'aborting' the recipe instruction, Pennell frees herself from the unsavoury materiality of food, from the labour of cooking and from what she calls the 'rule and measure' of recipe writing.[22] Thus liberated, Pennell is free to participate in the gastronomic field.

Unlike the domestic cook whose kitchen labour Pennell carefully elided from her columns (with the notable exception of Hannah Glasse), the literary masters of gastronomy feature regularly in Pennell's prose. In an essay on 'The Incomparable Onion', Pennell taunts her readers with a few lines of a recipe for *Sauce Soubise* pulled verbatim from Cassell's *Dictionary of Cookery*. Then she halts mid-sentence to query:

But why go on with elaborate directions? Why describe the exact quantity of flour, the size of the potato, the proportions of milk and cream to be added? . . . In telling or the reading these matters seem not above the intelligence of a little child.[23]

After silencing the regimented language of a straightforward recipe, Pennell calls on the celebrated author Alexandre Dumas for inspiration. Notably, she inserts him into her text, imagining him preparing *Sauce Soubise* before turning to Brillat-Savarin to sketch what she calls his 'unrivalled omelette' made with tuna, roe and shallots.[24] Shutting the book on an encyclopedia of cookery and turning to Brillat-Savarin and Dumas, Pennell overtly juxtaposes domestic cooking and recipe writing, which require no more 'intelligence' than that 'of a little child', with the luxury and creativity of gastronomy and gastronomic literature. Pennell again refuses to provide clear practical directives, underscoring that her 'recipes' are meant to inspire her readers' imaginations, enabling them to feast on her words.

As Shishko points out in this volume, the women who read Pennell's column were unlikely to head straight to the kitchen to cook from her words. In fact, the unpractised cook would be hard-pressed to make a dish from her columns. Rather, Pennell's writing was intended to inspire her readers to see a dish. Since the early nineteenth century, gastronomes have argued that the capacity to write so vividly about a dish that readers can envision it in their minds' eye and can taste its ideal essence on their minds' palate is itself a form of artistry. In depicting the pleasures of eating as nourishment for literary inspiration, gastronomes seek 'the poetic transformation of food into discourse'.[25] Scholar Denise Gigante situates the express goals of gastronomic literature within a broader historical context to argue that it functions as 'an expansion of the eighteenth-century discourse of aesthetic taste, a cultural field opening onto the material pleasures of the appetite'.[26] The gastronome fixes these pleasures in language.

If a gastronome can be defined as an artist, then Pennell's drive to aestheticise dishes and the meal might be understood to reflect her desire to move beyond the realm of criticism, to become an artist in her own right. Situated within the gastronomic field, her columns participate in a tradition of nineteenth-century writing that aimed to distil the pleasures of gastronomy in a literary art form, one loosely based on the forefathers she cites throughout her essays – Grimod, Brillat-Savarin and Dumas. In fact, Dumas's *Le Grand Dictionnaire de Cuisine* features prominently in the origin story that Pennell often told about her initiation into gastronomy. In this narrative, which

appears in several of her autobiographically based books, the poet and literary editor William E. Henley features as a catalyst in her emergence as a gastronome. Tellingly, in her autobiographical narrative *Nights: Rome, Venice, in the Aesthetic Eighties; London, Paris, in the Fighting Nineties*, Pennell embeds this story within a description of Henley's prowess as a literary editor, one who mentored some of the most innovative and talented writers of the nineteenth century. In Pennell's own words:

> The men who would tell you in their day, who will tell you now, of the great debt they owe to Henley, are men of the most varied interests . . . Ask . . . [H. G.] Wells adrift in a world of his own invention; ask [Rudyard] Kipling steeped in the real, or [J. M.] Barrie lost in the Kail-Yard; ask Kenneth Grahame on his Olympian heights or George S. Street deep in his study of the prig – ask any one of these men and a score besides what Henley's sympathy, Henley's outstretched hand, meant to him, and some idea of the breadth of his judgment and taste and helpfulness may be had. Why, he could condescend even to me when, in my brave ignorance, I undertook to write that weekly column on Cookery for the *Pall-Mall*. He it was who gave me Dumas's *Dictionnaire de la Cuisine*, the corner-stone of my collection of cookery books.[27]

Aside from paying a fine tribute to Henley, here Pennell embeds several celebrated British novelists within the origin story of her emergence as a gastronome. In so doing, she signals her intention to claim a place alongside those authors who loom so large on her bookshelves – figures such as Dumas, Grimod and Brillat-Savarin. In the way she crafts this narrative, Pennell likewise foregrounds that she moves easily among artists and that she wishes to learn about cookery from masterful writers, rather than from technical experts.

Throughout her columns, Pennell makes it expressly clear that she drew inspiration from the founding fathers of gastronomic literature and that she was well steeped in the literary and culinary finesse that differentiates their writing from the practical cookbook. In one instance, she lauds the imagination needed to create aesthetically resonant dishes and the recipes from which to prepare them, noting that in contemplating the 'consummate *bouillon*' Dumas's 'mighty mind runs riot. Not even the adventures of the immortal Musketeers stimulated his fancy to wilder flights. His direction, large and lavish as himself, would the economical housewife read with awe and something of terror.'[28] Here Pennell praises the gastronome's ability to concoct dishes 'lavish' enough to strike 'terror' into the housewife.

She charges her own reader to examine Dumas's words with 'reverence' and to 'carry out his every suggestion with devotion'.[29]

In addition to its reliance on the founding fathers of gastronomic literature, Pennell's cookery column also draws from seventeenth-century professional chefs, most notably Giles Rose, the royal cook for Charles II, from whom she quotes extensively. Rather than demeaning his prose as she does Glasse's, Pennell lauds the poetic quality of Rose's recipes, calling them 'fantastic' 'devices' and 'pretty fancies'.[30] In *My Cookery Books*, Pennell explains her passion for the seventeenth-century cookbook and her reason for including Rose's recipes in her own columns:

> Stateliness and elegance were the order of the day in the seventeenth century . . . And the cookery books are full of . . . brocaded language, full of extravagant conceits, full of artificial ornament; a lover writing to his mistress, you would say, rather than a cook or a housewife giving practical directions. After the modern recipe, blunt to the point of brutality; after the 'Take so much of this, add so much of that, and boil, roast, fry', as the dull case may be, each fresh extravagance . . . is as enchanting as the crook of Lely's ladies or the Silvio of Herrick's verse. I should not want to try the recipes . . . But they were written by artists . . . Rose leaves and saffron, musk and 'amber-greece', orange flower and angelica are scattered through them . . . The names of the dishes are a joy; . . . the eggs in moonshine; the conserves of red roses; the possets without end.[31]

Here Pennell outlines her preference for luxurious, lyrical language that exceeds the bounds of necessity. Rose's recipes appeal to Pennell, not because she wishes to reproduce them, but because of the pleasure she derives from the 'fresh extravagance' of their prose. As royal chef, Rose wrote about meals staged as elaborate performances to be carefully choreographed from beginning to end, meals that required scores of cooks and butlers, servers and master carvers, and even pantrymen. He approached food as an artistic medium, and his writing showcases a stylistic elegance that reflects the luxurious nature of the meals he prepared.

Pennell prized Rose's recipes, not for their practicality, but for their lyricism and their literary merit. She was so taken with the style of Rose's recipes, in fact, that she quotes several verbatim in one column, including them for the lavish, 'brocaded language', the stateliness and elegance of their prose – partridges are variously served with Holy Water, flavoured with sweetmeats and sugar plums, sauced with rosewater and wine. Ultimately, Pennell wanted to produce a column

that stands in for the material food itself, nourishing her readers with words. She likewise wanted to take part in a tradition of food writers whose stylistic elegance classifies their work as literature to be read for pleasure. Hers is a language of luxury.

Nevertheless, it is a luxury necessarily grounded in the body.

A Greedy Woman

Pennell repeatedly and emphatically turned away from practical instruction in order to embrace the pleasures of gastronomy and the creativity, wit and stylistic lyricism that nourish gastronomic discourse. To accomplish this feat, however, she had to jettison the labouring female body from her writing – a messy task, unnecessary for the gastronomes who came before her. Unlike the domestic servants and home cooks who toiled in privacy for little or no pay, many men cooked as professional chefs. As a result, male gastronomes could draw inspiration from a wealth of culinary artists. In turn, chefs had been codifying celebratory dishes, menus and banquets for centuries, leaving behind an abundance of writing from which the gastronome could create and feed his male appetite.

Pennell inherited this wealth of male-authored literature and its disquisitions on male appetite, an inheritance both material and symbolic. On the material level, she collected a vast library of culinary and gastronomic literature. On the figurative level, she incorporated male-authored culinary and gastronomic discourse into her column. Hannah Glasse's *Art of Cookery* stands out as the lone female-authored text featured in *Delights*. In keeping with the ambivalent prose of aestheticism, Pennell would variously challenge the 'merit' of Glasse's *Art of Cookery*, draw directly from its recipes and praise Glasse as 'ingenious'. In sharp contrast, Pennell showed no such ambivalence towards Rose, Dumas, Brillat-Savarin or Grimod, each of whom wrote about the culinary and gastronomic arts in a stylistically lyrical way. These men were able to do so, in large part, because they were not bound by the domestic tradition and its practical, messy, everyday chores.

With a few notable exceptions, including Brillat-Savarin's *Physiology*, nineteenth- and early-twentieth-century gastronomic writing excluded and demeaned women. Grimod, for example, famously held at least one dinner party where women were used as dinner napkins – more specifically their hair was used to wipe the soiled

fingers of his guests. As French philosopher and literary critic Roland Barthes explains with his usual perspicacity:

> in the vast mythology men have elaborated around the feminine ideal, food is systematically neglected; we commonly see woman in a state of love or of innocence; we never see her eating: hers is a glorious body, purified of any need. Mythologically, food is men's business; woman takes part in it only as a cook or as a servant; she is the one who prepares or serves but does not eat.[32]

Throughout her columns, Pennell grapples with how to give voice to woman's appetite within a mythology that casts her as cook or servant. She ultimately refuses either role, figuring herself as 'a greedy woman'.

In the introduction to the essays collected in *Delights of Delicate Eating*, Pennell acknowledges that 'the great interest of the following papers lies in the fact that they are written by a woman – a greedy woman'.[33] With these words, Pennell claims the right to showcase her own hungers – for food, for public voice and for recognition as an artist. The essays themselves, however, bear witness to the conflict between the ideal woman, the labouring female and the self-professed 'greedy woman'. Within the first essay collected in *Delights*, the conflict becomes manifest as Pennell juxtaposes the suffragette and the housewife, posing a set of tongue-in-cheek rhetorical queries:

> Why clamour for the suffrage, why labour for the redemption of brutal man, why wear, with noisy advertisement, ribbons white or blue, when three times a day there is a work of art, easily within her reach to be created? All his life a Velasquez devoted to his pictures, a Shakespeare to his plays, a Wagner to his operas: why should not the woman of genius spend hers in designing exquisite dinners, inventing original breakfasts, and be respected for the nobility of her self-appointed task? For in the planning of the perfect meal there is art; and, after all, is not art the one real, the one important thing in life?[34]

Here Pennell defines gastronomy as an art comparable to painting and to the performing arts and strikes a playful, parodic tone, which characterises much of her gastronomic writing. This passage also underscores a conflict that runs throughout *Delights*. On the one hand, Pennell works to portray meals as art and to showcase gastronomic writing – specifically her own – as among the literary arts. On the other hand, she inherits a rigidly gendered food

writing tradition, one in which women authored practical, regimented recipes for the home cook and men authored recipes for the professional kitchen or philosophical, aesthetically oriented essays and books. Women's food writing aimed towards functionality and men's aimed towards art.

Without a tradition of women's food writing steeped in the sensual pleasures of gastronomy, Pennell slides, at times, into difficult territory as she works to fashion a distinctively female voice within gastronomic literature. By picturing suffragettes as 'clamour[ing]', 'noisy', 'labour[ing]' bodies, she attempts to sidestep two of the contemporary stereotypes of women – politically vociferous New Women, on the one hand, and labouring kitchen drudges, on the other. Despite such sidestepping and tongue-in-cheek delivery, this passage underscores the freighted task Pennell shouldered as she strove to depict woman as simultaneously beautiful, imaginative and intelligent in the act of eating. Because of this difficulty, Pennell 'thrived on ambiguous, slippery language'.[35] Duality and contradiction likewise characterise her gastronomic writing. At times, it celebrates female appetite and brings the appetitive woman to life in lavish, elegant prose. At other times, it reduces women to tasty dishes (albeit, parodically) and denigrates domestic cooks and cookbooks. Because of this conflict, the self-proclaimed 'greedy woman' often uses language that obscures her innovative appetite. As Schaffer explains in her analysis of *Delights*, Pennell uses 'aestheticism to compensate for the fear of being greedy' and it is this fear 'of a female body out of control . . . that haunts this text'.[36]

This chapter argues that the 'greedy woman', however, is not the only figure to haunt Pennell's prose. It is also troubled by the 'labouring woman' who lurks just at the edges. As Schaffer points out, one of the many tensions at work in Pennell's food writing stems from her simultaneous drive 'to exalt cooking while avoiding cooking, to praise the labour she disavows'.[37] Not all cooking labour, however, troubles Pennell; she praises male cooks – amateur gourmands and professional chefs alike. Whereas she dwells occasionally on the gourmand who dabbles in the home kitchen, she works hard to suppress the female domestic cook. In one remarkable instance, Pennell is unable to keep the labouring body at bay, and she splashes onto the page, staining Pennell's prose and marring its aesthetic coherence. The column 'Spring Chicken' begins with a parodic, yet sensual reverie in which Pennell compares the tender flesh of *poussin* to art. Then the tone shifts and disintegrates as the labouring woman enters the scene. Towards the beginning of

one passage, Pennell playfully aestheticises the young chicken with a flamboyant tone, describing it as

> innocent and guileless as Bellini's angels, dream-like and strange as Botticelli's. It is the very concentration of spring; as your teeth meet in its tender, yielding flesh, you think, whether you will or no, of violets and primroses, and hedgerows white with may; . . . and, for the time being, life is a perfect poem. But – why is there always a but? – your cook has it in her power to ruin the rhythm, to make of melodious lyric the most discordant prose.[38]

Here the labouring cook erupts into the text, ending the playful prose with a 'discordant' note. In the next paragraph, the column makes a disorienting and troubling shift as Pennell attempts to rescue (or rewrite) the image of the cook. Turning towards her American heritage, Pennell pays a jarring homage to slave labour:

> Fried chicken! To write the word is to be carried back to the sunny South; to see, in the mind's eye, the old, black, fat, smiling *mammie*, in gorgeous bandana turban, and the little black piccaninnies bringing in relays of hot muffins. Oh, the happy days of long ago! It is easy to give the *recipe*, but what can it avail unless the *mammie* goes with it.[39]

Here the *mammie* and 'the little black piccaninnies' serve as phantom labourers. Without them, Pennell cannot provide a recipe for fried chicken because she eschews both the labour it evokes and the labour it requires. To write out concrete direction would also destroy the literary quality of her prose and align her text with the domestic labourer. By withholding the recipe altogether, Pennell refuses to bring the labouring body to life in her column. Her essays may figure the literary master Dumas artfully composing *Sauce Soubise*, but they refuse to linger on the domestic cook and her everyday labour.

They also refuse to enter the domestic kitchen. As a result, 'Spring Chicken' thrice refers its readers to 'Mrs. Glasse' for recipe instruction. Freed from such domestic chores, Pennell whisks her readers on a journey through Monte Carlo, Spain, England and Holland to vicariously sample chicken dishes before ending the essay with a French stew. She sketches the stew in order to pique her reader's appetite rather than to offer practical instruction, stating outright: 'Do you not grow hungry as you read? . . . As the beautiful mixture is stewing . . . thicken the liquor with yolks of eggs and the juice of lemon, and for ever after bless Mrs. Glasse for having initiated you into these ennobling mysteries.'[40] Here,

once again, Pennell eschews the labour of domestic recipe instruction, passing it to Hannah Glasse.

Despite the troubling presence of the labouring body and the difficulty Pennell has in liberating the greedy woman, *Delights* deserves praise for its valuable work in the gastronomic field. In urging women to nourish and to feed their hungers, Pennell transformed the practicality and economy of women's food writing into sensual, at times parodic, prose. She thus initiated a tradition of food writing in which women could move beyond their roles as cook and server to embrace the pleasures of gastronomy and to luxuriate in the language it nourishes.

'Playing to the Senses'

In an essay on Brillat-Savarin, the philosopher and literary critic Roland Barthes parses the French gastronome's work to applaud him for putting 'food in woman, and in Woman appetite', a monumental gesture in gastronomic literature and one that would largely remain an isolated instance until the arrival of Elizabeth Robins Pennell.[41] Even more importantly for this discussion, Barthes explores Brillat-Savarin's reflections on taste to argue that they articulate 'one of the most important formal categories of modernity: that of the *sequence* of phenomena'.[42] As laid out by Brillat-Savarin, the sequence of taste includes *direct* (flavour at the front of the tongue), *complete* (flavour passing to the back of the tongue) and *reflective* (meaning derived from the contemplation of flavour). According to Barthes,

> the entire *luxury* of taste is in this sequence; the submission of the gustative sensation in time actually permits it to develop somewhat in the manner of a narrative, or of a language: temporalized, taste knows surprises and subtleties; there are the perfumes and fragrances, constituted in advance so to speak, like memories.[43]

Within gastronomy, the structure of this narrative is orchestrated by the menu and by the composition, flavours, textures and sequence of dishes themselves. Within a restaurant, as in a theatre, the drama unfolds as a performance, at times strictly controlled and, at others, more free-form.[44]

The restaurant becomes the stage where the performance plays out. In the words of celebrated twenty-first-century chefs Ferran Adrià, Heston Blumenthal and Thomas Keller, 'The act of eating

engages all the senses as well as the mind. Preparing and serving food could therefore be the most complex and comprehensive of the performing arts.'[45] For the chef as artist, food is approached as an artistic medium aimed at creating an aesthetic experience within the diner. The gastronome must capture the sequential narrative of taste along with its 'surprises and subtleties', its 'perfumes and fragrances', in such a way that the readers can taste the dishes on their minds' palate. If effective, gastronomic literature piques the reader's appetite and sates it with language, which stirs memories of former eating pleasures. This heady mix of appetite, memory and language forms the aesthetic core of gastronomic literature, which aims, above all, to animate the imagination. Appetite begets memory which begets the imaginary taste of past pleasures.[46]

Beginning with Grimod's *Almanach des Gourmandes*, nineteenth-century gastronomic literature worked to define the art of eating, or gastronomy, as one in which the pleasures of the table nourish the imagination, giving flight to language nimble enough to raise embodied pleasures to the intellectual realm. In keeping with Grimod, Brillat-Savarin and Dumas, Pennell illuminates dining as an art form and the meal as an aesthetically nuanced performance. She serves as the literary scribe of gastronomy, transforming the pleasures of an embodied experience into words. As Pennell describes it, meals and the dishes that punctuate them should seek to achieve 'that joyful flamboyancy born of the artist's exuberance in moments of creation'.[47] Her cookery columns work to fix this joyful flamboyance in language.

At its best, *Delights* fastens onto and captures the seam between inside and outside and dwells on the aesthetic emotions, as Alice B. Toklas so aptly calls them, stirred by the consumption, contemplation and digestion of an exquisite dish – to reflect on what Barthes terms the 'luxury of taste'.[48] In these instances, Pennell showcases gastronomy as a performance with the power to trigger an aesthetic response that conjoins the body and the mind in a transformative experience. She articulates the transformative potential of meals and depicts dishes – the carefully composed ingredients themselves – as objects with the power to conduct an aesthetic performance. As an aesthetically inspired dish penetrates and plays with the senses, it liberates a complex mingling of memory, emotion, embodied knowledge and reflection, each of which contribute to taste. *Delights* repeatedly underscores the transformative nature of meals and illuminates their capacity to trigger existential memories that bring the past to life as a taste narrative. A simple dish of pasta becomes what Pennell calls

the magic crystal or beryl stone in which may be seen known things, dear to the memory: . . . [o]live-clad slopes and lonely stone palms; the gleam of sunlit rivers winding with the reeds and the tall, slim poplars; the friendly wayside *trattoria*.[49]

Dining on a simple plate of charcuterie unleashes

memories of the little German towns and their forgotten hilltops, visited in summers long since gone, of the little German inn . . . and the foaming mugs of beer, and the tall, slender goblets of white wine. Before supper is done, you will have travelled leagues upon leagues into the playtime of the past.[50]

Here, the sequence of taste contains the echo and shimmer of memory, which serves as a key protagonist in the narrative of taste, a narrative that folds back in time, enters the imagination, where it eddies, rambles and may even take flight.

Pennell repeatedly emphasises that the temporal nature of eating and the sequence of taste are essential components of gastronomy. Dishes 'pass' in succession, as 'the vague must give way to the decided'; 'a brief, gentle interlude' should be followed by a 'glorious, unexpected overture'.[51] Flavours, like the memories they evoke, swell and fade and 'last impressions remain to bear testimony' after the first impressions have been 'washed away'.[52] A meal's final flavours are like 'the ballade's *envoy*' or the 'final sweet or stirring scene as the curtain falls upon the play'.[53] In one particular description of an omelette soufflé, Pennell showcases the ephemeral nature of eating and illuminates the role that flavour plays in the construction of the taste narrative. As she describes, the soufflé

must be light as air, all ethereal in substance, a mere nothing to melt in the mouth like a beautiful dream. And yet in the melting it must yield a flavour as soft as the fragrance of flowers and as evanescent. The sensation must be but a passing one that piques the curiosity and soothes the excited palate. A dash of orange-flower water, redolent of the graceful days that are no more, and another of wine from the Andalusian vineyards, and the sensation may be secured.[54]

Here the fleeting flavours act as key players within the taste narrative, and their sequential rhythm structures the aesthetic experience, which can be 'secured' in a series of passing sensations. The pleasures arise from the evanescence of flavour; the gastronome's attunement

to the temporal nature of eating enables the full 'luxury of taste'.[55] In turn, the meal itself – the ordering of dishes and the sequence of flavours – becomes a voyage through memory, an aesthetic rapport, an amorous embrace.

Throughout *Delights*, Pennell lingers on those moments in which the bounty of nature meets the cultured palate and meals become works of art that stir a range of emotions within the diner, emotions that mirror that of an extended seduction. She likens the meal to an amorous encounter, one that variously piques and soothes until it reaches a 'stirring, glorious climax'.[56] Hors d'oeuvres 'should stimulate, but never satisfy' and 'each succeeding course must lead to new ecstasy'. In the end, a meal that has been carefully planned, prepared and presented should mimic the pattern of seduction, one in which each successive dish animates and plays with the diner's appetite and, ultimately, evokes a series of aesthetic emotions. If a meal rises to the level of gastronomy, it captures the diner in an aesthetic rapport, one in which the visual composition of dishes, the order in which they are served, the interplay of their flavours and textures, and the table setting itself seemingly transport the diner into another realm, unleashing pleasure, imagination, memory. A meal's capacity to stimulate the intellect by playing with the senses marks the meal as art.

As Pennell clarifies from the outset of her collected essays, she wrote to communicate 'the Beauty, the Poetry, that exists in the perfect dish'.[57] She wrote variously of a sandwich 'exotic and strange, some charm elusive and mysterious'; an omelette 'cloudlike, the loveliness gradually and gracefully disappear[ing], as in a poet's dream or a painter's impression'; a bouillabaisse so exquisite that

> from one end of the world to the other, you might journey in vain in search of an emotion so sweet as that aroused by the first fragrant fumes of the dish set before you, the first rapturous taste of the sauce-steeped bread, of the strange fish so strangely seasoned.[58]

These passages draw attention to the ephemeral nature of gastronomy and of its accompanying pleasures. They likewise fashion the 'elusive', 'mysterious' nature of eating pleasures into language.

Through her cookery column, Pennell worked to conceptualise and to communicate the aesthetic emotions of gastronomy, to fashion luxurious prose that rises above material need and practical instruction to 'spread the soul in glad poetic flight'.[59] This desire to soar above the body, however, left her struggling at times. She struggled because, of all the arts, gastronomy is the most embodied.

As scholar Barbara Santich writes, 'Gastronomy . . . is at the confluence of the streams of sensuality and intellect. It implies the meeting of mind and body.'[60] In turn, gastronomic literature transforms this confluence of streams into a cohesive narrative, one that dwells on what Barthes calls 'the luxury of taste'. As Pennell herself acknowledges, gastronomy is at core a practice that must attend to the body and to the mind.

Given the mythological inheritance of women, however, claiming the body and its appetites necessarily requires dealing with the labour and death, the decay and excrement, that ground gastronomy. In fact, most nineteenth-century gastronomic literature deals expressly with digestion and foregrounds death, often in a darkly humorous fashion. Pennell, though, worked hard to jettison the messy ends of eating from her prose. Figuring the 'greedy woman' as one who eats but does not serve or cook, however, elides the material contributions women have made to the culinary arts. The cooking woman, nevertheless, refused to be excluded from Pennell's column. Her uncanny appearances within the gastronomic essays of a self-proclaimed greedy woman signify a cultural shift, one in which woman could no longer be contained by the domestic cookbook and in which the domestic cookbook could no longer be elided from gastronomic discourse. With Pennell, both the cooking and the eating woman stepped onto the pages of gastronomy, where they would flourish in the twentieth century, helping shape the literary aesthetic of M. F. K. Fisher, Alice B. Toklas and Elizabeth David – women who moved nimbly between the home kitchen and the French restaurant, women who cooked, ate and wrote with lyricism, wit and, above all, voluptuous appetite.

Notes

1. Pennell, *Delights*, 56.
2. Pennell, *My Cookery Books*, viii.
3. Ferguson, 'Cultural Field', 599.
4. Ferguson, *Accounting for Taste*, 87.
5. Ferguson, 'Cultural Field', 637.
6. Spang, *Invention of the Restaurant*, 152.
7. Arndt, *Culinary Biographies*, 190.
8. Spang, *Invention of the Restaurant*, 150.
9. In his study 'Grimod de la Reynière's *Almanach des Gourmands*', Garval takes Brillat-Savarin to task for not referencing his debt to Grimod. Garval notes that 'all the ideas conveyed by Brillat-Savarin's twenty aphorisms

can be found in Grimod's *Almanach*, at least in embryonic form and often developed at length' (61).

10. Brillat-Savarin, *Physiology of Taste*, 53.
11. Ibid. 189.
12. Ibid.
13. Mennell, *All Manners of Food*, 267.
14. Kirshenblatt-Gimblett, 'Making Sense', 75.
15. Senelick, 'Consuming Passions', 45.
16. Schaffer, *Forgotten Female Aesthetes*, 47.
17. The quotations drawn from Pennell's columns are pulled from the American edition of her work, *The Delights of Delicate Eating*, reprinted in 2000 by University of Illinois and introduced by Jacqueline Block Williams.
18. Pennell, *Delights*, 7.
19. Ibid. 94, 98–9.
20. Schaffer, 'Importance of Being Greedy', 120.
21. Horrocks, 'Camping', para. 8.
22. Pennell, *Delights*, 218.
23. Ibid. 164.
24. Ibid. 167.
25. Abramson, 'Grimod's Debt to Mercier', 153.
26. Gigante, *Gusto*, xviii.
27. Pennell, *Nights*, 148–9.
28. Pennell, *Delights*, 84.
29. Ibid.
30. Ibid. 123.
31. Pennell, *My Cookery Books*, 10–11.
32. Barthes, *Rustle*, 253.
33. Pennell, *Delights*, 8.
34. Ibid. 12.
35. Schaffer, *Forgotten Female Aesthetes*, 16.
36. Ibid. 124.
37. Ibid. 110.
38. Pennell, *Delights*, 138.
39. Ibid. 139.
40. Ibid. 142.
41. Barthes, *Rustle*, 253.
42. Ibid. 250.
43. Ibid. 250–1.
44. The heading of this section pays tribute to Barbara Kirshenblatt-Gimblett's essay 'Playing to the Senses: Food as a Performance Medium', in which she writes: 'The materiality of food, its dynamic and unstable character, its precarious position between sustenance and garbage, its relationship to the mouth and the rest of the body, particularly the female body, and its importance to community, make food a powerful performance medium' (8).

45. Adrià et al.
46. As Barthes reflects, 'When I have an appetite for food, do I not imagine myself eating it? And, in this predictive imagination, is there not the entire memory of previous pleasures? I am the constituted subject of a scene to come, in which I am the only actor' (*Rustle*, 264).
47. Pennell, *Delights*, 32.
48. Barthes, *Rustle*, 250.
49. Pennell, *Delights*, 181.
50. Ibid. 73.
51. Ibid. 20, 56, 53.
52. Ibid. 215.
53. Ibid.
54. Ibid. 55–6.
55. Barthes, *Rustle*, 250.
56. Pennell, *Delights*, 56.
57. Ibid. 8.
58. Ibid. 30, 37, 102.
59. Pennell, *Delights*, 3.
60. Santich, *Looking for Flavour*, 173.

Bibliography

Abramson, Julia. 'Grimod's Debt to Mercier and the Emergence of Gastronomic Writing Reconsidered'. In *Rethinking Cultural Studies*, ed. David Lee Rubin, 141–62. Charlottesville: Rookwood Press, 2001.

Adrià, Ferran, Keller, Thomas, Blumenthal, Heston and McGee, Harold. 'Statement on the "New Cookery"'. *The Observer*, 9 December 2006. Accessed 5 December 2019. http://www.guardian.co.uk/uk/2006/dec/10/foodanddrink.obsfoodmonthly

Arndt, Alice. *Culinary Biographies*. Houston: Yes, 2006.

Barthes, Roland. *The Rustle of Language*. Trans. Richard Howard. Berkeley: University of California Press, 1989.

Beck, Leonard N. *Two 'Loaf-Givers' or A Tour through the Gastronomic Libraries of Katherine Golden Bitting and Elizabeth Robins Pennell*. Washington, DC: Library of Congress, 1984.

Brillat-Savarin, Jean Anthelme. *The Physiology of Taste: Or, Meditations on Transcendental Gastronomy*. Trans. M. F. K. Fisher. New York: Heritage Press, 1949.

Ferguson, Priscilla Parkhurst. *Accounting for Taste: The Triumph of French Cuisine*. Chicago: University of Chicago Press, 2004.

Ferguson, Priscilla Parkhurst. 'A Cultural Field in the Making: Gastronomy in 19th-Century France'. *The American Journal of Sociology* 104, 3 (November 1998): 587–641.

Garval, Michael. 'Grimod de la Reynière's *Almanach des Gourmands*: Exploring the Gastronomic New World of Postrevolutionary France'. In *French Food on the Table, on the Page, and in French Culture*, ed. Lawrence R. Schehr and Allan S. Weiss, 51–70. Routledge: New York, 2001.

Gigante, Denise. *Gusto: Essential Writings in Nineteenth-Century Gastronomy.* New York: Routledge, 2005.

Horrocks, Jamie. 'Camping in the Kitchen: Locating Culinary Authority in Elizabeth Robins Pennell's *Delights of Delicate Eating*'. *Nineteenth-Century Gender Studies* 3, 2 (Summer 2007). Accessed 5 December 2019. http://www.ncgsjournal.com.

Kirshenblatt-Gimblett, Barbara. 'Making Sense of Food in Performance: The Table and the Stage'. In *The Senses in Performance*, ed. Sally Banes and André Lepecki, 71–89. New York: Routledge, 2007.

Kirshenblatt-Gimblett, Barbara. 'Playing to the Senses: Food as a Performance Medium'. *Performance Research* 4, 1 (1999): 1–30.

Mennell, Stephen. *All Manners of Food: Eating and Taste in England and France from the Middle Ages to the Present.* Urbana-Champaign: University of Illinois Press, 1996.

Pennell, Elizabeth Robins. *The Delights of Delicate Eating.* Urbana and Chicago: University of Chicago Press, 2000.

Pennell, Elizabeth Robins. *My Cookery Books.* London: Holland Press, 1983.

Pennell, Elizabeth Robins. *Nights: Rome, Venice, in the Aesthetic Eighties; London, Paris, in the Fighting Nineties.* London: Heinemann, 1916.

Santich, Barbara. *Looking for Flavour.* Kent Town: Wakefield Press, 1996.

Schaffer, Talia. *The Forgotten Female Aesthetes: Literary Culture in Late-Victorian England.* Charlottesville: University of Virginia Press, 2000.

Schaffer, Talia. 'The Importance of Being Greedy: Connoisseurship and Domesticity in the Writings of Elizabeth Robins Pennell'. In *The Recipe Reader*, ed. Janet Floyd and Laurel Forster, 105–26. Burlington, VT: Ashgate, 2003.

Senelick, Laurence. 'Consuming Passions: Eating and the Stage at the *Fin de Siècle*'. *Gastronomica* 5, 2 (Spring 2005): 43–9.

Spang, Rebecca L. *The Invention of the Restaurant: Paris and Modern Gastronomic Culture.* Cambridge, MA: Harvard University Press, 2001.

Elizabeth Robins Pennell as an Early Champion of Popular Art

Kimberly Morse Jones

Elizabeth Robins Pennell's contributions to modernist art criticism, in particular the development of formalism, have been well documented.[1] An aspect of her pioneering criticism that has not been sufficiently addressed, however, is her promotion of certain forms of popular art, such as comics and, by association, music hall. What is most striking about Pennell's open-minded and perspicacious views on popular art, especially from an art-historical perspective, is the fact that they coincided with her patently elitist views on modernist art. That Pennell eulogised the esoteric style of James McNeill Whistler's work, art that needed explication to an audience entirely unaccustomed to his unconventional artistic ideas and techniques, in one breath, and extolled the virtues of the popular Victorian comic *Ally Sloper's Half Holiday* (*ASHH*), whose content and style needed no elucidation, in the next, may seem somewhat incongruous. Using her articles 'The Modern Comic Newspaper' (1886) and 'Our Tragic Comics' (1920) – both of which can be read as bookends of her career – as well as 'The Pedigree of a Music-Hall' (1893), the aim of this chapter is to situate Pennell as an early advocate of popular art, prefiguring both the avant-garde art's embrace of mass media and the development of popular culture studies, including comics studies, in the twentieth century. This chapter will also examine the tension between 'high' and 'low' art permeating Pennell's writings, which are fraught with contradiction.

'The Modern Comic Newspaper' (1886)

Pennell published 'The Modern Comic Newspaper' in the *Contemporary Review*, a British periodical aimed at liberal intellectuals, two years

after she and Joseph moved to England. One of her earliest articles, it was written around the same time she embarked on her career as an art critic and began formulating her aesthetic theories on art. Considering how prolific a writer Pennell would become on a wide array of subjects, it would be easy to assume that the topic was one amongst many, and, therefore, not of particular importance to her, or that it simply made for good copy. While the latter is certainly true, and the article did raise eyebrows – for a writer attempting to establish her reputation in a new country, this was probably strategic – Pennell believed *ASHH*, the central focus of the article, constituted some of the best of modern British illustration, which she would go on to champion in her larger body of art criticism, her early promotion of comics foreshadowing her support for illustrators like Charles Keene, Aubrey Beardsley and Phil May. Surprisingly, though, she did not discuss, at least not at any great length, the artistic merit of *ASHH*. Rather, as we shall see, Pennell framed her subject in cultural terms, and as such established herself as a cultural critic.

Alexander, popularly known as 'Ally', Sloper was a comic character that is generally regarded as one of the earliest of its kind. He first appeared in *Judy*, a magazine established in 1867 to rival *Punch*, but as a two-penny paper it appealed to the petty bourgeoisie rather than the upper middle class. After a brief absence, Sloper re-emerged two years later, at which time he established himself as a regular character. While Charles Henry Ross, a former civil servant, created him, his wife, Isabelle Émilie de Tessier, who worked under the nom de plume Marie Duval, drew the majority of drawings. David Kunzle has highlighted the progressive nature of her work, including the introduction of comic methods not universally adopted until the 1880s.[2] Sloper's name, which comes from the term 'to slope', meaning to abscond without paying, stems from the working-class character's lazy, fraudulent behaviour. He is depicted as a dishevelled bald man with a bulbous nose, suggesting his drinking habit, and later shown sporting a top hat and a tattered umbrella as pictured on the right in Figure 10.1. According to Kunzle, the hat and umbrella – two symbols of bourgeois respectability – became disreputable in the hands of Sloper's creators.[3]

Throughout the 1870s Sloper's presence expanded, as he began appearing in supplemental publications, such as *Ally Sloper's Comic Kalendar* and *Ally Sloper's Summer Number*, but the introduction of *ASHH*, a penny weekly magazine launched in 1884 by the publisher Gilbert Danziel, ushered in a new era of Sloper. Each week came a new picaresque adventure that appealed to the working and

Figure 10.1 William Giles Baxter, *The Russian Bear*, 1880s, pen and ink (original drawing for illustration to *Ally Sloper's Half Holiday*), Height: 251 mm image, Width: 325 mm image, Height: 277 mm sheet, Width: 356 mm sheet © Victoria and Albert Museum, London

middle classes alike.[4] By 1889, circulation reached 340,000, becoming the largest of any illustrated paper in Great Britain.[5] Now virtually unknown, Sloper was, according to Peter Bailey, the equivalent of today's Disney characters.[6] Scholars agree that the illustrator who replaced Duval, W. G. Baxter, brought about a more mature style.[7] Sadly Baxter died prematurely in 1888, at which time W. F. Thomas took over, continuing his predecessor's style. *ASHH* was published regularly up until 1916, and then only sporadically until 1923.

Although Pennell deemed the front-page drawings of *ASHH* 'extremely clever',[8] she had little to say about Baxter in 'The Modern Comic Newspaper'. It is clear, however, that she respected his work, as she later praised it in 'Our Tragic Comics'. Joseph, who often held similar opinions to his wife's, included Baxter, alongside the likes of Rembrandt and Dürer, in *Pen Drawings and Pen Draughtman*, originally published in 1889. And in his 1895 book *Modern Illustration*, Joseph described the artist as 'the most genuine caricaturist who has

ever lived in England'.[9] That Baxter's *Fifty Sloper Cartoons* forms part of the couple's collection, currently housed in the Library of Congress in Washington, DC, speaks to the couple's high regard for the artist's illustrations.

Instead of focusing on technique, as she would a few years later, Pennell concentrated on content and began with a call for artists to depict their modern surroundings, much like the 1863 essay 'The Painter of Modern Life' by the French poet and art critic Charles Baudelaire (whose work Pennell read), in which he championed Constantin Guys's illustrations of contemporary life. (It is also possible that another essay by Baudelaire, 'Some French Caricaturists', published in 1855, which David Carrier has argued anticipated comics, provided a paradigm for Pennell.[10]) Pennell chided the Victorian educated classes that 'embrace all bygone generations', leading to a 'contemptuous indifference to the modern world'.[11] Paraphrasing a passage by the character Mr Rose from W. H. Mallock's satirical novel *The New Republic* (1877), she wrote: 'the cultured of to-day linger so long in the boundless gardens of the past, that they forget to enter the house of the present'.[12] (It was widely known that the character Mr Rose was based on Walter Pater, whose artistic ideas Pennell adopted. Pater, however, as evidenced by his *Studies in the History of the Renaissance*, published in 1873, was in fact one of the very people Pennell would have found guilty of 'lingering' in the past.) Pennell continued by specifically targeting Algernon Swinburne's poem 'Atlanta in Calydon' and Edward Burne-Jones's painting *Mermaids and Sybils* for being out of touch with, or rather out of reach of, the average man or woman. She then bemoaned the lack of manifestations of popular artistic expression, which, she argued, are inherently tied to the vital present.

The greatest value of *ASHH*, Pennell concluded, was that it was 'pre-eminently a publication for the people. It is because Sloper appeals to the masses . . . that he has gained his present ascendancy, and will probably retain it.'[13] Pennell was correct in her assessment in numerous ways. *ASHH*'s primary audience comprised the first generation of beneficiaries of the 1870 Education Act, the first of a series of acts passed by Parliament that made education compulsory, thereby increasing literacy. Moreover, Sloper's debut coincided with the introduction of the half-holiday, when workers were given half of Saturday off, moving up the start of the weekend, as we now define it, to Saturday afternoon from Sunday. With more free time, and more money in their pockets, the working classes became partakers of the leisure industry. *ASHH* reflects this shift not only in that it

appealed to this new class of customer, but also in the types of activities Sloper and his friends participated in: attending the Derby races, going to the Royal Academy and spending the day at Margate.

Pennell's defence of Sloper is based primarily on the argument that he was a continuation of historical popular types. She began her article by tracing a history of continental masque characters, including Macchus and Pappus from ancient Rome, Arlecchino and Pulcinello from Italy, and Scapin and Pierrot from France, in order to establish an historical precedent, concluding, 'The examination of popular recreations shows that there has always been a strong though unconscious need to personify common and usually not very laudable instincts of human beings, and to set up the consequent personifications to public laughter.'[14] Masques, Pennell maintained, were at once universal and individualised for each nation. In England, the need to find humour in man's foibles manifested in the form of 'the wife-beating, brutal Mr. Punch'.[15] ('Mr Punch' of Punch and Judy is short for 'Punchello', the anglicised version of Pulcinello.)

Pennell maintained that, unlike other types of art, popular art, such as masques and comics, reflects the true character of the uneducated. Using the terms 'people' and 'uneducated' interchangeably, she maintained, 'The people, of course, do not find the definite means of expression of the educated. As a rule, they do not write books and criticisms and newspaper leaders, paint pictures, or design the houses and churches they often build.'[16] According to Pennell, part of the appeal of both continental masque characters and Sloper lay in their ability to relate to all people regardless of class: 'The old masques achieved popularity because they typified infirmities and absurdities based, not upon fashion,' she explained, 'but upon human nature, and were in sympathy with the unlettered majority as well as the cultured elect'.[17] (It is true that Sloper's fans came from a variety of classes; his many middle-class aficionados included William Morris and Edward Burne-Jones.) In popular art, therefore, she found a sense of authenticity, contemporaneity and universality. Roger Sabin has related Sloper to the nineteenth-century German idea of *volk*, the romanticisation of the common man, connected to an interest in ancient folklore.[18] Pennell's fascination with folklore undoubtedly sprang from her uncle, Charles Godfrey Leland, the American writer and folklorist, a figure who loomed large during her formative years. (Her interest in comics is akin to her interest in gypsy culture, as discussed by various scholars in this volume, in that she viewed both as authentic emanations of popular feeling.) One could argue, however, that while she was attempting to elevate popular art, Pennell was

simultaneously affirming it as a separate category, by implication a rung below traditional fine art, thus undermining her original intent.

By promoting *ASHH* as a 'publication for the people', Pennell appears to have been touting socialist ideals. It is true that the Pennells, upon arriving in London in 1884, dabbled in socialism. Most likely persuaded by George Bernard Shaw, who was a good friend, the couple attended socialist meetings. Elizabeth quickly soured on the idea, though, complaining about Shaw's incessant ramblings on socialism, at the expense of art, and questioning his true intentions as a socialist.[19] Even though the couple were not ardent socialists, their exposure to socialism, *au courant* in their immediate social and professional circles, must have cemented her pre-existing interest in working-class culture, as instilled in her by her uncle. Pennell was not necessarily a proponent of the working class, however, as her writings demonstrate a marked ambivalence towards them. In *Our House and the People in It* (1910), for example, a memoir of her interactions with her domestic staff and the beggars on her street, she displays a lack of understanding of, and at times blatant apathy towards, the plight of the poor. She also opposed the efforts of socialist proponents, such as William Morris and John Ruskin, who believed art could ameliorate the lives of the lower classes. In an article titled 'English Faith in Art', published in 1888, Pennell cast doubt on the effectiveness of these campaigns. After having visited the National Gallery on a bank holiday, 'less to see the pictures than the people', she concluded, 'I saw and heard little to encourage the expectation that art will prove something more and mightier than a refining and pleasure-giving factor in the lives of the . . . lower classes.'[20] They simply did not have the education to appreciate fine works of art, Pennell argued, proceeding, in a mocking tone, to provide direct quotes of overheard conversations as evidence of their ignorance.

What Pennell found intriguing about *ASHH*, therefore, was not that it was necessarily working-class, but rather it was decidedly *not* middle-class; that is, the comic was a counterpoint to bourgeois values. (The fact that Sloper was created by the middle class, as previously established, calls this assumption into question, a point she too recognised, but neglected to address.[21]) In other words, Pennell appreciated that *ASHH* was anti-establishment, or, to apply the word retrospectively, counter-culture. In these comics, she found originality and vitality, absent in the majority of Victorian art, which favoured morality and sentimentality. In order to appreciate the radical nature of Pennell's advocacy of *ASHH*, one should bear in mind that the idea that cultural value could be found in comics was utterly contrary to elitist notions of culture of her day, especially those put

forward by Matthew Arnold, who had narrowly defined culture as 'the study of perfection', or 'high' culture, in his book *Culture and Anarchy* (1869). Arnold had once been 'one of the chief heroes of [her] worship', his idealist views on culture appealing to a younger Pennell, but after attending his lecture in Philadelphia, she 'went away disillusioned', instead favouring Oscar Wilde, whom she found an 'exhilarating contrast' to Arnold.[22]

According to Pennell, another reason for Sloper's success was that 'he was made a reality rather than an abstraction'. She continued, 'It is easy to fancy just such an old man as [Sloper] shuffling along the Commercial Road or the New Cut.'[23] Not only was he based on 'real-life' people, but he also proved to be ubiquitous in Victorian visual culture. According to Sabin, Sloper was 'jokingly considered "real" by a proportion of the readership', thus 'develop[ing] a life outside the comics'.[24] Sloper not only came alive in print, but also appeared on buttons, pipes, umbrellas, jars of pickles, boxes of matches, snuff boxes, door stops, paperweights, mugs, walking sticks, tie pins, puppets, games, bottles of sauce and cigars. So much merchandise was produced that an exhibition showcasing an array of Sloper commercial goods went on display at the Royal Aquarium in 1888. He also appeared in street theatre, village parades, music halls and later in films (Figure 10.2). Pennell recorded that the Sloper character surfaced

Figure 10.2 Unknown, *Ally Sloper Run In*, about 1890, Collotype, 84.XC.873.5274, The J. Paul Getty Museum, Los Angeles

Figure 10.3 Henry Evanion, London, 1885? @ The British Library Board

at circuses, carnivals, waxwork shows, fancy-dress parties and ventril-oquist performances (Figure 10. 3).[25] Promoters attempted to engage readers by bestowing 'Friends of Sloper' Awards of Merit. Recipients included Prime Minister Gladstone, popular performers such as Annie Oakley and Connie Gilchrist, and many prominent artists, such as John Singer Sargent, John Everett Millais and Sir Lawrence Alma-Tadema, as well as the novelist and Pennell's fellow New Art Critic George Moore. These individuals, along with others, went so far as to send autographed letters of thanks. A simulacrum, Sloper took on a life of his own, becoming hyper-real.

Yet Sloper was not real, and herein lies the key to his appeal among the bourgeoisie: the freedom to enjoy his crazy antics, like hobnobbing with royalty, without running the risk of overturning social order. Applicable here is Mikhail Bahktin's theory of the car-nivalesque, in which he argued that the carnival's blurring of lines between the performer and spectator creates a sense of 'reality' or lived experience.[26] The carnival, however, is not an extension of real life; rather it provides a safe space, so to speak, in which alterna-tive realities, such as the breaking down of social hierarchies, can be

played out without repercussions. Moreover, that Sloper appeared in the form of a comic also provided a buffer from reality in that the medium occupies a liminal space between realism and abstraction. In other words, the abstracted or exaggerated features of a comic character allow the reader to more easily suspend reality. (In the case of Sloper, however, his outrageously bulbous nose could quickly backslide into reality, as a swollen nose connoted the reality of heavy drinking amongst the working classes.)

It can be argued that the fact Sloper was not real, and never would be, allowed the middle classes to enjoy his presence without stirring up social anxiety. After all, Sloper's native London is that of the middle and upper classes, 'minus the slums and rookeries', as Bailey has explained. Furthermore, Sloper is rarely shown doing any kind of real work. And, as Sabin pointed out, Sloper's attempts to infiltrate the upper echelons of society are inevitably thwarted; thus his 'incursions . . . reduce the threat to the mere comic, generally alleviating anxiety of any real penetration from below'.[27] Sloper, a rather impotent character, was unlikely to revolt, thereby removing readers from the realities of increasing discontent amongst the working class that would result in workers' riots in 1887, a year after Pennell's article was published.[28] On the other hand, Sloper could have been perceived as a threat because, as Scott Banville has contended, despite the fact that he appears to be unaware that he is breaking social protocol, his lack of shame can be interpreted as a sign that he believes that he is above the rules, that they simply do not apply to him.[29] Reports of striking railway workers wearing Sloper masks suggest that the bourgeoisie was not entirely insulated from the possibility of a proletarian revolt.[30]

'The Pedigree of a Music-Hall' (1893)

Pennell's interest in *ASHH* overlapped with her fascination with music hall, the two being closely related. Sloper's daughter, Tootsie, made a living as a music-hall performer, and music halls are mentioned frequently in the comic. By the same token, the Sloper character, as previously mentioned, often appeared on stage in music halls. The crossover between the comic and music hall was so substantial that Sabin has argued the 'Sloper phenomenon' cannot fully be understood without considering its manifestation both in print and on stage.[31] In an 1893 article titled 'The Pedigree of a Music-Hall', also published in the *Contemporary Review*, Pennell once again emerged as a champion of popular art, boldly arguing:

A line is drawn between the music-hall and theatre by the purist, who defines the latter as the temple of Art, with a big *A*, the former as the saloon of art, with a little *a*. It is an ingenious argument, but one based on fancy rather than fact . . . The art, with big or little *a*, as you please, belongs to the music-hall.[32]

As the title of the article suggests, she included a history of the popular theatrical and musical phenomenon, much as she had done earlier in her article on comics. Also, as with comics, Pennell argued that the roots of music hall lay in the Middle Ages. While she did not overtly lionise it as a manifestation of working-class culture, as she had done with Sloper, the idea that it was a popular working-class pastime pervades the entire article, although she did comment on its appeal to all classes, much like that of comics. As in 'The Modern Comic Newspaper', Pennell discussed music hall in nationalistic terms, presenting it as a contemporary art form that should be studied and nurtured before it was lost to the tides of history.

Once again, in 'The Pedigree of a Music-Hall', Pennell rebuked those who 'extol the past at the expense of the present'.[33] For Pennell, and others like her, including the artist Walter Sickert, the beauty of music hall lay in its quintessential modernity. Sickert, in an unsigned preface to the 'London Impressionists' exhibition catalogue held in 1889, expressed the group's desire to 'render the magic and poetry which they daily see around them'.[34] Sickert and his cohorts were undoubtedly influenced by depictions of Paris's cabaret music halls created by Édouard Manet and Henri Toulouse-Lautrec, whom Pennell also greatly admired. In addition to revering music hall for reflecting modernity, she saw it as an expression of contemporary vernacular culture, which, like comics, stood in stark contrast to bourgeois philistinism. In her prolific art reviews, Pennell expended a great deal of intellectual energy castigating the middle class's taste for imitation and pretence, and chiding the Victorian art world, particularly the Royal Academy, for placing commerce above aesthetics. Barry J. Faulk has made an important distinction regarding Pennell's penchant for vernacular culture, arguing that she, and other contemporary writers on music hall, by highlighting the vernacular 'endeavored to conventionalize a distinction that was largely semantic between "mass culture", tainted by its association with commerce, and untainted vernacular culture', thus 'pars[ing] out authentic expression from more contaminated forms'.[35]

Although seemingly at odds with the implicit elitism of 'high' art, Pennell's upholding of vernacular culture (or *volk*) can be seen as the

opposite side of the same coin in that they both challenged bourgeois philistinism. This argument, however, ignores the fact that Pennell acknowledged the mass appeal of comics, and the same could be said for music hall, as evidenced by her previously quoted statement – that 'it is because Sloper appeals to the masses . . . that he has gained his present ascendancy, and will probably retain it'. (That these popular forms of entertainment generated considerable income for publishers and theatre proprietors is a point she conveniently chose to ignore.) It should be borne in mind that popular culture was understood at the time, in the words of Raymond Williams, as both 'culture actually made by people for themselves' (vernacular or *volk*) and that which is 'well-liked by many people' (mass culture).[36] While these two definitions tend to be viewed as somewhat oppositional, the former being framed in a more positive light than the latter, it appears that the terms co-existed more easily in Victorian times, or at least they did not appear to have presented an irreconcilable conflict in Pennell's mind.

Pennell's nuanced understanding of vernacular culture helped boost her credibility and reinforce her standing as a cultural arbiter. (That she signed all three articles discussed in this chapter, a practice she rarely employed in her art criticism, indicates that she did, in fact, wish to make a name for herself in this regard.) An increase in the number of music halls, and the same could be said for comics, coincided with a rise in professionalisation.[37] It was essential, therefore, that Pennell speak with a voice of authority, one of the educated elite in a position to identify the cultural value of popular culture that in her view the less educated were not cultivated enough to recognise. According to Faulk,

> Contemporary middle-class accounts of music hall often made class lines separating mass audiences more visible. Perspectives on the aesthetic quality of music-hall performance often reinforced the trained prejudices about art and the people held by social elites. Accordingly, the rhetoric of the popular often reinforced the culture protocols of an upper-middle class. Thus the endeavor to signify the popular helped consolidate the group identity of a professional cadre, authorized by their unique and often exclusive knowledge of art and culture.[38]

Where did Pennell stake her claim of authority? As Dave Buchanan discusses in Chapter 1 of this volume, she drew her authority from both study and experience. In addition to spending long days at the British Library researching her subjects, it is evident from the article

that she had spent time at music halls. In fact, she went so far as to chide those who condemn music halls without ever having visiting them, writing: 'But the critic does not go to the music-hall.'[39] This snide remark is intended to implicate critics for not stooping below their perch to experience the culture of the common man. It is true that Pennell had visited music halls, both in London and Paris, yet a denizen of them she was not. She can be grouped with intellectuals who occasionally frequented such places, including the author Max Beerbohm, who commented that he visited music halls to 'feel [his] superiority to the audience'.[40] In *Nights: Rome, Venice, in the Aesthetic Eighties; London, Paris, in the Fighting Nineties*, a collection of reminiscences published in 1916, Pennell admitted to having only visited the Folies Bergère, the Parisian cabaret music hall made famous by Manet, out of respect for the artist, attributing her visit to a desire 'just to see and to know'.[41] This was followed by a visit to the Moulin Rouge, which, as she found it 'dull', did not inspire her to return. Such aloofness indicates that she, like Beerbohm, adopting the position of a mere observer, considered herself above the revelling of the lower-class audience. It cannot be proven, of course, but the same could be argued for Pennell's exposure to *ASHH*. She undoubtedly read it, as evidenced in her article, but it is highly unlikely that she rose to the level of an avid fan, purchasing a copy every week.

Pennell's admission that she desired 'just to see and to know' in the above passage is interesting. Her insider knowledge of popular culture, whether it be of music hall or comics, placed her at the heart of what could be considered, at times, coded pastimes. The ease with which she recalled certain performances and lyrics suggests she was 'in the know', as do her parenthetical explanations such as 'the gentlemanly villain in linen (according to music-hall conventions, a starched collar symbolizes villainy)' or 'the stage capitalist, irascible but benevolent (his overcoat, worn in midsummer, denoting wealth)'.[42] Bailey has written about the idea of knowingness, which he defined as 'what everybody knows, but some know better than others', and music hall, arguing that by the 1890s both working-class and middle-class audiences participated in music-hall knowingness,[43] although interpreters, such as Pennell, still had a place in helping to educate the latter.

To return to comics, this knowingness is precisely the type of intellectual capital Pennell needed to help fill in the gaps for her middle-class compatriots who were less knowledgeable about the topic. In an article published in the *Atlantic Monthly*, Agnes Repplier, admitting she knew little about comics, commented that *ASHH* appears to be

'exceedingly amusing if one could only understand the fun'.[44] While certain nuances were perhaps lost on Repplier (she was an American, so this could be attributed to a difference in nationality as well as class), acknowledging that she did not understand the comic is somewhat of an exaggeration. Rather it could be argued that she feigned ignorance in order to reinforce her middle-class status and separate her from the hoi polloi, thus widening the gulf between classes, as indicated by the tone of the following observation: 'Everybody – I mean, of course, everybody who rides in third-class carriages – buys [*ASHH*], and studies it soberly, industriously, almost sadly.'[45] Middle-class readers thus required an interpreter. (The degree to which this need was real or perceived is another matter.) Mentioning Pennell, who was a close friend of hers, by name, Repplier wrote:

> Mrs. Pennell, indeed, with a most heroic devotion to the cause of humor, and a catholic appreciation of its highways and byways, has analyzed Ally Sloper for the benefit of the Known Public which reads the Contemporary Reviews . . . But, alas! it is not given to the moderately cultivated to understand such types without a good deal of interpretation.[46]

With more than a whiff of sarcasm, Repplier proceeded to explain: 'Here are the pictures, which I am told are clever; here is the text, which is probably clever, too'; but she confessed, in spite of Pennell's best efforts, 'their combined brilliancy conveys no light to my mind'.[47]

In a sense, Pennell's positioning herself as an interpreter of comics and music hall is similar to her positioning herself as an interpreter of Whistler's work. All three were new, or relatively new, phenomena and needed explication. The primary difference, however, is that the first two were decidedly lowbrow, while the last was unquestionably highbrow, which matters because Pennell was not, of course, working-class. Although Repplier did not explicitly state the irony of a middle-class woman explaining an aspect of working-class culture to her own class, this idea can be inferred from her article, reminding us of Raymond Williams's observation that 'popular culture was not identified by the people, but by others'.[48] Another reviewer, wishing to also highlight class difference, was not so subtle, though, questioning whether Pennell, despite appearing knowledgeable on the topic, even understood *ASHH*.[49] This accusation would not have concerned Pennell because there was no one to challenge her; popular culture was a topic few educated (middle-class) people cared to write about and few (working-class) people were educated enough to write about.

In the words of Sabin, 'such arbiters of taste' can, therefore, be seen as 'essentially carving a niche for themselves by talking about pop culture',[50] while at the same time exploiting popular art's 'otherness'.

Pennell's decision to broach topics like comics and music hall, the former having been for the most part untouched up until that point, is striking, especially for a bourgeois woman. On the one hand, they were unusual choices: both would have been considered lowbrow and vulgar. On the other hand, one could argue that Pennell's subjects were not surprising given women's long association with 'low' art forms, such as embroidery and other types of domestic arts. Andreas Huyssen's 1986 essay 'Mass Culture as Woman: Modernism's Other' highlighted the link between women and mass culture:

> Time and again documents from the late 19th century ascribe pejorative feminine characteristics to mass culture – and by mass culture here I mean serialized feuilleton novels, popular and family magazines, the stuff of lending libraries, fictional bestsellers and the like.[51]

If we apply this line of argument to Pennell, then her subject conforms to Victorian societal expectations. While acknowledging the association between women and the aforementioned types of literature, Huyssen explained this did 'not, however, [apply to] working-class culture or residual forms of older popular or folk cultures', both of which, as has been discussed, are categories in which Pennell placed *ASHH*. By the last quarter of the nineteenth century, the study of folk culture had become assimilated into bourgeois culture, due to attempts by intellectuals, predominantly male, such as her uncle and others. Pennell was, therefore, essentially inserting herself into a mostly male-dominated sphere, making her early critiques on popular art even more remarkable.

It is worth noting that Pennell's views on comics in particular were atypical for the time. On the heels of a previous campaign against penny dreadfuls, many critics, morally outraged by their content, found comics like *ASHH* vulgar and made a point of setting them apart from 'high' culture. One critic described the modern newspaper, comics amongst them, as a 'fungus'.[52] Another critic opined:

> The influx of these millions of readers, who are so ignorant of life that they are contemptuous of its probabilities, and who display the same impartial indifference to the laws of language as to those of Art, has degraded not only creative writing, but also criticism.[53]

The anonymous author continued: 'Popularity that has no relation to merit constitutes, perhaps, the chief reason why criticism to-day has been almost entirely displaced in the columns of the Press by mere adulation.' While the author did not implicate Pennell directly, he or she did put forward *ASHH* as one such popular publication.

'Our Tragic Comics' (1920)

Thirty-four years after Pennell argued on behalf of *ASHH*, she published 'Our Tragic Comics' in the *North American Review*. She commenced the article by lamenting the fallen state of the medium:

> The most amiably disposed critic would scarcely call the comics of our daily papers masterpieces of art or humor. But he might deplore them as tragedies if he agrees with the philosopher that men and nations are known by what they laugh at.[54]

By 1920 Pennell had, because of World War I, returned permanently to the United States. Published in an American magazine, the article is concerned exclusively with American comics. One should bear in mind, therefore, that her rebuke of comics here is as much about the difference between British and American comics, or culture and society, as it is between nineteenth-century and twentieth-century comics, comparisons of which are beyond the scope of this chapter. Nevertheless, there are interesting correlations between this article and 'The Modern Comic Newspaper' that, when examined, help shed light on Pennell's views on popular art.

After lambasting the general state of comics in her native land, Pennell provided a potted history of the medium, as she had done in 'The Modern Comic Newspaper', tracing them back to masques. Like much of her later work, 'Our Tragic Comics' rings with nostalgia, the memory of erstwhile masques and other popular types, once revitalised in *ASHH*, now fade into the past: 'The fool's bells could not be heard above the whir of machinery. Pierrot's dainty clothes would soon be soiled and stained in the smoke of modern industry.'[55] With the nineteenth century, Pennell explained, came new types appearing in newspapers, like Honoré Daumier's Robert Macaire, Henri Monnier's Joseph Prudhomme and of course Baxter's Sloper. 'Ally Sloper, disreputable, vulgar old bounder that he was, is remembered because of the art with which Baxter recorded his exploits and varied his vulgarity', she wrote.[56]

Pennell attributed the artistic decline in comics in part to the ability to print illustrations as easily as text, causing the comics industry to grow apace. With this came a dramatic increase in the number of comic characters, so many, she argued, that it was difficult to keep track of them. As a result they lost their uniqueness, unlike Sloper, whom Pennell found truly one of a kind. What is more, comics now appeared daily in the form of a longer sequence of panels, further watering down their potency. As Sabin has reminded us, nineteenth-century comics were very different in that they appeared more like a newspaper or magazine with 50 per cent of the space devoted to text, rather than being heavy on images in the way we are accustomed to now.[57] In particular Pennell targeted *Mutt and Jeff*, created by Bud Fisher in 1907, one of the first daily comic strips, that is, printed as a strip of panels, as opposed to just one. It tells of the misadventures of a mismatched duo, Mutt and Jeff, 'who have been figuring on the same page of the same paper, day by day, for the last two years'.[58] Pennell continued:

> We have grown accustomed to them. They are as much a part of our daily life as the milkman and the baker, it is as fixed a habit to laugh at them in the evening as to gather in our quart and our loaf in the morning, and we would as soon put up with the unlooked for in the bread or the milk as in their humor.[59]

Mutt and Jeff's popularity extended beyond the US, making it one of the first comic strips to receive popularity worldwide. (It was Mutt and Jeff's ubiquity that led the artist Marcel Duchamp to alter Mott, the manufacturer's name, to R. Mutt for the signature on his famous *Fountain* from 1917.[60])

By 1920 comics had become a mainstay of everyday life, shifting from counter-culture to the mainstream. According to Pennell,

> It is the hold they [comics] have taken on the public that gives them importance. They have become as characteristic a part of American life as the movies and the sodawater fountain. The names of their heroes are household words, the adventures they record are as eagerly looked for as the news of the world, the feeble jokes they get off are in everybody's mouth, their authors scarcely lag behind Charlie Chaplin and Mary Pickford in the race for millions.[61]

As the American appetite for comics grew more and more insatiable, Pennell argued, comics accommodated themselves to meet the demand:

Unquestionably, if the comics may not have been originally what the people wanted, they have become what the people want today, and appetite having a disconcerting way of growing by what it feeds on, the more people get of them, the less able will the people be to do without them.[62]

The perpetuation of comics, which rose to new heights with the advent of syndication, made it nearly impossible to maintain a high standard in terms of both content and artistic value, posited Pennell. 'The very essence of this humor is its reassuring freedom from any artistic or intellectual nonsense. It must give nobody the bother of thinking, it must not soar above the reach of the most sluggish imagination.'[63] The characters and plots, once carefully crafted, had become formulaic: a character stumbles, and on cue the reader laughs. She continued:

People laugh at the new symbols of humor precisely as they laugh at the man who slips on the ice or at the crude false face of the toy shop – that is, without thought. If they paused to think they probably would not laugh at the slip knowing it was painful, or at the false face knowing it to be silly. But the laugh comes before there is time to think because it is in response to a primitive instinct we have not outgrown; – the comics, however, see to it that thought cannot interfere with the laughter they excite, for they provide nothing to think about.[64]

Pennell concluded, 'If they [comics] reflect anything of the moment it must be a want of thought that should alarm us.'[65]

According to Pennell, comic characters' features had become clichés as well. Unlike Daumier, who 'watched the men and women about him until he knew humanity by heart', and Keene's 'cabbies' and 'drunks', each having 'a character of his own', modern comic draughtsman reduce 'all human emotion and its expression to a formula that could not disconcert a kindergarten'.[66] Exaggeration of features, such as Sloper's extraordinarily large nose, subtle in relation to those of twentieth-century characters, had become caricatures of caricatures:

Their ideal of fun is grotesque exaggeration of some physical characteristic, preferably to the point of deformity. The heroes of the comics may be tall or short, lean or fat, young or old; their noses may be tip-tilted or drooping; their hair abundant or scant; their mouths a circle or a line; but whatever their chief characteristic of face, form or features, it must be emphasized until it leaps to the eye of the least observant.[67]

These new practices, outlined by Pennell above, including use of multiple panels, repetitive, formulaic story-lines, and extreme caricature, the last two borrowed from vaudeville 'gags', helped to standardise the medium for syndication and foreign language editions.[68] As a result, Pennell opined, comics in the twentieth century, unlike those of the nineteenth, had neither beauty nor wit: 'But with the American editor who knows what the American people want, it is an article of faith that they do not want to be pestered with either art or wit in their comics and he gives them neither if he can help it.' She admitted that there were exceptions, but generally speaking 'good drawing in the comics is a mere accident'. For Pennell, the introduction of colour only made matters worse:

> One asks in dismay what is the use of art schools all over the country, of art lectures and art clubs, of docents in the museums, and critics in the press, of endless chatter about art and bringing it to the people, if the people's eyes are to be debauched and diseased weekly, if not daily, by these raw, crude, discordant washes and messes of the cheapest colored ink.[69]

Pennell ended the article by attributing the mass appeal of comics in the US to widespread public education. 'Education is a boon that has never hitherto been denied to the American', she wrote. 'He is what education has made him; his theaters, movies, magazines and papers are the outcome of his educated taste.'[70] It is rather the uneducated to whom we must look for uncontaminated forms of art. Pennell contended:

> What is apt to be forgotten today is that the standard of the people in these matters has always been higher when they were not educated, when their taste was formed by tradition, when nobody bothered about what they wanted and they shared in the beauty with which most men were satisfied.[71]

This attack contrasts with some of her other writings, including 'English Faith in Art', mentioned earlier, in which she claimed that a lack of education precludes the working class from cultivating a taste for fine art, thus reinforcing the divide between 'high' and 'low' art that she seemingly strove to dissolve. As elitist as ever, Pennell proclaimed: 'The truth we shrink from admitting is that only the few have ever cared for the things that education gives us.'[72] (As a self-appointed arbiter of taste, she would of course count herself one of the 'few'.)

Ultimately for Pennell early twentieth-century Americans comics signalled a shift away from the need for authorities on taste. 'In the days when education was for the few, the few set the standard, which the many, in their indifference, accepted without a murmur', wrote Pennell. 'But today it is not democratic form to defer to the few in any question, even of taste, nor does democratic mean quite what it used to.'[73] In other words, the opinions of cultural critics, such as herself, no longer held sway. She continued to distinguish between an old and new form of democracy, explaining:

> The old-fashioned idea of democracy is that each man should be free to take advantage of his opportunities, whether he made more out of them than anybody else or not. The new-fashioned idea of democracy is that no man shall be free to get more out of his opportunities than anybody else, whether or not the strong are sacrificed in this struggle for equality.[74]

This resulted, she concluded, in uniformity:

> We are to be standardized, cast in the same mould, we are to have our feet neatly turned in the one path in which we all must go . . . The lowest intellect must be respected, for the rich in mind have no more right to a larger share of the world's treasures than the rich in pocket.[75]

Pennell continued:

> The man who thinks today must keep it to himself out of deference to the many who do not. Thought, like labor, must seek the lowest level that injustice may be done to none. Better do without all adventure for mankind than let the intelligence and imagination it calls for become the monopoly of any one favored class or individual.[76]

Thus, it could be argued that there is an inverse correlation between the popularity of a particular art form and the need for so-called specialists in said art form. The escalation of mass media in the early twentieth century, therefore, posed an existential threat to Pennell and critics like her.

While 'high' and 'low' art seemed more easily reconcilable in Pennell's earlier articles, it appears from her later article on comics that the gap had widened, so much so that she was forced to change camps. Once a voice in the wilderness intent on elevating and preserving popular art, she became a naysayer, cautioning against popular art's standardisation of thought and culture. This

about-face may have stemmed from a genuine concern, from self-preservation or from a combination of the two. Regardless of her motivation, the implicit elevation of 'high' over 'low' art espoused in 'Our Tragic Comics', which foreshadowed Clement Greenberg's essay 'Avant-Garde and Kitsch' (1939) and Theodor Adorno and Max Horkheimer's chapter 'The Culture Industry: Enlightenment as Mass Deception' from the book *Dialectic of Enlightenment* (1947), undermined some of the ideas set forth in 'The Modern Comic Newspaper' and 'The Pedigree of Music-Hall'. Pennell's simultaneous promotion and negation of popular art does not devalue her contributions, but rather speaks to the complexity of navigating the 'high' and 'low', which over a hundred years on continues to preoccupy scholars.

Notes

1. See Morse Jones, *Nineteenth-Century Pioneer*, and Clarke, *Critical Voices*.
2. For more information on Marie Duval, see Kunzle, 'Marie Duval'.
3. Kunzle, 'First Ally Sloper', 41.
4. Bailey, 'Ally Sloper's Half Holiday', 9. While both the working and middle classes read *ASHH*, its largest readership was comprised of the lower middle class.
5. Bailey, 'Ally Sloper's Half Holiday', 10.
6. Ibid. 4.
7. Kunzle, 'First Ally Sloper', 46. The first few illustrations were taken directly from *Judy*. Pennell appears to have not known that Ross and Duval were the original creators of Ally Sloper, or she chose to overlook this fact. Joseph Pennell, in his book *Modern Illustration* (103), mistakenly identified Baxter as the 'inventor' of Sloper.
8. Pennell, 'Modern Comic Newspaper', 515.
9. Pennell, *Modern Illustration*, 103.
10. Carrier, *Aesthetics of Comics*, 107.
11. Pennell, 'Modern Comic Newspaper', 510.
12. Ibid. 509.
13. Ibid. 521.
14. Ibid. 511.
15. Ibid. 514.
16. Ibid. 510.
17. Ibid. 515.
18. Sabin, 'Ally Sloper: First Comics Superstar?'.
19. Pennell and Pennell, Pennell Papers, box 197, diary entry dated 26 October 1887.
20. Pennell, 'English Faith in Art', 453.

21. Pennell, 'Modern Comic Newspaper', 523.
22. Pennell, *Our Philadelphia*, 344.
23. Pennell, 'Modern Comic Newspaper', 517.
24. Sabin, 'Ally Sloper: First Comics Superstar?'.
25. Pennell, 'Modern Comic Newspaper', 521.
26. See Bakhtin, *Rabelais and His World*.
27. Bailey, 'Ally Sloper's Half Holiday', 14.
28. Sabin, 'Ally Sloper: First Comics Superstar'.
29. Banville, 'Ally Sloper's Half-Holiday', 157.
30. Sabin, 'Comics versus Books', 113.
31. Sabin, 'Ally Sloper on Stage', 206.
32. Pennell, 'Pedigree of a Music-Hall', 579.
33. Ibid. 581.
34. Baron, *Sickert*, 15.
35. Faulk, *Music Hall and Modernity*, 3.
36. Williams, *Keywords*, 237.
37. See Perkin, *Rise of Professional Society*.
38. Faulk, *Music Hall and Modernity*, 7.
39. Pennell, 'Pedigree of a Music-Hall', 582.
40. Rough, 'Sickert's Mirror', 144.
41. Pennell, *Nights*, 280.
42. Pennell, 'Pedigree of a Music-Hall', 580.
43. Bailey, 'Conspiracies of Meaning', 138.
44. Repplier, 'English Railway Fiction', 86.
45. Ibid.
46. Ibid.
47. Ibid.
48. Williams, *Keywords*, 237.
49. 'Magazine Notes', 19.
50. Sabin, 'Comics versus Books', 108.
51. Huyssen, *After the Great Divide*, 9.
52. Sabin, 'Comics versus Books', 111.
53. 'Popular Writers and Press Critics', 145.
54. Pennell, 'Our Tragic Comics', 248.
55. Ibid. 249.
56. Ibid. 250.
57. Sabin, 'Comics versus Books', 108.
58. Pennell, 'Our Tragic Comics', 251.
59. Ibid. 252.
60. Duchamp stated: 'Mutt comes from Mott Works [J. L. Mott Iron Work], the name of a large sanitary equipment manufacturer. But Mott was too close to I altered it to Mutt, after the daily cartoon strip "Mutt and Jeff" which appeared at the time, and with which everyone was familiar' (Camfield, *Marcel Duchamp*, 13).
61. Pennell, 'Our Tragic Comics', 255.

62. Ibid.
63. Ibid. 252.
64. Ibid. 255.
65. Ibid.
66. Ibid. 254.
67. Ibid. 252.
68. Cole, *How the Other Half Laughs*, n.p.
69. Pennell, 'Our Tragic Comics', 253.
70. Ibid. 257.
71. Ibid. 256–7.
72. Ibid. 257.
73. Ibid.
74. Ibid.
75. Ibid.
76. Ibid. 258.

Bibliography

Bailey, Peter. '"Ally Sloper's Half Holiday": Comic Art in the 1880s'. *History Workshop Journal* 16 (1983): 4–31.

Bailey, Peter. 'Conspiracies of Meaning: Music-Hall and the Knowingness of Popular Culture'. *Past &Present* 144, 1 (1994): 138–70.

Bakhtin, Mikhail. *Rabelais and His World*. Bloomington: Indiana University Press, 2009.

Banville, Scott. '"Ally Sloper's Half-Holiday": The Geography of Class in Late-Victorian Britain'. *Victorian Periodicals Review* 41 (Summer 2008): 150–73.

Baron, Wendy. *Sickert: Paintings and Drawings*. New Haven and London: Yale University Press, 2006.

Camfield, William. *Marcel Duchamp: Fountain*. Houston: Houston Fine Art Press, 1989.

Carrier, David. *Aesthetics of Comics*. University Park: Pennsylvania State University Press, 2000.

Clarke, Meaghan. *Critical Voices: Women and Art Criticism in Britain, 1880–1905*. Aldershot: Ashgate, 2005.

Cole, Jean Lee. *How the Other Half Laughs: The Comic Sensibility in American Culture, 1895–1920*. Jackson: University Press of Mississippi, 2020.

Faulk, Barry J. *Music Hall and Modernity: The Late-Victorian Discovery of Popular Culture*. Athens: Ohio University Press, 2004.

Huyssen, Andreas. *After the Great Divide: Modernism, Mass Culture, Postmodernism*. Bloomington and Indianapolis: Indiana University Press, 1986.

Kunzle, David. 'The First Ally Sloper: The Earliest Popular Cartoon Character as a Satire on the Victorian Work Ethic'. *Oxford Art Journal* 8 (1985): 40–8.

Kunzle, David. 'Marie Duval and Ally Sloper'. *History Workshop Journal* 21 (1986): 133–40.

'Magazine Notes'. *The Critic* 16 (July–December 1891): 19–20.

Morse Jones, Kimberly. *Elizabeth Robins Pennell: Nineteenth-Century Pioneer of Modern Art*. Burlington, VT: Ashgate, 2015.

Pennell, Elizabeth Robins. 'English Faith in Art'. *Atlantic Monthly* 61 (April 1888): 449–61.

Pennell, Elizabeth Robins. 'The Modern Comic Newspaper: The Evolution of a Popular Type'. *Contemporary Review* 50 (1886): 509–23.

Pennell, Elizabeth Robins. *Nights: Rome, Venice, in the Aesthetic Eighties; London, Paris, in the Fighting Nineties*. Philadelphia: Lippincott, 1916.

Pennell, Elizabeth Robins. *Our Philadelphia*. Philadelphia: Lippincott, 1914.

Pennell, Elizabeth Robins. 'Our Tragic Comics'. *North American Review* 211 (1920): 248–58.

Pennell, Elizabeth Robins. 'The Pedigree of a Music-Hall'. *Contemporary Review* 63 (1893): 575–84.

Pennell, Joseph. *Modern Illustration*. London: George Bell and Sons, 1895.

Pennell, Joseph. *Pen Drawing and Pen Draughtsmen*. New York: Macmillan, 1897.

Pennell, Joseph and Pennell, Elizabeth R. Joseph and Elizabeth R. Pennell Papers. Harry Ransom Center. University of Texas at Austin.

Perkin, Harold. *The Rise of Professional Society in England*. London and New Haven: Routledge, 1989.

'Popular Writers and Press Critics'. *Saturday Review* 81 (1896): 145–6.

Repplier, Agnes. 'English Railway Fiction'. *Atlantic Monthly* 68 (1891): 78–87.

Rough, William. 'Sickert's Mirror: Reflecting Duality, Identity and Performance'. *British Art Journal* 10 (Winter/Spring 2009/10): 138–44.

Sabin, Roger. 'Ally Sloper: The First Comics Superstar?' *Image & Narrative* (October) 2003. Accessed 30 March 2020. http://www.imageandnarrative.be/inarchive/graphicnovel/rogersabin.htm

Sabin, Roger. 'Ally Sloper on Stage'. *European Comic Art* 2 (2009): 205–25.

Sabin, Roger. 'Comics versus Books: The New Criticism at the "Fin de Siècle"'. In *Transforming Anthony Trollope: Dispossession, Victorianism and Nineteenth-Century Word and Image*, ed. Simon Grennan and Laurence Grove, 107–29. Leuven: Leuven University Press, 2015.

Williams, Raymond. *Keywords: A Vocabulary of Culture and Society*. London: Fontana, 1983.

'At the Museum *comme à l'ordinaire*': Elizabeth Robins Pennell and Exhibition Culture

Meaghan Clarke

Elizabeth Robins Pennell arrived in London in 1884 and rapidly became a frequent occupier of museums, exhibition spaces and galleries. She remained a constant presence in the Royal Academy and adjacent galleries until she left London in 1917. Her experiences of these spaces, recorded in her diary and prolific art writing, are illuminating. Kimberly Morse Jones has demonstrated Pennell's significance as a 'pioneer of modern art criticism'.[1] Pennell was crucial to the development of the New Criticism in 1893. This chapter will explore her writings immediately after her arrival in London, in the 1880s and early 1890s. Critics have said that the flâneuse was an impossibility, yet Pennell's perambulations show London as a viable space for social networks, leisure activities, workspaces and visual information, given its geography of galleries and museums, tea-shops and stores. For Pennell, exhibitions were a worksite, where she studied paintings, sculptures, prints, design objects and photographs, often alongside a network of other professional writers and artists. She was also alert to working people's alternative uses of the same spaces. I will argue that her texts offer insight into the myriad ways in which working women utilised the city. Moreover, her observations and experiences of museum sites, such as the British Museum, National Gallery and Royal Academy, enhance our understanding of exhibition culture in this period of constant change.

Pennell's written diaries are a rich source for an exploration of gender politics and exhibition culture. (They have been wonderfully transcribed by John Waltman; however, certain aspects of her diary were eliminated, specifically 'references to shopping trips,

house cleaning details and several searches for quarters'.[2]) In order to explore Pennell's experiences as a professional journalist and 'flâneur', I will return to the diaries alongside her published texts.[3] Initially, the chapter will consider the wider context of Pennell's writing on the metropole and the London art world. This will be followed by a consideration of a series of museum and gallery sites, in a sense mimicking Pennell's spatial experiences of the city, in order to demonstrate her multifaceted use of London spaces for her own purposes.[4]

In 1891 Elizabeth Robins Pennell summarised trends in the British press for her column in the American magazine *Chautauquan*:

> I was buying a magazine the other day at a London bookstand when, I hardly know why, I was suddenly struck, as I have never been before, with the number of papers published for the sole benefit of women. There I saw the *Ladies Pictorial*, *Queen*, *Lady*, *Woman*, *the Gentlewoman*, and the *Women's Penny paper* . . . Women have also gone very thoroughly into journalism. You have only to go to one of the press views in a London art exhibition to find out how many are art critics, while the pictures they criticise show how many are artists. One of the leading dailies has a woman for its Paris correspondent. I doubt if there is a newspaper that does not have several women on its staff. [5]

Pennell identifies the recent proliferation of women's magazines (and she would write 'In the World of Art' for the penny magazine *Woman*). At the same time art reviewing became a regular aspect of the majority of general interest newspapers and periodicals; these also printed considerable numbers of articles and reviews by women. In fact it was the following year that Pennell featured in an *Art Journal* article on 'Art Critics of To-Day' and the accompanying illustration 'Press Day at the Royal Academy'.[6] Pictured in the top right, she was amongst a mêlée of writers intent on interpreting the latest offerings in the Royal Academy summer show. These were working and social occasions where she met with a series of overlapping networks of writers and artists. Press views and private views were key to her working life. Invitations or tickets were circulated and exchanged within her circle of journalists and editors, so she had the opportunity of covering the required shows.

Another contemporary illustration from the *Graphic* was of 'Visitors to the Loan Exhibition at the Guildhall Gallery' held from

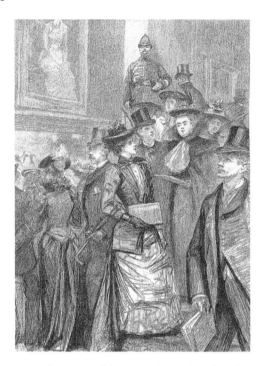

Figure 11.1 'Visitors to the Loan Exhibition at the Guildhall Gallery', *Graphic*, 1892

28 May to 30 June 1892 (Figure 11.1). The image is teeming with people, many of them women, making their way up and down the central staircase. In the centre there is a woman in profile, wearing a hat decorated with flowers or feathers perched high on her head and a jacket with puffed sleeves, striding purposefully up the stairs clutching a catalogue in her right hand. She turns to speak to another woman who has her catalogue open as if about to discuss one of the paintings on their left and right. The image points to the sheer numbers of women that made up this new cultural milieu and their centrality to exhibition culture.[7] But interestingly for this chapter, the woman in the centre resembles Pennell.[8] In a photograph of Pennell, pictured on the cover of this volume, she is wearing a fashionable tailored jacket with wide lapels and leg-of-mutton sleeves. She wears a hat high on her head trimmed with feathers and berries. Pennell's art writing was so prolific she was ever-present in such spaces, working dressed à la mode in a modern tailor-made. The visual parallel is significant because it hints at the ways in which she occupied the gallery spaces: the Guildhall was just one of many London establishments that she regularly visited and interpreted for her reading public.

'Flâneur for an Hour'

Pennell's arrival in London was contemporary with an expanding professionalisation for women art writers. A boom in print journalism made art writing, an arena in which women were already established, even more open to women. Women's rights were a subject of constant debate; Pennell herself was writing her biography of Mary Wollstonecraft (as discussed in chapter 2 by James Diedrick). The volume was republished as part of the 'Eminent Women' series in Britain that included *George Eliot* by Mathilde Blind; *Emily Brontë* by A. Mary F. Robinson; *George Sand* by Bertha Thomas; *Maria Edgeworth* by Helen Zimmern; *Margaret Fuller* by Julia Ward Howe; *Elizabeth Fry* by Emma Raymond Pitman; *Countess of Albany* by Vernon Lee; and *Harriet Martineau* by Florence Fenwick Miller. The volumes were well publicised, written primarily by women and in some cases controversial; many of these names, Robinson, Lee (Violet Paget), Zimmern and Fenwick Miller, recurred in Pennell's diary. The 'at home' salon of the aesthetic poet Robinson has been called a hybrid space by Ana Parejo Vadillo. It was exemplified by the 'Eminent Women' series where personal relations were transformed into professional ones.[9] The women of this formidable network were also art writers and would, therefore, cross paths at dinners, lectures, libraries and galleries.

The year 1894 saw the emergence of the figure of the independent, cycling, smoking New Woman in novels, plays and cartoons. But in many ways Pennell's working life took on many of these characteristics *avant la lettre*. Although she was married, she was not always with her husband. In 1885 she described travel to a dinner with journalist Henry Norman:

> Then started for the Gosse's, N. in the hansom with me. I had on the way two cigarettes and just by the Regent's Canal, our driver getting mixed up, we missed the other hansom and Joe and Unwin got there first. Instead of waiting they went up at once, which was embarrassing, as the G's supposed Norman and I had been driving alone.[10]

The mix-up did not seem to have any subsequent effect socially, but the episode also reveals she was already an 'advanced' woman in many respects.

Nor was Pennell necessarily accompanied by male publishers or writers. Around 1890 she frequently met her friend the writer Graham R. Tomson (Rosamund Marriott Watson). Their correspondence reveals one such plan: 'Are you busy on Monday? Or

could we meet at Hamilton's (the dress-maker's) 326 Regent St. at 4:30 have tea at our Hungarian bread-shop and look at the shops and flâneur for an hour?'[11] The Hungarian bread-shop, like the prevalent Aerated Bread Company chain of tea-rooms, was a vital space where women could meet. To 'flâneur' related to idle strolling around modern Paris (already a familiar location for Pennell). Their version of 'flâneur'ing often involved a combination of galleries, shops, tea and walking. It seems that Pennell and Tomson felt they were participating in this modern way of experiencing the city. In her biography of *Graham R.*, Linda Hughes has noted that although Baudelaire's original conception of the urban artist was resolutely masculine, Tomson was intent on following the lead in creating a poetry led by urban experience.[12] The impossibility of the flâneuse has been the subject of considerable debate in scholarship, and recent studies have looked anew at nineteenth-century urban spaces to challenge the idea that public space was exclusively male.[13] The correspondence and meanderings of Pennell and Tomson are exemplary in this context.

In fact they shared experiences of Paris through their correspondence:

> [H]ow welcome your counterfeit presentments were to us . . . The drawing is too charming for anything – I'm going to have it framed. Charles looks as if he had thoroughly enjoyed his dinner – and you have a most insolent appearance with your flaunting feather (Did you buy that new bonnet in the gay capital?). Mr Unwin does look the least bit sympathetic with J, but he is the only one of you who does. We wish more than ever that we were with you. Next year!!! – will all the 'giddy gang' meet here, as arranged on Sunday next?[14]

The 'giddy gang' described by Tomson, which in this case included Charles Whibley, assistant editor of the *Scots/National Observer*, and the publisher T. Fisher Unwin, was recorded in the sketch by Joseph Pennell, which does not survive. This was one of Pennell's annual trips across the Channel to cover the Salons. The occasional French phrases in her diary betray her early study in France and she was a confident traveller, evidently enjoying French dining and sociability alongside the galleries. Pennell affirms Ruth Iskin's arguments concerning the role of women as active spectators and consumers in the Parisian public sphere.[15]

This group of friends, although some more impecunious than others, indulged in 'sprees' and Pennell's diary is peppered with

references to dining in a variety of places. Eating at the Holborn, Solferino's or Gatti's, Pennell underlines Brenda Assael's recent arguments concerning London's gastro-cosmopolitan culture during this period.[16] Not only did Pennell participate in the transnational experience of London's restaurants, as an American who was already well travelled, but she shaped dining culture at least indirectly through her writing on food. Her important contribution to gastronomy, through her later food columns and volume, is addressed in this volume by Alex Wong, Bonnie Shishko and Alice McLean. London in the late nineteenth century was undergoing intensive transformation. Spaces of pleasure and leisure, such as theatres, shops, tea-rooms and galleries, were proliferating in the West End. Scholars have drawn attention to the importance of these new spaces for women. Lynne Walker has persuasively argued that women were remapping the West End.[17]

Importantly, it was not necessary to walk everywhere; galleries and exhibitions were open and easily accessible by public transport – it was possible to move with relative ease around the city. Modes of transport are highlighted and recur in Pennell's diary. In 1887 she wrote about a trip to see 'the World's Fair in Islington [Agricultural Hall] riding all the way on the top of a bus which was great fun'; in another diary entry she took the underground to Swiss Cottage. In 1890 her working-day record ended with 'did not get away til almost ten and then came home alone in a bus'.[18] Pennell makes clear the ways in which public transport facilitated her independence as an art journalist. By riding around the city on an omnibus she was seeing modern life subjects, such as urban streets, nightscapes, cafés and music halls, which were also depicted by the French-influenced artists she favoured. This was exemplified in Sidney Starr's *The City Atlas* (1889, National Gallery of Canada) where a woman sits at the front of an open-top bus. Moreover, Pennell's circles overlapped with those of other women undertaking literary responses to the same spaces; Vadillo has considered the lyric writings of Amy Levy, Alice Meynell and Tomson in relation to new technologies of urban mobility.[19]

'At the Museum'

Perhaps unexpectedly, given her soon widely acknowledged field of contemporary art reviewing, Pennell was a constant visitor to the British Museum. Sometimes we find she is visiting well-known displays, such as the Elgin Marbles: 'Went to the British Museum and

looked up at the frieze and the Metope of the Parthenon.'[20] But often her diary entries start with the phrase 'at the Museum', a fact she emphasised after a run of visits on 28 May 1885 'at the Museum *comme à l'ordinaire*'.[21] This was because in this period the British Museum was a dual site, the home of both objects and books. The domed British Museum Reading Room was where Pennell regularly worked; her diary is interspersed with discussions and meetings with cataloguer and then keeper of printed books Richard Garnett and other colleagues who were working there. It was also a convenient work-space, a short distance from her first London home on Bedford Street in Bloomsbury.

In her 'Woman's World in London' column for the American magazine *Chautauquan* she declared that London was the 'headquarters' for the English-speaking literary woman: 'The British Museum alone would be enough to attract her.' Somewhat self-referentially given her constant pursuit of copy, she acknowledged that many of the daily habitués of the Reading Room were hacks or working on commission, but boasted that the majority of literary women spent an occasional day there.[22] Literary scholars have emphasised the significance of the British Museum Reading Room for women poets and writers attempting to forge a career in London.

Susan Bernstein thinks about the British Museum Reading Room as heterotopic, a modern urban space defined through relationships. She references the poet and novelist Amy Levy's 1889 description of the Reading Room as an egalitarian space that was variously a 'workshop, lounge, refuge or shelter'.[23] Galleries and museums might be considered as analogous spaces. For women writers these 'workshops' were alternatives to the more intimate spaces of the 'at home'. Some of these professional relationships were apparent in the press of the 1890s, to those in the know, such as the 'Wares of Autolycus' in the popular *Pall Mall Gazette*, written anonymously by several women including Pennell, Meynell and Tomson.

Pennell's diaries do comment on one important change in the British Museum's display history. In 1890 she visited the sculpture galleries to see the electric lighting. This was a new development, already present in the Reading Room, but extended to the galleries in an effort to widen access to the collections for working people in the evenings. There was widespread praise of this in the press. An *Illustrated London News* engraving focused on the atmospheric experience of the colossal sculptures in the Egyptian galleries. However, in her diary Pennell was more critical, suggesting that the objects in the galleries be moved around 'so working men can see a range of

work' and that the ethnographic collections lent themselves better to the electric lighting.[24] This may also have reflected her own interests in this area. Years earlier she had undertaken research in indigenous communities, such as the Mi'kmaq, with her uncle the American folklorist Charles Leland in Nova Scotia and New Brunswick, and more recently attended his lecture on the 'Algonquin' in London.[25]

For many women art writers the National Gallery was a meeting place. For women working in the field of Renaissance art the building was crucial. Julia Cartwright's diaries record her meeting Vernon Lee to study works by Raphael and Signorelli, artists that would feature in her own publications.[26] But Pennell also climbed the steps, stood under the portico and went inside to examine works and observe the visitors. 'In the afternoon to the National Gallery with Bessie. Looked particularly at the Bacchus and Ariadne, Venus and Adonis, Bellini's Doge and Madonna and Da Vinci's Holy Family – dined at the Holborn.'[27] In 1884 it was Titian, Bellini and da Vinci which held her attention – and these would relate to her subsequent travels. For example, she would seek out Bellinis in the Academia in Venice and was particularly fascinated by the *Miracle of the Cross at the Bridge of San Lorenzo* by Giovanni Bellini (1496).[28] While Pennell did not become a specialist in historical periods, knowledge of art history gained from these collections was crucial for her multiple Italian travel articles.

In a subsequent diary entry she turned to the visitors: 'on the way back stopped for a little while in the National Gallery where there was an American in a blue red-spotted gown with a young man who was filled with amazement at the fact that many of the pictures were 400 years old – and who supposed the artists had painted the things as they supposed them to really be'. On a bank holiday she also chose to go to the National Gallery to 'see how people were impressed by the pictures'. She determined that amongst the crowd were 'not many working men and women'.

While of course all the people looked at all the pictures in passing, there were only a few in which they stood in groups. Principal of these was Rubens' 'Abduction of the Sabine Women'. It was so engrossing that it made people silent. One old workman after staring at it for about five minutes explained to the woman with him that 'they have been at war and the conquerors are carrying them off.' On the whole the Dutch and Flemish pictures were more popular than the Italian. One that drew attention was a little Dutch Court by Peter de Hooge. Among the Italian too I found that

it was the story that attracted – Even the Pinturiechios – 'the Marriage' and 'the Story of Griselda' – attracted men and women and children in turn examined the tall slim young men with their narrow pointed shoes and striped legs.[29]

Pennell's close observations give some account of what was happening in the spaces in relation to what were primarily narrative works, such as the seventeenth-century Dutch genre painting of Pieter de Hooch.[30] It was a subject she would return to in several galleries, including the new developments in the East End. The decade before, the Bank Holidays Act of 1871 had changed working-class leisure. The educational value of museums was not a new concept in the 1880s, having been established much earlier with the 1851 Great Exhibition; however, it was the subject of considerable debate, particularly around the confluence of religion and recreation. Diana Maltz gives a nuanced account of its relationship to the concerns about Sunday openings for galleries and museums.[31] Visitor numbers were monitored and reported by the institutions themselves, and Sara Selwood has recently revisited this data in light of the resurgence of similar arguments in late-twentieth-century British museum policy.[32]

For Pennell, as was the case for Cartwright and Lee, the National Gallery also had a social function. She may have met Tomson on the steps of the National Gallery, shown in the Tissot print *The Portico of the National Gallery, London* (Figure 11.2), but would more probably have worn a modern suit than the garb in that picture. In April of 1890 the National Gallery was the starting point for their perambulation around the city; this included not only galleries, but a trip to Liberty's to buy curtains. The following day she had changed her mind: 'Out all morning, changing my curtains for still uglier ones.'[33] Some of Pennell's pronouncements on shopping, or 'vile shopping' as she called it that week in her diary, seem to contradict scholarly emphasis on women shopping for pleasure during this period.[34] In this case she was perhaps reflecting on the Liberty's curtain drama, but her diary suggests her experience of it was both conflicted and constrained. At the same time shopping was a crossover realm implicitly connected to the collaborative gallery 'workshops' of these professional women. Their agency was underscored through their writing. Tomson was contributing a fashion column to W. E. Henley's *Scots Observer* – where, as Hughes notes, women were agents and connoisseurs.[35] The shared 'Wares of Autolycus' column would encompass a variety of subjects including art, food, fashion and interiors.

Figure 11.2 James Tissot, *The Portico of the National Gallery, London*, 1878, etching and drypoint on laid paper, plate: 38x21 cm, sheet: 47.4 x 29.4 cm, Metropolitan Museum of Art, New York

'Round of the Galleries'

In contemporary art the reviews of the annual shows were paramount. They could influence the reputation, and analogously sales, of artists' work, thereby giving Pennell a degree of respect even early in her career. Her networks of professional art writers soon overlapped with artists, and her diary gives clues about these working relationships. One such contact was the artist Emily Mary Osborn:

> In the afternoon went out to the Dunn Osborn establishment. Found Helen Zimmern there . . . Miss Dunn was very friendly and said she hoped I would come to dinner some day after Miss Osborn had finished with the pictures to be exhibited at Goupils' – that now they thought of nothing else. Miss O did not appear because she was hard at work on these same pictures.[36]

Mary Eliza Dunn, Osborn's companion, was clearly intent on cultivating a friendship with Pennell. The following week Pennell mingled at Osborn's private view and later in the month a dinner and reception was forthcoming at the 'Dunn Osborn establishment' where Zimmern was inevitably also present.[37] Osborn was an early advocate of women's rights and part of the 1850s Langham Place circle. By 1886 she was an established artist who had also benefitted from the patronage of Queen Victoria. Deborah Cherry has highlighted the importance of 'matronage' to Osborn's career: two years earlier she had completed a portrait of Barbara Bodichon for Girton College.[38] This suggests that Dunn and Osborn were very aware of the importance of women's networks and Pennell seemed to be a like-minded advocate.

In Pennell's various columns in the early 1890s written expressly for women readers she did highlight the work of women artists, with one definitive caveat: the shows of 'Lady Artists'. These separate exhibitions were 'apt to do more harm than good'. However, 'at the large galleries women hold their own, most admirably, not as mere amateurs or as "ladies" but as honest professional workers'.[39] For example, Elizabeth Armstrong Forbes's Academy work possessed 'more of the true artistic feeling than her husband, who has but lately been elected an associate of the Royal Academy'. In the former's *The Minuet* (Penlee House Gallery & Museum, 1892), Pennell found 'the figures carefully drawn, the textures well rendered' and 'the light studied with intelligence'.[40] Interestingly, she even seems to intimate that perhaps Armstrong Forbes was a more appropriate Academician; in fact, Stanhope Forbes resented his wife's Whistlerian coterie and was patronising about her early success at the New English Art Club.[41] Pennell also praised the *Self-Portrait* (National Museum Cracow, 1887) exhibited by the Polish artist Anna Bilinska 'in her working blouse, straightforward in treatment, honest in the portrayal of the intelligent but by no means beautiful face'.[42] The word 'intelligence' appears again, and Bilinska sitting on a stool, wearing a dark blouse and clutching brushes and palette, was clearly a modern working artist. Pennell also informed her readers about a younger artist, Ethel Wright, whose *Bonjour, Pierrot!* (Gallery Oldham), influenced by the French pantomime *L'Enfant Prodigue*, was hung on the line. As Pennell surmised, Wright's modern subject was a success, purchased by the city gallery in Oldham, and it had a dramatic impact on Wright's career. (Wright would later portray Christabel Pankhurst; National Portrait Gallery.[43]) In highlighting the women's work in the 'large galleries' and critiquing the

segregation of women's art Pennell echoed the egalitarian arguments expressed by another journalist, Fenwick Miller, as noted in Pennell's diary and columns.[44] However, Pennell did not actively join Fenwick Miller's cause and, as Kimberly Morse Jones has highlighted, Pennell expressed ambivalence about the women's movement particularly in her writing much later in her career.[45]

Pennell's writing about the Royal Academy also demonstrated shifting ideas across the 1880s. While she was to become a frequent critic of Royal Academy exhibitions and Royal Academicians, her early reviews were less unequivocal. Her early articles in the *American* also included long reviews of solo shows of the now established Pre-Raphaelites John Everett Millais at the Grosvenor Gallery and Holman Hunt at the Fine Art Society. These were generally laudatory, though 'unequal excellence' was noted in Millais's pictures; for example, *Miss Eveleen Tennant* (Tate, 1874) in a red dress with a basket of ferns was 'strikingly full of character and original in treatment', while *Mrs. Schlesinger* (private collection, 1876) was deemed 'as stupid and characterless as a photograph'.[46] In contrast, Pennell proclaimed in 1885,

> Nothing could be drearier than a walk through the eleven galleries of the Royal Academy. The wonder is, first that so many bad canvases should have been hung, and then that so many people could have been gathered together to look at and admire them.[47]

But a work that stood out was Lawrence Alma-Tadema's *A Reading of Homer* (Philadelphia Museum of Art, 1885) where a 'young Greek reads a page of the *Iliad* or the *Odyssey*, to three men . . . and a young girl . . . leans forward with an expression of interest'. The subject and the technique, the archaeological rendering of marble, were praised by Pennell as were works by Leighton and Herkomer.

Pennell's diaries reveal that friendship with Edmund and Ellen (Epps) Gosse meant that Pennell interacted on social occasions with Royal Academicians such as Alma-Tadema and his wife the artist Laura (Epps). A dinner at the Gosses recorded an array of luminaries and celebrities:

> At supper had a few words about tricycles with Mrs. Thornycroft who in a blue silk gown looked uncommonly pretty . . . Had a good look at Mary Anderson . . . girl in a brown plush gown who is a professor of Greek at Girton and unspeakably clever . . . Mrs. Tadema in white with a gold serpent around her arm was there.[48]

Agatha Thornycroft was renowned for her artistic dress; Mary Anderson was an American actress; the academic would have been the classicist Jane Harrison; and Laura Alma-Tadema can be seen wearing the gold serpent on her arm (J. S. & A. B. Wyon, serpent armlet, c. 1870, private collection) in her husband's neo-classical *The Sculpture Gallery*, 1874 (Hanover, New Hampshire, Hood Museum of Art).[49] This excerpt is indicative of the ways in which celebrity and fashionability intertwined in late-nineteenth-century artistic culture.

By the time Pennell arrived in London the Grosvenor Gallery was already interrupting the dominance of the Royal Academy on the exhibition calendar.[50] Moreover, Bond Street was increasingly populated by dealers and smaller galleries, adding even more venues to her itinerary, such as an afternoon at the Dudley Art Gallery to write up the Exhibition for the *American*. 'Thought it rather pauvre. Stopped at Dunthorne's. Saw him and Walker too.'[51] Another April day she went

> to the Dore Gallery, to the Dowdeswell's to see the Ford Madox Brown and to Morris' to see the Burne-Jones tapestry. PMG cycling notes in the afternoon, and in the evening to the Society of Arts to hear Talbot Reed lecture on printing.[52]

Pennell was obliged to offer reviews and these smaller shows provided considerable 'copy' for her columns (and she had personal contacts such as Robert Dunthorne, her husband's dealer). Yet she proclaimed in 1893: 'London already has too many exhibitions . . . The closing of the Grosvenor one felt to be a public blessing; had half Bond St. followed its example it would have been a gain to art and artists.'[53] While in reality the commercial sector helped to sustain her livelihood as a journalist, her comment suggests a degree of scepticism about the expanding market for art during this period. Pamela Fletcher and Anne Helmreich have demonstrated the impact of this change on the rise of the modern art market. In her analysis of Whistler's 1892 Goupil exhibition, Helmreich argues that

> commercial art galleries reveal the profound disjuncture in the Victorian age between practices that advanced private interests – specifically those of the monied elite – and rhetoric that demanded that the commercial sector serve the needs of the public, fostering sociability, advancing the arts, and benefitting the nation.[54]

Pennell's diaries and columns suggest awareness of this disjuncture.

Nonetheless, Pennell was not always negative about Bond Street, particularly if a large dinner was involved as at the new Grafton Galleries. The Galleries, located just off Bond Street, opened in 1893 with an exhibition of paintings and sculpture by British and foreign artists:

> [T]he Grafton opened with a legitimate flourish . . . its first collection presents so much of genuine artistic interest that there seems a chance of achieving that distinction which the Grosvenor and the New Gallery despite their pretentions never attained. The bewilderment of the criticism at the Press view was promising . . . There is none of the academic emptiness which passes for art with most people.[55]

More to the point, it exhibited the modern artists she favoured, and it was as a result of her promotion of works such as Degas's *L'Absinthe* that she was aligned with the New Art Criticism.[56]

In London, temporary exhibitions became part of the shifting landscape of annual shows. Some of these were held in alternative sites around the city, such as the aforementioned World's Fair in Islington. Another early example that Pennell attended was the Health Exhibition of 1884:

> To South Kensington in the afternoon to the National Portrait Gallery. Went all through and made notes for a letter to the <u>American</u>. Then to the Health Exhibition. Took tea, after frightful hunt for a satisfactory dining hall, drank coffee at the little Indian tea place, sat and watched the people and the lights till nine, and – home.[57]

Here Pennell moves between sites, tackling more than one gallery in a day. This was a tactic she developed soon after her arrival in London. This was to do with travelling to one region of the city, in this case Kensington (the National Portrait Gallery collection was temporarily housed at the South Kensington Museum), and getting as much done as possible in order to write multiple columns or articles. The Health Exhibition, at a site between the Natural History Museum and the Royal Albert Hall, was held to celebrate British advances in national health, sanitation and disease control. For Pennell these were working venues, but they were also combined with leisure and pleasure for her as they were for the majority of their visitors. This might involve visits to tea-rooms or riding the rollercoaster with some of the 'giddy gang' at the 1890 French

Exhibition. It also involved descriptions and interpretations of the sites and often illustrations provided by her husband.

Ease of travel across the Channel made Paris expositions (and salons) available to many, and these received extensive attention. The Paris Exposition Universelle of 1889 was cleverly turned into a cycling holiday by Pennell and her husband. The written results were parcelled out to a variety of different publications, including the *Graphic* and the *Pall Mall Gazette*, thereby providing income for the holiday. For the *Graphic* she entertained readers with her mishaps and success speeding through the journey from Dieppe on the new machine, a tandem safety bicycle, while the *Pall Mall* had an unsigned three-part series on the site.[58] Her diary revealed the pitfalls encountered in the curation of the international exposition, a truly expansive enterprise. After a 'very good breakfast on the Boulevard Saint Germain' she soon discovered that in the Fine Art section many of the galleries were unfinished: 'the American and English not to be seen, neither is the Italian; the Spanish Russian and German half ready. The French far more finished condition and more exhausting.'[59] The following day there was only time for the Panthéon for the bookshops and then an early train to Dieppe and back to London 'to work again' writing notes for the papers.

In conclusion, Pennell's early working life in London was peripatetic, constantly moving between galleries and exhibition spaces. A close reading of her diaries and publications during this time period offers an historical specificity often absent from accounts of exhibition culture during this period. It gives insight into the ways in which as a woman art critic she negotiated metropolitan culture and professional life even before the emergence of the New Woman. Pennell was an independent city dweller, crossing the city on buses and the underground. The British Museum, National Gallery and Bond Street (along with the ever-changing calendar of temporary exhibitions) were crucial workshops for women art writers; in these spaces Pennell undertook the close study of objects and histories as well as critiquing visitor responses and curatorship. Through exhibitions, galleries, studios and 'at homes' Pennell fostered relationships with writers, artists and dealers. While Pennell would become a consistent proponent of 'modern' work (especially the Glasgow Boys and Whistler), her early diary and writings suggest a more ambiguous critical position which offered support for a diversity of women artists as well as more established artist celebrities. But it was the 'giddy gang' who emerged as a vital point of contact for experiencing the overlapping spaces of work and pleasure.

Notes

1. Morse Jones, *Elizabeth Robins Pennell*.
2. Waltman, *Early London Journals*, 54.
3. Clarke, *Critical Voices*, 115–53.
4. On women in museums see also Leahy, *Museum Bodies*, 153–70.
5. Pennell, 'Woman's Council Table', 772.
6. Aliquis, 'Art Critics', 193–7.
7. Clarke, 'Women in the Galleries'.
8. Many thanks to Colin Cruise for this observation.
9. Vadillo, 'Aestheticism', 175.
10. Pennell, 'Diaries', 1 April 1887.
11. GRT to ERP, n.d. Pennell-Whistler Collection, box 266.
12. Hughes, *Graham R.*, 112.
13. See Balducci and Jensen, *Women, Femininity and Public Space*, 1–16.
14. GRT to ERP, Whit Monday, n.d. c. 1891, Pennell-Whistler Collection, box 266.
15. Iskin, *Modern Women*.
16. Assael, *London Restaurant*.
17. Walker, 'Vistas of Pleasure'.
18. Pennell, 'Diaries', 11 May 1886; 31 January 1887; 27 April 1890.
19. Vadillo, *Women Poets*. Pennell later published 'London's Underground Railways'.
20. Pennell, 'Diaries', 5 September 1885.
21. Ibid. 28 May 1885.
22. Pennell, 'Woman's World in London' (1891): 504.
23. Bernstein, 'Reading Room Geographies', 17–18. See also Bernstein, *Roomscape*.
24. Pennell, 'Diaries', 20 February 1890. On museum lighting see 'Electric Lighting'; Swinney, 'Evil of Vitiating and Heating the Air'; also Mamoli Zorzi and Manthorne, *From Darkness to Light*.
25. Leland, *Algonquin Legends*. Algonquian is the name of the cultural linguistic group that includes many First Nation bands, of which the Algonquins are one.
26. Clarke, 'Women in the Galleries'; Fraser et al., 'Introduction'.
27. Pennell, 'Diaries', 24 September 1884.
28. Ibid. 22 April 1885.
29. Ibid. 11 April 1887.
30. The Pintoricchio panels have since been reattributed. See Dunkerton et al., 'Master of the Story of Griselda'.
31. Maltz, *British Aestheticism*, 108–25.
32. Selwood, 'Museums for the Many?'
33. Pennell, 'Diaries', 14 April 1890; 16 April 1890.
34. For instance, Rappaport, *Shopping for Pleasure*.
35. Hughes, *Graham R.*, 117.

36. Pennell, 'Diaries', 29 May 1886.
37. Ibid. June 1886; 26 June 1886.
38. Cherry, *Beyond the Frame*, 196–8; Cherry, *Painting Women*, 102–3.
39. Pennell, 'Woman's World in London', (1892): 484–5.
40. Ibid.
41. Robins, *Fragile Modernism*, 112–16.
42. Pennell, 'Woman's World in London', (1892): 485.
43. Broadley, 'Painting Suffragettes', 159–84.
44. Clarke, *Critical Voices*, 2005.
45. Morse Jones, *Elizabeth Robins Pennell*, 30–2.
46. Pennell, 'Holman Hunt Exhibition', 376–7; Pennell, 'Millais Exhibition', 248–9.
47. Pennell, 'London Art Exhibition', 72.
48. Pennell, 'Diaries', 1 April 1890.
49. Calvert, *Fashioning the Artist*; Calloway et al., *Cult of Beauty*; Prettejohn and Trippi, *Lawrence Alma-Tadema*.
50. Denney, *At the Temple of Art*; Newall, *Grosvenor Gallery Exhibitions*.
51. Pennell, 'Diaries', 8 October 1885.
52. Ibid. 17 April 1891.
53. [Pennell], 'Grafton Gallery', 2.
54. Helmreich, 'Art Market', 447; see also Fletcher and Helmreich, *Rise of the Modern Art Market*.
55. [Pennell], 'Grafton Gallery', 2.
56. Morse Jones, *Elizabeth Robins Pennell*, 53–70; Clarke, *Critical Voices*, 130–41. Also Gruetzner Robins and Thomson, *Degas, Sickert and Toulouse-Lautrec*.
57. Pennell, 'Diaries', 16 September 1884.
58. [Pennell], 'To the Paris Exhibition', 11.
59. Pennell, 'Diaries', 13 May 1889.

Bibliography

Aliquis. 'Art Critics of To-Day'. *Art Journal, 1839–1912* (July 1892): 193–7.

Assael, Brenda. *The London Restaurant, 1840–1914*. Oxford: Oxford University Press, 2018.

Balducci, Temma, and Jensen, Heather Belnap, eds. *Women, Femininity and Public Space in European Visual Culture, 1789–1914*. Burlington, VT: Ashgate, 2014.

Bernstein, Susan. 'Reading Room Geographies of Late-Victorian London: The British Museum, Bloomsbury and the People's Palace, Mile End'. *19: Interdisciplinary Studies in the Long Nineteenth Century* (2 January 2012). Accessed 26 February 2020. https://doi.org/10.16995/ntn.632.

Bernstein, Susan. *Roomscape: Women Writers in the British Museum from George Eliot to Virginia Woolf*. Edinburgh: Edinburgh University Press, 2014.

Broadley, Rosie. 'Painting Suffragettes: Portraits and the Militant Movement'. In *Suffrage and the Arts: Visual Culture, Politics and Enterprise*, ed. Miranda Garrett and Zoë Thomas, 159–84. London: Bloomsbury, 2018.

Calloway, Stephen, Orr, Lynn Federle and Whittaker, Esmé, eds. *The Cult of Beauty: The Aesthetic Movement 1860–1900*. London: V&A, 2011.

Calvert, Robyne Erica. *Fashioning the Artist: Artistic Dress in Victorian Britain 1848–1900*. Dissertation, University of Glasgow, 2012.

Cherry, Deborah. *Beyond the Frame: Feminism and Visual Culture, Britain 1850–1900*. London: Routledge, 2000.

Cherry, Deborah. *Painting Women: Victorian Women Artists*. London: Routledge, 1993.

Clarke, Meaghan. *Critical Voices: Women and Art Criticism in Britain 1880–1905*. Aldershot: Ashgate, 2005.

Clarke, Meaghan. 'Women in the Galleries: New Angles on Old Masters in the Late Nineteenth Century'. *19: Interdisciplinary Studies in the Long Nineteenth Century* 28 (2019). Accessed 20 January 2020. https://doi.org/10.16995/ntn.823.

Denney, Colleen. *At the Temple of Art: The Grosvenor Gallery, 1877–1890*. Madison, NJ: Fairleigh Dickinson University Press, 1999.

Dunkerton, Jill, Christensen, Carol and Syson, Luke. 'The Master of the Story of Griselda and Paintings for Sienese Palaces'. *National Gallery Technical Bulletin* 27 (2006): 4–71.

'Electric Lighting of the British Museum'. *The Illustrated London News*, 20 February 1890, 164.

Fletcher, Pamela M. and Helmreich, Anne, eds. *The Rise of the Modern Art Market in London 1850–1939*. Manchester: Manchester University Press, 2011.

Fraser, Hilary, Avery-Quash, Susanna and Alambritis, Maria. 'Introduction'. *19: Interdisciplinary Studies in the Long Nineteenth Century* 28 (2019).

Gruetzner Robins, Anna and Thomson, Richard. *Degas, Sickert and Toulouse-Lautrec: London and Paris 1870–1910*. London: Tate, 2005.

Helmreich, Anne. 'The Art Market and the Spaces of Sociability in Victorian London'. *Victorian Studies* 59, 3 (2017): 436–49. Accessed 21 February 2020. https://doi.org/10.2979/victorianstudies.59.3.07.

Hughes, Linda K. *Graham R.: Rosamund Marriott Watson, Woman of Letters*. Athens: Ohio University Press, 2005.

Iskin, Ruth. *Modern Women and Parisian Consumer Culture in Impressionist Painting*. Cambridge and New York: Cambridge University Press, 2007.

Koven, Seth. *Slumming: Sexual and Social Politics in Victorian London.* Princeton and Oxford: Princeton University Press, 2004.

Leahy, Helen Rees. *Museum Bodies: The Politics and Practices of Visiting and Viewing.* Burlington, VT: Ashgate, 2012.

Leland, Charles Godfrey. *The Algonquin Legends of New England: Or Myths and Folk Lore of the Micman, Passamaquoddy and Penobscot Tribes.* Boston: Houghton, Mifflin, 1884.

Maltz, Diana. *British Aestheticism and the Urban Working Classes, 1870–1900: Beauty for the People.* Basingstoke and New York: Palgrave Macmillan, 2006.

Mamoli Zorzi, Rosella and Manthorne, Katherine, eds. *From Darkness to Light: Writers in Museums 1798–1898.* Cambridge: Open Book, 2019.

Morse Jones, Kimberly. *Elizabeth Robins Pennell: Nineteenth-Century Pioneer of Modern Art Criticism.* Burlington, VT: Ashgate, 2015.

Newall, Christopher. *The Grosvenor Gallery Exhibitions: Change and Continuity in the Victorian Art World.* Cambridge: Cambridge University Press, 1995.

Pennell, Elizabeth Robins. 'Diaries'. Joseph and Elizabeth R. Pennell Papers. Harry Ransom Center. University of Texas at Austin.

[Pennell, Elizabeth Robins]. 'The Grafton Gallery'. *Star* (17 February 1893): 2.

Pennell, Elizabeth Robins. 'The Holman Hunt Exhibition in London'. *American* (3 April 1885): 376–7.

Pennell, Elizabeth Robins. 'The London Art Exhibition'. *American* (6 June 1885): 72.

Pennell., Elizabeth Robins. 'London's Underground Railways'. *Harper's New Monthly Magazine* (January 1896): 278–87.

Pennell, Elizabeth Robins. 'The Millais Exhibition in London'. *American* (6 February 1886): 248–9.

Pennell, Elizabeth Robins. Pennell-Whistler Collection. Special Collections, Library of Congress, Washington, DC.

[Pennell, Elizabeth Robins]. 'To the Paris Exhibition on a Tandem Bicycle'. *Graphic*, 22 June 1889. British Library Newspapers.

Pennell, Elizabeth Robins. 'Woman's Council Table: Woman's World in London'. *Chautauquan* 12, 6 (March 1891): 772.

Pennell, Elizabeth Robins. 'Woman's World in London'. *Chautauquan* 13, 4 (July 1891): 504.

Pennell, Elizabeth Robins. 'Woman's World in London'. *Chautauquan* 15, 4 (July 1892): 484–5.

Prettejohn, Elizabeth and Trippi, Peter. *Lawrence Alma-Tadema: At Home in Antiquity.* Munich, London and New York: Prestel, 2016.

Rappaport, Erika Diane. *Shopping for Pleasure: Women in the Making of London's West End*. Princeton: Princeton University Press, 2000.

Robins, Anna Gruetzner. *A Fragile Modernism: Whistler and His Impressionist Followers*. New Haven and London: Yale University Press, 2007.

Selwood, Sara. '"Museums for the Many?" Rhetorical Optimism and the Failure of Sustained Political Will at Three London Government-Funded Museums – Then and Now'. *Cultural Trends* 27, 4 (8 August 2018): 270–95.

Swinney, Geoffrey N. '"The Evil of Vitiating and Heating the Air": Artificial Lighting and Public Access to the National Gallery, London, with Particular Reference to the Turner and Vernon Collections'. *Journal of the History of Collections* 15, 1 (1 May 2003): 83–112. Accessed 25 January 2020. https://doi.org/10.1093/jhc/15.1.83

Vadillo, Ana Parejo. 'Aestheticism "at Home" in London: A. Mary F. Robinson and the Aesthetic Sect'. In *London Eyes: Reflections in Text and Image*, ed. Stephen Barber and Gail Cunningham, 59–78. New York and Oxford: Berghahn Books, 2007.

Vadillo, Ana Parejo. *Women Poets and Urban Aestheticism: Passengers of Modernity*. Basingstoke: Palgrave, 2005.

Walker, Lynne. 'Vistas of Pleasure: Women Consumers of Urban Space in the West End of London 1850–1900'. In *Women in the Victorian Art World*, ed. Clarissa Campbell Orr, 70–85. Manchester: Manchester University Press, 1995.

Waltman, John. *The Early London Journals of Elizabeth Robins Pennell*. Dissertation, University of Texas at Austin, 1976.

Elizabeth Robins Pennell's Wartime Prose: *Nights* and *The Lovers*

Jane S. Gabin

During World War I, a momentous time for politics, literature and the arts, Elizabeth Robins Pennell published two longer prose works – the memoir *Nights: Rome, Venice, in the Aesthetic Eighties; London, Paris, in the Fighting Nineties* (1916) and a novella, *The Lovers* (1917).[1] These two books are important to discuss as part of any study of Pennell's career, but they are particularly interesting when considered as part of her complicated response to the war. The two works, published close together and based largely in England but partly on the Continent, capture, in very different ways, Pennell's reactions to the growing chaos of the world around her. In *Nights* she turns her attention to the past, immersing herself in the nostalgia of earlier, better days; only in *The Lovers* does she finally directly confront in a substantial aesthetic way the impact of the Great War.

The decade from 1910 to 1919 was a world-shattering time, and not just because of the war. It also saw the sinking of the *Titanic*, the Triangle Shirtwaist Factory fire, the massacre of the Armenians, the struggle for women's suffrage in England, and the fight for Home Rule in Ireland, including the bloody Easter Rising. Yet none of these events figure directly in Pennell's work. To be fair, she never wrote much about current events or politics. From the beginning of her career in the early 1880s, her concerns were always of a different sort, primarily aesthetic. She wrote about travel, cycling, art, food and a host of esoteric subjects (mischief, gardening, literature, London life) over the course of a prolific writing career. But after 1914, the dramatic events of the non-aesthetic world became harder to ignore.

In March 1915, Pennell published an essay called 'London Under the Shadow of War' in the *Atlantic Monthly*, and it was her one and only journalistic piece about the conflict. It records

for American readers her impressions of a great city at war, for, as she was too young to remember the American Civil War, this was her first experience of conflict up close. She finds that war has made London 'so extraordinary and so interesting' to her, with its contrasting images of fear, patriotism and bravado.[2] She describes an early food panic that drives her to Jackson's of Piccadilly to stock up on American comfort food. The immediacy of war comes to her in the absence of men she has come to rely upon: the local butcher, a baker, a waiter and a hairdresser, who all left to answer the call of their native France or Germany. 'I felt the grim tragedy the more,' she writes, 'because of the personal, the intimate, the everyday manner in which it interfered with me'.[3] Then she moves from her personal connections to the general picture of 'altogether a mad, topsy-turvy unbelievable London', with men in khaki drilling in the parks, refugees and wounded soldiers coming in through Charing Cross Station, and sports victories in print as large as the war reports in the papers.[4] Behind any gaiety, though, is the sorrow just a few miles away across the English Channel. She writes, 'I shrank from the cruelty of London taking its pleasures in the tranquil night; nobody, it seemed, could spare a thought for the British dead piled high at Mons.'[5]

No wonder then that by 1916, Pennell sought solace from the sheer madness of wartime conditions all around her in London by turning to the fond, peaceful memories of earlier decades. In *Nights*, she immerses herself in the past, fixing her gaze steadily over her shoulder at the happier times of the 1880s and 1890s. Admittedly, when *Nights* was published, Pennell was in her sixties, so a certain amount of nostalgia creeping into her writing should not be all that surprising. But I argue that the tone of *Nights* is so intensely elegiac precisely *because* she didn't want to face the horrors of the day. Only when nostalgia no longer worked for her did Pennell finally face the present in her writing, though in a way that was, for her, totally new.

Nights describes the Pennells' experiences in Rome and Venice in the 1880s, shortly after they had crossed the Atlantic from Philadelphia; and London, where they had a home, and Paris, where they spent a lot of time, in the 1890s, and their interactions with leading artists and intellectuals of the day. It is composed, in part, of essays that had also appeared previously in the *Atlantic Monthly*.[6] The section on London is longest, as that is where the Pennells spent the most time, and it takes place primarily in their Buckingham Street flat, which exists to this day. *Nights* has a conversational and sometimes pedantic or gossipy and name-dropping tone, painting vividly

the European art scene of the 1880s and especially the 1890s, which Pennell calls 'that delectable decade'.[7]

The general sentiment of *Nights* is that these earlier decades were much better times than the present day in which she is writing. People, she says, 'especially people doing our sort of work [journalism and art criticism], were much more awake in the Nineties, much more alive, much more keen about everything'.[8] People argued about art, about poetry, about exhibitions, and 'artists and critics were bludgeoning each other in the press'.[9] It was exactly this spirit of passion, intellectual debate and challenge that, she opined, imparted the most excitement to that decade: 'The Yellow Nineties, the Glorious Nineties, the Naughty Nineties, the Rococo Nineties, are descriptions I have seen, but the Fighting Nineties would be mine.' As she recalls it, 'Scarcely an important picture was painted, an important book illustration published, an important book written, an important criticism made, that it did not lead to battle.'[10] Her choice of wording is interesting here. Intellectual warfare – aesthetic battle – she recalls fondly, perhaps as a longed-for alternative to real battlefields which brought carnage too intense for Pennell to face.

While the main purpose of *Nights* seems to be reminiscence, the book also underscores the fact that Pennell's career, while seeming glamorous or idyllic in retrospect, was grounded in unrelenting effort:

> never was I without my inseparable note-book and pencil in my hand or in my pocket, never without good, long, serious articles to be written in my hotel bedroom. Even in London when I might have passed for the idlest stroller along Bond Street or Piccadilly on an idle afternoon, oftener than not I have been bound for a gallery somewhere with the prospect of long hours' writing as the result of it . . . So it has been throughout my working life: my day's task has had no other object than to get itself chronicled in print.[11]

This theme of the necessity of work appears early and often in *Nights*. Pennell portrays her earlier self as a committed travel writer and art critic, not as a person of privilege out to do the Grand Tour, which she most definitely was not. Neither her family nor Joseph's was prosperous; they had to work to get by. From an early age, Joseph was always drawing, always sketching, and when he was not creating art he was hunting for artistic subjects. Elsewhere, Elizabeth recalls, 'my first impression of J. was of a man who did not want to do anything except work'.[12] He glorified, and buried himself in, the ideal of labour to such an extent that his great wartime project *The Wonder of Work*

is actually an apt name for his own approach to art and life. But, to some extent, such a work ethic was expected of him, as a man.

Elizabeth, on the other hand, additionally had to contend with the fully fledged sexism that expected her writing to be an avocation, a charming add-on rather than a career. In order to validate her professionalism, Elizabeth reasoned, she needed to produce an impressive body of work. Would a male writer have been so concerned about writing 'long, serious articles'? Describing how she visited Paris annually for a week every May to see new art exhibits, Pennell notes the tremendous effort she expended. She recalls 'how many articles I had to write, how many prints and drawings, statues and pictures, I had to look at in order to write them', and she takes pride in her 'success in never leaving my editors in the lurch'.[13] Her output certainly was prolific. In 1894 alone she published over a hundred articles, mostly art criticism, in a variety of journals including the *Daily Chronicle*, the *Nation* and the *Fortnightly Review*. And her achievements matched quality with quantity; Pennell's work was respected, even sought after, in the periodical art world. In fact, Meaghan Clarke has written that Elizabeth Robins Pennell's essays 'contributed to a transatlantic assessment of modernism' at a time when the art world was becoming 'increasingly internationalized'.[14]

Before setting out on her recollections of times in the great cities of Europe, Pennell explains her choice of title. For her, in her glory days, night-time was a combination of work and play, the best of both worlds. She spends many pages at the beginning of the volume outlining all the tasks and assignments that kept her days busy. The idea of recreation or play was something apparently anathema to her upbringing: 'The manner of playing was entirely new to me in the beginning. All conventions bind with a heavy chain, but none with a heavier than the Philadelphia variety.'[15] So she turned her play into work as well, writing countless pieces about the travel-as-play journeys she took with her husband. She explains that her account of 'how I played I cannot help hoping has a wider interest. These old nights were typical of a period, and they threw me with many . . . who did much to make that period what it was.'[16] She clearly states her intention then to reminisce in *Nights*, to make the past live again, and to give herself (and readers) escape from the present through pleasure in remembering. Memory becomes an antidote to the present.

The narration of these adventures begins with chapters on the Pennells' exploits in Italy in 1884. She and Joseph were young, just a few months from their more restricted upbringing in Philadelphia. In Rome, the Pennells 'followed the streets wherever they might lead',

stopping at a church or an art gallery or garden, relying on serendip-
ity in their ramblings.[17] They visited area restaurants and chatted
with the locals and admired the uniforms of the soldiers. Elizabeth
began to enjoy relaxing among people she did not know and 'settled
down to idleness and coffee with as little scruple as the natives'.[18]

Yet she also made a strong distinction between 'tourists' and
dedicated individuals like herself who were there to nurture their
understanding of aesthetics. She learned that a French café advertis-
ing in awkward English that there one may '*Meet of Best Society*'
simply attracted tourists.[19] That did not interest her. She did not
want mere Americans, but only those of her more cosmopolitan
intellectual disposition. Finally, they met at one café their desired
companions and, from then onward, 'I do not believe we were ever
left to pass an evening alone.'[20] She writes: 'The quality of the talk
was as amazing: bewildering, revolutionary, to anybody who had
never heard art talked about by artists.'[21] Pennell found all of this so
new, so European, so intellectually stimulating.

Her memories of Rome reflect her dual interest in work and plea-
sure in those long-ago days. One of Pennell's most treasured experi-
ences was a dinner at an old inn at Pompeii. A long table sat different
groups of people, and at one end were the Pennells 'with the Swiss
artist and an old German professor of art and an older Italian archae-
ologist', and all the conversation was about art, so that it 'made me
feel at home'.[22] Meanwhile, 'the American tourists at the other end
of the table deplored the disorder and noise until we sent them the
longest and most expensive way up Vesuvius to get rid of them'.[23]
This can be seen as funny, yet it is an echo of her occasionally conde-
scending attitude. Art was for her and her kind. One of the aspects of
international travel that she loved best was communing with fellow
cosmopolitan expatriates on a similar intellectual level – but differ-
entiated from the vulgar and culturally unaware 'American tourists'.

Venice was likewise a pleasure for Pennell, although her first
impression was as hazy as a Turner canvas:

> I did not thrill, I shivered with cold and damp and fog as the gondola
> pushed through the yellow gloom in the sort of silence you can feel, and
> tall houses towered suddenly and horribly above us, and strange yells
> broke the stillness before and behind, when another black boat with a
> black figure at the stern, came out of the gloom, scraped and bumped
> our side, and was swallowed up again.[24]

Her accounts of the various cafés they sampled and the Americans
they met are lively and often humorous. She wryly describes one

British artist as 'the weariest man who breathed. It made me tired to look at him.'[25] She speaks of their friendship with the American artist Frank Duveneck, and although at that point she had not met Whistler, whose works she would later champion, he was legendary in Venice:

> I hardly hoped ever to meet him; I certainly could not expect that the day would come when he would be our friend . . . But had my knowledge of him come solely from those months in Venice I should still have realized the power of his personality and the force of his influence. He seemed to pervade the place, to color the atmosphere.[26]

Although Pennell thinks there was much to admire in Venice, it was simply a way station. It lacked the right balance of work and pleasure for her tastes. In its beauties and diversions they found more distractions from the real world – again, the world of work. Venice was 'a City of Dreams' in which 'we were the real Lotus Eaters drifting to the only Lotus Land where all things have rest'.[27] It was delusional, lovely and tempting; it was not, however, for them. She says that if she and Joseph 'were to hope for figs with our bread, or even for bread by itself, we had to move on to the next place where work awaited us'.[28] Therefore, they tore themselves away from fantasy and indulgent delight, in favour of, she says in her final sentence of this section, 'a world where no lotus grows and life is all Labour'.[29]

London, which comes next, takes up more than half the book, and this section is truly a paean to that city. In the 1890s, in their London neighbourhood, which Pennell calls 'The Quarter', their flat became a hub of discussion and festive eating and drinking, a continuation of activities that had begun at their previous apartment in Bloomsbury. There was nothing formal about these meetings and invitations seem not to have been involved. Writers and artists both Elizabeth and Joseph knew from popular publications simply began to stop in, and the word spread until the gatherings turned into a crowded salon.

Regularly, on Thursday evenings, their upstairs flat in Buckingham Street was filled with the interested and – at least to some – the interesting. Their neighbours in 'The Quarter' included Thomas Hardy, George Bernard Shaw and J. M. Barrie. In the 'London' section of *Nights*, Pennell obviously relishes her memories of Thursday nights, when their apartment filled with a sparkling array of cognoscenti and figures in the arts. Their guests included Violet Hunt, George Moore, Pearl Craigie (John Oliver Hobbes), Kenneth Graham, Max Beerbohm, Aubrey Beardsley, William Ernest Henley, the editor Henry Harland,

illustrator Walter Crane, publisher John Lane, and illustrator Phil May, who contributed many humorous pictures to *Punch*. Harland and Beardsley considered both Pennells trusted advisors and invited them to a special celebratory dinner when the first issue of *The Yellow Book* was published in 1894. *Nights* includes extensive discussion of *The Yellow Book* and also of Elizabeth's great friendship with Beardsley. The Pennells' friendship with their compatriot James McNeill Whistler flourished and became devotion. Surely, the Pennells and their circle of friends and acquaintances were not only familiar with, but at the centre of, all the aesthetic and political ideas, trends and events swirling around them.

This section is written, though, with much more of what the memoir theorist Sven Birketts calls a 'double vantage point' (as in, combining past and present) than the Italian sections, and for good reason.[30] Pennell was still in London when writing *Nights*, and, therefore, it would have been almost impossible for her not to compare past London and present London. Not surprisingly, in this section Pennell clearly conveys a distinct sense of the best being over:

> And yet now only two or three of the old friends of the old Thursday nights are left to look down with us upon the river where it flows below our windows . . . It is not only the dead we have lost. Time has made other changes as sad as any wrought by Death.[31]

Pennell doesn't specifically mention the war here; the 'changes' and 'Death' could just refer to her personal losses, friends and family who have aged and, in some cases, passed on since the 1890s. It is difficult, though, not to infer that she is also referencing the conflict on the battlefields that, by 1916, haunted life everywhere in England and Continental Europe. As she had written in her 1915 *Atlantic Monthly* essay, Londoners now saw 'all the machinery of war in a town accustomed to the parade of war'.[32] The war was real and near and each day Londoners felt its 'haunting message of danger and sorrow and horror'.[33]

The final section of *Nights* focuses on Paris, then as now a centre of the art world and the city (of the four in the book) mostly closely associated geographically with the war. Here Pennell revels in her memories of visits to artists' studios, to museums, to salons and to cafés. She mentions lilacs and horse-chestnuts several times, and the sight and fragrance of spring blooms permeate this part of *Nights*. People travelled to this city for many reasons, she writes, but the best was 'for sheer love of Paris in the May-time'.[34] Her memories of the

city of light are, not surprisingly, most closely associated with spring, the season most bursting with new life and promise.

The double vantage point is even stronger here than in the London section. For over two decades – even before the Grand Palais, where these exhibits are now held, opened in 1900 – Pennell and other critics and observers went to see the new artworks displayed every May. She seems to regret only two things: one, that all the work she put in reviewing the new art prevented her from seeing more of the sights of Paris. And two, that so many of those who accompanied her in earlier trips to the salons have died. She is pleased, though, that she has so many good memories of wonderful dining, as 'our special business was the study of art and in Paris dining and art are one'.[35] She goes to some performances and visits a number of cafés, including the one presided over by Aristide Bruant. Yet this entire section of *Nights* is overhung not with blossoming spring flowers but with the spectre of death. This dark focus is not necessarily a result of the Great War only, although the sole exhibition Pennell describes seeing in Paris during the conflict shows 'the wounded, the maimed, the dying'.[36] It is also the realisation that the best part of her own journey is over. What was is gone, and familiar routines have retreated into an untouchable past: 'The spring nights still are beautiful on the *Boulevards* and *Quais* but only ghosts walk with me along the old familiar ways, only ghosts sit with me at table in restaurants where once I always ate in company.'[37]

This section is a touching elegy to her youth. But the ghosts are from both the present and past, anonymous soldiers and her own former self. Seventy pages later, she considers herself an old woman at sixty: 'Of all the many ghosts that walk with me along the old familiar ways, the one keeping most obstinately at my side is that of my own youth, reminding me of the prosaic, elderly woman I am.'[38] She worries that this trip to Paris-of-memory represents a line of demarcation between everything that has happened in her world and what is to come:

> Does it mean, I wonder, the end of all old days and nights for me in Paris, as the war that has shut fast the *Salon* doors means the end of the old order of things in the Europe I have known? Shall I never go to Paris again in the season of lilacs and horse-chestnuts? Already I have ceased to meet my old friends by day in front of the pictures of the year and to quarrel with them over it by night at a *cafe* table, or in the peaceful twilight of the suburban town and park and garden. Am I to lose as well the link with the past I had in the *Salon*, am I to lose perhaps Paris?[39]

Here the War creeps into Pennell's work, in her very act of commemorating the past: 'Who can say at the moment of my writing, when the echo of shells and bullets is thundering in my ears?'[40]

Nights is one long *ubi sunt*, and the constant name-dropping can be forgiven because in exchange we receive an eyewitness description of vibrant individuals meeting together during a colourful era. The book is a 'ramble down those crowded, haunted, resounding Corridors of Time' in which we see, in passing, writers such as Robert Louis Stevenson, D. S. MacColl and Charles Whibley; artists such as John Singer Sargent, Auguste Rodin and Edgar Degas.[41] Pennell was acutely aware that one era was even then in the process of yielding to the next, as 'the banging, the battering, the bombarding of the younger generation at the Victorian door against which it was desperate work to make any impression at all'.[42]

While Pennell's recollections in *Nights* are mostly positive, the recurrent sadness of the present, especially in the second half of the book, is almost overwhelming. Presciently, Pennell feels that nothing will ever be the same. The brightness and optimism of her early prose, and what Paola Malpezzi Price refers to as Pennell's 'deep-seated sense of adventure',[43] referring to her days of cycling and tramping around Britain and Europe, are now relics of the past.

Nights captures one response to the War, and it resonated with some. One contemporary reviewer commented that the book served as welcome relief from unpleasant news. Robert Lynd, writing in *Publishers' Weekly*, called *Nights*

> the most interesting volume of travel and reminiscence to appear this spring. A million leagues away it seems now, with Europe, Europe everywhere and not a bit to enjoy. And yet how it all comes back to us in her more than welcome pages. Such friends and such evenings![44]

Soon enough, however, the Great War forced Pennell to abandon her backward-looking tendency and, finally, focus squarely on the present. She moved on from her nostalgia for the glories of the 1880s and 1890s, and was compelled to examine the conflict directly, in some way beyond what she had already achieved with her first-person, journalistic account in 'London Under the Shadow of War' from 1915. The War permeated the Pennells' flat thoroughly and affected them with deep melancholy. Just a couple of streets from Charing Cross Station, evidence of the war was right in their front yard. The streets were thronged by thousands and the cheering at the nearby station disturbed the tranquillity of the flat and invaded their lives. They could hear the sounds of troops shipping out:

regiments or companies or squads of the new breed of British soldiers, in khaki or tweeds or blue serge or black coats or corduroys, in military caps or cap cloths or top hats of bowlers or no hats at all, without a gun to their name, or a band or a bugle, singing, whistling, straggling in anything but time.[45]

And they saw the wounded returning, 'the strangest and saddest sight of all'.[46]

The War affected the work of both Pennells, though in very different ways. Raised in the Quaker tradition, Joseph had a deep horror of war and violence. Writing about him years later, Elizabeth said that Joseph was sickened thinking of how the beautiful places he had seen and sketched earlier in Europe were now being bombed and obliterated. In addition, while no longer a religious man, he 'could not throw off so easily his legacy from many generations of Quakers, from forefathers who since the days of George Fox had been men of peace'.[47] When sent by his publishers, Lippincott/Heinemann, to render illustrations of the industry serving the war effort, he went with very mixed feelings, for he did not wish to glorify the conflict. He loved seeing the industrial works in the north of England, for instance, and considered them beautiful if he did not think about the fact that they were designed to kill people. In her biography of her husband, Elizabeth says that Joseph was forever altered by the War. That 'tragedy', she says, 'never altogether lifted its shadow from his life'.[48] With the conflict raging, Joseph threw himself into his work responsibilities, his lectures on art history, his organising of exhibits and his printmaking as 'distractions to help him forget, if only for a moment, the horror that haunted him'.[49]

Elizabeth also must have been profoundly affected, but, unsurprisingly, she did not talk about it much in any of her partial memoirs. Instead, for the first time in her professional writing life, she turned to long-form fiction in order to explore the experience of war through one couple's story. Perhaps she thought that her first-person account in 'London Under the Shadow of War' was too narrow and detached a perspective, that her descriptions of the war's impact on her London life were inadequate. She needed to tell a story that went beyond her own experience, and for that she needed fiction. The result was her novella *The Lovers*, published at the height of the conflict. This is an expanded version of a 1911 short story 'Les Amoureux; An Idyl of a London Garret,' originally published in the *Century*, the popular American magazine that had published so much of the Pennells' early work about cycle-travel and art. The story is a voyeuristic vignette of a couple enjoying the heady passion of a new marriage in London.

But the second, longer version that became *The Lovers* was designed to highlight the pointless suffering imposed by the conflict. Pennell expands the story to include the man's visit to her home, as a result of her publishing the original tale. Then, narrating the progress of the letters she is given by the young woman, she depicts the man during army training and in the trenches at the front. The story begins the same way: two young artists, never referred to by specific names but as 'L'Amoureux' and 'L'Amoureuse', live in a nearby studio. At first Pennell, like some beneficent observer, watches them from her own windows. She realises they are torn from each other by the Great War, and, later, reconstructs the man's days at the front, as he volunteers for the first available regiment and moves from training to Flanders. She does not idealise the conflict but is blunt about both its heroism and futility. *The Lovers* is a bleak picture from the point of view of the neutral looker-on who recalls happier and more optimistic times. Here she contrasts the frenzied public enthusiasm about the Boer War with the grim resolve of the Great War:

> I remember the scenes in the streets, the frantic farewells, the Mafficking orgies when the London crowds speeded the British troops on their way to South Africa during the Boer War. But there has been no such demonstration to the troops bound for Flanders and Egypt, for Gallipoli, Mesopotamia, Salonica . . . Now and then, from my comfortable bed, I hear cheering at Charing Cross Station and I know a troop train is starting out over the bridge, and soldiers are off to be butchered.[50]

Pennell waits until that very last word to inject her opinion, and it is pejorative and graphic. Now, with the war under way, she adds her own anti-war voice to the story. 'He [the male protagonist] was one of the millions', writes Pennell in her introduction to *The Lovers*, 'who go and come as they are bidden',[51] and later she says he must perceive

> the preposterous uselessness of the wholesale slaughter, the madness of men from one end of Europe to the other hard at work killing each other for few could say what – the inhumanity of the cold, calculating, mechanical modern method of fighting – the uselessness, the madness, the inhumanity that is the true tragedy of the most tragic war the world has ever reeled under since the world began.[52]

The language is forceful, its nouns and adjectives full of Pennell's revulsion. Perhaps she hoped the story would be read by people of

feeling and would be one more significant stone in an anti-war monument.

For her, the War meant not only the death of this one young man in *The Lovers*, but also the death of art and aestheticism. She writes with regret:

> Those whose memory can get clear of the shadow hanging over us all and went back to 'Before the War' will recall ... when *les jeunes* of London used to meet in the late evening at the far end of the café they patronized to plot insurrection in their work, and to dazzle each other by the length of their hair, the width of their hat-brims, the yearning eccentricity of their clothes.[53]

This all seems so innocent and joyful, and in fact it was. The small victories of youth and the eager campaigns of its artists were to be overshadowed by the loss of almost an entire generation.

Generally, the book was favourably assessed, with, for example, the *Boston Transcript* considering *The Lovers* '[o]ne of the few enduring books that have come or that are to come out of the great conflict'.[54] And the *New York Times* agreed: 'Because it is so simple, so tender, so human, so true, so absolutely of the stuff of life in wartime days, Mrs. Pennell's little tale deserves wide reading.'[55] However, in the long run, *The Lovers* turned out to be not so 'enduring' and never did attain a wide readership. It has descended into obscurity.

Once the conflict ended, Pennell's parable was forgotten, bypassed by other, more emotional war stories. Perhaps because they are unnamed, the main characters never take on a more memorable aspect. Pennell may have wished her lover/soldier to be a kind of Everyman, and his female counterpart to represent all the women who suffer when wars occur; but instead they are, for some readers, anonymous, difficult to fully connect with. *The Lovers* may not be great fiction, but it is memorable as a limited glimpse into lives limited by the Great War. And it marks the closure of a period not only for Pennell, but for her generation as well.

By early 1918, both Pennells had returned to America, after more than thirty years abroad, and although this insulated them geographically from the theatre of war, the return home did little to improve their overall mood. The nostalgia of *Nights* carries over to a different kind of nostalgia, one concerning their native land. Writing in the summer of 1918, Pennell finds herself unpleasantly surprised by the changes that have occurred in America during her absence. A person of her experience and intelligence certainly could not have

imagined it looking exactly as it had when she left in 1884. But she is disappointed in both what she sees and what she feels. 'I could hardly have recognized myself', she writes, as a 'young, eager seeker after adventure who had sailed for Europe in the dim, remote Early Eighties.'[56] Rather than feeling celebratory about all that the United States had accomplished in her absence, she reports feeling 'not at home but homeless, bewildered by the big differences in my country and the people'.[57]

Nevertheless, the two books Pennell produced during the War convey her incisive literary skills, both as a memoirist and as a fiction writer. By 1918, she may have felt that everything wondrous in her life had already occurred. Still lying ahead are important parts of her literary career – her work on Whistler, her study of Italian gardens and her two-volume retrospective of Joseph Pennell's life. But her wartime writing marks a turning point; she didn't write another memoir of her own and she never again tried her hand at fiction.

Today, *Nights* stands as an original and elegiac depiction of the daily life of artists and writers in some of Europe's major centres in the late nineteenth century. Joseph may have been the visual artist of the couple, but Elizabeth demonstrates a fine eye for delineating detail, for recalling important moments, and for recreating a great sense of the *joie de vivre* of those days and evenings. She conjures up, with great tactile detail, 'the impression of great space, and lofty ceilings, and many canvases, and big easels, and bits of tapestry and the gleam of old brass and pottery, and excellent dinners, and, of course, vehement talk, and a friendly war of words'.[58]

The Lovers, though it is not that outstanding a work of fiction, is important because it captures the effects of the War on just two people – a microcosm of world-wide catastrophe. The journalist in Elizabeth Robins Pennell saw a very human story and allowed the quotidian details in one soldier's letters to speak about the utter insanity of the conflict. It is significant, though, that she never again wrote about this topic. Instead, she spent the two decades remaining in her life to concentrate on what had always given her the most pleasure: writing about art and artists.

Notes

1. Pennell did publish one other book during the war, her partial memoir *Our Philadelphia*. But as it was published in 1914, it was written mostly, if not entirely, before the war began.

2. Pennell, 'London', 397.
3. Ibid. 398.
4. Ibid. 399.
5. Ibid. 403.
6. As 'Roman Nights' and 'Venetian Nights'.
7. Pennell, *Nights*, 117.
8. Ibid. 118.
9. Ibid. 119.
10. Ibid. 188, 189.
11. Ibid. 20, 21.
12. Pennell, *Our Philadelphia*, 151.
13. Pennell, *Nights*, 229.
14. Clarke, '1894'.
15. Ibid. 23–4.
16. Ibid. 24.
17. Ibid. 35.
18. Ibid. 41.
19. Ibid.
20. Ibid. 45.
21. Ibid. 45–6.
22. Ibid. 68.
23. Ibid. 69.
24. Ibid. 74.
25. Ibid. 90.
26. Ibid. 91–2.
27. Ibid. 112.
28. Ibid. 113.
29. Ibid.
30. Birketts, *Art of Time*, 17.
31. Pennell, *Nights*, 212.
32. Pennell, 'London', 398.
33. Ibid. 407.
34. Ibid. 228.
35. Ibid. 245.
36. Ibid. 302.
37. Ibid. 227.
38. Ibid. 298.
39. Ibid. 303.
40. Ibid.
41. Ibid. 298.
42. Ibid. 199.
43. Malpezzi Price, 'Elizabeth Robins Pennell', 5.
44. Lynd, Review of *Nights*, 1329.
45. Pennell, 'London', 404.
46. Ibid.

47. Pennell, *Life and Letters*, 2: 143.
48. Ibid. 2: 134.
49. Ibid. 2: 158.
50. Pennell, *Lovers*, 94–5.
51. Ibid. x.
52. Ibid. 160.
53. Ibid. 34–5.
54. Review of *The Lovers*, *Boston Transcript*, 6.
55. Review of *The Lovers*, *New York Times*.
56. Pennell, 'Stranger', 889.
57. Ibid. 890.
58. Pennell, *Nights*, 300.

Bibliography

Birketts, Sven. *The Art of Time in Memoir: Then, Again*. Minneapolis: Graywolf, 2007.

Clarke, Meaghan. '1894: The Year of the New Woman Art Critic'. Accessed 1 August 2019. http://www.branchcollective.org/?ps_articles=meaghan-clarke-1894-the-year-of-the-new-woman-art-critic

Lynd, Robert. Review of *Nights*, by Elizabeth Robins Pennell. *Publishers' Weekly* 89 (1916): 1329.

Malpezzi Price, Paola. 'Elizabeth Robins Pennell: Pioneer Bicycle Tourist in Italy, Travel Writer, and Cycling Advocate for Women'. *Lingua Romana* 11, 2 (Fall 2013): 4–20.

Morse Jones, Kimberly. *Elizabeth Robins Pennell: Nineteenth-Century Pioneer of Modern Art Criticism*. Burlington, VT: Ashgate, 2015.

Pennell, Elizabeth Robins. 'Les Amoureux; An Idyl of a London Garret'. *Century* (June 1911): 217–23.

Pennell, Elizabeth Robins. *The Life and Letters of Joseph Pennell*. 2 vols. Boston: Little, Brown, 1929.

Pennell, Elizabeth Robins. 'London Under the Shadow of War'. *Atlantic Monthly* (March 1915): 397–407.

Pennell, Elizabeth Robins. *The Lovers*. London: Heinemann, 1917.

Pennell, Elizabeth Robins. *Nights: Rome, Venice, in the Aesthetic Eighties; London, Paris, in the Fighting Nineties*. Philadelphia: Lippincott, 1912.

Pennell, Elizabeth Robins. *Our Philadelphia*. Philadelphia: Lippincott, 1914.

Pennell, Elizabeth Robins. 'Roman Nights'. *Atlantic Monthly* (November 1911): 675–85.

Pennell, Elizabeth Robins. 'A Stranger in My Native Land'. *North American Review* (June 1918): 880–90.

Pennell, Elizabeth Robins. 'Venetian Nights'. *Atlantic Monthly* (October 1912): 527–36.

Review of *The Lovers*, by Elizabeth Robins Pennell. *The Boston Transcript*, 20 June 1917.

Review of *The Lovers*, by Elizabeth Robins Pennell. *New York Times*, 17 June 1917.

Afterword

Kimberly Morse Jones

Elizabeth Robins Pennell's prolificacy as a writer is incontrovertible, and, given that she did not have access to today's time-saving technologies, quite remarkable. But such astounding output, as Jane Gabin pointed out in this volume, did not come easily. Pennell herself seemed intent on driving this point home, as the first line of *Nights: Rome, Venice, in the Aesthetic Eighties; London, Paris, in the Fighting Nineties* (1916) reads: 'If I wrote the story of my days during these last thirty years, it would be the story of hard work.'[1] And again in *Our Philadelphia* (1914) she described her job as 'downright hard labour'.[2] Pennell could probably be classified as what we would today call a workaholic. She had no family for which to care, or religious, political or social affiliations with which to be involved; nor did she have any hobbies unrelated to work. Rather, her life centred utterly on her career. It is the concept of work and how it relates to professional nineteenth-century women like Pennell that I wish to briefly discuss in closing.

Pennell's insistence on stressing her proclivity for work is noteworthy, especially when one considers, as Dave Buchanan explains in chapter 1 of this volume, that she rarely wrote about herself and tended to downplay her accomplishments. That she chose to highlight this particular aspect of her life in two semi-autobiographical writings is therefore revealing. It appears that Pennell was concerned that the seemingly carefree and cosmopolitan nature of her work might obscure the true graft her profession entailed. 'No doubt the work often looked to others uncommonly like play, but it was work all the same', she wrote.[3] This is understandable given titles like *Play in Provence* (1892) and *The Stream of Pleasure: A Narrative of a Journey on the Thames from Oxford to London* (1891). Pennell refused to expand upon her working habits, however, arguing, in her

usual self-deprecating way, that while '*how* I worked during all those long hours is to me an all-absorbing and edifying spectacle, I am not so vain as not to realize that I must be the only person to find it so'.[4]

Pennell's withholding of details regarding her working habits stemmed from the idea, prevalent in the artistic circles in which she moved, that work should appear spontaneous and effortless, in spite of involving a great deal of mental exertion. In her biography of James McNeill Whistler, Pennell's primary object of devotion, she explained that the artist made a conscious decision to 'conceal[] every trace of toil'[5] in his work. 'Yet', she continued, 'his letters . . . are full of regret for his slowness . . . No one knew the hard work that produced the simplicity.'[6] She too admitted to working slowly and with great care:

> [N]obody could know . . . how slow I have always been with my work and also, to do myself justice, how conscientious as I do not mind saying, though to be called conscientious by anybody else would seem to me only less offensive than to be called good-natured or amiable.[7]

Like Whistler, Pennell did not object to hard work itself but rather to the outward display of hard work; art (or writing) should, therefore, eschew the appearance of being overwrought or overworked.[8]

Although Pennell refused to detail her working habits in *Nights*, she did offer a glimpse of her approach to art criticism in *Our Philadelphia*, writing:

> As a critic I never could get to the point of writing round the pictures and saying nothing about them like many I know for whom five minutes in a gallery sufficed, nor to be frank, did I try to. Neither could I hang an article on picture. I might envy George Moore . . . because he could and did. I can remember him at an Academy Press View making the interminable round with a business-like briskness until, perhaps in the first hour and the last room, he would come upon the painting that gave him the peg for his eloquence, make an elaborate study of it, tell us his task was finished, and hurry off exultant. But envy him as I might, I couldn't borrow his briskness. I had to plod on all morning and again all afternoon until the Academy closed, to look at every picture before I could be sure which was the right peg or whether there might not be a dozen more pegs and more. And I had to collect elaborate notes, not daring to trust my memory alone, and after that to re-write pages that did not satisfy me.[9]

Pennell's acute awareness that her process – looking, looking some more, note-taking, writing and rewriting – contrasted with that of

her fellow New Art Critic George Moore suggests a degree of self-consciousness. Living today in an age that has given rise to the Slow Movement, it is easy to appreciate Pennell's modus operandi and sympathise with her for feeling uneasy about the pace at which she worked. Yet her apologetic tone, given her penchant for irony, which Alex Wong examines in these pages, might equally be interpreted as an oblique attack on Moore's slipshod style, as suggested particularly in the first line of the passage quoted above.

Pennell's work required both physical and mental exertion. After all, she did cycle thousands of miles, including a journey over the Alps, and walk across Scotland for her and Joseph's books and magazine articles. Trudging through Academy on press view days as an art critic must also have been physically taxing. Indeed, Pennell remarked: 'Just to see the Academy meant an honest day's labour and in Paris there were two *Salons*, each immeasurably bigger.'[10] She once proclaimed, 'I have never yet managed to sit down to my day's work without the feeling which I imagine must be the navvy's [digging labourer's] as he starts out for his day's digging in the streets.'[11] To some the act of writing might conjure up images of sitting leisurely at home in front of a desk, but Pennell explained that her profession, in addition to 'days upon days at [her] desk writing', 'called for research, days of reading in the Art Library at South Kensington, the British Museum, the London Library, days of seeing people and places, days of travelling'.[12] While arguably the effort of the navvy digging the streets far outweighs that of Pennell traversing the city, both do require a degree of physicality. Pennell's statement shows that her work necessitated not only a metaphorical public presence in the form of a disembodied voice in the press, but also, as Meaghan Clarke highlights in her chapter, a literal, corporeal presence in public spaces, both of which challenged late-nineteenth-century gender norms. What is more, Pennell's art criticism took her to unsavoury working-class neighbourhoods in London's East End, spaces bourgeois women generally avoided,[13] thus narrowing the metaphorical gap between herself and the navvy: just as he enters her neighbourhood to work, she enters his for the same purpose. (Of course, the chasm between Pennell, a middle-class female writer, and the navvy, a working-class male labourer, could not be narrowed in her day, a point of which she was well aware.)

Pennell's association between herself and the labourer could be interpreted as an attempt to tap into the notion of the virtuous working-class hero, as promoted in the writings of Thomas Carlyle and John Ruskin, as well as Ford Madox Brown's painting *Work* (1863), to boost her own heroism. These figures considered work

'a moral imperative that could overcome the spiritual threat of Victorian materialism',[14] an idea that came to be known as the 'gospel of work'. In fact, Pennell's association of the writer and the navvy digging the streets parallels Ruskin's association of the writer and the agricultural labourer digging the earth. Victorian intellectuals, such as Carlyle, Ruskin and Brown, had a deep-seated anxiety about the value of their intellectual work in comparison to that of manual labourers, which benefitted the country both economically and morally. Tension regarding the value of manual versus intellectual labour, the latter being associated with idleness, stemmed from the preceding century and was perpetuated throughout the nineteenth century.

Pennell's own writings, such as *A Canterbury Pilgrimage*, wherein she romanticises hop pickers, also glorify manual labour. This did not extend to work that takes place within domestic spaces, however. As I mention in chapter 10, she often showed a disdain for her servants. Unlike the hop pickers and the navvies, from whom Pennell maintained a comfortable distance, the housekeepers and charwomen occupied space in her home, making it difficult to maintain the position of the aesthetic, disinterested observer she often adopted in her writings. Their problems – poverty and alcoholism, for example – inconveniently became hers. Rather than heroines, these women became characters in a Zola novel.

Pennell's alignment with Ruskin, whom she frequently derided in her writings, in part because of his famous enmity with Whistler, is surprising. However, for Pennell work was not a moral imperative as it was for Ruskin, but rather was closely associated with her own work as a writer, and as such links her to another one of her idols – Walter Pater, who, as Marcus Waithe has explained, conceived of literature as a form of labour.[15] Contrary to popular belief, the 'gospel of work' and Aestheticism, which was associated with idleness, were not necessarily antithetical. According to Richard Adelman, Carlyle made room for passive contemplation in his *Sartor Resartus* (1833–4),[16] and Pater appears to have embraced the value of work both in his personal writings and in his essay 'Style' (1888), in which he recounted Gustave Flaubert's inducement to 'Work! God wills it.'[17] Although possibly parodic, due to the Carlylean tone of this part of the essay, 'Style' nonetheless indicates that Pater viewed writing as work. In addition to Pater, Pennell, particularly in her reference to digging, may have been influenced by another fellow aesthete, Oscar Wilde, who, along with other 'amateur navvies', participated in Ruskin's scheme for Oxford undergraduates to repair a road in the nearby village of Ferry Hinksey (now North Hinksey).[18]

For Pennell to compare her work to that of a manual labourer would have been far more subversive than it would have been for Ruskin or Pater, as the Victorian working-class hero was, by definition, male. (This might account for the contempt she felt for her all-female domestic staff, whose work was not deemed heroic.) According to Martin A. Danahay, 'The Victorian period registered the most extreme form of gender segregation yet seen in an industrialized nation.'[19] 'This gender segregation', he continued, 'was articulated and reinforced by images and texts that either implicitly or explicitly argued that work was "manly" and, therefore, inappropriate for women.' Pennell thus challenged an existing division of labour. She was not alone, however, as journalism allowed her and other women journalists unprecedented freedoms.[20] These 'New Women', although many of them, including Pennell, would not have identified as such,[21] 'helped subvert the gendered definition of "man's work" and provoked a crisis of male self-definition'.[22] The presence of women in traditionally male-dominated spaces compounded existing anxiety amongst middle-class men about the association between intellectual male labour, defined in opposition to the 'manliness' of manual labour, and femininity, as the majority of their work was carried out in the domestic sphere.

Professional work, however, meant something different for women from what it did for men in the late nineteenth century. Women's forays into new fields, including journalism, have been seen by some scholars as evidence of a newfound confidence. This may be true to a certain extent. That Pennell took on the daunting task of writing a biography of Mary Wollstonecraft, an undertaking, as James Diedrick concludes here, fraught with difficulty, after only having published a handful of articles, suggests a degree of confidence and even audacity. Role models like A. Mary F. Robinson and Vernon Lee with equally strong work ethics probably helped buoy Pennell. But, as Gillian Sutherland has argued, the perception of the intrepid New Woman was mostly a media construct and not a reality.[23] This argument helps make sense of Pennell's paradoxical self-assurance and self-abnegation, observed by Buchanan in these pages.

While a career may not have provided middle-class women like Pennell with the fully fledged confidence some scholars have assumed, it did impart to them a degree of dignity that had heretofore been denied them. For Pennell, the dignity of work, as discussed in a chapter from *Our Philadelphia* titled 'The Miracle of Work', resulted from the process of self-discovery:

From the moment I began to work, I began to see everything from the standpoint of work, and it is wonderful what a fresh and invigorating standpoint it is. I began to see that everything was not all of course and matter of fact, that everything was worth thinking about. Work is sometimes said to help people put things out of their minds, but it helps them more when it puts things into their minds, and this is what it did for me. Through work I discovered Philadelphia and myself together.[24]

Similarly, reflecting back on her life in *Nights*, Pennell pronounced,

I see in memory my life by day as one long vista of work. It is mostly a beautiful vista, the more beautiful, I am ready to admit, because the work I owed the beauty to forced me to keep my eyes open and my wits about me.[25]

It is clear from these passages that work satisfied Pennell's intellectual curiosity and gave her, like many people, a sense of purpose without which she might have floundered.

It is important to note, however, that Pennell identified work itself, not necessarily the act of writing, as the catalyst for her new worldview. To return to her digging metaphor mentioned earlier, it is worth noting that she was not the first woman writer to associate writing with digging. The French writer George Sand (nom de plume of Amantine Lucile Aurore Dupin) once commented that she 'could not bear to be idle and useless', and admitted that while writing allowed her the independence she desired, she would rather have supported herself by digging the earth, a job, like that of the navvy, deemed inappropriate for bourgeois women. Unlike Sand, it is doubtful that Pennell would have changed places with the labourer, but nevertheless this statement is interesting because it suggests that writing was thrust upon Sand as one of a handful of viable career options for women. While we will never know precisely how Pennell felt about writing, we should not assume that it provided her with the fulfilment one might assume; she could have found satisfaction in other professions, but they were closed off to her.

Sutherland has argued that whatever newfound self-assurance the New Woman did possess stemmed from financial independence. Pennell's reminiscences support this assertion: 'My first cheque only whetted my appetite, but, in fairness to myself I must explain, through no more sordid motive than my desire to become my own bread-winner.'[26] While her declaration comes across as confessional in tone, Pennell had no need to feel ashamed, for, as Sutherland has

suggested, 'controlled adequate resources' allowed women choice, which if they wished enabled them to 'challenge prevailing social conventions'.[27]

That Pennell was driven to some degree by remuneration is evidenced by her own admission that during the 1890s she began limiting the number of long magazine articles and books she wrote in order to concentrate on 'doing' art criticism because writing newspaper articles brought in more income relative to the amount of time required.[28] Her emphasis on pay negates the romantic ideal of a great writer driven by genius alone. Rather, Pennell explained: 'My task was too laborious for the fine frenzy, or the inspired flights, reputed to be the reward of the literary life.'[29] D. J. Trela has exhorted 'modern observers of a nineteenth-century milieu, [to] be cautious about playing [the] "economic" card and ascribing mediocrity to writers' who write for financial reasons.[30] (Indeed, over the past few decades several scholars have done much to rectify this perception by highlighting the value of Victorian periodical writing, including that produced by women.[31]) One should be especially cautious about devaluing the work of women writers for this reason, as they were particularly susceptible to this type of criticism. According to Penny Boumelha, there exists an 'association of femininity with trash: with commerce, with the values of the marketplace, alienated labour, and inferior aesthetic values'.[32] It is hoped that, having highlighted the significance of Pennell's literary contributions in this volume, we can safely jettison this association as it pertains to her work and rightfully place her alongside other prominent and innovative thinkers of her day.

Notes

1. Pennell, *Nights*, 13.
2. Pennell, *Our Philadelphia*, 242.
3. Pennell, *Nights*, 13.
4. Ibid. 22.
5. Pennell and Pennell, *Life*, 163.
6. Ibid. 165.
7. Pennell, *Nights*, 229.
8. Barringer, *Men at Work*, 319.
9. Pennell, *Nights*, 229–30.
10. Ibid. 230.
11. Pennell, *Our Philadelphia*, 242.
12. Pennell, *Nights*, 21.
13. Clarke, 'New Woman', 38.

14. Danahay, *Gender at Work*, 125.
15. See Waithe, 'Strenuous Minds'.
16. Adelman, *Idleness*, 84.
17. Waithe, 'Strenuous Minds', 159. Pater's 'Style' originally appeared in the *Fortnightly Review* in December of 1888. The essay was included in Pater's *Appreciations*, published the following year.
18. See Anon., 'Amateur Navvies'.
19. Danahay, *Gender at Work*, 1.
20. See Clarke, 'New Woman'.
21. See Schaffer, 'Nothing but Foolscap and Ink'.
22. Danahay, *Gender at Work*, 6. See also ibid. 'Conclusion'.
23. Sutherland, *In Search of the New Woman*, 8.
24. Pennell, *Our Philadelphia*, 233–4
25. Pennell, *Nights*, 14.
26. Pennell, *Our Philadelphia*, 244.
27. Sutherland, *In Search of the New Woman*, 8.
28. Pennell, *Our Philadelphia*, 244; Pennell, *Nights*, 20.
29. Pennell, *Our Philadelphia*, 242.
30. Trela, 'Introduction', 3.
31. I am referring to the work of Linda H. Peterson, Barbara Onslow, Laurel Brake, Margaret Beethem, Maria Damkjaer, Alexis Easley, Marianne Van Remoortel and F. Elizabeth Gray, amongst others.
32. Boumelha, 'Women of Genius', 178.

Bibliography

Adelman, Richard. *Idleness and Aesthetic Consciousness, 1815–1900.* Cambridge: University of Cambridge Press, 2018.

Anon. 'Amateur Navvies at Oxford'. *The Graphic* (27 June 1874): 607.

Barringer, Tim. *Men at Work: Art and Labour in Victorian Britain.* New Haven and London: Paul Mellon Centre for Studies of British Art and Yale University Press, 2005.

Boumelha, Penny. 'The Women of Genius and the Women of Grub Street: Figures of the Female Writer in British *Fin-de-Siècle* Fiction'. *English Literature in Transition* 40 (1997): 164–80.

Clarke, Meaghan. 'New Woman on Grub Street: Art in the City'. In *Gissing and the City: Cultural Crisis and the Making of Books in Late Victorian England*, ed. John Spiers, 31–40. Basingstoke: Palgrave Macmillan, 2005.

Danahay, Martin A. *Gender at Work in Victorian Culture: Literature, Art and Masculinity.* London and New York: Routledge, 2016.

Pennell, Elizabeth Robins. *Nights: Rome, Venice, in the Aesthetic Eighties; London, Paris, in the Fighting Nineties.* Philadelphia: Lippincott, 1916.

Pennell, Elizabeth Robins –. *Our Philadelphia*. Philadelphia: Lippincott, 1914.

Pennell, Elizabeth Robins and Pennell, Joseph. *The Life of James McNeill Whistler*. London: Heinemann, 1908.

Schaffer, Talia, 'Nothing but Foolscap and Ink'. In *The New Woman in Fiction and in Fact: Feminisms*, ed. Angelique Richardson and Chris Wallis, 39–53. Basingstoke: Palgrave Macmillan, 2001.

Sutherland, Gillian. *In Search of the New Woman: Middle-Class Women and Work in Britain, 1870–1914*. Cambridge: Cambridge University Press, 2015.

Trela, D. J. 'Introduction: Communities of Women, Widening Spheres'. *Victorian Periodical Review* 31 (1998): 1–8.

Waithe, Marcus. '"Strenuous Minds": Walter Pater and the Labour of Aestheticism'. In *The Labour of Literature in Britain and France, 1830–1910: Authorial Work Ethics*, ed. Marcus Waithe and Claire White, 147–65. London: Palgrave Macmillan, 2018.

Index